GERHARD RICHTER

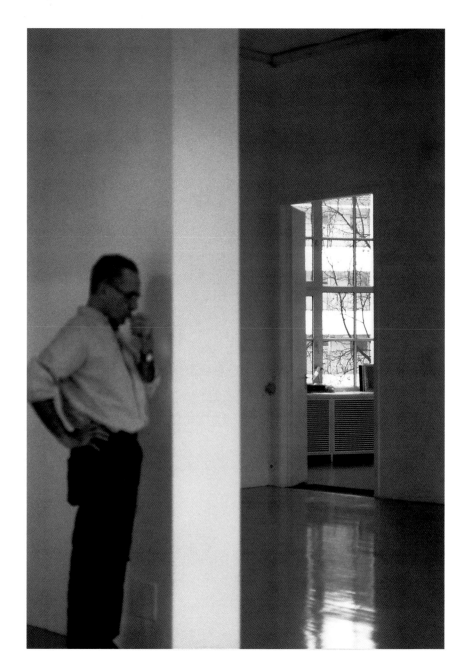

GERHARD RICHTER, 1990.

GERHARD RICHTER

A LIFE IN PAINTING

DIETMAR ELGER

TRANSLATED BY
ELIZABETH M. SOLARO

THE UNIVERSITY OF CHICAGO PRESS CHICAGO AND LONDON

DIETMAR ELGER is director of the
Gerhard Richter Archive and chief curator
at the Galerie Neue Meister, Staatliche
Kunstsammunlungen Dresden. He is
former curator for painting and sculpture
at the Sprengel Museum in Hannover.
Between 1984 and 1985 he was the
secretary in Gerhard Richter's studio. He
has organized numerous exhibitions on
modern and contemporary art and has
written and edited their accompanying
catalogs.

ELIZABETH M. SOLARO is a translator of
works from the German.

© 2002 DUMONT LITERATUR AND KUNST VERLAG, KÖLN
© 2002 FÜR DIE ABGEBILDETEN WERKE VON GERHARD RICHTER BEIM KÜNSTLER
ENGLISH TRANSLATION © 2009 BY THE UNIVERSITY OF CHICAGO
ALL RIGHTS RESERVED. PUBLISHED 2009
PRINTED IN CHINA

18 17 16 15 14 13 12 11 10 09 1 2 3 4 5

ISBN-13: 978-0-226-20323-2 (CLOTH)
ISBN-10: 0-226-20323-9 (CLOTH)

LIBRARY OF CONGRESS CATALOGING-IN-PUBLICATION DATA
ELGER, DIETMAR.
 [GERHARD RICHTER, MALER. ENGLISH]
 GERHARD RICHTER: A LIFE IN PAINTING / DIETMAR ELGER ; TRANSLATED BY
ELIZABETH M. SOLARO.
 P. CM.
 INCLUDES BIBLIOGRAPHICAL REFERENCES AND INDEX
 ISBN-13: 978-0-226-20323-2 (CLOTH : ALK. PAPER)
 ISBN-10: 0-226-20323-9 (CLOTH : ALK. PAPER)
 1. RICHTER GERHARD, 1932– ——CRITICISM AND INTERPRETATION. I. TITLE.
ND588.R48E4413 2099
759.3——DC22
[B]
 2009030840

♾ THE PAPER USED IN THIS PUBLICATION MEETS THE MINIMUM REQUIREMENTS OF THE
AMERICAN NATIONAL STANDARD FOR INFORMATION SCIENCES——PERMANENCE OF PAPER
FOR PRINTED LIBRARY MATERIALS, ANSI Z39.48-1992.

CONTENTS

ILLUSTRATIONS

This book has been modestly re-
vised from the German edition, published by Dumont, to make it more acces-
sible to the Anglophone reader. One of the virtues of this biography is that it is
steeped in German history and culture; however, details that are well known in
Germany may be unfamiliar to most Americans and others—the significance of
July 20, for example, or the particulars of the Baader-Meinhoff affair. This edi-
tion establishes a broad historical context for these and other events and provides
background on people, places, and post–World War II German politics that will
allow readers to better appreciate their impact on the life and work of Gerhard
Richter and his many friends, rivals, and associates.

Richter describes a key element of his painting practice—the blurring of
forms and obscuring of his own process—using the coined word *Vermalung*,
which has no precise equivalent in English. The translator here follows the
artist's lead, rendering it as "inpainting." A note exploring the nuances of the
term accompanies the detailed discussion of Richter's handling of paint in
chapter 7.

Another term in need of comment is *Abstraktes Bild*, the title Richter gave many
of his works starting in the late 1980s. *Bild* is generally translated as "picture"—
and the curator Robert Storr has remarked that the designation "reinforces the
impression . . . of shoals, riptides, and cresting waves" amid the paintings' scraped

and layered pigments. In keeping with Dietmar Elger's preference, however, the title is here translated as *Abstract Painting*.

Unattributed quotations from Richter, Kasper König, and others come from recorded interviews conducted by Elger in 2001, in preparation for this biography, or from subsequent conversations.

GERHARD RICHTER

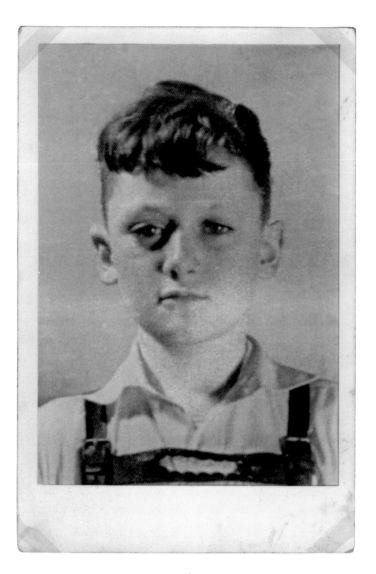

FIG. 1.1. GERHARD RICHTER, CIRCA 1938.

1 DRESDEN

The city of Dresden is one of Germany's oldest urban centers. Located near the country's eastern border, it was, before World War II, a charming baroque city and an important government seat, internationally renowned as a place of great culture and learning. It was in Dresden that the great Romantic painter Caspar David Friedrich had plied his trade in the early nineteenth century, and by 1900 the city had become a bustling hub of contemporary art.

Dresden is also the birthplace of Gerhard Richter, one of Germany's most important postwar painters and, indeed, one of the most esteemed artists in the world today. Richter was born on February 9, 1932, in the Hospital Dresden-Neustadt, not far from the city center. Of course 1932 is important in German history for other reasons as well. Within months of Richter's birth, Adolf Hitler's National Socialist German Workers' Party gained a majority in the Reichstag, or national parliament, and on the eve of the boy's first birthday, Hitler was appointed chancellor of Germany.[1] Taking advantage of a fire set in the parliament building, possibly by his own people, Hitler then hastened to consolidate his power and to launch the radical military regime that came to be known as the Third Reich. There is no need to dwell here upon the countless atrocities committed by Hitler and the Nazi military, which very nearly extinguished whole cultures and their communities. Suffice it to say that Dresden was a singular tragedy. By the end of the war, it would lie in rubble, irremediably transformed, first by Hitler and his

drastic policies, and then by Allied bombing, which left vast sections of the city in cinders and many thousands of its inhabitants dead.

Richter was still only a boy when the war ended in Europe. Yet the artist recalls growing up an ordinary child in an ordinary household struggling to cope with the extraordinary pressures of National Socialism. His childhood, he says, was largely pleasant if uneventful—though he is quick to admit that his memories are shaped by the self-absorbed perspective of youth and may not always reflect the facts (fig. 1.1).

Gerhard's mother, Hildegard Richter, neé Schönfelder, was twenty-five years old when the future artist, her first child, was born. Hildegard came from a solidly middle-class family who were the proprietors of a large brewery in the Bavarian city of Kulmbach, but throughout her life, first as a daughter and then as a wife, she never quite attained the elevated lifestyle she desired. Her father, Ernst Alfred Schönfelder, had been a talented concert pianist who unfortunately demonstrated little talent for brewing. Within a few years of giving up his vocation to take the helm of the family enterprise, he had propelled it into bankruptcy. Herr Schönfelder then moved his family to Dresden with the idea that they could live on their investments while he pursued a new career in music. This project never amounted to anything more than a hobby, but still, the Schönfelders were in Dresden, which suited Hildegard. She adored the bustling city and growing up there together with her younger sister, Marianne, and older brothers, Alfred and Rudolf.

In Dresden Hildegard trained as a bookseller, a highly esteemed profession in Germany. She had a passion for literature and music and, like her father, played the piano well. "My mother had such an elitist way about her," Gerhard said decades later. "To be a meaningful person, from her perspective, one had to be a writer or artist or intellectual."[2] However, she never displayed any particular affinity for the visual arts.

Gerhard's father, Horst Richter, had studied mathematics and physics at the Technische Hochschule in Dresden and taught at a gymnasium, the equivalent of an American high school. Horst and Hildegard married in 1931, but it was not a happy match: the couple's interests and values were entirely different. Hildegard enjoyed a brisk social life, was a voracious reader, and had many cultural interests, while Horst seems to have been more of a homebody and less driven to succeed. Dogged by chronic unemployment in the late 1930s, as Germany's social, economic, industrial, and educational systems were transformed under National Socialism and as the country ramped up for war, Horst finally landed a teaching position in Reichenau, a town today called Bogatynia and located in Poland, about eighty kilometers south of Dresden. When the Richters moved there, Reichenau had a population of about 7,400 and supported a variety of industries, including cement manufacturing, coal mining, and textiles. The most attractive thing Richter recalls about Reichenau was that it had a public swimming pool. Gisela, Gerhard's younger sister, was born there in November 1936.

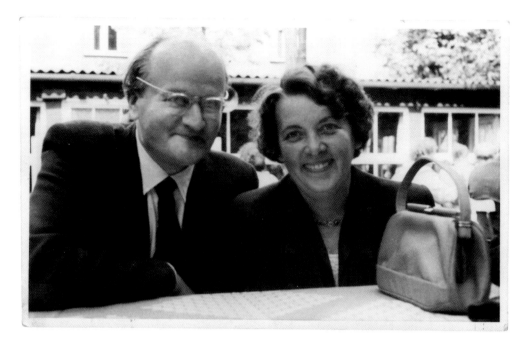

FIG. 1.2. HORST AND HILDEGARD RICHTER, 1956.

The move from the lovely, bustling metropolis of Dresden, with its theaters, concerts, and cinemas, to Reichenau, a drab locale steeped in heavy industry, was a blow to Hildegard—although it very likely saved her life and those of her children. The small town offered little stimulation, and to make matters worse, she regarded her husband as her intellectual inferior. Horst was a deeply religious man who sustained himself by attending Protestant Evangelical services every week. Hildegard countered his piety with her own fierce beliefs, absorbed from the writings of Friedrich Nietzsche.

Because Horst was a teacher, he was forced to join the National Socialist Party, though, as Gerhard remembers it, his father never bought into its ideology. In fact Richter does not recollect that anyone in either of his parents' families was an avid supporter of Nazism; like so many other German families at the time, the Richters and the Schönfelders were apolitical. In the countryside, in little towns like Reichenau and the even smaller town of Waltersdorf, where his parents later moved, they were spared the necessity of attending party rallies or participating in special deployments. Later, in 1942, with the war in full force, Gerhard was conscripted into the Pimpfen, the program that prepared children to become members of the Hitler Youth. Still, he managed to avoid most of the odious paramilitary field exercises and tent camps thanks to his mother, who willingly filled out and signed his absence forms, claiming illness.

Gerhard, who went by the nickname Gerd, was his mother's favorite, and Hil-

degard projected the full sum of her unfulfilled hopes and ideals onto her son. She encouraged his early interest in Nietzsche and in Goethe, Schiller, and other classic writers, whose books she kept about the house. She had nothing but reproach for Horst, given his failure to distinguish himself, going so far as to intimate to young Gerd that Horst may not even have been his father (fig. 1.2).

On September 1, 1939, when Gerd was seven, Hitler's troops invaded Poland, marking the start of World War II. Almost immediately, Horst Richter was drafted into the military and mobilized to the eastern front. He served in Hitler's military for the duration of the European campaign, with the result that he was absent during the most crucial years of his son's development. The war was hard on the Richters, as on other families, in ways that belie a little boy's cheerful memories; it touched them in ways Gerhard would begin to comprehend only much later, as an adult. His mother's brother Rudi was killed early in the war. Her sister, Marianne, was first sterilized and then starved to death by the Nazis in the Psychiatrische Landesanstalt Großschweidnitz, a hospital for the mentally disabled. Richter would commemorate the two in paintings from 1965: *Uncle Rudi* (CR 85; fig. 5.9) and *Aunt Marianne* (CR 87; fig. 5.5).[3]

In 1943 Hildegard moved her children out of Reichenau to the even smaller town of Waltersdorf (population 2,500), in the extreme southeast corner of Germany, on the border with the current Czech Republic, about twelve kilometers from Zittau.[4] There the family lived on the village's eastern edge, in subsidized housing, which Richter would later recall as "depressing." The austerity of the Richters' financial situation made it necessary for Hildegard to sell her beloved piano.

As fighting raged on, Horst Richter was shifted to the western front, where he was captured by the Allies. He spent the rest of the war in an American prisoner of war camp. Finally released in 1946, he made his way home to an indifferent wife and to children who greeted him as a stranger. As with many returning veterans, Horst's presence served only to disrupt the harmony of the family. Through a series of moves and good fortune, Gerhard and his sister had been spared any direct experience of the horrors of war. In fact, thirteen-year-old Gerd found the end of the campaign to be a great adventure, replete with genuine rifles and pistols. He and his friends discovered discarded weapons everywhere and held target practice in the woods surrounding Waltersdorf. "I always found that interesting—when things go bang," he later told Jürgen Hohmeyer of the Hamburg-based newsmagazine *Der Spiegel*.[5] Even today, with unusual candor, Richter stands by his youthful enthusiasm: "That was the most exciting time of my life, and I think of it fondly."

For a long time after the war, groceries were hard to come by. Waltersdorf, located in eastern Germany, had come under the control of the Soviets as a result of the Potsdam Agreement, drafted by the USSR, the United States, and the United Kingdom to regulate the postwar occupation and reconstruction of Germany

and other territories. Gerd and his father would take to the road, sometimes for days, trying to sell various household objects or trade them for food. As a former Nazi Party member, Horst would never again be allowed to teach. Desperate for employment, he finally went to work as a laborer in a textile mill in Zittau.[6]

Gerd had already begun to commute to Zittau to attend a college-preparatory school. But, alas, he failed nearly every subject; he even brought home poor grades in drawing. After a year he was forced to drop out and instead enrolled in a vocational school, also in Zittau, that offered courses in stenography, bookkeeping, and Russian. Two years later, in 1948, he graduated.

The months and years immediately following the war were, on the one hand, chaotic and difficult but, on the other, characterized by an atmosphere of political awakening, possibility, and intellectual freedom—at least for a while. The provisional government, the Sowjetisches Besatzungs-Regime, donated many books expropriated by the Soviets from private collections to public libraries, which put long-forbidden literature again within reach. In the local library in Waltersdorf, Gerhard devoured books by authors who had been persecuted by the Nazis: Thomas Mann, Lion Feuchtwanger, Stefan Zweig. Their writings awoke in him a nascent literary ambition, and the teenager tried his hand at romantic verse. At the same time, an endless supply of illustrated books prompted his own first drawings. Richter vividly remembers a nude figure copied from a book in 1946 as his earliest serious effort. And he recalls his parents' reaction when they found the drawing under his bed. For once, Horst and Hildegard agreed on something: both were shocked at the work's erotic content—but enormously proud of their son's obvious talent.

When Gerhard heard one day that Hans Lillig, an artist from the region, had come to Waltersdorf to paint a mural at the elementary school, he rushed over to see. It was his first encounter with a professional artist, and he was allowed to watch Lillig work. He marveled at the painter's technique and the progress of the mural, a fascination that may have lingered and perhaps even affected his decision later in art school to specialize in the genre. Meeting Lillig also afforded the budding artist the chance to show some of his own drawings to a "colleague" for critique.

By 1947 things were starting to come together for Gerhard: by day he attended vocational school in Zittau, and at night he took a painting class. Before the end of the course he realized, with a certain satisfaction, that no one at the school had the skill to teach him anything more. He began to concentrate intently on art, experimenting with various media, painting watercolors, and collecting old master prints published by E. A. Seemann Verlag in Leipzig (fig. 1.3). In one self-portrait from 1949 (fig. 1.4), Richter painted himself brimming with confidence. The gleaming right eye fixes the viewer as if to proclaim the young artist's talent, while the left side of the face and the shoulder recede into darkness. "It had to do with being an introvert. I was alone a great deal and drew

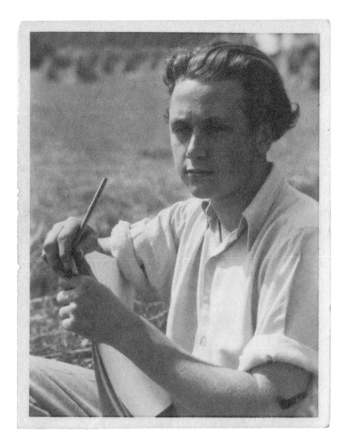

FIG. 1.3. GERHARD RICHTER, 1950.

a lot." He remembers having grown increasingly private after his family moved to Waltersdorf. "Automatically I was an outsider. I couldn't speak the dialect and so on. I was at a club, watching the others dance, and I was jealous and bitter and annoyed. So in the watercolor all this anger is included. . . . It was the same with the poems I was writing—very romantic, but bitter and nihilistic, like Nietzsche and Hermann Hesse."[7]

By the time Gerhard finished vocational school in 1948, he had moved out of his parents' house in Waltersdorf and was living in a residence for trade apprentices in Zittau. Though deeply preoccupied with art and art history, he was also a pragmatist and thus decided to pursue a more sensible vocation. He considered various options, including becoming a forest ranger; that inspiration was short-lived, however, as the program involved a course of intense physical training and, according to Richter, he simply was not strong enough to qualify. Lacking a gymnasium diploma meant professions such as medicine and dentistry were also out of the question, so his mother tried to arrange a place for him in a printing plant. This he rejected after the first interview, repulsed by the strong smell of chemicals.

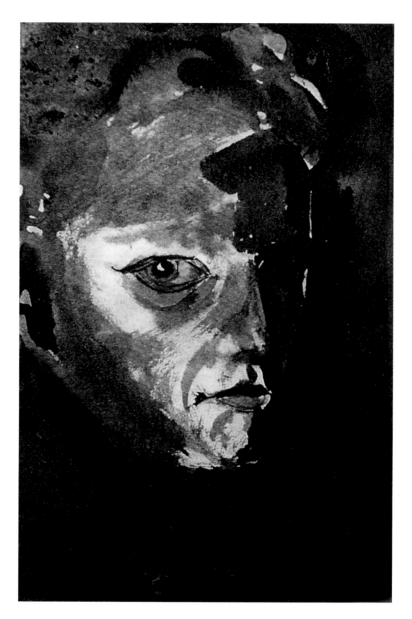

FIG. 1.4. *Self-portrait*, 1949. WATERCOLOR ON PAPER. LOCATION UNKNOWN.

With his talent for drawing, young Gerhard finally secured a position with a sign painter in Zittau. He spent about six months cleaning and priming shop signs, preparing them for repainting by other employees. Bored, he quit the job in February 1950 and hired on as an assistant set painter at the municipal theater in Zittau, where he painted the sets for productions of Goethe's *Faust* and *Wilhelm Tell*. This was much more to his liking. "I enjoyed the work, which had at least something to do with art when we painted the large backdrops."[8] When the season ended, as was customary, the employees were assigned less glamorous jobs such as tending to the building's upkeep. Told to repaint the stairway, Gerhard refused. By then, five months into the job, the apprentice saw himself as a full-fledged artist and above such things. He was abruptly fired.

Somewhat later Richter would claim that he had also apprenticed with a photographer—a bit of misinformation that still occasionally makes it way into his biography.[9] He did actually receive a simple plate camera from his mother as a Christmas present in 1945, and the father of his friend Kurt Jungmichel operated a photography lab in Waltersdorf, where Gerd was allowed to develop film and work on his own pictures. The 1965 painting *Cow II* (*Kuh II*; CR 88) is based on one of his earliest photographs. As this and other of Richter's gray photo-paintings began to attract attention in the mid-1960s, critics and collectors frequently asked if the images were personally significant. Some in fact were, but for many years Richter would deny it, or dismiss any personal association as irrelevant. Not only did he want to protect his private life—Richter has always been a deeply private person—but by then he wanted the public to engage with the issues of media and reality that had come to preoccupy him in his practice.

But that would all come later. In 1950, after two aborted apprenticeships, Gerhard was just deciding to become a professional artist, and not everyone was as impressed with his talent as he was. When he applied for admission to the Dresden Art Academy (Hochschule für Bildende Künste Dresden) for the winter semester of 1950–1951, his portfolio was summarily rejected. His work was deemed too bourgeois for his country's socialist sensibilities, but he received a valuable suggestion: if he really wanted to train at the academy, he was told, he should first get a job at a state-run business and then reapply. State employees apparently received preferential treatment when it came to competitive admissions. So Richter went to work as a painter at the Dewag textile plant on October 2, 1950. The following spring he again applied to the Dresden Art Academy and this time was promptly accepted. He quit the textile plant on May 31, 1951, and packed his belongings. After sixteen years he was on his way back to Dresden, his hometown, to pursue a career in art.

The Dresden he returned to in 1951 was still in ruins. Only a few buildings had been rebuilt since the devastating Allied air attacks of February 13 to 15, 1945. It was almost as if the great cultural metropolis had vanished in a single, incendiary stroke. "Everything had been destroyed," Richter recalled. "There were only

piles of rubble to the left and right of what had been streets. Every day we walked from the academy to the cafeteria through rubble, about two kilometers there and back." The students' path led them past the spectral ruins of the Frauenkirche (the Lutheran Church of Our Lady), the most important landmark of the former baroque capital.

Because Richter's parents did not belong to the "class of workers and peasants" but to the academic middle class (even though his father worked as a manual laborer), he did not qualify for a full scholarship. Most students at the academy received decent stipends, but he had to make do with a third as much. At first, he lived with a great aunt on his mother's side in Langenbrück, some distance from the city. Aunt Gretl, as he called her, also gave him money to purchase art supplies and other necessities.

Days at the academy began punctually at eight o'clock, with eight full hours of instruction. In addition to studio courses, such as painting and life drawing, the school offered a strong academic curriculum, with subjects ranging from art history and aesthetics to Russian, Marxist theory, and political economy. Richter learned an enormous amount at the academy: the techniques of working in various media, the precise observation required in life drawing, and lessons of composition, all of which, even then, he regarded with some skepticism. It was important to the instructors that their charges acquire skills in a broad spectrum of traditional painting genres—portrait, still life, landscape. "It was a very sound education," Richter acknowledges. "Perhaps these experiences stir up a certain Ur-trust in Art, which has always kept me from wanting to be a 'modern' artist."[10]

Richter valued the cultural openness of this postwar period, especially in the field of literature, but it turned out to be only a brief interlude. Soon after the founding of the German Democratic Republic on October 7, 1949, the state called its artists to duty. Walter Ulbricht, the first secretary of the Socialist Unity Party of Germany, propagated the idea of the so-called "new man," the "hero of work" who would help build a strong, socialist Germany. Art was obligated to support and, indeed, to celebrate this labor: "In that the artist visualizes what is new and progressive in humanity, he helps in training millions to this new humanity."[11] Art was subordinated to political doctrine, instrumentalized as a medium for educating citizens, and there was little doubt about the government's preferred style—socialist realism—which was only to be deployed on prototypical subjects imported from the USSR. The job of the artist in the GDR, known in the West as East Germany, was to create monumental statues of Marx and Lenin and to represent the worker in the factory and the farmer in the field as heroes in the battle for a triumphant socialism.

In the academy's library, the books available to students covered the history of Western art only through impressionism. Publications about modern and contemporary trends in art—which under the Soviet regime, not unlike that of the Nazis,

had come to be viewed as a symptom of late bourgeois decadence—were stored in closed stacks, and students were allowed to look at them only in exceptional circumstances. Even work associated with Die Brücke, the group of expressionist artists founded in Dresden in 1905 by Ernst Ludwig Kirchner, Erich Heckel, and Karl Schmidt-Rottluff, was deemed inappropriate for young, susceptible eyes and minds. Instead, the nineteenth-century Russian realist Ilya Repin, the German Adolf Menzel, and the twentieth-century social realist Berhard Kretzschmar were lauded as exemplars. "It was all politically and ideologically grounded," in Richter's assessment. "The goal was socialist realism, and the Dresden academy was especially obedient in this regard."

Because art was meant to perform a social—that is, public—function, the private market was suppressed. The state, its institutions, and its factories became the only customers for art and thus could discipline artists who would not conform simply by withholding commissions. What resulted was inevitably homogeneous art grounded in the lowest common denominator. "Socialist realism is truly idiotic. It doesn't bring anything, is hokus, nothing but illustration," said Richter in 1985, annoyed, even after forty years, that the practice persisted in East Germany. "And the people don't get anything out of it. There is nothing alive or new in that art."[12]

There were two notable efforts to liberalize the strict stylistic guidelines of socialist realism during Richter's time at the academy, if only to a small degree. On June 17, 1953, workers marched in protest of the ongoing militarization of their country, as well as the absurdly high production quotas being mandated by the Soviets. The protests in Berlin and elsewhere were quickly suppressed, but they brought into sharp relief the dreadful economic plight of East Germany at the time. Exacerbating the situation was a growing crackdown on "illegal" organizations and political groups. Surviving in East Germany, both physically and creatively, was becoming harder and harder, and great numbers of workers were leaving the country.

In the aftermath of the June uprising, East Germany's Deutsche Akademie der Künste (German Academy of the Arts) requested that the government's strictures be loosened to encourage greater artistic diversity—but to no avail. The following year saw a small gain, however, when the magazine *Bildende Kunst* published several works by Italian realists Renato Guttuso and Gabriele Mucchi, who rendered social themes in styles influenced by Picasso, Van Gogh, and other artists of the European avant-garde. But Guttuso and Mucchi had both fought against fascism during World War II, as partisans, and Guttuso had been a member of the Italian Communist Party since 1940. Given such impeccable credentials, the Italians were tolerated, and in 1955 Guttoso was even designated an affiliate of the German Academy of the Arts in East Berlin. Pablo Picasso was also accepted in East Germany because he was a member of the French Communist Party, which he had joined in 1944, following the liberation of Paris. As

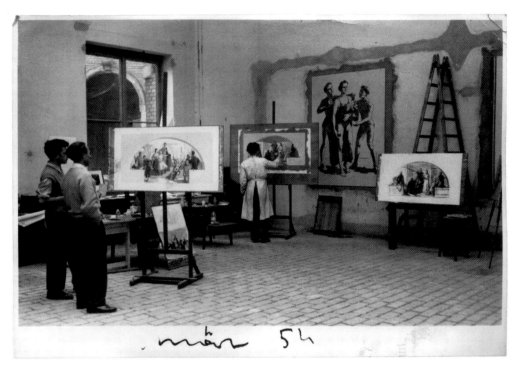

FIG. 1.5. RICHTER (LEFT) WITH HEINZ LOHMAR IN LOHMAR'S MURAL CLASS, 1954.

one of the party's most illustrious members, he took part in the 1949 Congrès Mondial de la Paix in Paris and designed the event's now-famous poster, featuring a white dove.

Richter took full advantage of this tiny rupture in government policy to follow, at a safe remove from the academy, the debates about the new stylistic and intellectual challenges of modern art. The students "had a general sense of what was going on," he says. "The stuff from the West circulated. Everyone had something to pass around that excited us." The budding artist also had an aunt in the West who sent him books, catalogs, and, now and then, the photography magazine *Magnum*. Like many of his fellow students, Richter produced, alongside the official assignments, a second, private body of work, painted in the evenings and on weekends at home. "I certainly painted more than the other students," he says. "There were of course my assignments—the realistic still lifes, nudes, landscapes, etc., etc.—and, at the same time, I attempted more interesting experiments in modern art."

A second, even more important step toward artistic independence was Richter's decision to enroll in the new mural painting class conducted by Heinz Lohmar (fig. 1.5). He chose Lohmar over Hans and Lea Grundig, who at the time were the most prominent teachers in Dresden but, from Richter's perspective, had less to

offer him.[13] As Richter told Robert Storr in 2001, Lohmar was "a very interesting type, a little gangster." Born in 1900 in Troisdorf near Cologne, Lohmar, a Jew and a member of the Communist Party, had emigrated in 1933 to Paris, where he had been a minor surrealist. At war's end, Lohmar returned to Germany to live in the Soviet-occupied zone. Even so, as Storr puts it, he "remained a comparatively well-informed and cosmopolitan figure."[14] In any event, Richter thought he could learn from him.

Richter had of course been interested in mural painting ever since he watched Hans Lillig working at the elementary school in Waltersdorf. He had come to admire the work of great muralists like the Mexican modernists Diego Rivera and Alfredo Siqueiros, and mural painting offered several advantages over other kinds of art practice. Because murals required a measure of interpretive formalism otherwise prohibited under socialist realism, he thought he might be able to exercise more creative and stylistic freedom without risking the censure of the cultural bureaucracy. In addition, being a certified mural painter brought with it financial security; he could count on having a day job and a steady income in a state-run company if he needed it.

In Lohmar's class Richter met Rudolf Sitte, younger brother of the painter Willi Sitte, who later became president of the East German Artist's Union (Verband bildender Künstler). The two were never more than acquaintances, however. Richter was much closer to classmates Wieland Förster and Wilfried Wertz and to the sculptor Helmut Heinze. What little free time he had was spent with them or with Marianne Eufinger, his future wife, whom he had met when he first enrolled at the academy. Marianne, nicknamed Ema, was a fashion and textile design student at the academy and lived with her parents in their Dresden villa. Her father, Heinrich Eufinger, was a respected physician. The couple had not been dating long when Richter moved out of Aunt Gretl's house and rented a furnished apartment with some friends, just two doors down from Ema.

Unfortunately for Gerhard, the textile department at the Dresden academy was discontinued in 1952, and Ema transferred to a program in East Berlin. There she participated in the uprising of June 17, 1953, which resulted in her expulsion. She relocated to the town of Heiligendamm on the Baltic coast and enrolled in the Fachschule für Angewandte Kunst (Academy of Applied Arts, founded in 1949), where she finally earned her diploma.

After four semesters in the mural painting department, Richter and his classmates had to complete a round of tests in various academic subjects, as well as a studio project. For his project, Richter painted *Communion with Picasso*, depicting an evening meal in the academy cafeteria, which earned him admission to the final, two-semester, intensive course required for a degree in mural painting. To let off steam, he also staged a couple of photographs of himself and two friends attempting to cope with their anxiety over the impending exams. The titles, *Insanity* (*Wahnsinn*) and *Hanging* (*Erhängung*; fig. 1.6), put an existential

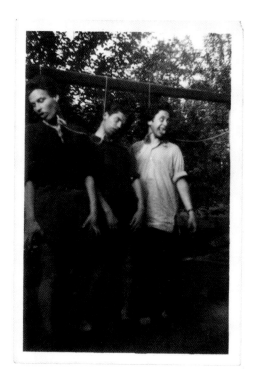

FIG. 1.6. *Hanging (Erhängung)*, 1955.
FROM LEFT: JOACHIM JASTRAM, ALFRED
THOMALLA, RICHTER.

spin on goofy student humor. The snapshots made their way into a family photo album, one of the few belongings Richter would take with him when he fled to the West.

In December 1955, as the young artist entered his final semester, he was assigned a high-profile thesis project: he was to paint a mural for the foyer of the Deutsches Hygienemuseum (German Hygiene Museum) in Dresden. The foyer was approximately six meters wide with a staircase on one side leading to the upper story. In a report published in the September 1956 issue of the journal *farbe und raum (color and space)*, Richter wrote:

> In a discussion with the director of the Hygiene Museum, Dr. Friedeberger, my teacher, Prof. Lohmar, and the responsible architect, Mr. Küntzer, we agreed that the painting should be "hygienic" in its content but rendered in a way that did not compete with the scientific seriousness of the exhibits. It was decided that the mood of the foyer should be festive and jovial, cheerful, and simultaneously soothing, clear, and simple. These requirements arose from the room's function— it is a transitional space, but with comfortable chairs, it offers visitors the chance to . . . relax.[15]

The title, or at least the theme of the project, was to be *Joy of Life (Lebensfreude)*. The artist painted the walls surrounding his five-by-fifteen-meter mural in tones

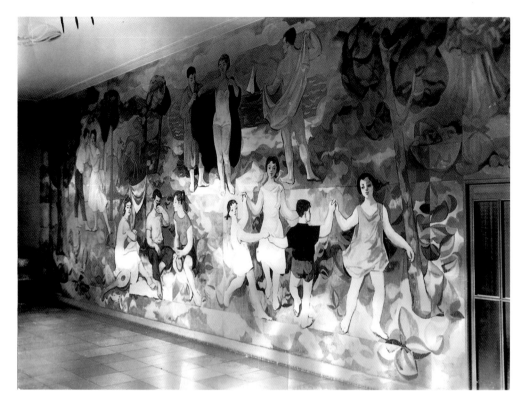

FIG. 1.7. MURAL AT THE GERMAN HYGIENE MUSEUM, DRESDEN, 1956.

of white, gray, and red. "The effect of the painting should be similar to that of wallpaper or tapestry," Richter wrote:

> which means the center is abandoned and any sense of three-dimensional space, of depth, is totally eliminated. I avoided any sense of perspective as well as any overlapping that might suggest space by placing things next to each other. . . . I worked with a limited palette, mixing shades out of the dominant colors ochre, black, and English red, and I covered the surface with consistent vertical brushstrokes. . . . One can achieve a differentiated coloristic effect with adjacent and overlapping strokes of different colored paint even with minimal shading. To keep the surface as surface, I treated the things in the background, e.g., clouds, mountains, water, occasional trees, the same as the objects in the foreground . . . to connect them to each other ornamentally and to stylize them almost evenly. The stylization emphasizes on the one hand the ornamental and the decorative and on the other hand the content, evoking characteristics such as liveliness, health, etc. To accentuate these characteristics, the different scenes also occur outside, which should represent only the unforced expression of the joy of life without any symbolic or scientific message.[16]

The result is a lively tapestry of figures, cleverly connected one to the next by a landscape of trees, plants, and a scattering of animals (fig. 1.7). Its subjects include a couple under the trees, a woman and two men on the beach, a picnic scene, children playing, and a portrait of the consummate German family—the mother a worldly Madonna, the father, seen nearby and in profile, an observant protector.

The mural was painted over in the 1960s. As far as can be discerned from the existing photographs, Richter succeeded in organizing the large wall surface so that the individual scenes, taken together, make a unified composition, the view guided from one cluster of figures to the next. To give the huge surface a formal structure, Richter divided it into eight equal fields based on the dimensions of a door set in the wall's lower right-hand corner. "In this way," he said, "the surface was organized and the door was incorporated as an element of the composition's structure."[17]

The mural appears to have been apolitical, without any ideological reference other than what might be construed as the celebration of a joyful socialist system liberated from fascism. Only the nuclear family on the far right strikes a mildly political chord in that it expresses the archetype of communism's "new humanity": the tractor in the background identifies the family as members of the esteemed farmer class. White doves of peace fly overhead, a detail that appears nowhere else in the mural.

The project was judged "very good" by Richter's examiners, earning him the coveted status of certified mural painter. Officials at the Hygiene Museum were so enchanted with the mural that they immediately asked Richter to paint another

FIG. 1.8. RICHTER IN HIS ROOM, LATE 1950S.

one for the other wing of the building. Richter prepared several proposals and even painted a sample in his studio, but he never completed the commission. During a 1994 restoration at the Hygiene Museum, workers discovered Richter's thesis project under a thick coat of white paint. A discussion ensued about whether or not to uncover the mural now that the artist had become so famous. When the newspaper *Dresdner Morgenpost* asked Richter what he thought of the idea, he was dismissive: "It's nonsense to treat this peace-joy-happiness ideal as a relic. Please just leave it painted over as it is." (This has not stopped authorities from recently uncovering several sections of the mural.)[18]

Richter graduated from the Dresden Art Academy in 1956 and soon had enough commissions to work on his own. As a freelancer he was spared the less desirable, albeit safer, alternative of full-time government employment. He soon availed himself of a new program at the academy for promising young artists: in exchange for teaching an occasional evening class in life drawing that was open to the public, he was awarded a private studio and a stipend for three years (fig. 1.8). Having a bit of financial security not only supported his ambition but also allowed him to make an important personal decision. On June 8, 1957, he married Ema in West Germany, her parents having moved to Oldenburg in Lower Saxony the previous year.

Conditions in East Germany had worsened in 1956. Uprisings in Hungary, Poland, and Czechoslovakia led to stricter measures to prevent emigration to the West, and any liberalizing trends in the arts were suppressed. In the years leading up to Richter's defection, he completed several murals. For a kindergarten he painted a composition of flying carpets, knights atop elephants, exotic palaces,

and patterns drawn from porcelain paintings on Meissen tiles, using a naïve style and taking the *Tales of 1,001 Nights* as his inspiration. For a school in the town of Görlitz, on the Polish border, he painted a sundial and a stylized map of the area, accentuating the rivers that defined the border, the Oder and the Neisse, and the streets that connected the German city and Poland. In early 1958 he executed a mural at the regional government headquarters of the Socialist Unity Party in Dresden, depicting police forces attacking a crowd of demonstrators. Not by accident, the uniforms worn by the police in this battle between the working class and their oppressors resemble those worn during the Weimar Republic.

During the extra three years he spent at the academy, Richter also produced dozens of plans for mural commissions that were never completed. For a school gymnasium, he designed a frieze with work and sport motifs. For the staircase of an official building he suggested an Arcadian seaside scene. Richter rendered the drawings for these projects with great skill and loving attention to detail, though his focus was never solely on the mural's ostensible subject. Invariably, he incorporated the spatial characteristics of the room in his preliminary drawings, and in this way tried to capture a complete impression of architecture and painting. "I've always enjoyed designing rooms," he says even today.[19]

Richter's hope that he would enjoy a modicum of artistic freedom as a muralist was satisfied to some extent. However, on April 20, 1958, the artist wrote a sharply worded letter to the weekly journal of the Deutscher Kulturbund (German Culture Association), entering into a public debate about whether or not the requirement that murals serve a didactic function restricted creative freedom:

> There are now so-called commissioning boards established to improve the nature of the assignments and to overcome hostility to art, i.e., to "reconcile" [the client and the artist]. Their responsibility is to consult with and help both sides. Unfortunately, these boards do not always do this in the best, most goal-oriented way. Ideally such a board would consult with the client and the artist to make constructive suggestions on the theme, size, the nature of the representation, site, etc. when the commission is first granted. In addition, no significant discussions with the artist should take place in the absence of the client; instead the board should focus on advising and convincing the client [of the work's worth], for whom this type of help is much more necessary than for the artist.[20]

Nonetheless, the letter offered a positive report on Richter's own professional situation:

> Of my most recent commissioned work, a mural on the SED regional building in Dresden, I would like to say that I never felt limited in terms of "creative freedom" (such lovely words!). I never took seriously, or had to take seriously, the nasty remarks from one or the other of my colleagues such as "huge rearrangement" and "Soviet naturalism," that were meant to warn me before starting work—quite the

opposite. I would like at this time to express the wish that my colleagues could work very often with such understanding clients. Of course I have had my share of disagreements; that would not be the point. It has been these disagreements that often helped me further [my work] and allowed me to do much more than I had originally planned. Not because I *had* to, but because—after I had become convinced of the correctness of my clients' opinion—I *wanted* to.[21]

Even Richter's financial expectations were largely met. Between his stipend and the income from freelance projects he earned enough to buy a motorcycle (fig. 1.9) and later a car (although his great-aunt Gretl contributed 2,000 marks toward the M 7,500 price of a new Trabant).

In 1957 Richter tried his hand at book illustration, completing at least two sets of drawings that he proposed to sell to publishers as the basis for new, illustrated editions of classic works. His twelve ink drawings for a prospective edition of the *Diary of Anne Frank*, for instance, focus intently on the teenage girl's face, rendered in fine lines and situated against a dark background that is equally well drawn. Another eighteen pages of drawings depict the adventures of a nameless group of small dark men with broad-brimmed hats who traverse an ever-changing landscape. In the city they pause spellbound in front of a giant billboard featuring a bikini-clad model. They march, bent over, through a leafless forest under the command of a single figure. In the last pages they meet a tragic end. Richter draws some of them (unsurprisingly) hanging from trees (fig. 1.10), some being eaten by giant beetles,

FIG. 1.9. RICHTER WITH MARIANNE (EMA) EUFINGER, CIRCA 1957.

FIG. 1.10. *Untitled*, 1957. PEN AND INK DRAWING. LOCATION UNKNOWN.

some buried beneath a sinister black cloud. The Kafkaesque mood is unmistakable, and a sense of individual anonymity resonates with the strain of existential gloom then pervasive in the Eastern Bloc. Neither series was ever published.

In 1958 Richter worked on a painting that depicted three workers on their lunch break, reading, eating, smoking a cigarette. But he soon abandoned any attempt to propagate the socialist image of the ideal man through isolated images, opting instead for the broader reach of poster design. One of his posters features a call to political action—"Your vote, a commitment to the defense of peace" (*Deine Stimme ein Bekenntnis zur Verteidigung des Friedens*)—and a stylized dove. Another, for the fortieth anniversary of the October Revolution in Russia, depicts bursting chains and wires, over which floats a red rose, a symbol of the Socialist International. Although neither motif—the dove or the flower—is original, Richter at least managed to exploit them in modernist terms.

In addition to state-sponsored projects, Richter produced numerous works of his own. These never crossed the boundary of what was acceptable in East Germany—but they did push at it gently. "I was always looking for a third way in which Eastern realism and Western modernism would be resolved into one redeeming construct. Besides, working underground, defiantly unknown and isolated, was never for me—that was not my thing."

Richter had access to examples of Western modern art, at least to those deemed acceptable for East German books and magazines. The artists who most inspired him were the German impressionists Max Liebermann and Lovis Corinth, but he also admired Paul Gauguin, the Italians Marino Marini and Renato Guttuso, and, above all, Picasso. It is evident in photos of Richter's early paintings that he owed a great deal to these artists, though he no longer owns any work from this period. When he fled to West Berlin in 1961, he had to leave everything behind. All he managed to bring along were some negatives and pictures of work glued into photo albums. One of those photographs shows a painting, probably from 1957, of two young women resting on a white towel on the beach, one wearing a swimsuit, the other nude behind her (fig. 1.11). The subject appears to have been adapted from his 1956 mural in the Hygiene Museum. The work also bears a striking resemblance to Paul Gauguin's 1897 nude *Nevermore (O Tahiti)* and the double portrait *Et l'or de leur corps* (1901).

In late 1958 the state-run film company, DEFA (Deutsche Film-Aktiengesellschaft), decided to commission a portrait of the actress Angelica Domröse, who was making a new movie, *Confusion of Love* (*Verwirrung der Liebe*), with director Slatan Dudow. Richter recalls the actress coming to the Dresden Art Academy so the students could paint her; the winning portrait would be featured in the film. Richter painted two likenesses of the famous actress, both in three-quarter view. The first painting was entirely conventional, but in the second one the sitter takes on the fixed appearance of a statue (fig. 1.12). The sleeveless dress, rendered in segmented planes, is derivative of cubism, and the soft round contours of Richter's

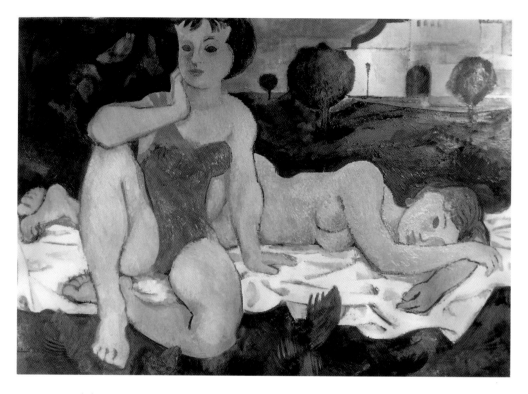

FIG. 1.11. *Untitled*, CIRCA 1957. LOCATION UNKNOWN.

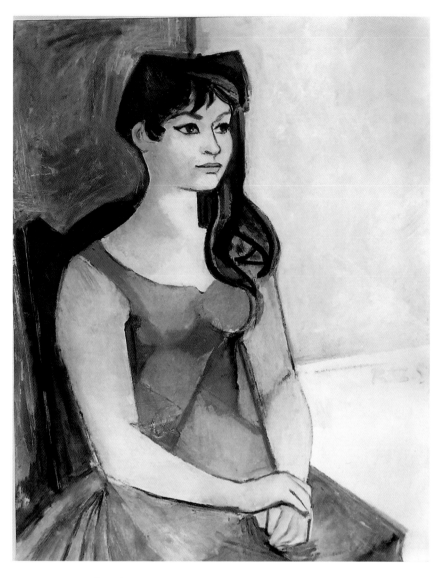

FIG. 1.12. *Portrait of Angelica Domröse*, 1958. LOCATION UNKNOWN.

bathers from the previous year have yielded to a more severe, linear execution. Though someone else's painting was chosen for the movie, Richter went on to develop the formal vocabulary he had hit upon here. The cubist influence is even more apparent in a group of drawings from 1959, several of which bear a striking resemblance to Picasso's paintings of his last wife, Jacqueline Roque, from 1954. Picasso shines through, too, in a cluster of ink still lifes featuring skulls (fig. 1.13). The skull had surfaced as a motif for Picasso while he was living virtually in seclusion in Paris during the Nazi occupation; Richter would return to the skull as a subject much, much later in a small group of oil paintings from 1983 (CR 545/1–3, 547/1–2, 548/1–2) and in three pencil drawings from 1986.

Of Richter's works from 1959, one study in oil stands out in that the young artist appears to be pitting his own drawing ability against that of his idol. The painting (fig. 1.14), now in the collection of the Cabinet of Prints and Drawings in Dresden castle (Kupferstichkabinett der Staatlichen Kunstsammlungen Dresden), depicts a cowering nude with her back to the viewer and references the exhausted bodies that populate Picasso's paintings from his Blue Period (1901–1904). The figure has her knees pulled up to her chest; her head sinks into her folded arms, supported by the bent knees. The proportions of the bony body are precisely observed and rendered, above all in the suggestion of the raised spine. The brown tones lend the subject a depressive presence, and Richter has scraped off wide swaths of color, giving the figure a hardness and heightened intensity.

During the last part of 1959 Richter also began work on a small group of still

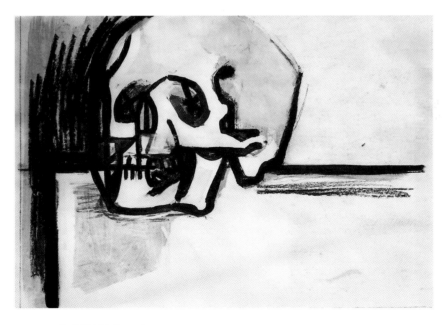

FIG. 1.13. *Skull (Schädel)*, 1956. INK ON PAPER. LOCATION UNKNOWN.

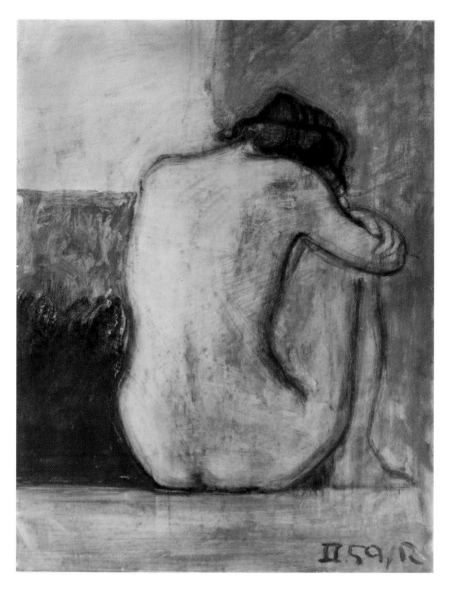

FIG. 1.14. *Seated Nude from Behind (Sitzender Rückenakt)*, 1959. OIL STICK. 91.5 X 63.5 CM.

lifes reminiscent of Giorgio Morandi, producing different constellations of glasses, bottles, and jugs. He had seen five of Morandi's small still lifes during a transformative journey to Kassel in West Germany to visit Documenta 2. During the long Cold War in Germany, between endless economic and military blockades, Kassel gradually emerged as a city on the front line of democracy. Less than fifty kilometers from the border with East Germany, it was perfectly positioned to present new developments in modern and contemporary art as expressions of political freedom, in direct opposition to the immovable force of socialist realism. The first Documenta, held there in 1955, had sought to restore to prominence those prewar German artists whose work had been decried by the Nazis as "degenerate" during the 1930s.

At the time, trips into Western Europe were still possible, though they required special permission. In 1955 Richter and a fellow student, Wilfried Wertz, had traveled to Hamburg, then hitchhiked to Munich and back to Dresden. Richter also visited Paris that summer as part of an organized bus trip. There he took in the sights, visiting not only museums and galleries but also Montmartre and various jazz clubs. Later, in 1958, he seized on an opportunity to attend the Brussels Universal Exposition, and in the summer of 1959 he received permission to travel by train to Kassel to attend Documenta 2.

The organizers of Documenta 2 concentrated on postwar art, hailing painterly abstraction as the new *Weltsprache der Kunst* (universal language of art). Werner Haftmann, a freelance writer and historian who lived on the Tegernsee and who would head the Neue Nationalgalerie in Berlin from 1967 to 1974, wrote the introduction to the Documenta catalog, propounding a teleological approach to the development of contemporary art: "The general direction that has laid itself out over these past fifteen years is . . . very clear. If all artistic thoughts of the years immediately following the war are in play, from expressive realism to surrealism to concrete art, all of these individual directions finally flow into abstract art, with 1950 as the approximate critical year."[22]

Two artistic personalities stood out as exemplars: Ernst Wilhelm Nay, a significant representative of the Informel movement in Germany, and the American "action painter" Jackson Pollock. Art critic Harold Rosenberg had coined the term "action painting," in his 1952 article "The American Action Painters," to describe a kind of painting centered on process and gesture. Other critics, such as Clement Greenberg, called the new art "abstract expressionism." "Art Informel" (the term was invented by the French critic Michel Tapié in 1952) was a kind of gestural abstract painting that stressed the physical act of painting itself, in contrast to the more geometric, cerebral abstraction practiced earlier in the century by modernist masters like Picasso, Braque, and Mondrian. Informel canvases were produced through spontaneous brushwork and the application of paint by smearing, dribbling, or splashing. Such painting has much in common with the abstract expressionism practiced by Pollock. Some of the most famous European artists who worked in this vein and whose work Richter probably encountered were the Italian Alberto

Burri (a friend of Robert Rauschenberg), Georges Mathieu, and Jean Fautrier. For Richter, the term "Informel" also connotes a spirit of otherness and a commitment to alternative solutions to problems. In this sense, even after he moved on to figurative painting, Richter never stopped thinking of himself as an Informel artist.

Abstraction, in various guises and with various agendas and designations, had, after the war, become the emblem of artistic freedom. The turn to abstraction and process, and its ascendancy over figurative, end-driven modes of expression, now fueled the thriving art scenes in New York, Paris, Amsterdam, Cologne, Düsseldorf, and other cities. Large, important paintings by the European Nay and the American Pollock hung front and center as Richter entered the main gallery of the Fridericianum exhibition hall at Documenta: Nay's six-and-a-half-meter-wide *Freiburger Bild*, executed for the University of Freiburg in 1956, and Pollock's monumental composition *Number 32*, from 1950. Pollock's painting in particular, along with some works by Lucio Fontana, "enormously impressed" Richter: "The sheer brazenness of it! That really fascinated me and impressed me. I might almost say that those paintings were the real reason I left the GDR. I realized that there was something wrong with my whole way of thinking."[23] Richter could not afford to buy the three-volume catalog, which at DM 34 was the equivalent of more than a hundred U.S. dollars today. Instead he took photo after photo of the magnificent artworks to share with his friends back in Dresden.

In the wake of Documenta Richter initiated what would turn out to be a lifelong campaign to explore the facts, problems, and possibilities of abstraction, starting with several mixed-media works on paper. As these early attempts suggest, the late, small abstractions of French painter Jean Fautrier must have bedeviled and inspired him as much as the large paintings by Nay and Pollock. When questioned about Fautrier in 1986, Richter readily acknowledged his influence: "The impasto, the painterly messiness, the amorphous and material quality"[24]—a description that could easily apply to Richter's own Informel experiments of 1959. In those works, paint is the sole carrier of form. It appears to spread itself out over the surface of the paper in wild, gestural swirls without any concern for composition. Richter would later describe these early attempts as "pretty childish."[25] They failed, he said, because he had perceived abstract art as merely a visual phenomenon. He did not yet have the training to grasp its expressive, philosophical, or critical capacities. It would take until the early 1960s, in Düsseldorf, for him to acquire those skills.

During the decade and a half that Richter lived in East Germany, he never had a solo exhibition, though he participated in several group shows. In late 1959 one of his paintings was featured in the Dresden Christmas Exhibition (Dresdner Weihnachtsausstellung). The painting's subject was the view from Richter's apartment window, over the neighboring housetops to the buildings beyond and, in the distance, the cloudy sky over the city. In a German program broadcast on BBC radio, the painting received a positive mention and was called an ideal example of the art developing in the German Democratic Republic. For Richter, this praise

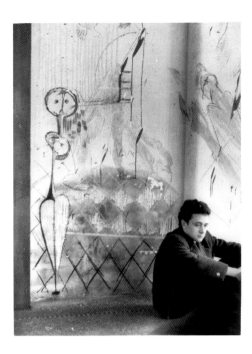

FIG. 1.15. RICHTER AT DRESDEN ART
ACADEMY, CIRCA 1955.

served more as a warning. He was becoming increasingly dissatisfied with his own work; what he had once considered good work artistically now seemed to him "mannered and inhibited." New artistic orientations involving radical departures from the norm did not, however, seem possible—not in East Germany. Occasional junkets to the West and brainstorming with friends could not begin to provide the level of stimulation he sensed he needed. He was frustrated that he could not seem to integrate the vocabulary of abstract expressionism successfully into his own work (fig. 1.15). Moreover, he knew that, while abstract art might find an audience among the East German elite, it would never be widely admired or recognized—and recognition has always been important to Richter.

On the other hand, Richter had his own studio, as well as a stipend. He received enough commissions to live comfortably and to buy a car. His work was valued, and it was receiving some recognition in London. But it was exactly this level of ease that struck him as dangerous: a life of arranging his activities according to the dictates of patrons and a stifling political system:

> In the end, things were going well for me in the GDR. As a mural painter, I was not as exposed to the formalist accusations as other painters were, and I received commissions for murals. I could have lived off this work and would have stayed reasonably unchallenged by the system. But that was an unsatisfactory prospect, above all because the paintings that I painted on the side, which were my true concern, became worse and worse, less free and less genuine.

It became clear that he really had to leave East Germany. The fact that Ema's parents were already living in the West must have made the decision that much easier.

By the time Richter decided to make his escape, the Iron Curtain between the Soviet-dominated East and the West was beginning to close, seemingly for good. At the heart of the matter was the Soviet plan to build a wall through the center of Berlin to secure the eastern zone. In the West the Berlin Wall would serve as an infamous symbol of communist tyranny, and for twenty-eight years its formidable, stolid countenance would loom over the former capital of Germany.

In March 1961 Richter traveled alone to the Soviet Union, first to Moscow and then on to Leningrad. He traveled as a tourist but brought along more luggage than he actually needed. On the return trip, the train stopped in West Berlin. Richter deposited his suitcases at the train station and continued on to Dresden to fetch Ema. The borders between the two Germanys were by then near to being sealed, and the best odds for escape to the West continued to be through Berlin. Construction of the wall would not begin for another five months, and the subways and light railways (U- and S-Bahn) still ran freely between the Soviet-occupied and Western zones. East German citizens were thoroughly checked as they boarded trains to West Berlin, and were made to disembark if authorities suspected they might be trying to defect—for example, if they carried suitcases. Between 1958 and the construction of the Berlin Wall, which began on August 13, 1961, seven hundred thousand East German citizens took advantage of this last opening in the Iron Curtain to flee to the West.

The evening before he and Ema were scheduled to leave Richter sold his Trabant. The next morning a friend drove them to East Berlin. There they boarded the S-Bahn and reached the western sector of the city without difficulty. They immediately went to the social welfare office to register as refugees, and each received DM 150 in transition assistance. A few days later they were moved across East German territory to elsewhere in West Germany, where they spent eight days in a refugee camp before being allowed to go on to Oldenburg, the prosperous city in Lower Saxony where Ema's parents lived. (Gerhard's parents, by contrast, were never allowed to leave the East, not even to visit their son. The couple remained in Waltersdorf, where Hildegard died in 1967 and Horst a year later.)

Richter would not return to Dresden for twenty-five years, and then only to attend the opening of the exhibition "Positions" (*Positionen*), on December 10, 1986, in the Staatlichen Kunstsammlungen Dresden. Given the gradual rapprochement between East and West Germany, the exhibition included works by eight West German artists, among them Richter, Konrad Klapheck, Günther Uecker, and Sigmar Polke.[26]

Richter wrote notes to himself throughout the 1960s. In one from 1962 he explained his reasons for leaving Dresden: "I did not come here to escape 'materialism'; here its dominance is far more total and more mindless. I came to get away

from the criminal 'idealism' of the socialists."[27] In other notes he elaborated on his motivations and his evolving approach to art, reality, and the complex inter-relations of photography and painting, which would soon come to dominate his practice. These notes were never intended for publication, so when he sent several to gallerist Heiner Friedrich in 1964, he did so hesitantly, as the accompanying letter explains:

> Enclosed are the "notes," which have turned out to be a little too basic. What is missing is everything that I can't explain, or am afraid to write. That I only appreciate 3 to 4 Pop artists; that my painting is traditional, yet nevertheless new (or new for this reason) and in a way totalistic (at least in the intent or the convictions or beliefs); why painting is done at all; what I enjoy thinking about (what I think at all and always about basic beliefs); that one does not paint for fun; what painting has to do with religion (the Christians and all of the others should beware of painting); what kind of conception of the world painters help to build. I also can't explain why I actually paint a photo, in general and in particular a certain photo; what it is that I find enormously fascinating; and what meaning the representational has for me. What I described is really only that which can actually be described, that which is logical, just one view. (One also wouldn't want to capitulate to the drivel of the critics, who can't even stick to the few facts, but speak in inexact terms, i.e., that I am skillful [every commercial artist is more skillful], that I learned to paint in the East [I did create a reputation there, but I did not learn to paint, since when does anyone learn to paint somewhere anyway].) Etc., etc.,—As I mentioned, I can't write very much about it.[28]

To finalize his break with the East, Richter meticulously glued photos of the works he had produced there onto cardboard, cataloged them in two thick portfolios, and put the portfolios away. The aim was to put paid to a discrete phase in his work and life. Gerhard Richter did not want to have anything to do with this early work ever again.

Richter's formative years under National Socialism and the strain of trying to develop as an artist in a repressive socialist system most surely contributed to the reserve one notices in his public persona, in the carefully formulated detachment with which he paints, and in his resistance (until recently) to the suggestion that the work he has produced throughout his lifetime is in any way personally motivated. Part of what makes Richter's work so strong, in fact, is that he is a paradox: a fine painter working from both keen intellect and complex emotions. The disturbance—the adventure—that inhabits his work when native self-expression is brought into critical tension with the intellectual will to paint what *is* constitutes an important theme of this book.

2 CAPITALIST REALISM

As Richter plotted his removal to the West, his thoughts inclined first toward Munich as a promising place to start a new life. For a young man coming from the East, Munich held many attractions. Located in the south of Germany not far from the Bavarian Alps, it was a cultured, prosperous city that had been meticulously rebuilt after the war. Its record of supporting the visual and performing arts was centuries old. The Munich Academy of Fine Arts (Akademie der Bildenden Künste München), founded in 1808, still enjoyed a fine reputation even if its programs were somewhat traditional, and the old-master collection of the Alte Pinakothek was unparalleled. But before he headed south to explore Munich, Richter first wanted to look in on an old school friend from Dresden who was living in Düsseldorf, Reinhard Graner. Graner had not been active in an art scene in years but told Richter that he suspected Munich's might be too conservative for the kind of painting he wished to pursue. He thought Düsseldorf might be more to the artist's liking and offered to show him around.

Brimming with vitality, Düsseldorf had blossomed into an urbane economic and cultural center thanks to the resources lavished upon it after the war by the United States. By 1961, when Richter arrived, Düsseldorf was a city of artists. Many who had come to study at the Düsseldorf Art Academy (Staatliche Kunstakademie Düsseldorf) stayed on in the city after they finished, thriving in the tolerant atmosphere. As artist Heinz Mack put it, a touch ironically: "Düsseldorf behaves so indifferently toward art, that [any kind of thing] is tolerated. Munich would

never be capable of such indifference. The people of Munich would climb up onto the barricades. That is positive for Düsseldorf."[1] It was a time, too, when the city's artists treated each other with mutual respect. In 1953 a number of painters who worked in the Informel mode had banded together to form Gruppe 53, with the purpose of supporting all the newest trends in art. The annual show Gruppe 53 sponsored could be counted on to offer not just Informel painting but also the superreal canvases of the proto-Pop painter Konrad Klapheck, the color explorations of Gotthard Graubner, or early works by the irreverent Joseph Beuys.

With this contemporary edge, Düsseldorf, along with Cologne, had developed quickly into a major art center of the newly constituted Federal Republic of Germany (West Germany). As early as 1947 the Kunstverein für die Rheinlande und Westfalen had resumed a regular exhibition program. In 1953, following extensive renovation, the Düsseldorf academy reopened its doors, attracting some of the greatest talents of the era. By the time Richter arrived in 1961, its faculty boasted the likes of Karl Otto Götz, Gerhard Hoehme, and Georg Meistermann—all important Informel artists—and Beuys would join that summer. Within a few years, the Städtische Kunsthalle would establish an exhibition program that focused exclusively on modern art, a program complemented by the superb collection of twentieth-century art assembled by the Kunstsammlung Nordrhein-Westfalen, which today occupies two buildings just steps from the Rhine River.

And long before Richter arrived on the scene, two dealers in particular had distinguished themselves as important proponents of contemporary art. In May 1957, within a fortnight of each other, Jean-Pierre Wilhelm launched his Galerie 22 at Kaiserstraße 22 and Alfred Schmela a tiny space at Hunsrückenstraße 16/18. These galleries would contribute decisively to the success of contemporary art in West Germany.

Wilhelm was the scion of an upper-middle-class family, superbly educated and articulate. His gallery quickly became an arena for the newest trends in literature and music as well as in art. With a multitude of contacts, Wilhelm was adept at stimulating media attention and building networks of collectors. One of the first artists he cultivated was the Düsseldorf painter Winfred Gaul, who said of him, "[Wilhelm] himself was not creative, but he was stimulating because he saw everything, knew everything and everyone. And he shared this knowledge with us. He was a figure whom one cannot value highly enough."[2] Galerie 22 also represented Götz, Karl Fred Dahmen, Emil Schumacher, and the American painter Paul Jenkins. In a white heat of activity, Wilhelm introduced the work of Jean Fautrier to Düsseldorf, produced a musical Happening, and in May 1960, exactly three years after he opened the gallery, shuttered it on a high note with a joint showing of Cy Twombly and the iconoclast Robert Rauschenberg.

Alfred Schmela's grand opening came on May 31, 1957, precisely two weeks after Wilhelm's. His tiny storefront in Düsseldorf's old city center would outlast Galerie 22, and Schmela (1918–1980) would turn out to be of singular importance

to Gerhard Richter, giving him his first solo show, in 1964, and thus helping to launch his career. By the mid-1960s, being in Schmela's stable meant you were an artist to be reckoned with. Schmela was himself a painter. Having earned a degree in civil engineering, he took art lessons from the painter Jo Strahn, then moved to Paris, where he studied with André Lhote. By 1956, however, he was back in Düsseldorf, resigned to the fact that he possessed neither the talent nor the temperament to earn a living from his own painting. But he had also discovered that he had a keen eye for spotting talent and a penchant for selling art. At his gallery's debut, he presented a group of monochromatic paintings by the twenty-nine-year-old Nouveau Réaliste artist Yves Klein. With prices ranging from DM 100 to DM 500 (equivalent to roughly $3,000 to $15,000 today), Klein's paintings did not attract many buyers. The show was panned in the *Düsseldorfer Nachrichten* by Karl Ruhrberg (who from 1965 to 1972 would head the Städtische Kunsthalle Düsseldorf and from 1978 to 1984 the Museum Ludwig in Cologne): "The whole thing is nothing more than an attempt to see how far one can take the bluff and how much one can earn off the snobbery of one's fellow men."[3]

Unruffled by the poor reception, Schmela went on to champion many other artists of the German and international avant-garde, including Rupprecht Geiger, Gotthard Graubner, Jean Tinguely, Christo, Lucio Fontana, and members of the group known as ZERO. Founded in 1957, the same year Schmela opened his gallery, by former academy students Heinz Mack and Otto Piene (who were later joined by Günther Uecker), ZERO sought a new aesthetic beginning, which the members associated with the renewal of German society. Taking as their signifier a return to the null point, ZERO, they hoped to surmount recent German history with an artistic intervention that would somehow offset the effects of Nazi terror and a war that had killed millions. By 1962 ZERO was *the* up-and-coming art movement in West Germany.

ZERO advocated purity, taking light and the color white as the basis for an ethical aesthetics. It stood for the "triumph over darkness," Uecker wrote in 1961—"a white world . . . a human world, in which a person experiences his colorful existence, in which he can be alive."[4] The central element in Uecker's art was the nail. Working mostly on white surfaces, he composed nails into structural fields that appeared to move and shift in response to light breaking over them. He mined the aggressive potential of the nail in his reliefs as well as in numerous installations. Although Richter would eventually become friends with Uecker, ZERO art baffled him: "It was too unbroken, too esoteric—the pure light, the pure white. One would have to be very faithful in order to create and propagate something like that."

Schmela was also the first dealer in Düsseldorf to show the work of the Americans Robert Motherwell, Sam Francis, and Kenneth Noland. And, of course, he became an early advocate of Richter, who never forgot his debt to the dealer; in 1967, when the gallery closed temporarily to prepare to move to more spacious quarters, Richter commemorated the old space with a painting titled *Galerie* (CR 145/2).

Düsseldorf's status as an art town was further bolstered by activities in numerous other cities in the densely populated Rhineland, where a tight network of cultural organizations had sprung up after the war. The city's proximity to Paris also created opportunities for meaningful exchange: Düsseldorf's galleries showed the work of the Ecole de Paris. Götz and Hoehme had their first solo exhibitions in Paris in 1954, the Informel painter Peter Brüning in 1961. The members of ZERO, especially Uecker, developed close ties to the French Nouveau Réalisme movement, which included among its members Yves Klein, Georges Mathieu, Arman, and Jean Tinguely, all of whom had their first German solo shows in Düsseldorf. A class of enthusiastic collectors also contributed to the city's growing reputation as an art center.

When Richter arrived in Düsseldorf in the spring of 1961, Ema was staying with her parents in Oldenburg. Finding himself utterly alone and free at last to paint whatever he wished, he had no idea how to begin. "I just went into a park and tried to paint this park. It was totally nonsensical: I had no one to interact with." Gradually, he began to meet people. Through Herbert Schmidt, for whom he would eventually paint a family portrait (*Familie Schmidt*, 1964; CR 40), he met Peter Brüning. A visit to Brüning's studio afforded Richter his first opportunity to show his portfolio to a West German artist, one with a completely different viewpoint from his colleagues in Dresden. Richter was taken aback when Brüning praised his representational work but showed little interest in the Informel paintings. "That astonished me, because I thought that one had to paint abstract paintings here in the West."

Five years out from earning his degree in Dresden, Richter decided once more to apply to art school. It would turn out to be a defining move. It wasn't that he lacked technical skill; he was probably one of the best-trained artists in Düsseldorf. What he lacked were contacts, the company of kindred spirits, which he had missed dreadfully since leaving the East. Happily, his time at the academy in Düsseldorf would more than fill the void. He would meet some of his best friends there—Konrad Lueg, Sigmar Polke, and Blinky Palermo. Forty years later, Richter would look back wistfully on the period: "It was a very encouraging time, to be in a city with so many artists. Many were in competition with one another, and that spurred us on. Here in Cologne [in 2001], in comparison, I feel a little alone."

There were two ways to be admitted to the Düsseldorf academy: by being accepted into a class by a particular instructor or through general application. Still haunted by the rejection of his initial application to the Dresden academy, Richter did not want to take any chances, so he applied directly to an instructor named Ferdinand Macketanz, whom he had heard would take anyone. Macketanz had studied at the academy with the German expressionist Heinrich Campendonk and had been on the faculty since 1953. He taught drawing and painting, specializing in the traditional genres of portrait, landscape, and still life.

Richter had arrived in Düsseldorf during the spring, but Macketanz could not

make space for him until the winter semester, which began in October. For a mature painter like Richter that was a painfully long time to wait, and he persuaded the academy to let him start using the facilities on an informal basis right away. He was assigned a studio space and, as a refugee, received a monthly stipend of DM 350 for two years, hardly a princely sum, but enough to sustain him. As soon as Ema arrived from Oldenburg, the couple moved into a one-room apartment at Hüttenstraße 71. Nearing thirty now, Richter felt he had little time to waste. He arrived at the academy every morning punctually at eight, carrying a briefcase packed with his lunch and other supplies. Businesslike and reserved, he would stay in the studio all day, working at his canvas as if it were an eight-to-five job. Such disciplined behavior was totally out of place in the freewheeling world of the academy, with students and faculty coming and going as they pleased.

The situation was utterly to Richter's liking, and he produced a flurry of work. "By the time the winter semester began, I had already painted so much that people had to pay attention to me. I had practically the whole classroom to myself and covered the walls almost up to the ceiling." The paintings he produced during those months, in contrast to the weak imitations that followed his 1959 visit to Documenta, demonstrated a deepening understanding of the power of abstract expression. "I realized, above all, that all those 'slashes' and 'blots' were not a formalistic gag but grim truth and liberation, that this was an expression of a totally different and entirely new content."[5] Rather than serving to advance a political agenda or to decorate a public space, the new paintings explored the individuality of their creator. They were existential expressions of emotional states, liberating declarations by an artist who was no longer the instrument of a repressive ideology. The summary application of paint in his murals and the mannerism of the other work he had produced in East Germany now gave way to a free painterly abstraction that ranged back and forth between heavy impasto and surfaces shimmering through thin, transparent layers of color. Today Richter cites Jean Dubuffet, Jean Fautrier, Lucio Fontana, and Francis Bacon as having been his chief inspirations then. One can also see a resemblance to the Italian artist Alberto Burri, though Richter claims not to have been aware of him at the time. (Burri, an associate of Robert Rauschenberg, produced works so thick with paint that they were more like paint constructions than paintings.)

Some of the new paintings, all from 1962, bear titles that are so evocative as to severely restrict interpretation: *Scar* (*Narbe*), *Aggression*, *Lamentation/Complaint* (*Klage*), *Injury* (*Verletzung*), *Wound*, *Resection*. Other titles are more mellifluous—*Breakfast in the Country* (*Frühstück im Grünen*), *A Small Celebration* (*Kleine Festlichkeit*)—though all the works employ the same formal vocabulary. Most radically, Richter's painting had rejected illustration in favor of gestural expression. Gone were the figurative motifs; the surfaces of these paintings came from the intense physical engagement of an artist with his materials. The canvases were saturated with oil paint and enamel and when pulled onto stretchers resembled

wrinkled, leathery skin. Like Fontana, Richter was attacking the surface, but far more aggressively: there are two huge, gaping wounds in *Two Festivals in the Country* (*Zwei Feste im Grünen*; fig. 2.1). In *Shirt* (*Hemd*) Richter glued an old wrinkled shirt so thickly onto a plank of wood that its surface calls to mind Burri's work.

Richter showed some of these pieces in the review exhibition of student work held in February 1962. There he met Konrad Lueg, an enormously likable character. Born Konrad Fischer, the Düsseldorf native had taken his mother's maiden name for his alias as a painter. His mother had always encouraged his interest in art, unlike his father, who was perhaps overstrict. In rebellion, Konrad left gymnasium in his last year without sitting for final exams and signed up for private lessons in drawing and painting; the result was an outstanding portfolio that gained him instant admission to the art academy in Düsseldorf. There, he studied first under the award-winning painter Bruno Goller and quickly became involved in student politics.[6]

When Lueg met Richter, he was already about to switch into the class taught by K. O. Götz, and he had no trouble convincing Richter to switch too. Götz had already noticed Richter's paintings.

> I remember the exhibition at the academy in February 1962; his Informel paintings hung in the dark hallway downstairs. But soon after this, he started making *Verkehrszeichen und Signale* [traffic sign and signal] paintings and installing them next to the roadside. These, forgive the expression, signaled a turn away from Informel painting to something more concrete, hard-edged, less expressive, and driven by popular culture. One of the early proponents of the trend was Winfred Gaul. When Gaul visited me at the academy and took a look in my classroom, he was surprised to see the signs hanging on the wall. Gaul was also making traffic sign paintings at the time and complained, "Just when you think something new has surfaced in the art world, it's already being practiced at the academy."[7]

Six months after the student show, Richter presented the work once again, in a public exhibition. This was Richter's first professional exhibition, a two-man show in the Junge Kunst (Young Art) gallery in Fulda with fellow student Manfred Kuttner, whom he had also met at the student review. Like Richter, Kuttner was a product of the Dresden Art Academy, though the two had never met there. Kuttner was a slender fellow with a narrow, striking face. He wore his brown, curly hair severely combed back. Born in Greiz, in the state of Thüringen, he had emigrated to the West in 1959 and enrolled at the Düsseldorf academy in 1960. After studying with Gerhard Hoehme for a semester, he too had transferred into Götz's class. Upon graduating, he took a job in a paint factory, and thus ended his artistic career. Kuttner's paintings were nothing like Richter's; they were inspired instead by the ZERO aesthetic in which traditional composition yielded

FIG. 2.1. *Two Festivals in the Country (Zwei Feste im Grünen)*, 1962. LOCATION UNKNOWN.

to a consistent, rhythmic order that eschewed the hierarchization of painting elements. The emotional states so evident in Richter's work at the time were counterbalanced in the show by Kuttner's cerebral productions. While Richter gave his paintings titles rich in association, such as *Excess (Exzeß)* and *Object of Devotion (Objekt zur Andacht)*, Kuttner's works sported abstract, affectless labels such as *oo.btz* and *Y-4485*.

Richter presented thirty-seven paintings and reliefs in Fulda, along with two portfolios of drawings: twenty-six white ones (DM 140 each) and twenty-three yellow ones (DM 100 each). In addition to a title, Richter gave each painting a number, leaving little doubt that he had created more than eighty paintings that year. The show ran from September 8 to September 30, and the accompanying catalog offered the first critical analysis of the artist's work, by the scholar Alexander Diesenroth: "Richter's works are of an emotional nature. He allows an internal event to play itself out in the space of the picture, or he lifts and destroys its flatness from the background. The economy with which he uses paint makes this process even more forceful and increases its seriousness, whether it concerns a creation in black, gray, white, or green, whereas the repositioning of the 'horizon' has either a redemptive or an oppressive effect."[8] For Richter, this work was concerned less with connecting with Western critical fashion than with personal emancipation and the aesthetic expression of his own distress and uncertainty. Never again, though, would he allow such a blatant display of emotion in his work. That his work could be read rather than seen upset him. There was supposed to have been a subsequent exhibition in the Galerie Hella Nebelung, one of the first galleries to open in Düsseldorf after the war. In retrospect, Richter expresses great relief that it never came to pass: "Who knows what would have become of me had I been successful with those paintings?" Instead of showing them, he burned them, seeking yet again a new beginning. Only this time, he was not alone.

By the summer of 1962, Richter, Lueg, and Kuttner had all transferred into Götz's class. Götz, born in 1914 in Aachen, had been a member of the international artists' movement CoBrA and later a founder of Quadriga. CoBrA (an acronym for Copenhagen, Brussels, and Amsterdam, whence most of the participating artists hailed), took as its mission the liberation of color and form but lasted only a few years, from 1949 to 1952.[9] The Quadriga painters—Götz, Bernard Schultze, Heinz Kreutz, and Otto Greis—initially put forward a collective identity when they showed together at the Frankfurter Zimmergalerie Franck, in December 1952. Like that of other Informel artists, Götz's work from the early 1950s reflected the dynamism of action painting: paint applied to the canvas in quick, animated rhythms, the spontaneous motion of the brush or the scraper always discernable as a track or trace. In 1959 Götz was appointed professor of painting at the Düsseldorf academy.

Richter treasured his time with Götz. "His ambition was not to create a class in

which everyone was his *pupil*. He came around now and then, puffed on his pipe and said, 'Don't let me disturb you.' And he was correct. The less he said to us, the more we came together on our own." When Richter later taught at the academy himself, he followed the lead of his beloved instructor. Talking to Robert Storr in 1996, he explained, "I could never imagine that students would want to hear something from me. I came into the classroom and said, 'Excuse me, I don't want to disturb you.'"[10] For Richter it has always been essential that students develop a strong technical foundation, and so when he teaches, he insists they begin at the beginning, with still life—just as he had done in Dresden.

Götz's class that semester turned out to be flush with talent, including the future installation artist and sculptor Franz Erhard Walther. Also enrolled was Sigmar Polke, who, like Richter, came from the East and would go on to become one of Germany's leading artists. Polke was born on February 13, 1941, in the town of Oels in Lower Silesia. Over many years and through seemingly endless disputes, the boundaries of Lower Silesia have shifted as it has come under the control of one country after another, but the dominant population has always been Polish. On the heels of World War II, the particular area in which the Polkes lived was annexed to Poland in accordance with the Potsdam Treaty, and the German population—including them—was expelled. For several years the Polkes lived in Thuringia, but the dreadful economic adversity that plagued East Germany during the early 1950s prompted them, like so many others, to move to the West while the borders were still open. In 1953 the family settled in Düsseldorf.

Sigmar completed an apprenticeship as a stained glass painter in 1960 and entered the art academy in 1961. After a trial semester, he took a class from Gerhard Hoehme. Then in 1962, he too transferred into Götz's class. There he found himself in a group of four—Richter, Kuttner, Lueg, and himself—of which Lueg was the undisputed leader. "After all, we other three had come from the East," Richter says. "Konrad was the most informed. He was always lugging around art magazines, and he always had the latest copy of *Art International*. He knew everyone in Düsseldorf: Alfred Schmela, Jean-Pierre Wilhelm, Manfred de la Motte, Peter Brüning." Richter was nine years older than his friends, but age was never an issue. In 1964 he noted:

> Contact with like-minded painters—a group means a great deal to me: nothing comes in isolation. We have worked out our ideas largely by talking them through. Shutting myself away in the country, for instance, would do nothing for me. One depends on one's surroundings. And so the exchange with other artists—and especially the collaboration with Lueg and Polke—matters a lot for me: it is part of the input that I need.[11]

Richter and his chums offered each other moral support and looked for oppor-

tunities to exhibit their work. Yet the foursome showed together as a group only once, in a space at Kaiserstraße 31a in May 1963. Richter in particular resisted the idea that they constituted a collective, probably because of his Eastern Bloc experience, where the collective agenda always came first. As he told Hans-Ulrich Obrist, "There were rare and exceptional moments when we were doing a thing together and forming a kind of impromptu community; the rest of the time we were competing with each other."[12]

The friends egged each other on and took inordinate pleasure in attacking all the latest trends, their self-confidence swelling into such arrogance that nearly anything that came their way was ridiculed. "We quickly agreed among ourselves that everything around us was stupid. We knew it couldn't go on this way." The problem was they also had no tangible idea for an alternative, at least not until they encountered a heady new trend making waves on the other side of the Atlantic: American Pop art.

ROY LICHTENSTEIN

In 1963, thanks to Lueg, the four friends found themselves staring at something they had never seen before: a reproduction in the January issue of *Art International* of Roy Lichtenstein's painting *Refrigerator* (1962). The American Pop artist had appropriated what appeared to be a newspaper advertisement showing a young housewife cleaning her refrigerator and beaming seductively at the viewer, an image meant to appeal to consumers. His style, adapted from American comics, was actually a kind of "no style": a flawless application of paint that left no trace of an artistic signature. Intrigued, Richter, Polke, and Lueg were each immediately stimulated to experiment with what seemed a most unartistic practice. They even talked about painting and displaying multiple copies of Lichtenstein paintings in order to elevate the painterly appropriation of common media reproductions to yet another metalevel, but the project never gelled.

It has sometimes been assumed—erroneously, says Richter—that his own impulse to bring mass media into his painting was initiated by *Refrigerator*.[13] That is just not true, he claims. In fact, his first impression was that "the painting went too far . . . it was too silly. But it did make you think." What's more, he had already been integrating media images into his painting for several months before seeing the Lichtenstein; what initially prompted him to do so he cannot recall. In 1964 he wrote, "My first Photo Picture? I was doing large pictures in gloss enamel, influenced by Gaul. One day a photograph of Brigitte Bardot fell into my hands, and I painted it into one of these paintings in shades of grey."[14] At other times, he cites the painting *Party* (1962; CR 2/1; fig. 2.2) as his first raid on popular media. This is also Götz's recollection. He remembers the painting taking shape in his classroom:

FIG. 2.2. *Party*, 1962. MIXED MEDIA. 150 × 182 CM. CR 2/1.

The first painting of this kind . . . shows a group of young party guests raising their glasses in a toast. The painting is about 150 centimeters wide. When I came into the class about a week after Richter made the painting, he had cut short slits in it, probably to destroy the impression of illusion. A few days later, he hastily sewed up the slashes with thread and left the ends hanging loose. He had poured red enamel paint through the slits from the back of the painting. Seen from the front, bloody red streaks ran out of the slits, and it looked as if a lunatic with an ax had gone after the festive party guests. But this version also did not appear to satisfy Richter; when I saw the painting the following week, he had pounded long nails through it in various spots and bent them over in front. He had probably just met the nail artist Uecker. In any case, Richter said to me, "Now I don't like the painting any more at all."[15]

Party is the most famous example of this transition in Richter's development, and it is one of the few works from the time to survive. The painting depicts 1960s television host Vico Torriani flanked by four party girls. Laughing, the figures lift their glasses to toast the viewer. The scene exudes the carefree but highly staged festivity that enlivened popular variety shows on German television during the 1960s. These shows and their manufactured merriment served as a balm to the divided nation's bruised ego and masked the horror of the recent past. In the new West German republic, any serious effort to come to terms with the Nazi past and the unspeakable war crimes committed under Hitler was eagerly suppressed, overwhelmed by the optimism surrounding Germany's "economic miracle" (*Wirtschaftswunder*)—the rapid growth spawned by a new currency system and by the massive reconstruction funded primarily by the United States under the Marshall Plan.

Richter painted *Party* primarily in black and white, consistent with the original image—but the legs of one woman are painted in color. Richter eventually glued the original photograph onto panel 9 in his *Atlas*, an ongoing compilation of source material for his projects that he formally began to assemble in 1970.[16] One can see there how he drew a pencil grid over the photograph in order to transfer and enlarge it onto the canvas. The clump of five happy figures fills the shallow space of the picture to the point of claustrophobia. The painting's upper edge crops the scene at the level of the eyes: individuality thus becomes anonymity— an ongoing theme for Richter.

Richter's first impulse was to leave the painting exactly as he had copied it from the photograph, but having not yet confronted Lichtenstein's work (or the work of any Pop artist, for that matter), it was impossible for him to accept such a direct copy as an original work of art. *Party*, in his judgment, was lacking a crucial intervention. Resorting to the same, limited vocabulary of the work he had shown in Fulda, he foregrounded his artistic intentions through destructive action. He slashed at the canvas with a knife, then stitched up the wounds but also

accentuated them with drips of blood-red enamel paint. The attack also relayed Richter's intense dislike of the superficial party scene in West Germany, but the message was so brutally frank that he quickly lost interest in the painting. For him, it proved that the vocabulary of his Informel work was incompatible with painting from photographic models, producing paintings with what he would later pejoratively term "literary effects."[17]

When Richter showed *Party* in the joint exhibition with Polke, Lueg, and Kuttner at Kaiserstraße 31a, the critic for the *Rheinische Post* took notice:

> Gerhard Richter has converted a magazine photo—a group of decorous smiling young ladies with one gentleman—into a large-format painting in oil. But [the viewer's] own smile fades in the face of the horrifying slashes and rips imposed on tender young female flesh through the use of red enamel and nails and other bloody effects intended to call into question the cheap, flat, and "putrid" qualities of this festive occasion.[18]

In 1966 Richter was interviewed on the German television show *Kunst und Ketchup* (Art and Ketchup) and agreed to present *Party* because the producer "absolutely wanted to film it." But he took control of the interview, explaining that *Party* was actually a bad painting and an exemplar of what Pop art is *not*. Richter was about to destroy the canvas when Günther Uecker intervened, asking if he might have it to decorate his basement. Thus *Party* survives. In 1993 the painting came onto the market when Uecker divorced, and sold for DM 400,000, roughly equivalent to $350,000 today.

Another early example of Richter's engagement with popular media was the large painting *Pope* (*Papst*; 190 × 190 cm), also from 1962. Here he translated a photograph of Pope John XXIII into a work patently influenced by the English painter Francis Bacon's dramatic renderings of Pope Innocent X, itself made after Diego Velasquez's portrait. In Richter's representation, the figure of the pope—ostensibly God's institutional representative on earth—is omitted, his nonpresence rendered as a white, reversed-out form. Today Richter considers the painting "a crude illustration" of the themes of theism and anti-Catholicism, involving more literary effects: "I soon rightly destroyed the canvas."[19]

In fact, Richter destroyed most of his early works. They are known now only through reproductions in his well-organized archive. There was never, however, a radical break of the sort suggested by his self-organized catalogue raisonné (*Werkverzeichnis*, or "work list," as he terms it). This catalog is one of Richter's ongoing projects—a work in itself—and has long been a subject of controversy. Catalogues raisonnés are ordinarily assembled by scholars, who strive to document every authentic work by a given artist, and are organized chronologically. For Richter, the point is less to establish authenticity than to establish a trajectory within the artwork that he deems acceptable. His catalog does not include all of his work,

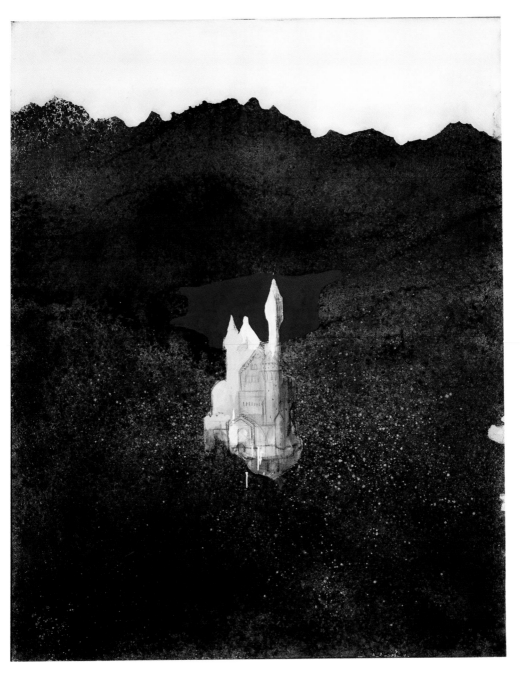

FIG. 2.3. *Neuschwanstein Castle (Schloß Neuschwanstein)*, 1963. OIL ON CANVAS. 190 X 150 CM. CR 8.

nor is it consistently chronological. The artist has always excluded his earliest work; while some critics would like to believe that it documents the first paintings that incorporate media images as source material, this is simply not the case.

Still, the contact with Lichtenstein's work proved essential for Richter. Lichtenstein confirmed something that he had himself been struggling to come to terms with: that it was a legitimate practice to reproduce media images in paint. To be sure, a Lichtenstein painting is never a precise copy: if one compares *Refrigerator* with its source—a common newspaper ad—the creative interventions are noticeable. Nor are Richter's gray photo-paintings, the next work he would produce, as "photographic" as they may seem in reproduction. Not only did Richter alter the original images, but the paintings, as painted surfaces, have a distinctive presence. Despite Lichtenstein's direct influence on how he came to redefine the possibilities of painting, Richter has never seen himself as an heir of American Pop art. While he appreciates the early work of Lichtenstein, Claes Oldenburg, and Andy Warhol (with whom he has most often been compared), he has never seen his practice as derivative of theirs. "I had very little interest in any critique of packaged culture or the consumer world," he has said.[20]

By the time the Düsseldorf academy held its next student review in February 1963, Richter's work had developed significantly. This time he presented three new paintings made from photographs: *Stag* (*Hirsch*; CR 7), *Neuschwanstein Castle* (*Schloß Neuschwanstein*; CR 8; fig. 2.3), and *Nose* (*Nase*; CR 11). "When I copied the first photos, I had the feeling for the first time that I was doing something special and, above all, something of my own. In the jargon of the day, it was 'radical.' And those who saw it suddenly had no argument, except for the one that it was unacceptable simply to ignore the rules and copy a photo." The paintings created a minor scandal: some of the other students found *Stag* hard to take, saying it reminded them of sofa upholstery. Nevertheless, the artist was finally showing paintings that he would continue to value, works that would make their way into his catalogue raisonné rather than onto the burn heap.

Although Richter would not publish the first official catalog of his paintings until 1968, he began to document this new body of work systematically starting in 1963. Here is how he described the procedure to the Italian gallerist Plinio de Martiis: "Except for numbers 23, 24, 25, and 26, all paintings are photographed according to scale and enlarged."[21] A contact print would then be pasted on a sheet of A4 paper, together with the film number and the title of the painting, and the artist would assign the work a number.

Table

The first, prized position in Richter's catalogue raisonné is occupied by the painting *Table* (*Tisch*; fig. 2.4) from 1962. The painting allows different interpretations,

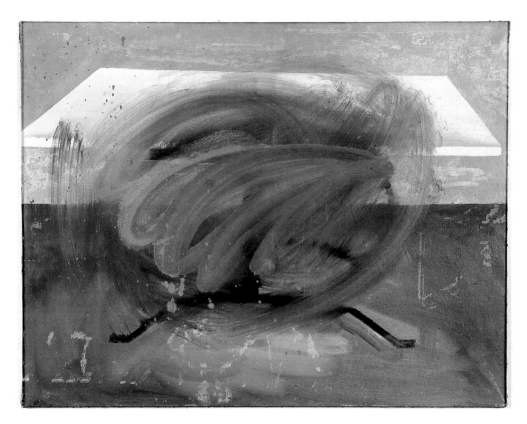

FIG. 2.4. *Table (Tisch)*, 1962. OIL ON MUSLIN. 90 X 113 CM. CR 1.

depending on whether one sees it as the natural issue of Richter's previous work or as a prelude to his reflections on photographic reproduction and painterly autonomy, which came into sharp focus the following year.

Richter had come across the source photo for *Table*—an illustration of a modern, two-legged table with a white top under the headline "Un Tavolo allungabile di Gardella" (An expanding table by Gardella)—in the Italian architecture and design magazine *Domus*. He began by painting an illusionistic copy of the illustration in black and white, then partially obscured the image by painting over it with a powerful, circular gesture:

> I painted [the table], but was dissatisfied with the result and pasted it over with newspaper. One can still see . . . the imprint where the newspaper was stuck to the freshly painted canvas. I was dissatisfied because there was too much paint on the canvas and became less happy with it, so I overpainted it. Then suddenly it acquired a quality which appealed to me and I felt it should be left that way, without knowing why. I destroyed or overpainted many pictures during this time. This became the first painting in my worklist; I wanted to make a new start after my work in East Germany, but also after the many pictures I had painted in the West, among which were a number of photopaintings. I wanted to draw a line, indicating that these paintings were in the past, and so set "Table" at the top of my worklist.[22]

In contrast with *Wound*, *Aggression*, and *Party*, all of which have an element of critique, affect, or commentary, *Table* is free of literary effects. The painting presents a banal, empty table. The expressiveness of the Informel gesture is simultaneously referenced and replaced by a kind of overpainting that disturbs the illusion of representation without destroying the image. In this way the two dominant strains of addressing reality through painting, the gestural and abstract versus the figural—often viewed in the 1960s as mutually exclusive—are brought into dialogue. The result is a positive phenomenon that has never ceased to fascinate Richter. *Table*'s number-one position in his catalogue raisonné is no coincidence; he placed it there, quite intentionally, to establish the programmatic basis for his subsequent work.[23]

The catalog has allowed Richter to extend the dialogue between representational modes beyond a conflict within a single canvas, providing a means to position entire groups of work that he was developing concurrently—abstract paintings, romanticized landscapes, and still lifes—as different ways of examining reality. As Richter put it in a 1977 letter to Benjamin Buchloh, a scholar and critic of singular importance to his career:

> I look for the object and the picture: not for painting or the picture of painting, but for our picture, our looks and appearances and views, definitive and total.

How shall I put it: I want to picture to myself what is going on now. Painting can help in this, and the different methods = subjects = themes are the different attempts I make in this direction.[24]

Without question, 1962 had been a watershed year for Richter. He first rejected the kind of illustrative art he had been required to make in East Germany, then became so dissatisfied with the Informel work he had produced since coming to the West that he burned almost all of it. By then he had become particularly disenchanted with the kind of formalist aesthetic that seeks harmonic balance in abstraction. "With Formalism, I mean, whenever someone views a painting formally and then concludes—and this really bothers me—up here there are three hooks, you must strengthen this rhythm, from the right come four more, then you set a balancing weight, and now it's fine. That is a terrible way of looking." To paint traditional figures or landscape impressions was also not an option. Richter knew from drawing after nature that there are always corrections, stylizations, alterations, and with these, a compositional intervention in making the work.[25] Richter was looking for motifs that could be rendered without "literary effect," historical bias, and the decorum of traditional composition. Photos in his family albums and images scavenged from newspapers and magazines presented a way out of the dilemma. They were the perfect source material for transforming the figurative into paintings without having to compose anything himself.

"A photograph—unless the art photographers have 'fashioned' it—is simply the best picture that I can imagine," Richter said in 1966.

It is perfect; it does not change; it is absolute, and therefore autonomous and unconditional. It has no style. The photograph is the only picture that can truly convey information, even if it is technically faulty and the object can barely be identified. A painting of a murder is of no interest whatever; but a photograph of a murder fascinates everyone. This is something that just has to be incorporated into painting.[26]

Working from a photo eliminates the artifice of form, color, composition. The photo defines these elements, which have only to be translated into paint. The intention is to give paintings the most unartistic, impersonal, and distanced character possible. All elements traditionally associated with the *work* of art are excluded. Even so, the image should retain its character as a painting. Any close inspection of Richter's paintings reveal they are not, as critics in the 1960s liked to call them, "painted photos." Their coloration and the surface resulting from the way the paint is applied are, quite simply, unique.

The paintings' unartistic character is meant to correspond to the arbitrary choice of subject matter. Richter abstained from using spectacular scenes and

assiduously avoided any hint of personal motivation in his selection. There are many banal subjects in the works he painted over the next few years; moreover, the paintings seem to vacillate randomly among subjects and genres.

Richter remembers discussing his source material with Lueg and Polke. "We reassured each other that the real pictures were in newspapers and magazines. And then we would consume and analyze them voraciously." Richter also used several photographs from the family album he brought with him from East Germany, though for years he resisted acknowledging their private origin. *Uncle Rudi* (*Onkel Rudi*; CR 85; fig. 5.9) and *Aunt Marianne* (*Tante Marianne*; CR 87; fig. 5.5), both from 1965, are two exceptions: in the titles to these works the artist embraces his relationship with the person represented. By contrast, nothing in the title *Renate und Marianne* (1964; CR 31) alludes to the fact that it depicts his wife, Ema, and her sister Renate. Nor is the Horst in *Horst with Dog* (*Horst mit Hund*, 1965; CR 94; fig. 5.10) identified as his father. Richter borrowed other photos from friends, such as the one that served as a model for *Man with Two Children* (*Mann mit zwei Kindern*, 1965; CR 96), donated by Sigmar Polke.

An aunt in Oldenburg collected magazines for her nephew and mailed a batch to Düsseldorf every few weeks, including the latest issues of *Stern, Revue,* and *Quick*. Richter was drawn to images of ordinary, unknown people whom fate had momentarily pushed into the public eye. But he also painted prominent figures without revealing their identities; the nearly unmistakable figure of Jacqueline Kennedy thus hides behind the title *Woman with Umbrella* (*Frau mit Schirm*, 1964; CR 29; fig 3.10). Other subjects included consumer goods, landscapes, military airplanes, architecture, and groups of unknown people. Richter's method of painting assigns an identical value to every person and object represented in order to establish an emotional distance between the viewer and the subject. All figures are equally important, and equally unimportant. Thus, Richter challenges the viewer to consider what meaning can possibly be assigned to an image of Kennedy's assassin, Lee Harvey Oswald (*Oswald*, 1964; CR 16), when it appears in the catalogue raisonné between a painting of an ordinary cow (CR 15) and the blurred image of a German fighter jet (*Schärzler*; CR 17).

During the 1972 Venice Biennale, Richter tried once more to explain why photography had come to mean so much for his painting:

> Because I was surprised by photography, which we all use so massively every day. Suddenly, I saw it in a new way, as a picture that offered me a new view, free of all the conventional criteria I had always associated with art. It had no style, no composition, no judgment. It freed me from personal experience. For the first time, there was nothing to it: it was pure picture.[27]

The dialogue between painting and photography is as old as photography itself. The fearful predictions of the French history painter Paul Delaroche, who

believed that photography would be the death of painting ("La peinture est morte!"), never quite came to pass, though there is no question that the two mediums have competed and profoundly affected each other in both theory and practice. It was not long after the invention of photography that the medium took on and even bettered some of the functions of painting; whether in portraiture, the recording of cityscapes, or scientific illustration, it at least seemed to offer greater objectivity and precision. The purported objectivity of photographic representation and its mechanical process also served to complicate and delay its acceptance as an artistic medium, even though many of the early photographers were, first and foremost, painters. Jacques-Louis Daguerre, for one, had been a theatrical scene painter before he invented the daguerreotype in 1839. In truth, the practice of photography served to embolden painting, even helping to pave the way to abstraction. The French impressionists, Edgar Degas in particular, incorporated in paintings the unconventional compositions often revealed in photographs, as well as the radical instantiation of detail. In the twentieth century, artists used photographs and photographic reproductions in making collages and assemblages, and painters drew from them in rendering speed and motion. Finally, starting in the late 1950s, Pop artists in the United States and Britain, as well as the artists of the French Nouveau Réalisme movement, began to explore photography as a mass medium and to critically engage its function.

As many have noted, artistic engagement with photography has prompted or inspired all sorts of critical questions regarding objectivity, manipulation, authenticity, and cliché in photographic perception, aura and its loss as a result of unlimited mechanical reproducibility, and the suggestive potential of photographs as reproduced images in the mass media. Once Marshall McLuhan's *Understanding Media* (1964) was published in German in 1968, critics began interpreting Richter's confrontation with photography as the renewal of painting in the visual experience of reality. The represented subject in one of his paintings did not seem to be what interested him, but rather the qualities of the medium through which the subject was represented. "The different possibilities surrounding this proof of reality began to interest Richter," offered Dieter Honisch, who curated Richter's show at the 1972 Venice Biennale. "He thus examined not so much the artistic aspects of the photograph, which already interprets reality, but rather the document as it was used in photojournalism and the amateur photo, which enables certain clichés of representation to be revealed."[28] Richter, however, has always defended his work against this interpretation. In a 1993 conversation with Hans-Ulrich Obrist, he stated emphatically, "Many critics thought that my art was a critique of contemporary life: criticizing it for being cut off from direct experience. But that was never what I meant."[29]

As an artist during the 1960s, Richter did not question the objectivity and authenticity of photography itself (this in a day before digital imaging). Indeed

he has always worked to transfer the attributes and vocabulary of photographs into painting. He said, in a 1972 interview with the journalist Rolf Schön:

> I'm not trying to imitate a photograph; I'm trying to make one. And if I disregard the assumption that a photograph is a piece of paper exposed to light, then I am practicing photography by other means: I'm not producing paintings that remind you of a photograph but producing photographs.[30]

Richter intends, on the one hand, to undermine representational painting but, on the other hand, to rescue it from the turbulent discourse surrounding artistic practice during the second half of the twentieth century. Eschewing the traditional creative choices of composition, color, genre, and style, he transfers the fundamentals of photography, a relatively unburdened medium, to the painted representation. The black-and-white palette and "blurriness" are only the most obvious qualities of the paintings he began to produce in the 1960s. Easily as important is the distance inherent in photography (*mediale Distanz*) that he borrows for his painting: the objectivity, mechanical production, and lack of creative composition. For Richter, composition in photography follows a simple rule: "Composition is when the main person stands in the middle."[31] And Richter's paintings present themselves as photographs, taking on as many characteristics of the medium as possible. In this way Richter has succeeded in producing works disengaged from the orthodoxies of modern art, paintings that reject the formalism of Clement Greenberg and offer a new and different justification for a medium that had, in some quarters for more than a century, been repeatedly pronounced dead. Painting, then, was able to survive *as* photography in Richter's practice.[32]

Still, in hindsight, Richter's photo-paintings of the early 1960s are eminently painterly. *Terese Andeszka*, from 1964 (CR 23; fig. 2.5), does not look anything like a photograph. The painting depicts a beach scene, one of Richter's favorite subjects back in Dresden, with three figures: Terese Andeszka, her husband, and their son. The source image came from a newspaper clipping, which Richter enlarged to a 170–by–150-centimeter canvas with the aid of a penciled grid, transforming the black and white of the newsprint into a range of graduated gray values. The figures are slightly out of focus, suggesting a poorly made photograph. More important, however, is that the painting reproduces the edge of the picture and a line of text, thus declaring the image's origin in the mass media. The intent is not to force a "literary effect" but to establish a media-determined distance. Richter is no longer painting a beach scene, but instead a photographic reproduction of a particular beach scene as it was published in a newspaper. In this way, the representation takes on the character of a quotation.

But Richter takes the personal removal yet a step further. Although the caption in the original clipping, which is pasted into the *Atlas* (panel 8), reveals why

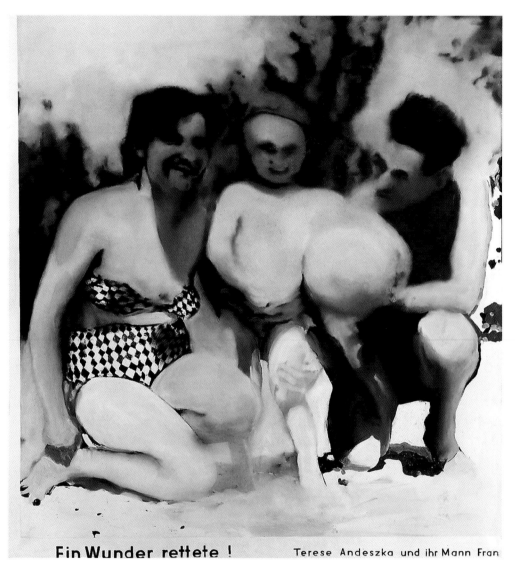

FIG. 2.5. *Terese Andeszka*, 1964. OIL ON NETTLE CANVAS. 170 X 150 CM. CR 23.

the unknown Andeszka had become the subject of a newspaper story—that she "and her husband Franz were refugees"—Richter chooses not to include the text in the painting, and thus forecloses any direct link to the discourse of a divided Germany, to the media's handling of the fate of individuals, or to his own status as a refugee from the East. That Richter copied this particular image suggests—despite his claim that his selection of material is strictly arbitrary—that his personal experience can indeed influence his choice of subject matter.[33] Although allusions to the refugee problem cannot be found in any other of his paintings, Richter does collect a number of newspaper clippings on the topic in the *Atlas*, including (on the same panel as the clipping about Andeszka) another beach scene showing six young women along with the headline "They planned their escape in a bathing paradise." By eliminating the back story, however, Richter opens *Terese Andeszka* to a discussion of the media-specific qualities of painting and photography.

KAISERSTRASSE 31A

When Lueg, Kuttner, Polke, and Richter first got together, they viewed their association as an opportunity to talk about art and lend moral support as each pursued his own, independent practice. Eventually, however—and against Richter's better judgment—the members of the cadre began to see themselves in more organized terms, especially Lueg, who by 1963 had graduated from the academy and was out in the world trying to make it as a freelance artist. "It was a solitary life. I did not have a gallery that would show my paintings and attend to my interests," he recalled in 1989, in a rare interview with the collector Stella Baum. "My former fellow students Sigmar Polke and Gerhard Richter were in the same situation I was. All three of us searched in vain for a gallery."[34] Wanting to improve his own situation and to generate exhibition opportunities, Lueg took action: He typed up an official announcement of the formation of "Gruppe 63," obviously referencing Gruppe 53, founded ten years earlier. The goal of that group, as articulated in its manifesto, had been "the advancement and preservation of artistic achievement, especially through the organization of art exhibitions according to artistic position, as well as companionship."[35]

Lueg learned a lot about Gruppe 53 from his friend Peter Brüning, who had been a member, and in his announcement for Gruppe 63 he described the renewed need for such an organization: "Today, after ten years, there is again a group of young people who are in the same situation as the founders of the Gruppe 53 at that time. They lack opportunities to exhibit, venues in which to publish, and financial means." Lueg hadn't in mind anything doctrinaire; he had no wish to produce a manifesto. Rather, he imagined several practical advantages that would come from such a group: "1. Exhibition opportunities on a larger scale; 2. Financial

contributions from the city and state; 3. A collective jury of their own; 4. High quality catalogs; 5. Contact with critics, dealers, and collectors; 6. Exchanges with other groups. . . ."[36]

Lueg had an equally specific idea about who should belong to Gruppe 63. He wanted to define a new, exclusively young generation of Düsseldorf artists, and on the back of the typed page, he scribbled the names and ages of desirable compatriots. Gerhard Richter, age thirty-one, topped the list, followed by Kuttner and Polke, and then Kuno Gonschior, Jochen Hiltmann, Gotthard Graubner, Ferdinand Kriwet, and the photographer Bernd Becher, who later, with his wife Hilla, became a highly influential teacher for the so-called Becher school (Andreas Gursky, Thomas Ruff, Thomas Struth). Mentioned as a critic was the twenty-two-year-old Hans Strelow, with whom Lueg had gone to school. Strelow later became a correspondent for the *Frankfurter Allgemeine Zeitung* in New York City, and today he owns a gallery in Düsseldorf.

In the end nothing much came of Lueg's proposal. No exhibition opportunities had materialized since Richter and Kuttner's show in Fulda, and no gallerists were knocking at the door, so the four artists decided to take matters into their own hands and find a space where they could show work for themselves. Climbing into Lueg's car, they drove the streets of Düsseldorf's old town center and finally found a vacant store at Kaiserstraße 31a, kitty-corner to Jean-Pierre Wilhelm's long-closed Galerie 22.

On March 30, 1963, the foursome wrote to city officials, asking to rent the space for eight days. In the first draft of the application letter, Lueg once again advanced the idea of a collective identity, naming Gruppe 63 as the applicant. Richter, however, edited the letter and crossed out every reference to the group. In the final version the artists emphasized the noncommercial nature of their venture: "The exhibition does not have a commercial purpose, but seeks to inform about a new figurative direction in art and to exhibit for the first time a group of young Düsseldorf artists." Richter added another sentence to appeal to the city's sense of itself: "We believe that you, our city of Düsseldorf, known for your support of the arts, will be supportive of our efforts."[37] All four artists signed the application, which was approved.

Thus, on Saturday morning, May 11, 1963, Richter, Kuttner, Lueg, and Polke threw open the doors to their first and only exhibition as a collective. They had taken great care with the invitations. Each card was unique and featured at its center a different postage stamp–size newspaper clipping that one of the artists had glued there by hand (fig. 2.6). The edges of the invitations were decorated with a profusion of isms, some culled from an article by Barbara Rose that had appeared in the all-important January 1963 issue of *Art International*, and some made up: "Pop Art? Imperialist Realism? Antikunst? Nouveau Réalisme? Neo Dada? Junk Culture? Common Object Painting? Pop Around?" and so on. By co-opting contemporary artspeak and using it as filigree, the artists sought to

FIG. 2.6. EXHIBITION ANNOUNCEMENT, KAISERSTRAßE 31A, DÜSSELDORF, 1963.

demonstrate the currency of their own artistic position without having to define it conceptually.

In a letter Richter sent to the newsreel company Neue Deutsche Wochenschau in advance of the show, he describes it as the "first exhibition of 'German Pop Art.'" "For the first time in Germany, we are showing paintings for which such terms as Pop Art, Junk Culture, Imperialist or Capitalist Realism, New Objectivity, Naturalism, German Pop and the like are appropriate."[38] (This was Richter's first usage of the term "capitalist realism," an expression he would later regret coining, when gallerists starting using it to market not just his work but that of other artists.) He goes on to stress the originality of the work in the show:

> Pop Art is not an American invention, and we do not regard it as an import—though the concepts and terms were mostly coined in America and caught on more rapidly there than here in Germany. This art is pursuing its own organic and autonomous growth in this country; the analogy with American Pop Art stems from those well-defined psychological, cultural and economic factors that are the same here as they are in America.

And with a rhetorical flourish, Richter transforms the artists' failure to find a gallery into a conscious decision: "This exhibition is not a commercial undertaking but purely a demonstration, and no gallery, museum, or public exhibiting body would have been a suitable venue."[39]

Richter would resort to the "demonstration" throughout his career, and even occasionally apply the term to professional gallery events. As he explained to the author, the formulation was appropriate to the art scene at the time, and it also provided a psychological buffer against disappointing sales. Sales were particularly important to Richter, not only for commercial reasons but also because of the artistic recognition they brought. In a letter he wrote a year later to Heiner Friedrich, Richter remarked on a forthcoming exhibition in Galerie h in Hannover, noting: "We can hardly count on sales there; the gallery appears to be insignificant. We should be more concerned with having a demonstration."[40]

In any case, the opening at Kaiserstraße 31a turned out to be a success. The modest rooms were crowded with visitors. Photos taken at the opening show Joseph Beuys, Gotthard Graubner, Heinz Mack, and Günther Uecker all in attendance.

Richter exhibited the paintings *Party* and *Dead* (*Tote*; CR 9) as well as two works that no longer exist: *Shooting* (*Erschießung*) and *Ice skater* (*Eisläuferin*; CR 2). Lueg presented several large-format mixed-media works on canvas from 1962 and 1963 that explicitly referenced the thirty-four dye-transfer illustrations of Dante's *Inferno* that Robert Rauschenberg had exhibited at Galerie 22's final show in 1960. Unfortunately none of the surviving photos document Kuttner or Polke's work, so we do not know what they showed. A few days

after the opening, a review appeared in the *Rheinische Post* titled "The Last Stitch":

> Pop art, the latest rage from America, has found its way to Düsseldorf and created an exhibition forum for itself because "after all, something has to happen," as the group of young enthusiasts ensures, as they knit this last stitch. What the intended purpose was could not exactly be determined from the smoke-clouded conversations, but the exhibitors definitely want to shock. Whether from naïve conviction or for the sake of titillation could likewise not be adequately determined. Looking at the things on show, one cannot help but see that the distance between these objects and art is a great one.[41]

Only Kuttner escaped the critic's wrath. "The kinetic paintings of the Thüringian painter Manfred Kuttner rise advantageously above these sensationalistic tabloidlike banalities."[42]

The review made one thing clear to Richter: "Manfred Kuttner and his grid pictures did not belong with us!" While the others incorporated trivial, private, and public media images in their work, Kuttner painted geometric grids suspended in a programmatic zone somewhere between concrete art and ZERO. The foursome only exhibited together one more time, in 1964, when René Block put them in a large group show at his Berlin gallery titled "Neodada, Pop, Décollage, Kapitalistischer Realismus."

A few weeks after the Düsseldorf exhibit closed, Richter and Lueg drove to Paris with their wives, Ema and Dorothee, in Lueg's Peugeot. Still pumped up by the show, they were going to introduce themselves to the Parisian galleries as "German Pop artists." Their first stop was Ileana Sonnabend's elegant space on the Quai des Grands Augustins. Sonnabend represented the New York program of her former husband Leo Castelli. Hers was one of the first galleries in Europe to show the work of the American Pop artists Andy Warhol, Jasper Johns, and James Rosenquist, and of Robert Rauschenberg. In May 1963 she had presented the exhibition "Pop Art américain." Although there was no show up when they walked into the gallery, Richter and Lueg were received by Sonnabend and had their first look at an original painting by Lichtenstein. Richter was almost more impressed by the work's packaging—clear plastic foil—than he was by the work itself. In Düsseldorf artists could only afford brown packing paper. Lueg was so intimidated by the whole experience that he insisted his friend go into the other galleries alone while he waited outside. "This made it easier for me as well," Richter said later. "I went to Iris Clert [who represented most of the artists associated with Nouveau Réalisme in Paris] with both our portfolios. I could then show Konrad's portfolio and talk about that and use the opportunity to introduce myself too." The trip took them to some other galleries as well, but it did not, alas, produce a show.

It would be several years before Ileana Sonnabend got around to contacting

Richter. In 1966 she nominated him for a prize and wrote to request some material: "I have been asked to recommend artists for the Marzotto Prize, and I have submitted your name. I have some photos that you had sent me and others from Mr. Zwirner. If you have better and more recent ones please send them immediately, along with a 'curriculum vitae.'"[43] The following year Sonnabend would visit Richter in his Düsseldorf studio and buy a small color chart he had made. She also attended his opening, on October 13, 1967, at the gallery Wide White Space in Antwerp. She never, however, came around to representing him.

FLUXUS

"When I went to study with Götz in Düsseldorf in 1961 . . . I was pretty nonplussed and desperate to start with. What eventually set me free was the encounter with Fluxus and Pop Art."[44] The Fluxus movement stood against all traditional artistic categories—especially painting, which it dismissed as a bourgeois expression. Fluxus was concerned with dissolving conventional, static work and transferring it into an aesthetic process. Its chief artistic forms were Actions and Happenings (or "events," as some Fluxus artists preferred to call them). Physical objects were assigned the status of relics, the documentary residue of an event. The Fluxus artists crossed all manner of disciplinary boundaries in their activities, connecting the visual with musical and theatrical modes of expression. Art and life should no longer be separated, they said; all behaviors that come into play in daily life should be subjected to aesthetic interpretation and staged as art. The Fluxus artists reveled in their antics and critiques of social convention, presented themselves aggressively, and, more than anything, *loved* to provoke an audience.

Joseph Beuys was the leading figure of Fluxus in Düsseldorf. Born in Krefeld in 1921, he had studied art in Düsseldorf from 1947 to 1951 with Ewald Mataré, and in the summer of 1961 he was appointed professor at the Düsseldorf academy. When Richter encountered him for the first time at school, he thought Beuys was a student. Though fascinated by the charismatic sculptor, Richter distanced himself from the older artist's political and artistic "sense of mission." Together with Lueg, he attended Beuys's legendary "Stallausstellung" (October 26–November 24, 1963), in which he exhibited works from the collection of Franz Josef and Hans van der Grinten in a converted cow stall in Kleve. In the catalog for "Beuys zu Ehren," a 1986 show in honor of Beuys at the Städtische Galerie im Lenbachhaus in Munich, Richter had this to say: "In a cowshed somewhere out beyond Kleve, I saw my first Beuys exhibition. I was amazed, dumbfounded, impressed—although my own affinities were with a different and far more 'official' art (Fontana, Pollock, Newman, Fautrier, and the rest), which seemed to me to operate as if within a protective order, an unspoken consensus. With Beuys it was always different: he unsettled me, because he didn't play by the rules."[45]

Richter had the same uneasy reaction to the other Fluxus artists. He attended at least three of their events. On June 16, 1962, the former gallerist Jean-Pierre Wilhelm presented the concert "Neo-Dada," featuring Nam June Paik, in the Düsseldorfer Kammerspiele. Simultaneously, thanks to Joseph Beuys, the large "Festum Flexorum Fluxus" was held at the Düsseldorf Art Academy. Fluxus founder George Maciunas, Dick Higgins, Tomas Schmit, Alison Knowles, Arthur Köpke, Daniel Spoerri, Wolf Vostell, and Emmett Williams all took part in the two-day event. George Brecht premiered his *Drip Music* here, in which he let water drip from a tall ladder into an aluminum bucket, and Beuys performed his *Siberian Symphony, First Movement* on opening night. On stage, next to the grand piano where Beuys played some improvisations, stood an easel with a dead rabbit hanging from it. For Beuys, the rabbit symbolized the existential experience of birth, life, and death. This was the first time it became a central element of one of his Actions.

Another provocative high point of the festival was June Paik's *Fluxus Contest*—a pissing contest featuring a bucket on the open stage, which Frank Trowbridge won with a momentous duration of fifty-four seconds. In 2001 Richter could still remember the event vividly. "Shocking absolutely shocking—they pissed in the tub, sang the German national anthem, covered the audience with paper, poured laundry detergent into the piano, attached microphones to fountain pens."[46]

One of the most important events for Fluxus in Germany was the "Festival der neuen Kunst—Actions/Agit-Pop/Decollage/Happening/Events/Antiart/ l'Autrisme/Art Total/Refluxus," held in the Technische Hochschule in Aachen on July 20, 1964. Richter, Blinky Palermo, and Manfred Kuttner were among the more than eight hundred people, mainly male students, who filled the auditorium that evening (fig. 2.7). Artists participating in the event included Bazon Brock, Stanley Brouwn, Henning Christiansen, Robert Filliou, and, again, Köpke, Vostell, and Williams.

The event achieved considerable notoriety in the history of Fluxus because several artists in the audience tried to take over the forum to advance their own interests. Timm Ulrichs, a self-proclaimed *Totalkünstler* (total artist) from Hannover, complained so volubly that the "actors" had stolen his ideas that nothing could be done until he was escorted from the room. Franz Erhard Walther took advantage of the large audience to stage his own Happening, which amounted to climbing over the rows of desks and spraying pine scent at the audience. But it was during Beuys's appearance, as he slowly melted a block of lard over a small stove, that the audience had finally had enough and stormed the stage. They had been provoked, but they were also probably just looking for a fight. As the chaos grew, an audience member's suit was damaged by the explosion of the small stove, which Beuys set off, or by acid thrown by one of the students. In any event, the man in the damaged suit shoved Beuys, knocking him down. Nose bleeding, Beuys whipped the audience into an even greater frenzy by raising his right arm in a "Heil Hitler" salute while holding up a crucifix in his left hand—creating an

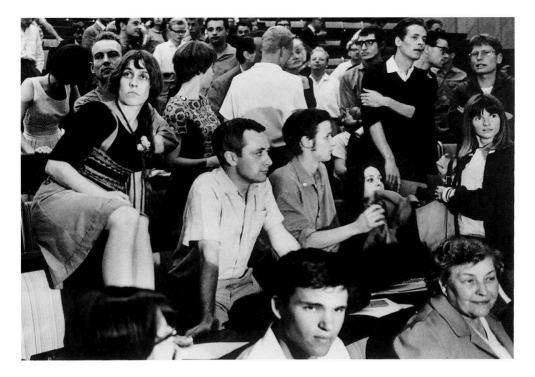

FIG. 2.7. FLUXUS-FESTIVAL AT THE TECHNISCHE HOCHSCHULE, AACHEN, 1964. UPPER LEFT: MANFRED KUTTNER (HALF COVERED); CENTER: RICHTER AND BLINKY PALERMO.

instantaneous association with the martyrs of Operation Valkyrie, the plot to as-sassinate Hitler that had been carried out by members of the German resistance on the same date—July 20—in 1944.[47]

Police finally broke up the riot. Afterward, different theories were put forward to explain the audience's aggressive behavior. For Germans, July 20 had become a sacred date, prompting students who attended to accuse the Fluxus artists of ridiculing the more than two hundred members of the German resistance who had been executed in retaliation for the assassination attempt. The students had also been frustrated by the artists' opaque behavior; conversely, the event's organizers described the audience as virtually insensate. Privately it was said that if there had been more women enrolled at the academy and hence in the audience, the aggression might have been mitigated. Richter, typically laconic, commented on the evening in a letter to Heiner Friedrich: "Fluxus on July 20. Beuys was beaten bloody. The show interrupted."[48]

There is no question that Fluxus had a radical antipainting viewpoint, repre-sentative of a growing consensus among artists and some influential critics that painting as an avant-garde practice had reached a dead end. Richter, however, never responded defensively. Indeed, Fluxus made him feel even more empowered

to do his nontraditional photo-painting. "Yes, it is curious, but I don't actually find it contradictory. It's rather as if I were doing the same thing [as Fluxus] by other means, means that are less spectacular and less advanced," he said in a 1986 interview with Buchloh. On another occasion he added, "It was so absurd and destructive. It inspired me to try out some real nonsense, like copying photographs in oil paint."[49]

"LIVING WITH POP"

In 1963 Richter and Lueg offered their own playful interpretation of the Fluxus proposition that art and daily life should be connected, in a performance event they staged in the Mobelhaus Berges, a furniture store in Düsseldorf. The two artists, having tried and failed to find a gallery, again decided to take control of the situation and launch their own exhibition. The ever-resourceful Lueg knew everyone, and he had enormous charm; it did not take him long to convince the owner of Berges—one Herr Faust—to turn over a small office in the store for a show. He and Richter began generating ideas for how to use the space, but nothing seemed to gel until the store owner asked if they would hang some paintings in his showrooms as part of the bargain; then everything seemed to fall into place. "Actually, it's about the worst thing that can happen to a person, to exhibit in a furniture showroom. But it was exactly this that attracted us," Richter mused in hindsight. The two artists wrote up a report, dated September 12, 1963, that described the project in some detail:

> A number of exhibition concepts were rejected, and it was resolved to hold a demonstration as follows:
> a) The whole furniture store, exhibited without modification.
> b) In the room set aside for the exhibition, a distilled essence of the demonstration. An average living room as a working exhibit, i.e. occupied, decorated with suitable utensils, foods, drinks, books, odds and ends, and both painters. The individual pieces of furniture stand on plinths, like sculptures, and the natural distances between them are increased, to emphasize their status as exhibits.
> c) Programmed sequence of the demonstration for 11 October 1963.

The two artists also tape-recorded some fragmented quotations to be played over the public address system during the demonstration.[50]

The "Demonstration for Capitalist Realism" took place on Friday, October 11, 1963, at 8 p.m. Four paintings by each artist had been hung on the showroom walls, where they stayed through October 25. Richter showed *Pope, Stag, Neuschwanstein Castle,* and *Mouth* (*Mund,* 1963; CR 11/1). The show also included a work by Beuys in the coat room, which Beuys installed himself. In their exhibition report Richter

and Lueg described the work as "hat, yellow shirt, blue trousers, socks, shoes; to which 9 small slips of paper are attached, each marked with a brown cross; beneath is a cardboard box containing Palmin [cooking fat] and margarine."[51]

Richter had first used the term "capitalist realism" in his letter to the newsreel company Neue Deutsche Woche the previous April. The intent then had been to satirize socialist realism, but now it captured perfectly the idea of an exhibition in a furniture store: "It was a catchy slogan. It was a capitalist world of goods that we were showing. After all, our exhibition was the entire furniture store. This was meant to be ironic, but in no way critical of society."

The artists designed an invitation card with a green balloon pulled through the "o" in the title "Leben mit Pop," and this printed instruction: "1. Blow it up! Pay attention to the inscription! 2. Let it burst! Pay attention to the noise! Pop!" The slogan "Leben mit Pop bei Berges" (Living with Pop at Berges) was printed in white type on the green balloon. Of course, the instruction to destroy the balloon did possess a slightly anarchistic edge, something the store owner would later regret. But in the beginning, hoping to garner publicity, Mr. Faust paid for advertisements to run in several newspapers. In the local paper *Mittag*, there appeared an illustration of Claes Oldenburg's *The Store with Meats* (1962), with the caption "The exhibition 'Leben mit Pop' at Berges will be something like this."[52]

On opening night two store employees handed out program bills as they greeted visitors at the entrance. In addition to describing the program, each hectographed page bore a unique, sequential number.[53] At 8:05 p.m., visitors heard an announcement: "Good evening, ladies and gentlemen. I welcome you in the name of the Berges store and the artists Lueg and Richter." Dance music followed, with a second announcement five minutes later: "Good evening, ladies and gentlemen. Please take a seat in the waiting room [upstairs] and wait until your number is called." Guests were then transported by elevator up to the store's fourth floor where, in another waiting area, stood a papier-mache figure of U.S. president John F. Kennedy. (Earlier in 1963 Kennedy had declared solidarity with West Germany in a celebrated speech in West Berlin. Little more than a month after the Berges opening, he would be assassinated.) Also in attendance was a papier-mache figure of the gallerist Alfred Schmela (fig. 2.8). "Schmela," according to Richter, "was Konrad's idea. Schmela couldn't come to the opening, so we built a double." Chairs had been placed in the upper waiting room, each with a current newspaper on the seat. Fourteen sets of deer antlers borrowed from Richter's father-in-law adorned the walls. (Richter later painted two of the sets in gray and added the small canvas to his catalogue raisonné as number 80/20.)

The music was soon interrupted again by a third announcement: "Those ladies and gentlemen with numbers one through nine are asked to enter the exhibition room."[54] The designated visitors then entered a showroom of modern, functional furniture, featuring Lueg and Richter as part of the décor:

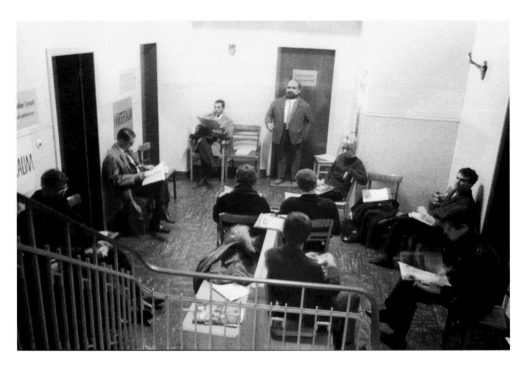

FIG. 2.8. WAITING ROOM AT "LIVING WITH POP" (LEBEN MIT POP), 1963.

A tea trolley bearing a vase of flowers, and on its lower shelf the works of Churchill
and the homemaking magazine *Schöner Wohnen*. A cupboard with assorted con-
tents. A wine-red chair. A gas stove. A green chair, occupied by K. Lueg (dark suit,
white shirt, tie). A small occasional table; on it, a television set (showing news
followed by *The Adenauer Era*). A small standard lamp. A couch; reclining thereon,
with a detective story, G. Richter (blue suit, pink shirt, tie). A table set for cof-
fee for two, with cut marble cake and *napfkuchen* [Bundt cake] and coffee in cups,
plus 3 glasses and a plastic bag containing 3 bottles of beer and 1 bottle of grain
spirit. The walls are painted white, with no pictures or other adornment. Next to
the door is a wardrobe, containing the official costume of Prof. J. Beuys.[55]

The furniture was presented on plinths wrapped in white cloth (fig. 2.9), the pieces
placed far enough apart to decontextualize them. The sculptor Reiner Ruthen-
beck, who was a student at the academy at the time, took many photographs to
document the evening.

At 8:30 p.m. the artists stood up, and a new announcement over the public
address system invited visitors to attend the second part of the demonstration:
"Ladies and gentlemen, in a few minutes the grand tour through all further ex-
hibition rooms will begin."[56] The tour led from the fourth floor through every
department of the store down to the basement. It was accompanied by dance music

from the loudspeakers, interrupted sporadically by announcements. Lueg and Richter had lifted ten fragments from promotional brochures, removed product names and price information, and edited them together lightly: "Single or double room? The problem is solved in an entirely different way with the wide Swedish bed. The bureau shows the contrast of wood to glass doors." Then more music, and another announcement: "The precious, genuine period furniture that we admire in castles, museums, and old, well-maintained houses was also made of birch and cherry."[57]

In their report on the event, Lueg and Richter described how the evening ended:

> Most of the visitors fail to observe the prescribed itinerary and scatter or stray into the various departments. By approximately 9 p.m., all the visitors have reached the kitchen department. They seat themselves in the 41 display kitchens and drink the beer provided. One visitor (an art student) protests against the Demonstration by removing all his clothing except a pair of swimming trunks. He is escorted from the building with his clothes under his arm. By 9:30 p.m. the last visitor has left the building.[58]

In all, 122 visitors were counted.

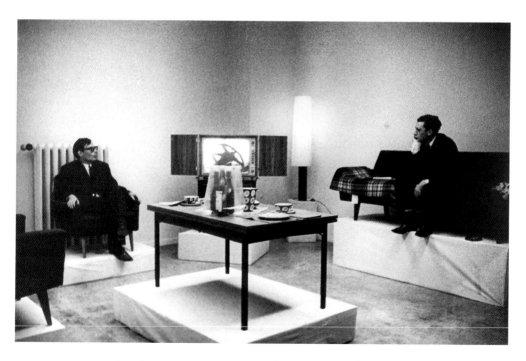

FIG. 2.9. KONRAD LUEG (LEFT) AND RICHTER ON DISPLAY IN "LIVING WITH POP," 1963.

Richter and Lueg were hardly the first artists to stage an event in a retail environment. Two years earlier, in December 1961, Claes Oldenburg had opened a store—called the Store—on Second Street in New York City, where he sold painted plaster replicas of a shirt with tie, a pink cap, ladies black shoes, and other consumer objects. The Store had also become a regular venue for Happenings. And in 1963, the year of Lueg and Richter's demonstration, Oldenburg created his *Bedroom Ensemble*, a complete bedroom set with double bed, armoires, lamps, mirrors, a chair, pictures, and window shades. A quick glance gave the impression of a perfectly ordinary display in a furniture store, but closer inspection revealed that something was amiss. The three-dimensional image of a modern room was in fact too perfect, and altogether superficial: Oldenburg had fashioned everything out of plastic and imitation wood.

Nor were the two Düsseldorf artists the first to present themselves as exhibition objects. In 1961 Piero Manzoni (whom Richter admired) had exhibited himself on a plinth. Nonetheless, Lueg and Richter staked out a unique position with their demonstration. The display of objects on white plinths created the necessary theatrical distance for the role playing of the artists, who objectified themselves as apolitical middle-class citizens in the society of the economic miracle. "We presented ourselves not as artists, but as sculptures. I wanted to display myself as an occupant, as a member of the petit bourgeoisie, with his pathetic blanket on the sofa," said Richter later. Their situation came across as hopeless, unsophisticated, boring, banal—and thus undermined the promise, proclaimed in neon above the store's display windows, of "Better Living with Berges." While Richter-on-display lost himself in a cheap detective novel and Lueg sat next to him, whiling away the time, the private idyll of a table set with coffee and marble cake was upset by the copy of Churchill's memoirs and the news show on television, referencing the bitter residue of recent German history and contemporary politics under Chancellor Konrad Adenauer, whose planned resignation took place that evening.

As the sociologist Berthold Franke described the world of the middle-class German citizen:

> His home is in reality a kingdom ruled by apolitical normality. There he finds shelter in times of relative quiet and protection from politics, which is really just 'dirty business.' In the well-tended privacy of the family, house, and garden, which is offered by the Biedermeier idyll as a static alternative to the threatening crowds of the mass age, the middle-class man ekes out a decidedly apolitical life—as long as he is left alone.[59]

Lueg and Richter had produced an absurdist exposé of this normalcy, what Susanne Küper assessed as a caricature of "that part of the population that follows political events only from the safe distance of the television or newspaper."[60] The fiercely critical demonstration did not, however, honestly represent Richter's own attitude,

which was ambivalent. Even as he sought to position himself within the artistic avant-garde, he desired the order and security of middle-class life.

Sigmar Polke did not participate in the event. As Richter remembers it, the two had just had a minor falling out, and in fact all four friends were starting to drift apart.[61] Kuttner was on the outs, and when, two years later, the exhibition "Kapitalistisch Realisme. Richter, Lueg & Polke" was mounted by Galerie Orez in the Hague, Richter wrote to Heiner Friedrich, "Unfortunately I really don't want to do this, because we three do not have such a fixed program and unified appearance. . . . I would prefer a solo exhibition."[62]

Among those who attended the "Demonstration for Capitalist Realism" was nineteen-year-old Kasper König, then an intern at Rudolf Zwirner's gallery in Cologne (and today the director of the Museum Ludwig in Cologne). König was so impressed by what he saw that he bought the Kennedy figure and persuaded the Cologne conservator and collector Wolfgang Hahn to buy the one of Schmela. König vividly remembers taking his prize on the train to his parents' house in Münster a month later. Kennedy had just been shot in Dallas, and König had to endure an incessant stream of verbal abuse from the other passengers.[63] König would eventually buy from Richter the painting *Stag*, also exhibited at Berges, as well as *Dead* (CR 9) and *Administrative Building* (*Verwaltungsgebäude*, 1964; CR 39). The object by Joseph Beuys was reassembled in 1988 and sold by his estate to the Anthony D'Offay Gallery in London.[64]

Alas, the demonstration did not prove a success for the owner of the Mobelhaus Berges. According to Lueg:

> the people wandered freely through the building and also through the display windows, where they tried out the beds. The beds had only been assembled provisionally and they collapsed, one after the other. Herr Faust wanted to take us to court! A year later, however, when he realized that our 'demonstration' had been written about in numerous publications, in which the name of his business was mentioned again and again, his anger dissipated.[65]

Later Richter would downplay the magnitude of the "Demonstration for Capitalist Realism." But art-world players were quick to latch on to the term "capitalist realism" and to apply it to subsequent work, whereas he would have preferred that it be treated as a sort of one-off: "I want to be in my studio and paint, not on the stage and act."[66]

Despite his preoccupation with painting, Richter did, however, generate numerous ideas for Happenings and other Fluxus-like events during the 1960s, some of which actually came to fruition. In 1962 he, Lueg, and Polke had made a great show of submitting some objects to an annual Christmas exhibition in Düsseldorf. Just as the artists had intended, the organizers were provoked by the bucket of Christmas windmill cookies, the ski boot sprayed with artificial snow, and the

FIG. 2.10. RICHTER OUTSIDE THE FÜRSTENWALL STUDIO, 1965.

gingerbread man in a Baroque frame, and went so far as to summon the police.[67] They considered organizing bus tours of the Neander valley near Düsseldorf, in which the landscape would be presented to the passengers as art. And in 1965 Richter wanted to purchase and exhibit as a readymade a one-and-a-half-meter-tall clown that erected itself and then collapsed, over and over at regular intervals. ("It cost DM 600, and that was too expensive for me at the time. Sometimes I regret not having bought the clown.") Richter and Lueg also came up with, but eventually dropped, an idea for an exhibition to be titled "Sex and Mass Murder," which would juxtapose pornographic photographs and images from German-run concentration camps. To produce such a spectacle in Germany, or perhaps anywhere in the world, would at the time have been unspeakable. But as to other experimental projects, Richter did complete one titled "Volker Bradke" in 1966, and in 1968 he collaborated with Günther Uecker on several performances during their joint show at the Baden-Baden Kunsthalle.

"Richter lived at Hüttenstraße 71," Uecker recalls, "almost across from where I

had a studio, and so he came by fairly often. It fascinated him that I had formulated something that was mere pattern yet had a Gestalt."[68] In 1963 Uecker moved to a new studio at Fürstenwall 204. When the workshop of the upholsterer next door became vacant, he arranged for Richter to rent it (fig. 2.10). Until then, Richter had only been able to paint at the academy. Now, thanks to his friend, he moved into a studio of his own. The room was small and uncomfortable and lacked running water, but Richter stayed there until 1970. Uecker, though only two years older than Richter, had already achieved a measure of prominence in the art world when the two first met. He was showing with increasing success at Galerie Schmela and had exhibited with ZERO in Rome, Antwerp, Brussels, and Amsterdam. When a large group show was held in the Museum Haus Lange in Krefeld in 1963, "[Uecker] was the star," remembers Richter. "He was a charming person and it was very interesting to get to know an established side of the art scene through him. . . . We had our studios next to each other, and because he had many visitors, I sometimes had to lock myself in so that they wouldn't look in on me."

Richter's third and final show at the Düsseldorf Art Academy took place in February 1964. He presented four new paintings *Secretary* (*Sekretärin*; CR 14), *Cow* (*Kuh*; CR 15), *Stukas* (CR 18/1), and *Terese Andeszka*.[69] Kasper König, who attended the student review, was particularly impressed by *Secretary*: "That's when the penny dropped for me. I was very enthusiastic about the way Richter represented reality and found his own world of motifs."[70]

A holiday break followed, and then Richter began his final semester. At the end of the summer term, in July 1964, Richter left the academy without a diploma and without having received the designation of Meistershül, an honor bestowed on the top graduating students, which usually entitled them to a year of private studio work at the academy. But a diploma had never been his aim; he already possessed one from a distinguished art school. What he had wanted more than anything was to find a community of like-minded artists and to establish useful contacts in the art world. On both counts, he succeeded: In dialogue with Lueg and Polke he had developed his own approach to painting as something that discovers itself anew as photography. And together, he and his friends had organized their first public shows and made important contacts with galleries. By the time Richter left the academy, he had already had his first professional exhibition.

3 DRAMATIS PERSONAE

By the summer of 1964, Richter
was hard at work to fulfill the demands of a busy exhibition schedule. Gallerists
who had taken notice of the young artist and contributed crucially to his career
in the year following art school included Heiner Friedrich, René Block, Alfred
Schmela, and Rudolf Jährling.

HEINER FRIEDRICH

In an ironic twist, Richter's all-important first professional show took place in
Munich—the city he had been advised, upon emigrating from East Germany,
was too staid to advance his interests—at Galerie Friedrich & Dahlem. Founded
the previous year by Heiner Friedrich, his wife Six, and Franz Dahlem, the gal-
lery showed such forward-thinking artists as Georg Baselitz, Uwe Lausen, Blinky
Palermo, and Cy Twombly and then, as American conceptual and minimalist art
began to gain traction, Walter de Maria, Carl Andre, Donald Judd, Fred Sandback,
and John Chamberlain.

From June 10 to July 10, 1964, as Richter was preparing to leave the academy,
fourteen of his paintings hung in the new gallery. Simultaneously, in a separate
room, Friedrich debuted the paintings of Peter Klasen. Klasen, born in Lübeck
in 1935, had studied under Informel painter Hans Trier at the Hochschule der
Künste in Berlin, where Baselitz had been one of his classmates. At Galerie

Friedrich & Dahlem, Klasen presented works that, like English Pop art, juxtaposed the erotic and the industrial, linking female nudes to consumer objects, hardware, and electrical switches. To promote the two-man show, Friedrich printed a poster for each artist.

That spring Friedrich had traveled to London to visit Kasper König, who was by then studying art history at the Courtauld Institute and working at the Robert Fraser Gallery. Friedrich had come hoping for leads on interesting young London artists; instead, König (who had attended the "Demonstration for Capitalist Realism" and purchased the Kennedy figure) could not stop raving about a young painter in Düsseldorf: Gerhard Richter.

Friedrich immediately made an appointment to visit Richter in his studio, and the two reached an agreement to show Richter's work in Munich. Among the paintings exhibited were *Stag*, from the "Demonstration for Capitalist Realism"; *Neuschwanstein Castle* (fig. 2.3); *Dead* (CR 9); *Alster* (1963; CR 10); *Bombers* (1963; CR 13); and *Oswald*. The poster for the exhibition featured, on one side, the military-themed *Stukas* and, on the reverse, small illustrations of other works and a list of everything in the show. The poster also featured an anomalous text that reported on a contest for glider planes:

> Prescribed course: flight to Göppingen-Berneck and return to take-off point at Roth-Kiliansdorf, total distance 147 Kilometers. Bad weather caused numerous emergency landings. Rudolf Lindner (Nabern/Teck), who had taken over the lead in the standard class from Heinz Huth after the second trial, force-landed his Phoebus near Bopfingen after flying approximately 100 km. Rolf Kuntz (Braunschweig) landed on the Hausknecht, near Böhmenkirch, 694 m above sea level. As this went to press, the World Champion, Heinz Huth, and the leader of the open class, Rolf Spanig (Speyer), were still in the air.[1]

In 1993 the Swiss art critic Hans-Ulrich Obrist asked Richter why he had included this textual readymade in the poster. Richter explained: "To me it was the same as a found photograph. But I don't think anyone got it, because it just disappeared on the poster. Later I often tried out texts or text montages of the same kind."[2]

The exhibit also included three paintings no longer found in the artist's catalogue raisonné, two of which are reproduced on the poster: *Battleship* (*Schlachtschiff*) and *R. Alter*. The third was *Matterhorn*. As with his previous work, Richter later destroyed many of the early photo-paintings when he was not satisfied with their quality.

Soon after the show closed, Friedrich wrote to the artist:

> The reaction to the exhibition was, in part, very fierce; the critique of your work was not objective for the most part and did not address your problems [that is, the aesthetic and intellectual problems Richter sought to address in the photo-

paintings]. The attendance was good, due in large part to the review in the evening paper. The other published reviews were trivial. Sold were the *Vögel* [*Birds*]; the gallery has bought *Ferrari*, *Schätzler*, and *Tisch* [*Table*]; and I would ask you to donate *Fußgänger* [*Pedestrians*] to the gallery as a contribution toward expenses.

Friedrich also offered an important piece of advice: "Begin to paint on canvas and work with only the best paints, and regularly."[3] Up to that point, Richter had primarily painted on muslin, which was cheaper. He honored the gallery's request for the gift of a painting, not an unusual practice.

The review cited by Friedrich had appeared in Munich's *Abendzeitung*. The critic W. Christlieb had written that "the works of both artists make an extraordinary impression and can hardly be overestimated in their potential consequences." Christlieb's opinion of Richter was particularly strong and precise: "Gerd Richter is discreet, tactful, cynical, subversive, infamous, evil, corrosive, a deserter, a Böcklin of nihilism. He paints large surfaces, gray on gray, but in such a way that one thinks they are enlarged magazine photos."[4]

The collaboration with Galerie Friedrich & Dahlem proved especially important over the course of the next eight years, as Heiner Friedrich not only sold many works on commission, but also bought some for himself. In 1964 he

acquired *Renate und Marianne* (CR 31), *Woman with Umbrella*, and *Arnold Bode* (CR 33), among others. The portrait of Arnold Bode, founder of Documenta, had actually been commissioned by Friedrich. Documenta 3 was scheduled to open in Kassel on June 27, just two weeks after Richter's opening (fig. 3.1), and the dealer calculated that the portrait would garner publicity for his fledgling gallery. As Richter wrote in 2000:

> Perhaps I had seen Arnold Bode, but surely only from afar; I had no idea of his importance, and he was naturally not interested in me. The idea for the painting came from Heiner Friedrich, who shamelessly wanted to use it to attract attention to himself and his artists. He somehow got hold of the photo and explained to me how important it was to paint this image. I was only half convinced, and so the painting is not only half painted, but also only half good. I never liked the painting, and Mr. Bode, who was supposed to have received it as a present, probably never liked it either. And in this he was correct, for he not only had the sense to see the necessity of a Documenta, but he also had a sense of quality.[5]

The collector Reinhard Onnasch later acquired the painting from Galerie René Block in Berlin. Today it belongs to the Neue Galerie in Kassel.

ALFRED SCHMELA

While Friedrich included Richter in a two-person show, it was Alfred Schmela who gave the artist his first solo exhibition, two months later (September 9–30, 1964). Schmela had already shown Konrad Lueg's work in his gallery, and he opened the new fall season with a group of paintings by Richter. Richter recalls his astonishment when, on opening night, he received a congratulatory telegram: "ALL THE BEST FOR THE MOST IMPORTANT EXPOSITION IN THE HISTORY OF GERMAN POP-ART. OLDENBURG, ROSENQUIST, LICHTENSTEIN."[6] His bewilderment was, however, short-lived; he quickly realized the telegram was a prank by Lueg—whose high assessment of the work was nonetheless genuine.

There is another reason the exhibition with Schmela stands out in Richter's mind. After the opening, as celebrants gathered in a bar, Richter sat with Lueg and Sigmar Polke at a table separate from the gallerist and the collectors. By that point his opinion of Schmela was set: "I couldn't stand him. He and the entire crowd had far too much of that [jovial] Rhineland way about them." This did not prevent the two men from working together; Richter could not afford to make a total break from Düsseldorf's most important gallerist. Nevertheless, apart from a one-day event he staged in connection with the "Hommage à Schmela" in 1966, this was Richter's one and only solo show at Schmela's gallery.

Among the paintings shown were *Terese Andeszka* and *Prince Sturdza* (*Prinz*

Sturdza, 1964; CR 32), which was featured on the invitation. Schmela only managed to sell one painting, but it was to the prominent collectors Gustav Adolf and Stella Baum, a couple from Wuppertal, who bought *Secretary* for DM 450 (about $750 today). Of this amount, as Richter vividly remembers, he received just a third, along with a dressing-down by Schmela: "Well, what do you think? This is a huge risk for me. How do I know what's going to become of you? You should be happy just to be part of such an important collection." At the same time, Richter knew that Schmela had the capacity to generate serious money. He had sold the painting *Couple* by Roy Lichtenstein to Willy and Fänn Schniewind for DM 12,000.

Willy Schniewind was one of the first collectors to have his portrait painted by Richter. The scheme of offering Richter's services as a commercial portrait painter was Schmela's. Richter readily agreed to it not only for commercial reasons, but also because such depictions fit with his practice of painting from private family photos. As samples of what was on offer, Richter made three portraits of Schmela. The first in particular corresponded to Richter's own idea of painting. On the 100-by-170-centimeter canvas, the gallerist appears six times, each time with a slight variation (CR 37/1; fig. 3.2). Both the stripes of a curtain behind Schmela's head and the formal division into six panes reference a passport photo booth in operation: thus the model is not merely a photograph but a mechanically produced photograph—photography without an author—adding another conceptual layer of anonymity and privacy to the image.[7]

What's more, the nature of the passport photo requires that the subject suppress emotion during the sitting; its objective is, after all, to create a recognizable depiction. Resemblance between portrait and subject, presumed in traditional painting, had been obsolete as a goal for nearly a hundred years, ever since objective image making had been arrogated to photography. Other possibilities for portrait painting, such as the exploration of affect, had instead came to the fore—for example, in the great, expressive portraits by Max Beckmann and Francis Bacon. Richter's commissions allow the value of physical resemblance back into portraiture. At the same time, given his approach, which is to work from a photographic model without intervention, Richter categorically rejects any element of subjective characterization, be it coloring or the expressive gesture of a brush. "I don't believe the painter need either see or know his sitter," said Richter in 1966, defending the portraits. "A portrait must not express anything of the sitter's 'soul,' essence or character. For this reason, among others, it is far better to paint a portrait from a photograph, because no one can ever paint a specific person—only an image that has nothing whatever in common with the sitter."[8]

In the earliest commissioned portraits, Richter adhered to the formal construction established in *Schmela*, painting *Portrait Dr. Knobloch* (1964; CR 41) as four adjacent views and *Portrait Schniewind* (1964; CR 42) as a three-part photo strip. In alternative versions of *Portrait Schniewind* (CR 42/1–2), Richter worked from

FIG. 3.2. *Portrait Schmela*, 1964. OIL ON CANVAS. 100 X 130 CM. CR 37/1.

pictures he found in the subject's family albums. In the years that followed, up to 1968, he made numerous other portraits, including one of Helmut Klinker of Bochum (CR 60), whose concept of collecting involved having as many different artists as possible paint his portrait. Lueg and Polke, among others, also painted images of Klinker.

RENÉ BLOCK

In spring 1964 (March 21 to May 3) Richter, along with Kuttner and Lueg, was included in a show called "Possibilities" (*Möglichkeiten*), one of several events held at the thirteenth annual exhibition of the Association of German Artists (Deutscher Künstlerbund) in Berlin. "Possibilities" was installed at the Haus am Waldsee, a contemporary art space with the mission of showcasing young, up-and-coming artists. The exhibition introduced new work by Raimund Girke, Hans Haacke, Ferdinand Kriwet, and Arnulf Rainer, as well as the ZERO artists Heinz Mack, Otto Piene, and Günther Uecker. Richter showed *Pedestrians* and *Stag*, and the latter was reproduced in the catalog. Lueg was represented by the large-format *Triptychon/B. R. D.* from 1963, Kuttner by three geometric paintings.

Twenty-two-year-old René Block, who lived in Berlin and was thinking of opening his own gallery, noticed Richter's and Lueg's work and promptly set up an appointment to visit the artists in Düsseldorf. They told him about the "Demonstration for Capitalist Realism" at the Berges furniture store and took him to visit Kuttner and Polke in their studios.

On September 15, 1964, Galerie René Block opened at Frobenstraße 18 in Berlin with the inaugural exhibition "Neodada, Pop, Décollage, Kapitalistischer Realismus." The four Düsseldorf artists were featured (Richter showed the painting *Philipp Wilhelm* [1964; CR 27]), along with K. P. Brehmer, Karl Horst Hödicke, Herbert Kaufmann, Lothar Quinte, and Wolf Vostell. By then Block was also working on a solo show for Richter, which would open just eight weeks later.

Block, born in 1942 in Velbert, attributed his dream of opening a gallery to the Hollywood film *Lust for Life,* which starred Kirk Douglas as Vincent van Gogh.[9] Not that Block identified with the artist—far from it—but he did feel an affinity with the artist's brother, the art dealer Theo van Gogh, and embraced the idea of the enlightened gallerist whose mission it is to help artists develop and prosper. This was Block's attitude throughout his career. On closing his gallery in 1979, he said, "My artists no longer needed a gallerist to fight for them. They were all established, the gallery had served its purpose, my art work was completed."[10]

Block viewed his gallery as a "moral institution," organizing shows that reflected the social and political concerns of the times—sometimes quite difficult ones.[11] In 1967, for instance, he organized an exhibition and fund-raiser titled "Homage à Lidice" as a remembrance of the brutal Nazi massacre that had taken place in a

small Czech town on June 4, 1942. The slaughter was in retaliation for the assassination in Prague of Reinhold Heydrich, a Third Reich official, by Czech resistance fighters. Six days after Heydrich's death, Gestapo and SS units arrived in Lidice. Every male over the age of sixteen was executed; women were separated from their children and shipped off to concentration camps. Lidice became an international symbol of the Nazi reign of terror in the occupied regions. In mounting his show, Block wanted to advance the ongoing confrontation of German citizens with their Nazi past, with proceeds from the event going to the citizens of Lidice. A number of important artists participated, including Richter. ("Homage à Lidice" is discussed in greater detail in chapter 5.)

Given his penchant for social and political issues, when presented with the notion of capitalist realism, Block embraced it, expanding the gallery's program—as well as the concept—to include not simply work by Richter and Lueg, but also that of Polke and (to Richter's dismay) Brehmer, Hödicke, and Vostell. "These artists treat the German petit bourgeois existence, which survived the war unscathed, with irony," explained Block, looking back on his ideological interpretation of the term.[12] The climate in Germany, particularly in Berlin, was tense; the Berlin Wall cast a dark shadow over the divided city, and a slogan like "capitalist realism" had the potential to be politically explosive. Thinking it would catch on, in 1965 Block prepared another exhibition titled "Kapitalistisch Realisme. Richter, Lueg & Polke," for Galerie Orez in the Hague.[13]

In 1971 Block published a lavish catalog of the graphic works of Brehmer, Hödicke, Lueg, Polke, Richter, and Vostell under the title *Graphik des Kapitalistischen Realismus*. In the preface he described Richter's choice of subject matter in terms of a class struggle. "Richter and Polke glorify the unartistic family photo or the apparently trivial magazine illustration, knowing full well that these and only these are the world of the more or less working masses."[14]

Richter was unhappy with Block's insistence on perpetuating the designation, which had become a kind of sales gimmick: "René Block appropriated the term 'capitalist realism' for himself. That was not acceptable to me. I really only wanted it to exist for the demonstration at Berges. No one wants to be labeled like that." But despite Block's infatuation with the term, "capitalist realism" never gained much traction in the art world. No other gallerist or curator used it, and none of the artists who had been part of Block's program showed any interest in forming a capitalist realist movement. Much later, in 1978, the term cropped up in a famous play by Botho Strauß. The pretext of the comedy is the preparation of a capitalist realism exhibition. Richter earned a mention in a scene involving three members of an art society:

> Richard: Very good. Onward! To the left, next door, all German realists: Sorge, Nagel, Richter, and their fellow travelers.
>
> Martin: Not Richter. Please no. We should honor him in an extra section.

Richard: The nature realists section?

Felix: But how come? He belongs to the photorealists.

Richard: But we only have landscape paintings from him. Fine. We'll make that decision later.[15]

Block followed his inaugural exhibition with a show of works by Stanley Brouwn. Next on the agenda was Richter's solo exhibition, titled "Paintings of Capitalist Realism" (*Bilder des Kapitalistischen Realismus*) and scheduled to open on November 17. As with the poster for his Munich show Richter culled text fragments from newspapers, and as with the public address announcements during the "Demonstration for Capitalist Realism" he recorded and played these readymades during the opening. The exhibit included fourteen paintings, some credited as on loan from Galerie Friedrich & Dahlem, a few others owned outright by Heiner Friedrich. Nevertheless, everything was for sale—including the magnificent *Christa und Wolfi* (1964; CR 24), painted from a family snapshot. Richter had donated the painting, priced at DM 1,125, to the gallery in order to raise money for a small monograph that Block said he wanted to publish.[16]

Richter set somewhat higher prices than he had for the show with Heiner Friedrich earlier that year. As he wrote to Friedrich, in a slightly resentful tone, he and Block had also agreed that Richter would receive two-thirds of any sales revenue and the gallery a third. In contrast, his contract with Friedrich had specified a fifty-fifty split.[17]

Block later admitted that, in the gallery's early days, he only had one collector in his pocket—a Mr. Wojan from Berlin. But Wojan refused to pay more than DM 400 for a painting—any painting—putting Block in the awkward position of having to ask artists to reduce their prices.[18] Despite the shaky beginnings and Richter's ambivalence about Block's marketing strategies, over the 1960s he developed into one of the gallery's most successful artists. Certainly some of the credit for that redounds to Block.[19]

RUDOLF JÄHRLING

As it happened, Richter missed the opening at Block's gallery. At the last minute Block had to postpone the event from November 17 to November 21, 1964, when Richter was to be in the regional city of Wuppertal. There, on the previous evening, he had been part of an opening together with Lueg and Polke in Rudolf Jährling's Galerie Parnass. From Richter's perspective a group show at Galerie Parnass was infinitely more important than a one-person exhibit at Galerie René Block. Galerie Parnass was a going concern, and, even sharing the space, Richter could exhibit more paintings there than he could at Block's. Because the exhibits ran concurrently, Richter was showing a total of thirty-six paintings that November, nearly

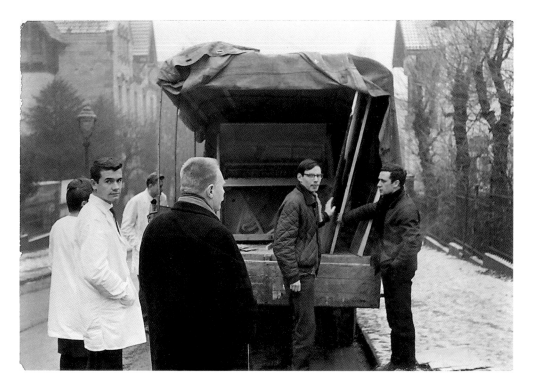

everything in his inventory, including some pieces he wasn't satisfied with and would later destroy, such as *Tame Kangaroo (Zahmes Kängeruh)*. In a letter he wrote to Friedrich right after the two openings, he said, "It's been very hard from my point of view, having two exhibitions at the same time. I don't want to do that again. I must also paint a bit slower and take it more quietly (so that when I have a terrific basic idea, like *Tame Kangeroo*, I can make it work better)."[20]

Rudolf Jährling, the owner of Galerie Parnass, was an architect who had been organizing exhibitions on the side since 1949. In 1961 he moved into a spacious villa at Moltkestraße 61 in Wuppertal, where over the years he presented a wide range of artists, including Hans Hartung, Alexander Calder, Friedensreich Hundertwasser, Gerhard Hoehme, Nam June Paik, and Carel Visser. His gallery was known not only for its exhibitions but also for a prestigious lecture series.

Jährling still vividly remembers his first meeting with Richter and his friends, in February 1964:

> A group of "capitalist realism" artists, Fischer-Lueg, Richter, and Polke, telephoned and asked if they could come by sometime and show me their things. "Sure," I said, "with pleasure!" And indeed the bell rang a little while later, and they stood next to a small truck with a tarpaulin in front of the door [fig. 3.3]. "Why don't

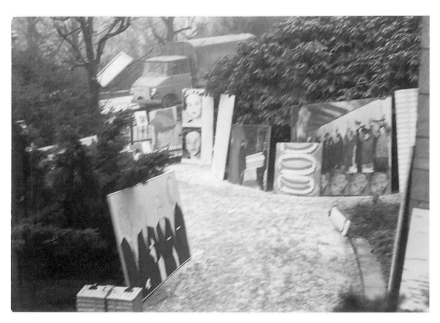

FIGS. 3.4 AND 3.5. ART IN FRONT GARDEN, GALLERY PARNASS, WUPPERTAL, 1964.

you come outside," they said. They had already set up their beautiful large-format paintings in the front garden in the snow [figs. 3.4, 3.5]. It looked fantastic: Art in snow! A neighbor was taking his little dog for a walk just then and called out happily: "Now you're doing exhibitions in your front yard. Where will it end?"[21]

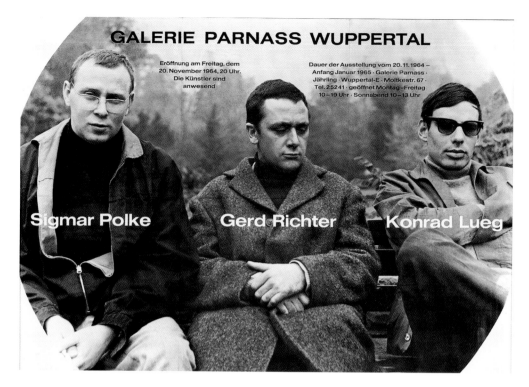

FIG. 3.6. EXHIBITION POSTER, GALLERY PARNASS, WUPPERTAL, 1964.

Manfred Kuttner was also part of the presentation, though he was not selected for the show, most likely due to the disparity between his work and that of the others. Richter had brought to the meeting his early painting *Hitler* (1962; CR 3), as well as *Stag, Alster,* and *Dead.*

Jährling was so enchanted by what he saw on the lawn that he committed to a group show on the spot. So much space was made available that Richter decided to push himself and show twenty-two paintings, a mix of new and older work, including *Stag, Neuschwanstein Castle, Cow, Oswald, Administrative Building,* and *Sphinx of Gizah* (*Sphinx von Giseh,* 1964; CR 47).

The Baums, who had recently acquired *Secretary* from Alfred Schmela, attended the opening and bought the small painting *Deckchair* (*Liegestuhl,* 1964; CR 36), and Jährling purchased *Phantom Interceptors* (*Phantom Abfangjäger,* 1964; CR 50) for himself.[22]

In his letter to Friedrich, Richter reported: "The opening was fine and festive. We didn't put on a show at all, just dance music from the radio."[23] It turned out to be Richter's only show at Galerie Parnass. Jährling had made up a simple black-and-white poster that featured a photo of the three artists (fig. 3.6). Richter says that one can tell from their body language that they were at odds once again. This time it was Lueg who held himself apart. He was by then

no longer their leader. Richter and Polke had matured, and each had formulated his own artistic position. And they were starting to get noticed—much more so than Lueg.

KONRAD LUEG

Lueg did not lack ability, but it was of a more modest and derivative sort than Richter and Polke possessed. Lueg's early paintings show the marked influence of Cy Twombly and Robert Rauschenberg, both of whom had shown at Jean-Pierre Wilhelm's Galerie 22 in Düsseldorf in May 1960, an exhibition Lueg certainly would have seen. Working large, Lueg deployed a wide range of techniques and media—acrylic, oil pastel, pencil—scattering nudes, portraits, and sundry objects across the surface of his canvases, then partially obscuring them beneath paint and pencil shading.

In 1962 Lueg's painting underwent a radical reorientation as he began to work in casein tempera. The tender, drawn subjects were transformed through bold and simple colors on large surfaces. Casein was not much favored by modern artists; it dried quickly and evenly and was brittle, making fine gradation and dense impasto impossible. It was more often used by professional sign painters, but Lueg wanted to experiment with simplifying his representations to fit the limitations of the medium. The result was a naïve, two-dimensional, intensely colorful style. In the manner of Pop art, Lueg sought out banal motifs centering on everyday pleasures, icons of advertising and sports: coat hangers, sausages on a paper plate, the Omo detergent salesman, boxers and soccer players. But only for an instant do his large paintings seem to convey the carefree mood of consumption that we associate with advertising. In fact, Lueg's depictions undermine that covenant of happiness. He maintains a careful, ironic distance, enhancing the artificial appearance of the superficial. Like Warhol with his screen printing, Lueg used his mistakes and running sprays of paint to maintain an aesthetic distance between his representations and the perfect depictions in advertisements.

SIGMAR POLKE

In Sigmar Polke's paintings the artist's wit and bite are unmistakable. The anarchist spirit of Fluxus and the pictorial techniques of American Pop permeate his irreverent depictions of minor, everyday pleasures (such as *Cookies* [*Kekse*] and *Chocolate Painting* [*Schokoladenbild*], both 1964) and examinations of petit bourgeois fantasies: *Palm Trees* (*Das Palmen-Bild*, 1964), for example, plays off the vacation to tropical climes as an antidote to the tedium of everyday life. Polke subjects these hyped-up images to a kind of ontological dissection

that reveals their origins to be, in a sense, less cultural than industrial. This he achieves by planting his work with fields of magnified benday dots, the "atomic structure" of images published in everyday print media. In Polke's work, as in Lichtenstein's, making these dots visible serves to emphasize the media origins of his source material. Similarly, Richter's use of black and white points back to photography.

GERHARD RICHTER

As Richter once explained it, one of his ambitions in simulating photography was to claim for painting the authenticity and objectivity generally associated with it.[24] At the same time he sought to strike a balance between the two mediums and to preserve painting as painting. Regarding the complex relationship between his photo-paintings, their painterly ambitions, and the photographs on which they are based, he remarked that even when he strove to attain a photolike appearance, he was not trying to compete with photography, thus setting himself apart from the photorealists, with whom he is sometimes grouped. "I made something different out of it—painting, to put it simply. And this—as far as its photographic qualities were concerned—was mostly not so good as photography because it also had to work as painting, which meant a completely different quality."[25]

One gets the impression from Richter's earliest works in this mode, such as *Coffin Bearers* (*Sargträger*, 1962; CR 5) and *Pedestrians* (*Fußgänger*, 1963; CR 6), that he took pains to prove their painterliness through a range of expressive gestures. Such a performance now seems unnecessary, but in the mid-1960s—with "the death of painting" the mantra of the day—the paintings appeared to possess a radical photographic agenda that needed qualification. Today, that political hue and cry has faded, and the viewer is free to appreciate Richter's early attempts precisely because of their unusual painterly surfaces. A close inspection of *Bombers* (CR 13; fig. 3.7), for example, from 1963, reveals how summarily Richter applied paint to produce a sketch of the subject, which nevertheless resolves into a "photo" when viewed at a distance.

Though ostensibly rendered in black and white, these paintings are actually executed in many variations of gray, a fact that becomes immediately apparent when any of them are viewed side by side. Richter always added some brown to the gray; without it the paintings would have appeared much too blue to evoke photographs. But he never measured out the proportion of pigments, so every painting is unique in tone. Moreover, by varying the amount of oil he mixed into his paints, he also varied the degree of impasto.

When Richter first began to work from photographs, he used a pencil grid drawn on the source image to transfer it onto the canvas. In 1964 he bought an

FIG. 3.7. *Bombers*, 1963. OIL ON CANVAS. 130 X 180 CM. CR 13.

episcope, which allowed him to work with greater precision. Both techniques of transferring images are mechanical methods that inhibit the interpolation of subjective content.[26] Yet one need only look at *Woman Descending the Staircase* (*Frau, die Treppe herabgehend*; CR 92), from 1965, to see how much Richter would interfere with a photograph, not for the sake of style per se, but for coherence. The newspaper photograph on which the painting is based shows a fashionable woman in evening gown, hair styled high on her head (fig. 3.8). But in enlarging the tiny image to a height of almost two meters, Richter also widened the staircase, and thus the whole composition, reattached a portion of the woman's head that had been cropped in the clipping, and stripped away the decorative carpeting and the wall paneling (fig. 3.9). These interventions center the female figure and display it more prominently.

Richter did retain the black-and-white character of the photograph but made no attempt to reproduce the tint. Still, the monochrome palette gives the painting something of the documentary character of a photograph, including the unemotional distance that medium brings to the subject.

Blurring in Richter's work serves as—or references—something akin to a photographic characteristic as well. In the final step of making a painting, Richter manipulates the surface while it is still wet, creating the optical effect of photographic blurring. He either smears the paint in horizontal strokes, as in *Woman Descending the Staircase*, thus enhancing the sense of dynamic movement, or he blurs the borders between all objects equally, as in *Terese Andeszka*. Either way, the blurring indexes the inexact relation between an object and its perception—or, as some critics explain it, a technical mistake that transpires if a camera (or its subject) moves at the instant the shutter is released. Because paint on canvas can never be out of focus, this creative blurring actually strengthens the tension and ambivalence between painting and photography.[27]

Blurring becomes, then, the visible sign of a much more complex interplay between the two mediums. In Richter's painting, it references not only a technical limitation of photography but also the pictorialist movement toward the end of the nineteenth century. Pictorialist photographers wanted to reform the stiff, posed tradition that had prevailed in professional photography by emulating the realistic flicker, or soft focus, of impressionist painting (which, in turn, sought to duplicate the way in which people actually see—imperfectly, at a glance, one ground gaining precedence over another). As the theoretician Willi Warstat, who in 1909 had already studied the perceptual phenomenon of photographic focus, observes, "We see only the main things and those details which our particular interests emphasize."[28] Considered in this context, photography historian Ursula Peters writes, "photographic focus becomes a disruptive factor for the advanced art photographers."[29] That Richter was firmly entrenched in this discourse is evinced in one of his early notes to himself:

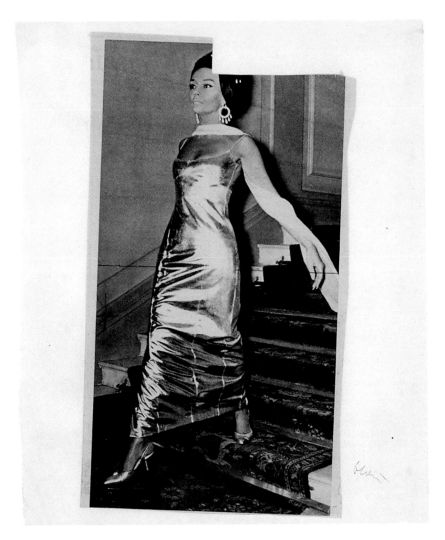

FIG. 3.8. *Atlas* (PANEL 13, DETAIL), 1964. NEWSPAPER CLIPPING.

I blur things to make everything equally important and equally unimportant. I blur things so that they do not look artistic or craftsmanlike but technological, smooth and perfect. I blur things to make all the parts a closer fit. Perhaps I also blur out the excess of unimportant information.[30]

As for the pictorialists, lack of focus thus becomes for Richter a visible expression of a philosophical position on the perception of reality, one that rejects the possibility of definitive truth. In a conversation with Rolf Schön, he confessed, "I can make no statement about reality clearer than my own relationship

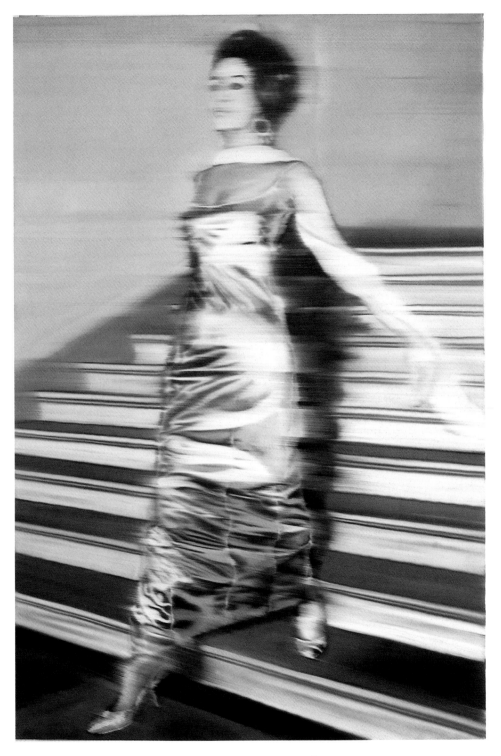

FIG. 3.9. *Woman Descending the Staircase (Frau, die Treppe herabgehend)*, 1965. OIL ON CANVAS.
198 X 128 CM. CR 92.

to reality; and this has a great deal to do with imprecision, uncertainty, transience, incompleteness, or whatever."[31]

Precisely because Richter's blurring operates in all of these registers at once—imitating a limitation of photography, but also referencing pictorialism and, transitively, impressionist painting—he can rightly describe his paintings in terms of either painting or photography:

> As far as the surface is concerned—oil on canvas conventionally applied—my pictures have little to do with the original photo. They are totally painting (whatever that may mean). On the other hand, they are so like the photograph that the thing that distinguished the photo from all other images remains intact."[32]

RICHTER AND WARHOL

Blurring diffuses the individuality of the people depicted and so depersonalizes the situations represented. Richter sees his smearing gesture as a mechanical process that in its effect can be compared to Andy Warhol's use of silkscreening:

> I was happy to have a method that was rather mechanical. . . . It is a normal state of working, to eliminate things. But Warhol showed me this modern way of letting details disappear, or at least he validated its possibilities. He did it with silkscreening and photography, and I did it through mechanical wiping. It was a very liberating act.[33]

Warhol transferred his first portraits using a silkscreen in August 1962. In early 1963, when Richter began to blur his paintings, it was unlikely he had seen Warhol's first efforts. But Warhol's use of technology and its subsequent critical reception served to justify and make a path for his own.

Whereas the socialite depicted in *Woman Descending the Staircase* reads, in the newspaper photograph, as an individual, the much larger surface area of the painting undercuts this. At the same time, the out-of-focus quality creates a further, subtle distance. Sometimes this amounts to a form of discretion corresponding to Richter's personal demeanor. In *Dead* (CR 9), for example, the gruesome scene of a man killed by a block of ice is softened and partially obscured by blurring that accompanies its transformation into paint. Yet Richter also resorts to blurring when there is absolutely nothing to conceal: His group portraits of anonymous people become a kind of magnet for the viewer's own associations. The same effect takes hold in depictions of architectural subjects, consumer goods, and other everyday objects. For instance, Richter connects his 1964 painting *Administrative Building* with his personal memory of postwar buildings in East Germany: "Looking

back on it now, it does remind you in a certain way of the type of buildings in the German Democratic Republic that were built by the party."[34]

In 1964 Richter painted the recently widowed Jacqueline Kennedy in *Woman with Umbrella* (fig. 3.10), one of the artist's earliest color photo-paintings. In this particular work, the color is a conscious intervention meant to override the documentary status of the original—and famous—black-and-white photograph. Color also helps veil the subject's identity as a tragic and glamorous personality on the world stage. Instead, Richter's depiction suggests a familiarity with the subject; she could easily be a personal acquaintance. A year later, Richter painted *Mother and Daughter (B)* (*Mutter und Tochter [B]*; CR 84; fig. 5.3). In this painting, the viewer can really only distinguish two women hurrying past the photographer in a blur and is unable fully to register that the younger one is Brigitte Bardot. Still the erotic charisma of the popular French actress with her long blonde hair comes through, accentuated by the painting's blur.

Richter's unique conception of a kind of painting based on photography offered a double yield: media images both freed him from the teleological burden of a prescribed art-historical trajectory and offered up previously overlooked subjects as worthy of painting. It is the norm for private snapshots to disappear from family albums and for images from the public media to pass quickly into obscurity; this is our expectation. Richter's paintings, however, anchor just such ephemeral images in our collective memory. The subjects he paints are given a lasting public presence. Instead of being dismissed as a mere family memento, a picture is now assessed using other criteria. The enlarged format and technical effects are here secondary considerations. What counts most is that, by transferring subjects from photographs into painting, Richter situates them squarely in an artistic milieu. *Family* (*Familie*, 1964; CR 30; fig. 3.11), *Family at the Seaside* (*Familie am Meer*, 1964; CR 35) and *Terese Andeszka* are thus interesting for the fact that Richter abstracts the ostensible subjects' individuality, their individual fates—and their banality—to emphasize their exemplary aspects.

In contrast to Warhol, with whom he is most often compared, Richter has no interest in portraits of famous people or in photographs that are already entrenched in our collective memory (for Richter such would have been Peter Leibing's 1961 photograph of a young East German border guard escaping over the barricades during construction of the Berlin Wall). In a 1984 interview with Wolfgang Pehnt, he explained: "I had very little interest in any critique of packaged culture or the consumer world. When I painted from those banal, everyday photographs, I was really trying to bring out the quality—i.e., the message— of those photographs, and to show what gets overlooked, by definition, whenever we look at small photographs. People don't look on them as art; but as soon as they are transposed into art they take on a dignity of their own, and people take note of them. That was the trick, the concern I had in using those photographs."[35]

FIG. 3.10. *Woman with Umbrella (Frau mit Schirm)*, 1964. OIL ON CANVAS. 160 X 95 CM. CR 29.

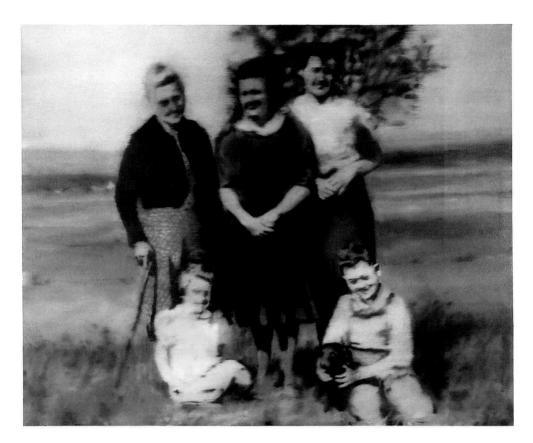

FIG. 3.11. *Family (Familie)*, 1964. OIL ON CANVAS. 150 X 180 CM. CR 30.

What his work and Warhol's do have in common is the rejection of the elitist attitudes and subjective gestures of what had become a mainstream avant-garde. Both artists tapped into the popular world of newspapers and magazines to develop a new reservoir of images, and from it they drew some common motifs. Both used the same published photograph for their renditions of Neuschwanstein Castle, an architectural confection built in the nineteenth century by "Mad" King Ludwig II and later used by the Nazis to store looted art. Richter's version dates to 1963, Warhol's to 1987. The Städtische Galerie im Lenbachhaus in Munich once exhibited the two works together for the sake of comparison. Richter's painting exemplifies his so-called early work (fig. 2.3). It is an intellectual exercise, juxtaposing various possibilities of representation: the castle, presented as an architectural drawing, is surrounded by a forest rendered as a textured green mass that recalls the *Paysages du mental* of Jean Dubuffet. In vivid contrast, Warhol's interpretation—a strong, colorful serigraph on canvas—emphasizes the kitsch and cult status of Ludwig's castle.

Richter and Warhol also both painted Jacqueline Kennedy, Warhol several times, though neither artist produced what might be termed a portrait of her. As mentioned earlier, Richter, in *Woman with Umbrella*, actually uses paint to conceal her identity. In his Jackie paintings Warhol does not attempt to capture personality either, but rather the public media spectacle surrounding her after the assassination of her husband. Just as the cameras of the press photographers zoomed in on the face of the mourning widow and as, in turn, the media reproduced their photographs millions of times over, Warhol produces repetitive iterations of the close-up image, but on canvas with the images increasingly abstracted and relieved, through the silkscreen process, of unnecessary detail. Such works testify to his preoccupation with already iconic images; yet they also attest to how the artist himself succumbs (without guilt) to our society's voyeuristic fascination with tragic events. Likewise, when scenes of deadly accidents surface in Richter's work, as in *Dead*, the series *Tourist* (1975; CR 368 to 370/1), or the cycle *18. Oktober 1977* (1985; CR 667/1 to 674/2), the details of the horrible events are always respectfully (and sometimes maddeningly) painted away.

Several exhibitions have explored the recurring scenes and symbols of death in Warhol's work. For Richter, the subject surfaces as early as 1956, in a preparatory sketch of a skull he made for the mural project at the German Hygiene Museum. More mature treatments of death occur first in 1962, in *Shooting* and *Coffin Bearers*, the first such work to be included in the catalogue raisonné. Following Warhol's untimely death on February 22, 1987, Richter noted, just before the opening of the spectacular Warhol retrospective at the Museum Ludwig in Cologne:

> Andy Warhol is not so much an artist as a symptom of a cultural situation, created by that situation and used as a substitute for an artist. It is to his credit that he

made no "art"; that he touched none of the methods and themes that tradition-
ally constrain other artists (thus sparing us the great mass of "artistic" nonsense
that we see in other people's pictures).[36]

Richter mistrusts our direct sensory experience of the environment but sees in
photography a tool that, precisely because of its limitations, can be used to achieve
a more objective perception.[37] He repeatedly emphasizes this supposed credibility
of photography and has attempted to carry it over into painting. Despite the va-
riety of subjects he paints and the seeming arbitrariness with which he alters his
style, Richter sees an overarching and coherent theme in his oeuvre, which is the
complexity of reality.[38] Within his framework, every subject is usable because it
has the capacity to amplify the variousness and inconsistency of our experience
and, in so doing, to draw attention to the very deficiencies that attend the thresh-
old of human perception. At the same time, Richter recognizes the inadequacy
of his efforts. He attempts to make this imperfection, which he also describes as
recognizable lack of focus, visible by blurring his subjects.

4 TRANSFORMATION

By the end of 1964 Richter was starting to make a name for himself. It had been less than two years since he and his friends had driven up and down the streets of Düsseldorf in Konrad Lueg's car, scanning storefronts for an empty space to show their work. Now he had exhibited with Heiner Friedrich in Munich, Alfred Schmela in Düsseldorf, René Block in Berlin, and Rudolf Jährling in Wuppertal. Several paintings had sold to prominent collectors, albeit at modest prices, but for the moment that suited him perfectly: "I preferred to make the paintings less expensive so as to sell them, because I somehow hungered so much for recognition that I was willing to let the best paintings leave the studio immediately." Also, Richter's financial situation was so precarious that the work, quite simply, had to sell. In March 1965 he sent René Block a price list for the twenty-five paintings then in his studio (figs. 4.1, 4.2). The prices ranged from DM 350 for the small ones to DM 1,600 for *Stag*.[1]

Heiner Friedrich would serve as Richter's main gallerist throughout the 1960s, presenting shows of new work in 1966 and 1967. In Berlin, René Block mounted Richter exhibitions in 1966 and 1969. And in 1968 Richter was given a show in Cologne by Rudolf Zwirner, who had been selling his work for several years. Richter appreciated the contribution a good dealer could make to his career. Letters to dealers from the mid-1960s stress his loyalty: he promises not to sell directly to collectors, but only through them.[2] Two decades later his position remained essentially the same: "Gallerists are important. Not only at the beginning. Without them, nothing works, because you need one (or several) who exhibit and sell the

work, who take care of everything, *who know everything*, and who stand up for you. Ideal people!"[3]

After all the activity of 1964, Richter disappeared back into the studio to prepare for the coming year, which again included a busy schedule of one- and two-person shows. He also participated in several group exhibitions that sought to capture the pioneering ethos of the moment with titles such as "Tendencies" (*Tendenzen*, Städtisches Museum Trier), "Points in Time" (*Zeitpunkte*, Museum Haus Lange, Krefeld), and "14 Aspects of Modern Painting" (Haus der Kunst, Munich).

The year 1965 also saw the publication of a book that included an early discussion of Richter's work. In *Pop Art: A Critical Report*, the author, critic, and painter

Rolf-Gunter Dienst surveyed the international Pop art phenomenon, just as it was being overtaken by the more intellectually challenging and decidedly antipainterly conceptualism and minimalism. Dienst assigned an enlightening and slightly didactic function to Richter's photo-painting: "He is no longer concerned solely with copying the image. Through his manner of representation, Richter wants to awaken deep-seated emotions and associations in the viewer, who may not have been aware of them before."[4]

Richter was working hard, but he paused long enough to be interviewed by the journalist Elmar Hügler for the television program *Kunst und Ketchup*, which addressed new trends in West German art. Hügler also interviewed Lueg, Sigmar Polke, Joseph Beuys, and others, though the lion's share of attention went to Wolf Vostell, a Berliner who was then being touted as Germany's hottest artist, and to the *24 Stunden Happening* (24-hour Happening) sponsored by Rudolf Jährling when he closed Galerie Parnass. The segment on the Düsseldorf artists was brief, but at least they had the chance to introduce their work and express their views on painting.

Richter seems to have been ambivalent about the exposure. In a letter to Heiner Friedrich he wrote, "By the way, we need to tread more lightly on the publicity front. The name Richter should appear only infrequently"[5]—a remarkable (but canny) comment coming from someone whose financial situation was tenuous at best. The stipend Richter received as a refugee had long since run out, and he was taking on side jobs to make ends meet. Günther Uecker helped him get a job building floats for carnival parades, he and Lueg cleaned the stairway of a castle near Düsseldorf, and he did some interior decorating for local bars. In April 1965 he wrote to Heiner Friedrich about one such odd job: "I will be working on the bar until April 30. After that there must be lots of painting; I'm so tired of the other stuff."[6] Ema helped by taking in sewing, and her parents provided a bit of additional support, allowing the couple to move from their tiny flat into a larger, three-room, government-subsidized apartment at Bensberger Weg 10. Richter's financial situation would not improve significantly, however, until the following year. In 1966 he had several important shows, produced a number of important artworks, started to present a new—and very different—body of work, and firmed up a network of dealers committed to handling and promoting his work (fig. 4.3).

While Block organized an exhibition for Richter, Lueg, and Polke at Galerie Orez in the Hague, Heiner Friedrich was booking shows for Richter in Rome and Zurich. At the Galleria la Tartaruga in Rome, only *Small Pyramid* (*Kleine Pyramide*, 1964; CR 48/1) sold (to an American collector), and Richter donated the large-format *Group of People* (*Personengruppe*, 1965; CR 83) to the gallery to cover expenses. Everything else was sent on to Zurich to hang in the City-Galerie, run by Bruno Bischofberger, from March 30 to April 16. And there Richter scored an important sale: the Kunstmuseum Basel, a high-profile museum that had made a name for itself as a pioneering collector of contemporary American art,

FIG. 4.3. GERHARD RICHTER, 1966.

bought the 1965 painting *Motor Boat*. The painting's surface had been scratched during transport, so it was sent back to Richter to repair. Despite his best efforts, he could not improve its appearance, so he made a new version for the museum (CR 79) and kept the damaged version for himself (CR 79a). This is the only early photo-painting he still owns.

Just as Richter was starting to attract serious notice for the photo-paintings, his thinking about art began to shift. Although he had worked in various media, Richter was—and is—first and foremost a painter. But by the mid-1960s painting had faded decisively from the avant-garde agenda. Committed painters like Pollock, Newman, de Kooning, and Still were now considered venerable old-timers, and the bright canvases of Pop art were being overshadowed by more cerebral projects. Even Heiner Friedrich was devoting less time to his regular artists and instead planning shows for American minimalists Walter de Maria, Carl Andre, and Donald Judd. It was against this backdrop of vast change in art practice and fashion that Richter, in 1966, penned the following, now famous note to himself:

> I pursue no objectives, no system, no tendency; I have no programme, no style, no direction. I have no time for specialized concerns, working themes, or variations that lead to mastery. I steer clear of definitions. I don't know what I want. I am inconsistent, non-committal, passive; I like the indefinite, the boundless;

I like continual uncertainty. Other qualities may be conducive to achievement, publicity, success; but they are all outworn—as outworn as ideologies, opinions, concepts and names for things.[7]

The seeming straightforwardness of this text has made it a key document in the Richter corpus. It has been taken to articulate his approach to the photo-paintings and to describe his complex relationship to experience. We will examine the note through that lens in chapter 5, but for now it should be read for what it is: a private address by an artist to himself in a time of important change. The first few lines are vintage Richter. From the standpoints of opticality and mediation, he had long been committed to uncertainty. However, the note also conveys a new intellectual dimension. In writing, "I steer clear of definitions. I don't know what I want," Richter seems to signal a new openness to experimentation, an interest in exploring different media and modes of production as he gropes toward a more eloquent and critical justification for continuing to paint.

Richter was not, of course, averse to all publicity. He continued to hope that René Block would make good on his promise to publish a book about him. On May 3, 1965, Richter wrote to Block suggesting they include "everyday texts" next to the reproductions of his paintings. The texts, he stressed, would perform as verbal collage, with the randomness and autonomy of individual fragments making it impossible to link them logically together or to the illustrations. "This means," Richter added the next day, "that no literary joke, or serious topic, or any other signification should be discernable."[8] This was consistent with Richter's use of text fragments on the poster for his first show with Heiner Friedrich and in the recording that had played during his opening at René Block's gallery. Richter viewed the use of text fragments as part of a larger aesthetic process focused less on the creation of an object than on its selection and reuse. They were, in a sense, readymades, as some critics would later describe the photo-paintings.[9]

In another letter to Block, Richter struggles to flesh out his ideas:

I am worried about the book. Tried to put texts together, but it didn't work. I was wrong when I thought it would be easy according to the formula (trivial, unliterary, not funny, etc.); there is no formula, just as there is no formula for choosing the photos that I copy. When texts appear in the book . . . they can only be those which I have already chosen, or which I've already sent to you or to Friedrich, or those recorded on tape, or those on the Friedrich poster, or those that I have laying around. Some of these could appear in the book (with the date) and these would be from me. But there are not enough of these texts. Who should make some additional ones? (and sign them). One possibility: another person chooses all of the texts (that way I wouldn't have anything to do with it). One or two texts of mine could appear with them. Second possibility: I choose a detective novel, all of which will be printed with the images interspersed in the text. . . . I would have

to shorten it (because of the length of our publication). This novel would then be from me. Third possibility: You choose a detective novel, do with it whatever you want and also sign and take responsibility for it. You could then take, for example, one or two texts from me as an epigraph, as is often done. I find the solution with the detective novel very good. It avoids boredom, does not offer too much access to the viewer, but is also very consequential and appropriate.[10]

With its musings about signatures and who makes what, the letter comes close to describing a Duchampian readymade: Duchamp had always been fascinated by how easy it was to authenticate as his own creation objects fabricated by others simply by signing them. In fact, though, Richter's direct antecedent was not Duchamp but the absurdist productions (including books) of Fluxus.

In the end, the publication never appeared, but Richter held onto the idea and used it a year later in the catalog for a joint exhibition with Sigmar Polke at Galerie h in Hannover.

GALERIE H

Galerie h was the enterprise of August Haseke, a teacher who enjoyed running an art space in his spare time. Haseke had been eager to mount a show for Richter, Polke, and Lueg, but when it finally opened on March 1, 1966, only Richter and Polke were represented (fig. 4.4). (Haseke later organized a separate exhibition for Lueg.) Richter showed thirteen paintings, including *Swimmers* (*Schwimmerinnen*, 1965; CR 90), *Tiger* (1965; CR 78), *Flemish Crown* (*Flämische Krone*, 1965; CR 77), and *Kitchen Chair* (*Küchenstuhl*, 1965; CR 97), for which he would win the Art Prize of the Young West (Kunstpreis junger Westen) in 1967.

"I enjoyed Hannover," Richter reported to Heiner Friedrich. "The exhibition looks very good. We haven't sold anything."[11] But, as he had acknowledged in an earlier letter, he had no illusions going into the show that there would be significant sales: "People like Haseke, they had a profession and ran a gallery on the side out of a love for art or as a means of social engagement. The commercial aspect did not play such a large role."[12]

More important than the show for Richter and Polke was the twenty-page catalog that accompanied it. The catalog incorporated staged photographs and snapshots of the two artists (figs. 4.5, 4.6) along with an absurdist text assembled from various sources. At Richter's urging, they picked a novel from the popular Perry Rhodan science-fiction series to use as a base text. "We'd read the stuff, and it fitted into the utopian naivety of the 1960s, with all those ideas about other planets. This inartistic, popular quality, it all went together with the photographs, magazines, glossies, that were the Pop side of it. All completely unimaginable today."[13] To build the text they compiled snippets from the novel, their own short writings, and bits of other pulp fiction. They spread everything out on the floor, shifted it around, and

FIG. 4.4. EXHIBITION AT GALERIE H, HANNOVER, 1966.

then put it back together. Richter described his own writing as a "self-disclosure in a humorous form." "I am averagely healthy, averagely tall (172 cm), averagely good-looking," he wrote. "I mention this, because that is how one has to look to paint good paintings."[14] His contributions range from basic information on the formats and materials of his paintings to bizarre, hybrid ideations about the status of painting in contemporary society, something that certainly concerned him and that he addressed in a mocking, zany tone. Meanwhile, Polke rhapsodized, referencing his raster paintings: "You can believe me or not, but I really see my environment in dots. I love all dots. I am married to many of them. I want all dots to be happy."[15]

Wildly different texts abut in a jarring montage; the only thing consistent about the narrative is that it is made unintelligible by the incessant intrusion of new voices. One can hardly follow the quick shifts between narrators and points of view, especially when the artists themselves pop into the story frame:

> The opalescent fluid found its way into their mouths and noses, and they felt as if they were drowning. Icho Tolot was still writhing and shrieking on the ground, while Rhodan, Richter, Redhorse, Polke and the three mutants were reduced to helpless spectators of the monstrous creature's agony.[16]

The catalog also provides a satirical send-up of the artists' friendship. "At the time we made the text, I was closer to Polke than I had ever been to anyone," Richter admits. Polke seems to have brought out the devil in his friend.

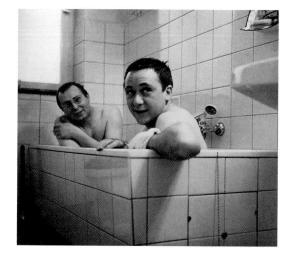

FIG. 4.5. RICHTER WITH
SIGMAR POLKE, 1966.

FIG. 4.6. EMA RICHTER, SIGMAR
POLKE, ANNA POLKE, KARIN
POLKE, GEORG POLKE, AND
GERHARD RICHTER, 1966.

Scattered amid the pseudoscientific language of low-brow science fiction, trivial scenes from dime novels, and banal everyday stories are Richter's ironic, sardonic pronouncements on art and artists. The humor served as a prophylactic whereby he could vent his spleen about paradoxical values in the art world as well as within his own nature. For example, Richter considered art produced in East Germany to be implicitly compromised by its role as a political instrument of the state. This, however, also meant that art was taken seriously there, whereas in the affluent market economy of West Germany he had seen how art could become trivialized—a condition Polke also mocked with his merry, dystopian universe of benday dots.

"There was a time around 1962–1967 when everybody seemed to be fascinated by art," Richter recalls. "They came to the studios and were amazed; they imagined that something [sensational] was happening. Then they were disillusioned when the newness wore off."[17] Few, though, seemed genuinely interested in the art; going to galleries was merely a form of entertainment. ("Which is better: collecting art, or drinking and whoring? Everything in its proper time.") For most, buying a painting was about staving off boredom or filling the empty space in their capacious new homes (hence the prominence of the dimensions of paintings in the catalog). Running just beneath the surface of Richter's commentary is a deep ambivalence: On one hand, he was judging his success in terms of how many paintings he sold; on the other, he was cynical and disappointed by what he thought motivated many collectors. The world of the moneyed class and the social elite had always been alien to him, despite the best efforts of his mother. Growing up in East Germany, an ostensibly classless society, may also have made him impatient with the air of self-importance with which some wealthy Germans conducted themselves in the West. And certainly during his years in Düsseldorf Richter did not find the ebullient Rhineland mentality either stimulating or congenial. Thus we find him sitting, in a display of inverse snobbery, at separate tables from his collectors at the celebratory dinners that customarily followed a vernissage.

In the text collage Richter produced with Polke, he propounded, perhaps with less irony than he realized, "If anyone wants to be a painter, he should first consider whether he is not better suited to be something else: a teacher, a government minister, a professor, a craftsman, a workman; for only truly great human beings can paint."[18] At the same time Richter wanted to avoid any hint of the sacred glow emitted by those of his colleagues, most notably Joseph Beuys, who had donned the mantle of shaman to become radical leaders of a new way in art and society. By developing a practice that relied on commonplace images, he distanced himself from the fierce upsurge of political movements that had come to dominate Europe. Too, his conservative personal appearance helped to preserve him from the delirious cutting edge. While he defiantly—and perhaps defensively—described the artistic personality as something apart from the norm, Richter never bought into the cliché of the artist as eccentric bohemian. Both he and Polke tried to fit themselves (albeit subversively) to the mood of the broader culture. In the Galerie h catalog, for example, they adopted a rhetoric of economic upswing, industrial development, and space-age technology, presenting their own kooky dabblings as somehow scientific.

Shortly after Galerie h, Richter joined Lueg in an exhibition at Galerie Patio in Frankfurt am Main (September 9–30, 1966), immodestly titled "Die beste Ausstellung Deutschlands" (Germany's Best Exhibition). On facing walls, Lueg installed two large paintings with silkscreened red and green kidney shapes. Richter showed the massive painting *Large Pyramid* (*Große Pyramide*, 1966; CR 131), which, at 190 by 240 centimeters, likewise took up an entire wall. He also displayed a print titled

Pyramid, mounted on canvas and published in an edition of ten (Editions CR 9). This show was rather conventional, but concurrently the two artists were working on a far more challenging idea for an exhibition at Galerie Niepel in Düsseldorf. They wanted to create a display of highly charged photographic works centered on the theme "Sex and Mass Murder."

Richter had already depicted human massacre in 1962 with *Execution (Erschießung)*, which he later destroyed, and he would revisit the theme of violent death throughout his career. For example, *Eight Student Nurses (Acht Lernschwestern*, 1966; CR 130) was based on newspaper photos of the women tormented, raped, and slaughtered by spree killer Richard Speck in Chicago. In 1991 Richter spoke about the tangled thematic of the collaboration with Lueg: "Without too much reflection, I can say that these two things, love and death—sex and crime—are two [of] the things that touch us most."[19]

In preparing for the exhibition, Richter and Lueg hunted down photographs of atrocities in Nazi death camps as well as sleazy images from German pornographic magazines. In contrast to the neutral images that normally served as Richter's models, these photos already carried the charge of something forbidden: the Holocaust images challenge the viewer to confront unspeakable horrors denied by the German people during the Auschwitz trials; the pornographic ones are meant to arouse illicit desire. Richter photographed the source images from books and magazines, then experimented with altering them through blurring and multiple exposures. He colorized a few of the concentration camp photographs using a saturated palette straight out of Pop art; some of these images made their way into the *Atlas* (panels 16–23). Lueg's estate includes a sheet of four pornographic images photographed by Richter, with a green and red grid added by Lueg.[20] Eventually, though, the project was abandoned: the images of Nazi genocide proved impossible for Richter to paint.

Meeting Polke and Lueg was undeniably fortunate for Richter. Today he stresses how important the relationships were to him, though the three were fiercely competitive and the way they treated each other, Richter acknowledges, "was not at all nice." In 1963, as Lueg was struggling to make work for the group's show at Kaiserstraße 31a, the others made matters worse by heckling him, says Richter, something that would came back to haunt them when Lueg had finally had enough and put down his brush to open a gallery. Richter's relationship with Polke was from the beginning especially competitive. Nine years Richter's junior, Polke was every bit his match as an artist. "I remember how close this friendship was, but also how tough it sometimes was. I didn't realize it at the time. For us it was just the natural way of dealing with each other. In retrospect, I'm amazed it was so brutal. All . . . of us were very unsure of ourselves, and each tried to cover this up in his own way," Richter has said. As is the way with cliques, this one finally disbanded, mostly because of Lueg's career change and Richter's gradual estrangement from Polke. "I can only say that that's the way it was. Polke drifted away into the psychedelic

direction and I into the classical. I found support in Gilbert & George. . . . And then in [Blinky] Palermo who was also retrieving the classical."[21]

DUCHAMP'S VISUAL INDIFFERENCE

In 1965 a retrospective of Marcel Duchamp's readymades toured northern Europe.[22] Richter took in the show during its stop at the Museum Haus Lange in Krefeld. It made a strong impression, as he reported to Heiner Friedrich, triggering shifts in his thinking—some large, some subtle—that would affect him long into the future.[23]

Richter seems to have been at once inspired and provoked by Duchamp's programmatic unorthodoxy. His immediate response to the exhibition was to paint the small-format *Toilet Roll* (*Klorolle*; CR 75/1; fig. 4.7) as a comment on Duchamp's most infamous readymade, *Fountain*. Duchamp had sent the object, a porcelain urinal bearing the pseudonymous signature "R. Mutt," to the 1917 Society of Independent Artists exhibition in New York City, where it had been summarily rejected by the exhibition board even though the venue was supposed to have been open to anyone—and presumably anything that could pass for art. The original *Fountain* has long since vanished, but a replica from the 1964 edition produced by Milan dealer Arturo Schwartz was on display in Krefeld. In a departure from his usual practice, Richter did not try to find a source photograph in a magazine but instead hunted down the consummate roll of toilet paper and photographed it himself. The result was a little painting so perfect that Heiner Friedrich moved quickly to buy it, for DM 200. (Richter also painted two slightly larger variations [CR 75/2–3)].)

If *Toilet Roll* was a sharp retort to Duchamp's famous bathroom fixture, the 1966 painting *Ema (Nude on a Staircase)* (*Ema [Akt auf einer Treppe]*; CR 134; fig. 4.8) can be understood as a more serious effort to redress what Richter took to be Duchamp's extraordinarily dismissive attitude toward painting. At the ripe old age of twenty-five, having exhibited *Nude Descending a Staircase No. 2* (fig. 4.9) at the 1913 Armory Show in New York, Duchamp had announced his intention to give up painting in order to devote himself full-time to chess. His decision signaled a paradigm shift in art, with painting ceding its preeminent position to an expanded concept of work freed from conventions, which opened the way to object-art. *Nude Descending a Staircase No. 2*, which today hangs in the Philadelphia Museum of Art, was represented in the Krefeld exhibition by a full-scale photographic replica— which was labeled, in apt Duchampian fashion, as equivalent to the original.

Ema (Nude on a Staircase), now in the collection of the Museum Ludwig in Cologne, may be Richter's most famous work. He wanted to paint a direct response to Duchamp's troubling, shambling, mechanical figure, and he asked Ema if she would pose. He tried photographing her in the studio, but the results didn't satisfy

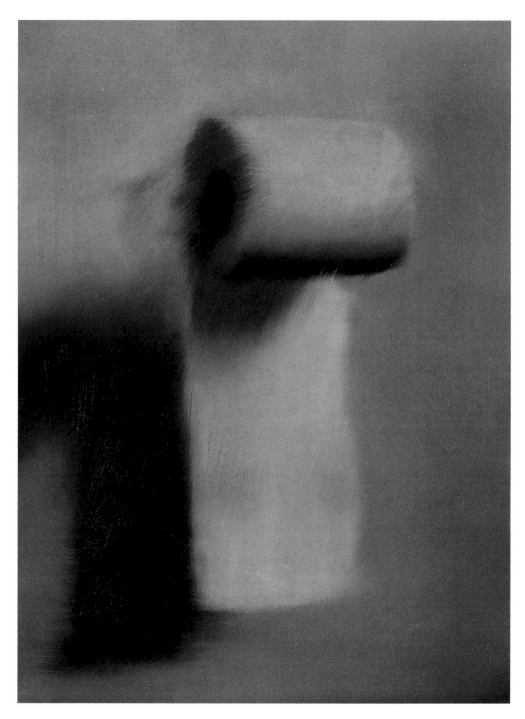

FIG. 4.7. *Toilet Paper (Klorolle)*, 1965. OIL ON CANVAS. 55 X 40 CM. CR 75/1.

him. Leading his wife out into the hallway, he invited her to walk slowly down the stairs, while he stood at the bottom snapping pictures. What resulted was an incandescent painting, the first to be made from one of Richter's own color photographs. Ema's body seems to shine from within, illuminating the unadorned space of the stairwell. The angular stairway, with its green-brown hue, offers a severe contrast to the soft contours of the female figure. Despite the frontal view, there is nothing provocative about this nude; the soft blurring gives the figure the quality of classical sculpture, thereby attaining a certain art-historical transcendence.

The contrast between this work and Richter's more provocative nudes of the following year is stark. Equally stark is the contrast between *Ema (Nude on a Staircase)* and Duchamp's similarly titled work; yet their relation is unmistakable, and dialectical. The motif and the muted colors of *Ema* do, without question, refer to Duchamp's nude, but the composition is different. Duchamp positions his figure in profile and registers its cascading, downward movement as if through time lapse, creating a systematic picture of motion. Richter takes up this theme of depicted movement in a multiple-exposure photograph that he says was a study for *Ema (Nude on a Staircase)*, although the piece is dated 1969, perhaps incorrectly, on panel 68 of the *Atlas* (fig. 4.10). This image is closer formally to Duchamp's painting than to Richter's. For Duchamp, *Nude Descending a Staircase No. 2* marked an artistic turning point in realizing the most radical possibility of simulating movement on static canvas; the effect was enough for him to declare painting's progress to be over. Richter painted his *Nude on a Staircase* out of "spite" at the arrogance of such a declaration, casting himself as an "anti-Duchampian by showing that the figurative tradition had not ended, that there remained more to do."[24] Richter's painting project throughout the late 1960s was intended to prove not only that painting is possible after Duchamp but also that a painting produced as a readymade—an estranged object—is a logical outcome of the then-prevailing debate about the death of painting.

Perhaps, too, Richter saw in Duchamp's insouciance the reflection of something faintly duplicitous in his own personality, manifested in his supposed indifference to the subjects he exploited. Certainly the encounter incited him to produce, in *Ema,* a work of uncommon candor. Indeed, he viewed the intimate origin of the painting as yet another strike against Duchamp. We know from the dated signature—"Richter V.1966"—that it was completed in May 1966. Because Richter rarely dates his canvases, we can surmise that the date of this one was especially important to him. By then he and Ema had discovered she was pregnant; their daughter, Babette (Betty), would be born seven months later, on December 30.

René Block offered *Ema (Nude on a Staircase)* to the Nationalgalerie in Berlin, but it was rejected by Werner Haftmann, the director, who said, "I do not collect photos, rather I collect painting."[25] That was his loss. A year later the collectors Peter and Irene Ludwig of Aachen acquired the work when it was displayed at Galerie Rudolf Zwirner in Cologne. Clearly, Duchamp's pseudosci-

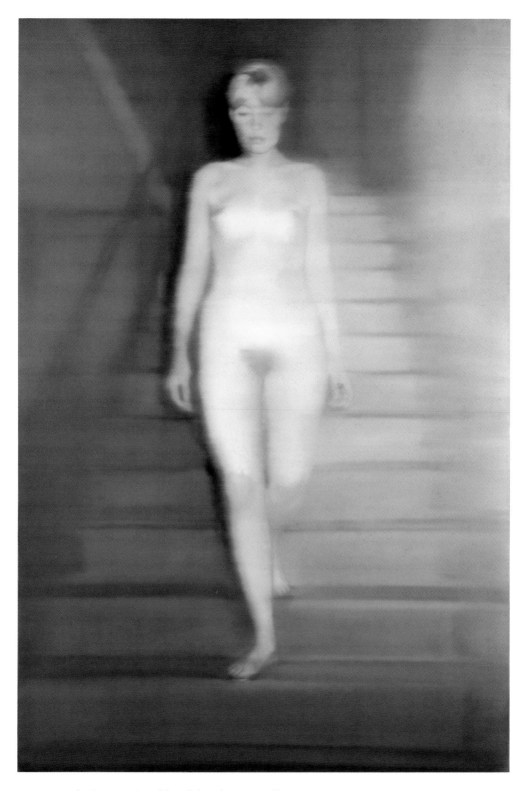

FIG. 4.8. *Ema (Nude on a Staircase)* (*Ema [Akt auf einer Treppe]*), 1966. OIL ON CANVAS. 200 X 130 CM. CR 134.

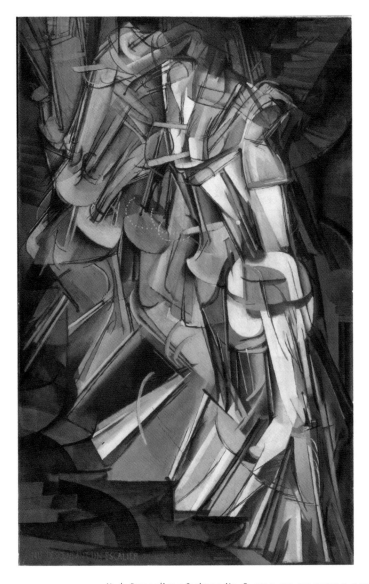

FIG. 4.9. MARCEL DUCHAMP, *Nude Descending a Staircase No. 2*, 1912. OIL ON CANVAS, 147 × 89.2 CM. THE LOUISE AND WALTER ARENSBERG COLLECTION, 1950.

entific experiments with the representation of motion had inspired, by negative example, a masterwork from Richter, one that develops a tension between the modernist ideal of a rushed, impersonal, mechanistic world and the quieter, more contemplative classical tradition of painting. The result is a large work of great intimacy, distilling a fragile instant in which the artist's emotional tenderness is uncharacteristically disclosed.

Richter continued to spar with Duchamp on and off for years. The latter's epic

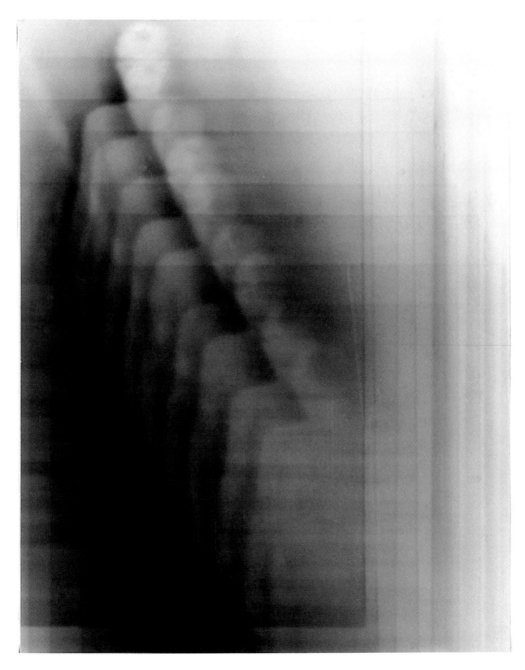

FIG. 4.10. *Atlas* (PANEL 68, DETAIL), PROBABLY 1966. PHOTO EXPERIMENTS.

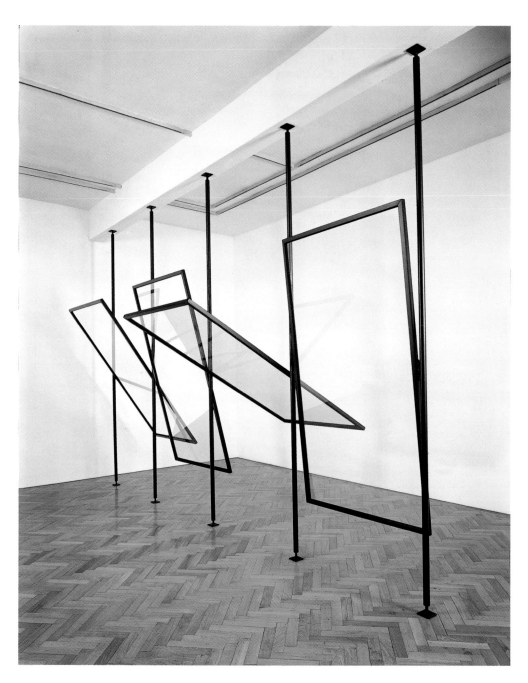

FIG. 4.11. *4 Panes of Glass (4 Glasscheiben)*, 1967. GLASS AND IRON. 190 X 100 CM. CR 160.

construction *The Bride Stripped Bare by Her Bachelors, Even* (also known as *The Large Glass*), loaded with scientistic speculation and sexual innuendo, prompted Richter to produce, in 1967, his own hypertechnic, stripped-down send-up, the transparent *4 Panes of Glass* (*4 Glasscheiben*; CR 160; fig. 4.11). The four panes are aligned side by side, each in an iron frame that rotates on a horizontal axis. In their simplicity and transparency, they defy literary interpretation or the temptation to psychologize, both of which are part and parcel with *The Large Glass*. "I think something in Duchamp didn't suit me—all that mystery-mongering—and that's why I painted those simple glass panes and showed the whole windowpane problem in a completely different light," Richter said in 1991.[26]

But the fierce engagement with Duchamp's systems and metaphysics may also have been the catalyst for some of Richter's new departures and experiments in painting. The first color charts (1966) and the shadow paintings (1968), for example, simultaneously fit and subvert the Duchampian profile. Both tropes inform Duchamp's very last painting, *Tu m'*, which features the traced shapes of shadows cast by actual readymades on the canvas as well as a long, vibrant line of color sample chips stretching into the distance, secured to the picture plane by a real metal bolt.

VOLKER BRADKE

As mentioned in chapter 3, Richter exhibited in Alfred Schmela's gallery only once more after his 1964 show. The occasion was a weeklong event at the end of 1966 called "Hommage à Schmela," engineered by the gallerist himself. Schmela had decided to close the old gallery at Hunsrückenstraße 16/18 and move to more spacious quarters. He had given any number of artists an early boost in their careers, so each day between December 9 and December 15 one of them, at his invitation, staged a send-off, beginning with Otto Piene and his *Schmela Rainbow*. Polke, Lueg, Beuys, Richter, John Latham, and Heinz Mack also participated.

Richter took over the gallery on Tuesday, December 13, with a multimedia event called "Volker Bradke." Volker Bradtke was an eccentric presence on the Düsseldorf art scene.[27] Photos in Richter's *Atlas* show a diffident, delicate young fellow hiding behind a pair of thick horn-rim glasses. As soon as he graduated gymnasium, Bradtke began to seek out the company of artists. He not only surfaced at gallery openings and in the bars where they hung out, he also tried, without success, to make art himself. Günther Uecker characterized him as "fly-by-night," but to Richter he was simply a "pitiable creature." Uecker said Richter was interested in Bradtke because of his background: "We knew his parents well. They really were prototypically middle-class. Unbelievably nice people, but also unbearable. This fascinated . . . Gerhard, the banality of their lives and the absolute artifice of their apartment decor." Bradtke himself "was a cliché between bourgeois banali-

ty—this way of doing everything precisely and meticulously—and a burgeoning radicalism."[28] To Richter, Bradtke embodied the uptight sensibility of the petit bourgeoisie, the class he and Lueg had targeted in their mock "Demonstration for Capitalist Realism." (For his contribution to "Hommage à Schmela," which took place two days before Richter's, Lueg reprised a feature of the demonstration, distributing an invitation to come for coffee and cake at the gallery, which he had decorated with kitschy floral wallpaper.)

Richter had already painted a large portrait of Bradtke (CR 133), which he used as the core of a multimedia display. (See *Atlas*, panels 24–26.) On the front of the gallery, he hung a large banner featuring Bradtke's painted head, while inside he presented a display of portrait photographs and a twenty-minute "antifilm" that shows Bradtke out of focus. Thus the event "Volker Bradke" turns out to be, rather than an homage to Schmela, a cynical celebration of banality that anticipates an aspect of the revolutionary movement then building in Europe: the elevation of the "simple man of the people" to heroic status. Warhol, in his shallow wisdom, had formulated the idea that everyone will one day be famous for fifteen minutes. Volker Bradke's fame actually lasted much longer—a whole afternoon in December 1966 (fig. 4.12).

WORKING WITH DEALERS

By this time Richter had been approached by several dealers who were interested in working with him on a serious basis. Rudolf Zwirner had already offered him a contract that promised a monthly advance of DM 500 against anticipated sales from a future one-man show.[29] Richter would have received half of the revenue from sales during that show and two-thirds of the proceeds from any sales Zwirner made before the exhibition. These were attractive terms, but Richter hesitated to enter into a binding commitment. For one thing, it would have meant cutting his ties to Schmela in Düsseldorf, something Richter was not prepared to do because, as he put it, Schmela had the "better reputation." He also feared alienating Heiner Friedrich; the contract would have given Zwirner first choice of works from Richter's studio, leaving only the remainders for Munich.

Actually, Richter wasn't interested in signing an exclusive agreement with anyone. He needed, he felt, a network of dealers to sell enough work to provide him a living. He also thought having gallery representation in different cities would increase his exposure and establish a broader interest in his work among collectors. So he not only turned down Zwirner but initially rejected an offer by Friedrich to act as his sole representative.[30]

In less than a year, however, he had changed his mind and designated Friedrich as his sole agent for a term of two years. Ema was pregnant, and faced with the birth of a child, the artist wanted the security of a regular paycheck. The contract

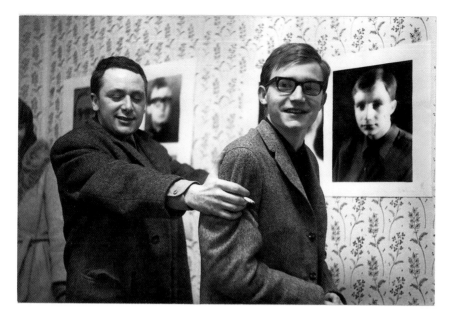

provided for monthly payments to Richter of DM 1,200, in return for which Friedrich was entitled to thirty paintings a year with a total retail value of DM 43,000—three times what he was paying out. Richter would also receive between one-third and one-half of the proceeds from any sales Friedrich made on his behalf, depending on the buyer. All sales were to be handled exclusively through Friedrich's gallery in Munich.[31]

This contract was in effect when Friedrich mounted a show in October 1966 of Richter's first color charts. The contract was altered the following year, increasing the value of the thirty annual paintings to DM 72,000. Richter, however, continued to receive the same monthly payment of DM 1,200, which now amounted to only 20 percent of the paintings' value, so the payment was renegotiated as an advance against sales. After the paintings sold, Richter would receive an additional payment, the amount again dependent on the buyer.[32] Friedrich could purchase additional paintings, beyond the requisite thirty, at the heavily discounted rate of 20 percent of value and sell them under the same conditions. For works sold on commission, Richter received 50 percent of the sale price. To determine prices, the revised contract spelled out a calculation based on the size of the paintings. "Gross value, or gross sale price of a painting equals the result of the following formula: 'Height + Width [in centimeters] x 10 = DM.'"[33]

In 1968 Richter would let his contract expire, having concluded that he could do better without it. From then on he would insist on a simple fifty-fifty split of

sales revenue—no matter the gallery, no matter the buyer. By then, he could afford to be choosy; he had plenty of opportunities.

NEW WORK

Soon after Ema gave birth to their daughter, Richter's work took a noticeable shift. He had been interested in erotic subjects ever since he was a teenager and had tried but failed, in collaboration with Lueg, to bring the erotic—or rather the pornographic—into conversation with atrocity. Now his attention was drawn back to sex, as he initiated a series of paintings of nude and seminude women (CR 148–157). A photograph showing him lingering among the canvases in a state of undress (fig. 4.13) suggests he may have been retreating into the studio as a sort of seraglio.

Aside from any personal fantasies, these paintings register a change in Richter's artistic practice. Although several follow his ostensibly random engagement with a single photograph,[34] others combine elements from different sources. For example, each of the three female figures in *Spanish Nudes* (CR 150; fig. 4.14) was plucked from a different photograph (see *Atlas*, panel 22). In the December 1967 issue of *Art International*, Richter said of the new paintings. "The nudes are a departure from the pure copying of a general photo because the images are artificially composed, and the result of that is that they become part of a broader theme in art (in reality, one would be dressed, of course) and one is drawn to them."[35] This statement marks a decisive complication in the artist's preoccupation with the authenticity of photographic representation. But Richter by no means reveals the *lie* of photography here; instead, just as he would do a year later in the lithograph *Transformation* (*Umwandlung*, 1968) and the portfolio *9 Objects* (*9 Objekte*), he enjoys its manipulative possibilities.

Still, even in montages like *Spanish Nudes*, Richter insists upon a distance between the female object and the observer. He sets up a kind of peep show, inviting the viewer to look and simultaneously frustrating the gaze through technique: the grisaille palette and soft blurring serve to defuse any erotic charge. Other paintings are similarly neutralized: In *Diana* (CR 155), the bilious green glow of the canvas serves as a repellant. *Olympia* (CR 157) features wide impasto dabs of the brush that prohibit the viewer from focusing on details. The same holds for *Bathers* (*Badende*; CR 154) and other works in the series.

Several of the nudes were featured alongside *4 Panes of Glass* in "New Work," Richter's May 1967 one-man show with Heiner Friedrich (fig. 4.15).[36] Curator Jürgen Harten attended the show and noted what he thought might be yet another commentary on Duchamp in the constellation of *4 Panes of Glass* and the pornographic motifs:

> That none of the Duchampian mysticism of *The Large Glass*, of the transformation of cosmic female "illuminating gas" that the bachelors blindly gorge upon, is to

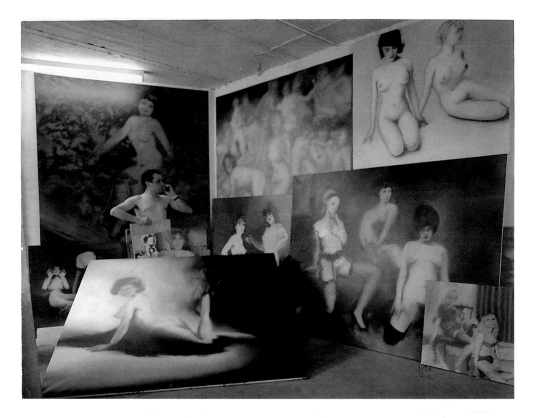

FIG. 4.13. RICHTER IN HIS STUDIO, 1967.

be seen in Richter's work does not rule out a similar thematic. Quite the contrary:
the painted porno-girls and their combination with the "Glasses" . . . allude both
simply and clearly to this.[37]

Shortly after the show opened Richter wrote Friedrich to complain. He was an-
noyed by the poor quality of the exhibition poster and irritated with himself that
he had not spent more time on it: "Now I'll have to hear from every pipsqueak that
I made a very poor poster. And it's all the more regrettable because the exhibition
is good and important, and I think the gallery is good and important." Richter also
wanted more advertising and urged Friedrich to talk to editors about publishing
some pictures. He offered to take an active role: "If you want, I could also write
or call the editors; you have to talk to me about this."[38]

By 1967 Richter's stature in the fledgling German art world was on a sure,
steady ascent. His work now commanded market attention and was regularly
featured in group and theme exhibitions. At the same time, his idea of success
was starting to change. No longer was he satisfied simply to sell paintings; he
was anxious for his work to have a serious critical reception. He asked Friedrich

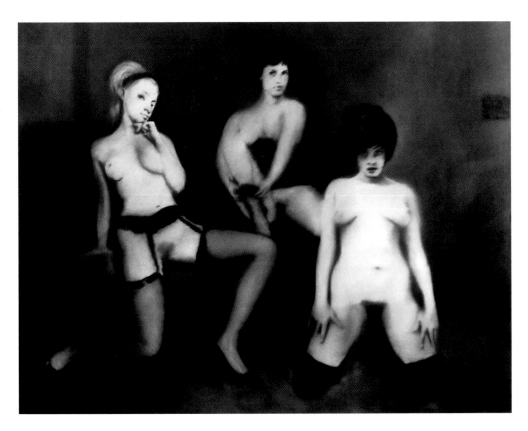

FIG. 4.14. *Spanish Nudes (Spanische Akte)*, 1967. OIL ON CANVAS. 160 X 200 CM. CR 150.

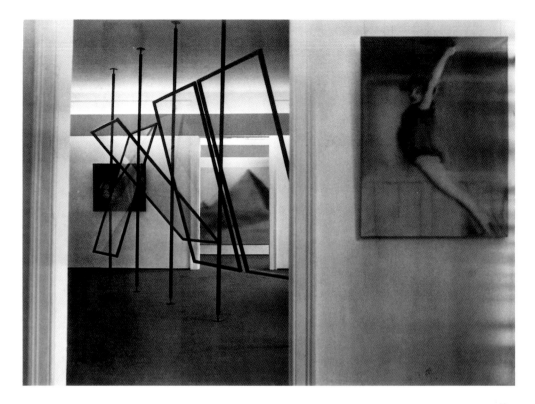

to "try to get the German translation of [the *Art International* interview] and send it to me so that I can make something out of it. The formulation 'he copies photos' is too little; the image to be constructed must be more precise, more complex and difficult."[39]

Another highlight of 1967: Richter received his first award, the Art Prize of the Young West, bestowed by the city of Gelsenkirchen, located northeast of Düsseldorf. The award came with a purchase prize of DM 2,000, which the city used to buy the painting *Kitchen Chair*. (The painting now hangs in the Städtische Kunsthalle in nearby Recklinghausen.) The ZERO artist Heinz Mack sat on the jury and championed Richter. "I never had much contact with him," Richter says today, "but he always let me know somehow that he appreciated my work very much."[40]

During the summer term of 1967, Richter served as guest professor at the Fine Arts Academy (Hochschule für Bildende Künste) in Hamburg. Paul Wunderlich, the magical realist painter, was going on sabbatical and had suggested Richter as his replacement.[41]

Richter was determined not to renew the contract with Heiner Friedrich, which was scheduled to end on March 31, 1968. So when Lueg resigned as art

teacher at the gymnasium in the Gerresheim neighborhood to open a gallery, Richter took over in order to supplement his income, even though he lacked the proper pedagogical credentials. The authorities saw his stint as a guest professor in Hamburg as qualification enough, at least until he could get proper training—which he never did. So after a year he was asked to leave; the school could no longer justify keeping him.

COLOGNE ART FAIR

It turned out that 1967 was a benchmark year for the contemporary art market in West Germany. In mid-September eighteen gallerists converged on Cologne to participate in the first Art Fair for Contemporary Art, organized by the Association of Progressive German Art Dealers. Among the participants were the galleries of René Block in Berlin, Alfred Schmela in Düsseldorf, and Rudolf Zwirner in Cologne. The atmosphere in the large Gürzenich Hall resembled that of a lively trade fair: temporary walls were packed tight with art hung in tall tiers. At Zwirner's stand one could view paintings by Konrad Klapheck. Hans Neuendorf of Hamburg showed the British Pop artist Allen Jones. And trendy Galerie Rolf Ricke, then still in Kassel, offered a selection of paintings by Warhol and objects by Gary Kuehn.[42]

The fair drew roughly fifteen thousand attendees and generated sales of DM 1.1 million, a convincing success—though, it must be said, the art was not as uniformly progressive as the participating dealers claimed. The most expensive work for sale was a Jackson Pollock from 1949, which Aenne Abels, from Cologne, offered for DM 150,000—and sold. At the end of the event, the weekly newspaper *Die Zeit* published a round-up:

> Most of the demand (according to numbers sold) was for graphic works selling for between DM 200 and 1,200. The biggest sales, nevertheless, were of "classic" modern works. The Cologne gallery Der Spiegel sold a painting by Max Ernst for DM 62,000 (*Der blaue Mond*, 1956) to a previously unknown collector. Galerie Zwirner found a buyer for an oil painting by Otto Mueller (*Sitzendes Mädchen am Schilf*, 1919–1921) with a price tag of DM 30,000. A 21-by-43-centimeter oil painting by Willi Baumeister (*Schwebende Welt*, 1954) was purchased for DM 9,500 (Galerie Stangl). But up to DM 15,000 were also paid for works by the younger generation of artists. . . . All but one painting by Konrad Klapheck, a sure bet for Documenta IV, sold for prices ranging from DM 4,000 to 6,000. Also among the favorites were other "Documenta hopefuls" such as Antes, Beuys, Graubner, Pfahler, Richter, and Uecker.[43]

The event marked the debut of an important art fair, which has since grown into the international spectacle Art Cologne. But it prompted numerous dealers to accuse the eighteen so-called progressive gallerists of a cartellike politics of ex-

clusion. Heiner Friedrich, for one, had not been allowed to participate, so he had installed "Demonstrative '67," featuring new, dynamic work by John Hoyland, Lueg, Palermo, Polke, Richter, Reiner Ruthenbeck, and Cy Twombly, in the DuMont Publishing House, just steps from the fair (fig. 4.16). Richter was represented by his ten-part *Color Chart* (1966; CR 144) and *Antlers* (*Geweih*, 1967; CR 167/1).

Two years later fifty thousand visitors attended the Cologne Art Fair and bought works with an aggregate value exceeding DM 3.5 million. The fair's great commercial success spawned many imitators. In 1970 the first ART Basel opened; modern art fairs followed in Paris, Chicago, Madrid, New York, and numerous other cities.

In October 1967 the gallery Wide White Space in Antwerp presented an overview of Richter's work from 1964 to 1967, with an emphasis on the photo-paintings. Several works were included that had not sold in Munich—*Wee Girls, Swimmers*, and *Sailors* (*Matrosen*, 1966; CR 126), which attracted the interest of the museum in Ghent—as well as the third version of *Toilet Roll* (*Klorolle*, 1965; CR 75/3).[44]

Sigmar Polke accompanied Richter to the opening. "I was with Polke in Antwerp. Was fun. But I could have saved myself the trip. Am beginning to hate openings," Richter grumbled in a letter to Heiner Friedrich a few days after he returned from Belgium.[45] This is not to say that he and Polke didn't have fun. In their hotel room the morning after the opening, Richter photographed them lying in bed, himself hidden under the covers, Polke in the bed on the right, grinning at him. The camera, positioned on a bureau, fixes a happy moment in their intense, complicated friendship. Richter made a print of the photograph, in an edition of eighty, which he titled *Hotel Diana* (1967). Beneath the image a line of text reads: "Saturday, October 14, 1967, between 11 and 12 o'clock (Antwerp, Hotel Diana; right Polke, left Richter)" (fig. 4.17).

In showing the artists spending a lazy morning supine in bed rather than upright at their easels, *Hotel Diana* offers an ironic foil to the (also ironic) fantasies of artistic omnipotence and pseudoscientific megalomania that characterized other of Richter and Polke's collaborations. In 1968, for example, the two produced an offset lithograph titled *Transformation* (*Umwandlung*; fig. 4.18), ostensibly documenting their dissolution and transformation of a craggy mountain top into a sphere. The caption punctiliously describes the event: "5 stages of a transformation undertaken by Polke and Richter. On April 26, 1968, the mountain was transformed into a sphere for a duration of two hours." The black-and-white photographs coupled with the text's precision lent an evidentiary air to the artists' claim that their own creative powers had allowed them to override the laws of nature and reshape the world according to their whim. In reality, of course, the images were a laboratory trick. (In 1992 Richter, working alone, would revisit the project, producing as belated evidence of their accomplishment eleven steel spheres, each 16 cm in diameter and engraved with the name of a mountain in the Swiss Engadin: Piz Fedoz, Piz Lagrev, Piz Sella, Piz Led, etc.)

Just a few weeks before producing *Transformation*, Polke and Richter announced

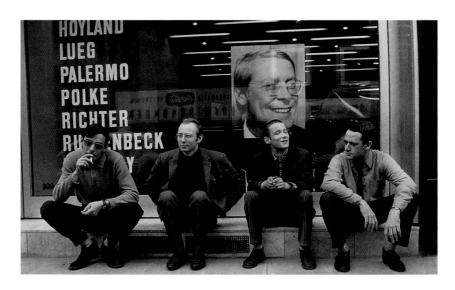

FIG. 4.16. KONRAD LUEG, SIGMAR POLKE, BLINKY PALERMO, AND RICHTER OUTSIDE GALERIE HEINER FRIEDRICH IN DUMONT-VERLAGHAUS, COLOGNE, 1967.

that they had succeeded in photographing a UFO. Richter reproduced the doctored image in the catalog for his exhibition in the Aachen public gallery Gegenverkehr (Oncoming Traffic), titling it *Ufo, photographed with Polke on March 6, 1968.*

The next year Richter took everything a step further when he produced the portfolio *9 Objects* (*9 Objekte*), once again invoking the presumed documentary value of the photographic image. Each of the nine black-and-white photographs captures a different wooden construction in a quotidian setting (fig. 4.19). The ordinary context suggests that the objects should also be ordinary. Close inspection, however, reveals that their apparent structure contradicts all rules of perspective—they could never really exist under the conditions shown. Richter had had the photographs professionally retouched, creating visual illusions like those for which the Dutch graphic artist M. C. Escher is famous. Here again, Richter presents himself as someone who both understands the laws of nature and knows how to suspend them. As he was able to demonstrate, we viewers are all too ready to be tricked by our belief in the authority of the photographic image. That collectors actually asked Richter if they could buy the wood constructions was a striking confirmation of this.

Each of these projects demonstrates that the image of reality we create for ourselves is implicitly deceptive, that objective truth does not exist, and that we allow ourselves to be manipulated far too easily. Richter's work has always been tinged by a kind of Nietzschean skepticism. "I don't believe in the absolute picture. There can only be approximations, experiments, and beginnings, over and over again."[46]

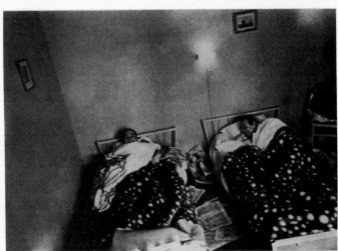

Samstag,14.Okt.1967,zwischen11u.12Uhr(Antwerpen,HotelDiana;rechtsPolke,linksRichter)

FIG. 4.17. *Hotel Diana*, 1967. SILKSCREEN ON BOARD. 29.2 X 40.2 CM.

5 Phasen einer von Polke und Richter vorgenommenen Umwandlung.
Das Massiv wurde am 26. April 68 für die Dauer von 2 Stunden in eine Kugel verwandelt.

FIG. 4.18. *Transformation (Umwandlung)*, 1968. OFFSET PRINT ON BOARD. 46.6 × 67.2 CM.

FIG. 4.19. FROM *Nine Objects*, 1969. OFFSET PRINT ON BOARD. 45 × 45 CM.

5 UNCLE RUDI

To go hunting for the soul of an artist in one of his paintings is not only risky but also, many critics would say, irrelevant. To become absorbed in ferreting out psychological and biographical minutiae is to lose sight of the better prize, the artwork itself. Established opinion typically valorizes the analysis of gesture, material values, composition, and spatial delineation as concrete evidence of the artist's strategic engagement with his medium and with larger aesthetic, temporal, political, and intellectual questions. Yet, when a German of Richter's vintage makes a portrait of a smiling man in a Nazi uniform, which he then flagrantly titles *Uncle Rudi*, how nearly impossible it is to suppress the wish to know more about the artist's connection to the figure in the picture and to wonder what moved him to paint it.

Many of the first critics to explore Richter's photo-paintings took him at his word when he said he pursued "no objectives, no systems, no tendency . . . [that he had] no time for specialized concerns." Some still do. As late as 1997 scholars like Susan Ehrenfried were writing that Richter's photo-paintings from the 1960s were characterized by a pointed "choicelessness, compositionlessness, stylelessness, and contentlessness."[1] Reviewers fretted over what they perceived to be the "irrelevance of the object" and the "haphazard arbitrariness" of the subject matter.[2] Only the medium appropriated—photography—united all the works.

Such a reception was perfectly acceptable to Richter for years. In fact he encouraged it with what Obrist calls his "energizing contradictions as both a painter and a writer."[3] Drawing on lessons learned as an Informel artist, when he felt embarrassed

by his thick, dark, personal outpourings of paint, he would stolidly maintain that subjective sentiment had no place in his art. Asked in a 1970 interview how he selected his subjects, Richter replied:

> Perhaps the choice is a negative one, in that I was trying to avoid everything that touched on well-known issues—or any issues at all, whether painterly, social, or aesthetic. I tried to find nothing too explicit, hence all the banal subjects; and then, again, I tried to avoid letting the banal turn into my issue and my trademark. So it's all evasive action, in a way.[4]

The notion that black-and-white photography was neutral also complemented Richter's personality, his sense of restraint and natural affinity for a grisaille palette. The supposed objectivity of photography and the seeming randomness of subjects in the sequence of paintings *Toilet Roll*, *Meadow*, *Flemish Crown*, *Tiger*, and *Motor Boat*— entries 75 through 79 in Richter's catalogue raisonné—seem to negate any possibility of emotional connection between the artist and the paintings' content.

Still, as Richter's fame has grown so has curiosity about the affective landscape that he now admits led him to paint some of the most haunting and visually disturbing images in his entire oeuvre—the portraits *Aunt Marianne* and *Uncle Rudi*, for example, which by their very titles provoke the viewer to speculate about the artist's personal life, as well as the fleeting images of Nazi war criminals and of seemingly ordinary people going about the daily business of living.

In reality the subject matter of Richter's photo-paintings is intimately tied to his private interests. In the great stretch of work produced between 1962 and 1967, he not only matured as a painter, broadening his range and raising his intellectual horizon, he also worked through a considerable amount of personal history. In a handout for a 1968 exhibition in Baden-Baden, Richter established a chronology for the previous five years:

> 1962 Painted the first photos (as a result of a radical change of views on art; "nothing to do with painting, nothing with composition, nothing with color"). The Happening movement and American Pop art had a supportive and affirming effect.
>
> 1962/3 Different themes from photos (in part still painterly and sentimental: Stag, Castle, Hitler, etc.).
>
> 1963 Airplanes, autos, etc. (smooth surfaces, photolike, journalistic; "every slice of reality is equally good"). Family paintings (from amateur photos; middle-class intimacy, storytelling, unprofessionally composed: "Composition is when the main person stands in the middle"), portraits (distanced, recognizable, and objective, in contrast to artistic portraits, which also show the soul).
>
> 1964 Landscapes (anonymous, brochurelike, not individually experienced; Sphinx, pyramids, etc.).
>
> 1965 Curtains, papers, columns (application of stylistic means used up to now for the invention of paintings and constructions). Scenes, animals, objects, etc.

(from magazines, coincidental extracts from reports; collection or posed composition in the "style of the time": lovers; mostly wiped over horizontally so that no detail becomes important and so that everything remains in motion: Tiger).

1966 Different themes (absurd composition of the snapshot: Volker Bradke; Emphasis on the picture's content, modern: murder of 8 student nurses, classical: nude on a staircase; dissolving the contour and blurring to bring forward the logical idea of space; Sheik, Chair, Elisabeth. Film about V. Bradke). . . .

1967 Nudes (partial departure from the principle of copying; posed groups, which are also thematically no longer common, but artful).[5]

Richter's tally makes at least one thing clear: The choice of subject matter was not as arbitrary as he liked to pretend. Clear lines of development and changing foci in his artistic pursuits were starting to emerge. In addition to private family scenes and seemingly random objects, he was interested in art-historical motifs. *Sphinx of Giza* (1964; CR 46, 47), *Angel's Head* (*Engelskopf*, 1963/1965; CR 48/7), *Milan: Cathedral* (*Mailand: Dom*, 1964; CR 49), and *Egyptian Landscape* (*Ägyptische Landschaft*, 1964; CR 53) were all based on images from art books or encyclopedias. More often than with other subjects, Richter used the defining strategies of enframement or integrated text to signal that these images were appropriated, thus establishing, on the one hand, a self-reflexive link between his painting and art history and demonstrating, on the other, that our reception of art is usually filtered through some other medium.

Richter also enjoyed working from the kind of staged photographs that are used in promotional brochures and advertisements. *Motor Boat*, for example, was based on an ad for the Kodak Instamatic camera, *Tourist Office* (*Reisebüro*, 1966; CR 120) on an ad for the travel agency Hapag Lloyd. The source for *Working in the Garden I* and *II* (*Gartenarbeit I–II*, 1966; CR 113, 114) was a trade journal. *Deckchair* (1964; CR 36), *Deckchair II* (*Liegestuhl II*, 1965; CR 89), *Two Women with Cake* (*Zwei Frauen mit Torte*, 1965; CR 95), *Girl in Armchair* (*Mädchen im Sessel*, 1965; CR 111), *Group under Palm Trees* (*Gruppe unter Palmen*, 1966; CR 118), and *Girl on a Donkey* (*Mädchen auf einem Esel*, 1966; CR 132) all derive from the visual rhetoric of advertising.

It must be said, however, that genuine tragedy lay behind many of the most blatantly banal paintings. Ingrid Misterek-Plagge tracked down, for instance, the source for *Frau Marlow* (1964; CR 28), an article titled "The Secret of the Poisons" from the magazine *Quick*. The woman depicted, whose name was Anni Hamann, had died after eating a poisoned praline intended for her mother. The murderer turned out to be a close family friend.[6]

Then there is the tragic figure of Helga Matura, a reformed prostitute whom Richter painted twice in 1966, first as a young girl sitting in the grass (CR 124) and then as an elegant woman in *Helga Matura with Her Fiancé* (*Helga Matura mit Verlobtem*; CR 125; fig. 5.1). Both likenesses derive from photographs featured

FIG. 5.1. *Helga Matura with Her Fiancé (Helga Matura mit Verlobtem)*, 1966. OIL ON CANVAS. 200 X 100 CM. CR 125.

in tabloid accounts of her lurid murder. According to an article in *Quick*, "Helga Matura, called 'Karin,' has been the uncrowned queen of the Frankfurt nights for nine years. She is the second Nitribitt ["Rosemarie" Nitribitt was a prostitute murdered nine years earlier in Frankfurt]. But—she has more class. She is even more beautiful. More desirable. And more depraved."[7] She was a well-born woman who had fallen into a life of prostitution and now dreamed of finding her way back out. Sadly, she was murdered on January 26, 1966. Her killer was never found. For the first painting, Richter purposefully erased any trace of Matura's reputation by abbreviating the text beneath the source photo (*Revue*, March 16, 1966) from "Murdered Party Girl: Helga Matura" to simply her name. While the first depiction radiates a youthful innocence, the second suggests a rather perverse anticipation of bourgeois marital bliss. With an arm around her oddly diminutive fiancé, Matura smiles for the camera.

Richter did not paint all of the pictures and ominous stories he collected from the tabloids, but he did include many of them in his *Atlas*. "At once a vast index of primary material and a device for reviewing and rethinking the many possible relations of one image to another as icons in their own right, as image-types, or as entries in his intellectual and artistic autobiography, *Atlas*," Robert Storr has written, "is a mechanism for simultaneously organizing and disorganizing information, a way of showing the artist's hand and of camouflaging his intimate connections to the contents on display."[8] One clipping on panel 8 tells the story of Alma Bellwinkel, who died of heart failure—or so her husband maintained, "but 14 years later the truth came to light." Also on panel 8 is the story of Anna Dörstein, who disappeared mysteriously with her three sons; the police investigation resulted in the husband's arrest on suspicion of murder. A second photo connected to the case (on panel 12) shows the married couple seated together, ostensibly content. Yet the accompanying text tells a different story: "Happy couple Dörstein? No, the appearance deceives. Anna idolized her husband, but he had already advertised: 'In search of pretty young woman.'"

Each of the murder victims smiles directly at the camera, frozen in an instant of ostensible calm and seemingly confident of a future. Yet behind each masklike face is a story of woe in which the subject winds up dead, in most cases murdered by someone in her own family. Given such clusters in the *Atlas*, Richter seems to have had little faith in the cultural construct of the family as a refuge. His domestic paintings are laced with deception. They are staged to dramatize the disturbing discrepancy between the often tragic imperfection of life and the hope for personal happiness.

PERSONAL PHOTO-PAINTINGS

Not every bleak event chronicled by Richter came from the popular media. A significant number related directly to his own life. In a 1986 interview with Benjamin Buchloh, he explained that he had selected his source images according to "content, definitely—though I may have denied this at one time, by saying that it had nothing to do with content, because it was supposed to be all about copying a photograph and giving a demonstration of indifference."[9] His admissions to Doris von Drathen in 1992 went even further: "That was an attempt at self-protection—saying that I was indifferent, that I didn't care, and so on. I was afraid my pictures might seem too sentimental. But I don't mind admitting now that it was no coincidence that I painted things that mattered to me personally—the tragic types, the murderers and suicides, the failures, and so on."[10]

Folding Dryer (*Faltbarer Trockner*; CR 4; fig. 5.2), from 1962, is one of the earliest paintings to make its way into the artist's catalogue raisonné. The ostensible subject is a housewife hanging her laundry on a folding rack. A large amount of white space has been left around the image, which includes a short text advertising the product. The work is a splendid examination of photography's relation to painting. Specifically, it alludes to the representability of reality and to mass media with its banal commercial motifs. It also offers a clever semiotic riff on the object, its visual representation, and its linguistic circumlocution. Yet at least as important for Richter in the choice of this image was a personal experience. In a 1990 interview he answered the assertion that his treatment of subject matter such as the dryer was ironic:

> If I [permitted it to be said that it was ironic, I did so to be left in peace]. Because at some point, of course, I did care about the motifs. I didn't find the clothes-drier ironic; there was something tragic about it, because it represented life in low-cost housing with nowhere to hang the washing. It was my own clothes-drier, which I rediscovered in a newspaper—objectivized, as it were.[11]

Today Richter adds: "We had this exact dryer. . . . And when you see it in the newspaper, you are completely shocked. You suddenly see yourself."

Many other paintings made from media images highlight the family theme, including the 1965 *Mother and Daughter (B)* (fig. 5.3), painted from a paparazzo photo of the French actress Brigitte Bardot: "If one wants to read that painting as having [an autobiographical reference] then [the young woman] is Ema, who looked a little like Bardot, the popular idol of the time" (fig. 5.4).

Frequently, Richter sought to work through complicated emotions by spinning childhood impressions into paint. For example, *Aunt Marianne* (1965; CR 87; fig. 5.5) seems meant to depict a moment of familial tenderness. It shows Richter's mother's sister, Marianne, as a girl barely in her teens, holding Gerhard as a baby.

FALTBARER TROCKNER

5,60 m nutzbare Trockenlängen!

DM 8.70

FIG. 5.2. *Folding Dryer (Faltbarer Trockner)*, 1962. OIL ON CANVAS. 99.3 × 78.6 CM. CR 4.

Just a few years later, when Marianne was eighteen, she would be shipped off to a psychiatric clinic in Großschweidnitz, where she would be murdered by Nazi doctors working in the Third Reich's Action T4 euthanasia program. Action T4 was designed to rid Germany of purportedly less desirable citizens, especially those with severe disabilities, including mental illness. The sentimental idyll depicted in this intimate study betrays nothing of her horrific demise; yet the image becomes urgent and deeply disturbing when viewed alongside another photo-painting from 1965: *Mr. Heyde* (*Herr Heyde*; CR 100; fig. 5.6).

Mr. Heyde presents a cryptic image: the head of a man wearing a hat and glasses is partially obscured by a second, uniformed figure, with both rendered in a horizontal blur of paint. Only the painted caption from the original newspaper clipping reveals the subject's identity: "Werner Heyde in November 1959, as he gave himself up to the authorities." The text hints at a punishable offense, but few viewers today, even in Germany, are likely to know the story behind the image. Prof. Dr. Werner Heyde was a German psychiatrist who helped organize the Nazi euthanasia program, which killed Aunt Marianne. After the war, Heyde adopted a pseudonym and, with the knowledge and protection of local authorities, lived undetected for years in Flensburg, where he worked as a neurologist and even appeared in court as an expert witness.[12] Exposed in 1959, he committed suicide in 1964, five days before he was to go on trial for war crimes.

Aunt Marianne and *Mr. Heyde*—numbers 87 and 100, respectively, in Richter's catalogue raisonné—would seem to be in direct dialogue. Taken together, they certainly deepen the historical dimension of Richter's family narrative. "At the time, it would not have suited me to make the backgrounds public," Richter says. "Then the paintings would have been seen as engaged with contemporary issues or as social commentary. This way no one bothered me, and everything remained anonymous. Now it doesn't bother me anymore if people know it." Many years later the pairing would take on an even more troubling aspect when a journalist revealed that Richter's first father-in-law, Heinrich Eufinger, a prominent physician of the Third Reich, had been assigned to the clinic where Marianne was interned.[13] Richter knew nothing of the matter until it was made public in 2006; apparently neither did Ema. But it demonstrates how inextricably entangled even second-generation Germans may find themselves with the "purification" programs of National Socialism.

In between these two works Richter painted a number of others, including the large group image *Swimmers* (fig. 5.7). The *Atlas* identifies the figures in the painting as members of a women's relay team who were training for the 1964 Olympic Games in Tokyo. With their athletic, healthy bodies and—presumably—healthy minds, the women offer a contrast to the subtext of the two other paintings.

During the mid-1960s Richter turned again and again to motifs related to the family (fig. 5.8). Denied a peaceful childhood himself, he set out—consciously or not—to expose the bourgeois idyll as a façade erected to mask human tragedy.

FIG. 5.3. *Mother and Daughter (B) (Mutter und Tochter [B])*, 1965. OIL ON CANVAS. 180 X 110 CM. CR 84.

FIG. 5.4. RICHTER IN HIS STUDIO WITH *Mother and Daughter (B)*, 1965.

In public projects like the "Demonstration for Capitalist Realism" and "Volker Bradke" Richter treated petit bourgeois society with unveiled contempt. Yet a number of paintings from the same period—*Family after Old Master* (*Familie nach altem Meister*, 1965; CR 26), *Family at the Seaside* (*Familie am Meer*, 1964; CR 35), and *Family in the Snow* (*Familie im Schnee*, 1966; CR 80/8) are all examples—suggest a longing for an ideal family and the kind of revels especially prized by the middle class.

Richter's wartime childhood and his parents' troubled relationship contributed to his difficulty coming to terms with male authority and to the ambivalence that laces his domestic scenes. We have already mentioned how relentlessly his mother, Hildegarde, had worked to turn Gerhard against his father. No opportunity to ridicule Horst was allowed to pass; if it wasn't his piety, which Hildegarde loathed, it was his family background. What could be expected of a man, she would remonstrate, whose father had been unfaithful to his wife and—it was said—had sired five illegitimate children? In the next breath, she would hail her brother Rudi

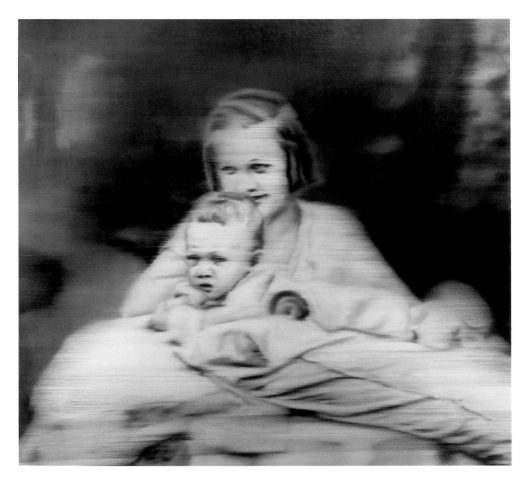

FIG. 5.5. *Aunt Marianne (Tante Marianne)*, 1965. OIL ON CANVAS. 120 X 130 CM. CR 87.

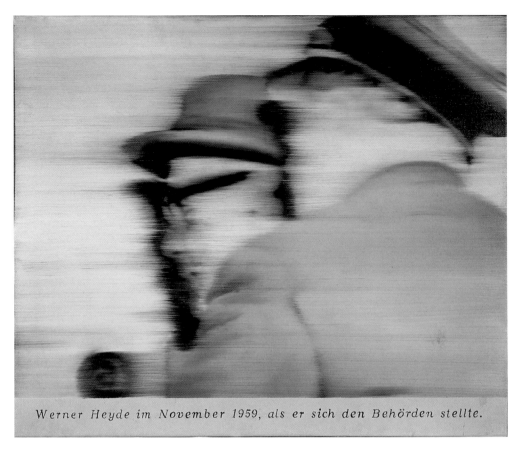

Werner Heyde im November 1959, als er sich den Behörden stellte.

FIG. 5.6. *Mr. Heyde (Herr Heyde)*, 1965. ACRYLIC ON CANVAS. 55 × 65 CM. CR 100.

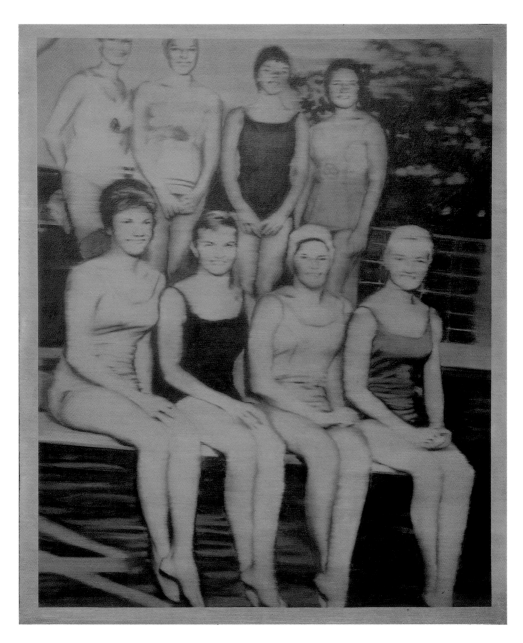

FIG. 5.7. *Swimmers (Schwimmerinnen)*, 1965. OIL ON CANVAS. 200 X 160 CM. CR 90.

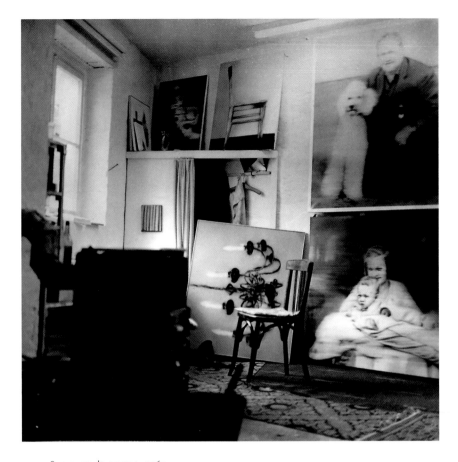

FIG. 5.8. RICHTER'S STUDIO, 1965.

as exemplary of what a man should be. "He was the brother of my mother, the family favorite. He was talked about very much, and he was presented to me as a hero. He was a charmer, a musical, elegant, brave, and handsome man. And my father, he was seen as this nonmusical good-for-nothing." His mother's incessant harangue had a lasting effect on Richter's ability to relate to his father and later on his own role as a parent.

It didn't help that Horst survived World War II in the relative security of a U.S. POW camp while Rudi and Hildegarde's other brother, Albert, perished "defending the homeland." And because Horst did not return home until the fall of 1946, he scarcely had a chance to defend himself against the horrible image that Hildegarde had presented to the children. In 1965, when Richter decided to paint his own portraits of the two men, he was going head to head with himself in a struggle to internalize some kind of male role model. To this end, he painted almost simultaneously, and in roughly the same format, the antipodal *Uncle Rudi* (CR 85; fig. 5.9) and *Horst with Dog* (*Horst mit Hund*; CR 94; fig. 5.10). Neither portrait attempts

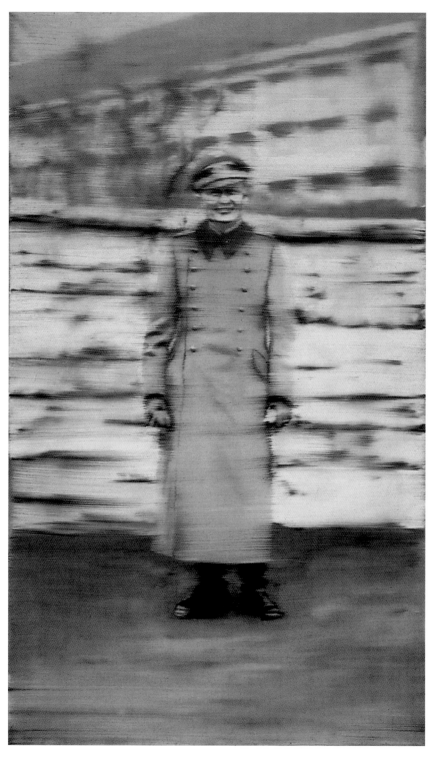

FIG. 5.9. *Uncle Rudi (Onkel Rudi)*, 1965. OIL ON CANVAS. 87 X 50 CM. CR 85.

FIG. 5.10. *Horst with Dog (Horst mit Hund)*, 1965. OIL ON CANVAS. 80 X 60 CM. CR 94.

to revise his youthful impressions; rather they confirm how he had seen these two men throughout his life. Rudolf Schönfelder, Richter's uncle, stands proudly for a photo in his elegant Wehrmacht officer's uniform. He smiles and poses forthrightly for the camera—a soldier full of cocky good cheer, a "young and very stupid" man, according to Richter, who would be killed in the first days of the war.[14]

Horst, having survived, appears here as an older man—plump, balding, hair sticking out wildly from both sides of his head. A towel is wrapped like a scarf around his neck, and he holds a woman's hat and a dog under his left arm. In contrast to strapping, vertical Uncle Rudi, Horst sits slumped, in a somewhat feminized posture. Richter recalls taking the photograph for the painting during his sister's wedding reception in 1959 and says that Horst was drunk at the time. The painting clearly depicts his alienation from his father. "With that ridiculous Spitz, the lady's hat, and the clownlike hair, I painted him as a pathetic figure—it fills me with pity today more than ever," commented Richter after seeing the work for the first time in more than thirty years in 2002 at his New York retrospective. There was, in hindsight, a surprising explanation for this distance: Shortly before the New York show, Richter learned by means of a genetic test that Horst Richter was not in fact his biological father, confirming a suspicion he had harbored since childhood and that had been fueled by his mother's insinuations. In addition to helping him understand his own emotional distance from Horst, it helped explain his mother's behavior.

In 2000 Richter painted a portrait of his young son Moritz (born in 1995) in three variations (*Moritz*; CR 863/1–3; fig. 5.11). In conversation with Julian Heynen and Benjamin Buchloh, he stated that the paintings could also be read as self-portraits.[15] The remark, which Heynen took as a joke, resonates with Richter's search for a meaningful identity in relation to his children. He recognizes himself in the portraits of his son (as he pointedly did not in the painting of Horst), making them significant markers of the process of his own personal growth.

As a young artist, Richter was not about to reveal how troubling much of this material was for him. So he painted his subjects in a way that made it nearly impossible to reconstruct their personal context; in almost all of them the viewer's attention is drawn to the mass-media motif while Richter works unnoticed through deeply felt private experiences. Nonetheless, he was grappling with the models of masculinity embodied by his uncle and his father, and the conflicting values they implied: to stand out and be counted was to risk annihilation like Rudi; to cower like Horst was to survive. To stand and smile? To crouch and hide? Both ways were cursed. In his notes from 1964–1965 Richter expressed the wish to disappear into the apolitical masses and not to distinguish himself: "I want to be like everyone else, think what everyone else thinks, do what is being done. . . . I don't want to be a personality or to have an ideology. I see no sense in doing anything different."[16] To be or not to be run-of-the-mill, part of the herd—that was the question.

Richter was simultaneously drawn to and repelled by bourgeois domesticity.

FIG. 5.11. *Moritz*, 2000. OIL ON CANVAS. 62 × 52 CM. CR 863/2.

FIG. 5.12. EXHIBITION POSTER FOR "DÜSSELDORFER SZENE," KUNSTMUSEUM, LUCERNE, 1969.
BLINKY PALERMO AND RICHTER, IN SUITS AND TIES, ARE THIRD AND FOURTH FROM THE LEFT.

In the science-fiction parody he wrote with Sigmar Polke, he meditated on the problem of becoming average, especially as an artist: "I am averagely healthy, averagely tall (172 cm), averagely good looking. I mention this, because that is how one has to look to paint good paintings."[17] These tongue-in-cheek musings signal an adolescent still in the process of individuation. Without a satisfactory role model, it took years after the birth of his first daughter for Richter to come to terms with adulthood and begin to work out how fatherhood could be an admirable state.

Despite his general ambivalence, there was one bourgeois virtue that the artist

took unequivocally to heart, which was to give his work a solid structure, to organize, catalog, and classify it according to a precise system, as evinced in the great care he has lavished on his catalogue raisonné and *Atlas*. In the catalogue raisonné, all the paintings are numbered, listed, and reproduced to scale. Meanwhile, the sources and preparatory drafts of Richter's work, along with other photographic material, are collected and neatly glued to large sheets of cardboard in the *Atlas*, a work in progress that has grown to more than 780 panels. For Richter's "gray paintings" (to be discussed later) there exists a separate unpublished list, which includes for each painting not only a number and to-scale reproduction but the technical details of the paints used. For a while Richter also compiled annual lists relating the works produced that year according to their formats, which he used to evaluate (and demonstrate) his annual productivity.

This need for order carries over to the artist's home and studio. When *New York Times* critic Michael Kimmelman visited Richter's studio in 2001, he was surprised and impressed by the extent of the discipline he saw there, ascribing to Richter an obsessive desire to control his surroundings. "Not a sheet of paper is on the secretary's black modular desk. Every roll of tape is kept in color-coded order on designated hooks in the workshop. Brushes are stacked in drawers Richter custom-designed on rolling shelves. After leaving a half-full coffee cup in the smaller studio one morning, I returned a short while later to find it gone and the desk wiped clean, although I never saw anybody enter or leave the room. When your works sell for millions of dollars, as Richter's do at auction, you can indulge yourself if you are an obsessive-compulsive. Richter's life, like his work, depends upon absolute control, and there is something both elegant and alarming about that condition."[18] Richter has a more practical explanation for his love of order. It makes day-to-day living easier.

Günther Uecker remembers Richter as "always totally bourgeois; he soon even bought himself a house. With his methodicism he was always putting everything in order. For me, he was a fascinating personality." Helga Meister described him in 1979 as having the manner of a "polite, knowledgeable customer service representative."[19] Just look at the exhibition poster for "Düsseldorfer Szene" at the Kunstmuseum in Lucerne (1969; fig. 5.12). Of the ten artists who participated—Joseph Beuys, Polke, Klaus Rinke, Jörg Immendorf, and Imi Knoebel, among them—only two are dressed in suit and tie: Richter and his then best friend, Blinky Palermo.

HOMMAGE À LIDICE

In 1967 Richter sent the portrait of Uncle Rudi to René Block in Berlin. Ever the progressive, Block was preparing an exhibition to commemorate the twenty-fifth anniversary of the massacre carried out in Lidice during the Nazi occupation of Czechoslovakia. Block was answering the call of Barnett Stross, a member of the

British parliament, who had taken up the rebuilding of the town as a major cause. Through the project "Lidice Shall Live," Stross urged artists around the world to contribute works to a collection that would honor the memory of the victims and provide support for free expression. Block took it upon himself to stage a show of socially conscious work by contemporary German artists. "Hommage à Lidice" ran from October 3 to November 15, 1967, and included works by twenty-one artists. Everybody Block approached agreed to participate, including Beuys, Konrad Lueg, Palermo, Uecker, Dieter Roth, and Wolf Vostell.

"One felt compelled to [donate] and also a bit proud," Richter recalls. *Uncle Rudi* seemed "the most suitable painting, and it pleased me that I had something appropriate and the others did not." The donated artworks ran the gamut from a colorful pillow by Gotthard Graubner to Bernhard Höke's *Anti-Nazi Spray*. Richter's small painting was without question the most powerful work in the show. The portrait of his ostensible role model wearing a Nazi uniform—the uniform worn by the perpetrators of the Lidice massacre—drew out hot-button issues of German collective responsibility and individual guilt. That the Wehrmacht officer in the painting had been the artist's uncle was a tacit acknowledgment that accountability now lay with his own generation of Germans, who had been children during the war.

"The exhibition is small but multifaceted. Surrounded by these lesser and greater attractions, however, it is important not to forget [the exhibition's] primary purpose, an 'Hommage à Lidice,'" reported the conservative newspaper *Die Welt*.[20] *Uncle Rudi*, described in the article as a "painted photograph," received only brief mention. The painting had been exhibited once previously, at Galerie h in Hannover, but through inclusion in "Hommage à Lidice," it gathered an explosive charge that has never left it. From Berlin, the show traveled to the Spála-Galerie in Prague, after which the twenty-one works were supposed to be donated to Lidice. But, alas, the exhibition ended prematurely when Soviet troops invaded Prague on August 20, 1968, to suppress the relatively liberal social policies enacted by the Czech government during a period known as the Prague Spring. In the ensuing conflict, more than two hundred people were killed and the twenty-one artworks disappeared; it was not until 1996 that they were found. Today *Uncle Rudi* and other works from the show are part of the Lidice Collection, based in the National Gallery in Prague.

CURTAINS, TUBES, DOORS, WINDOWS

By the mid-1960s Richter was losing the impetus to paint photo-paintings. As the medium's death knell continued to clang, he felt constantly pressured to discover new ways to extend painting's agenda. In some of his experiments of the period he seems clearly to be seeking an exit strategy. In 1964 and 1965, for example, he

devised a series of "curtain paintings," which constitute an ingenious respite from the photo-based work. The first of the curtains, small and sketchlike (CR 36a, 48/5, 48/14–16, 58), were followed by four large ones, approximately two meters wide (CR 54–57). Although the curtains exhibit a photolike illusionism and are rendered in the continuous gray scale of black-and-white photography, they were Richter's first works in several years to be created without a direct photographic prototype. (The idea came from the curtains in the six photo booth panels of *Portrait Schmela*, 1964.[21]) In 1972 Richter would remark that, during the 1960s, he had been less concerned with painting photographs than with using the methods of painting to produce actual photos.[22] In any case, "At some point, it no longer satisfied me to paint photographs; I took the stylistic devices of photos—the accuracy, lack of focus, illusion-like quality—and used them to make doors, curtains, and tubes."[23] The curtains, possibly more than anything else in this period, embodied this particular inflection of Richter's more standard approach to painting. Because the curtains lacked photographic models, he thought they would be immune to the gathering discourse that strove not to evaluate photography as an artistic practice but rather to critique painting in opposition to the younger medium.

With *Nude Descending a Staircase*, Marcel Duchamp had been less interested in depicting motion than in presenting the *idea* of motion. Similarly, Richter's paintings suggest the idea of a curtain more than they illustrate the thing. In all of the images the viewer's perception flickers between the recognition of an objective depiction and the optical effect of alternating light and dark. Richter considers the most successful to be *Large Curtain* (*Großer Vorhang*; CR 163/1; fig. 5.13), from 1967, because in terms of the succession of light and dark, it is the calmest. Also, the curtain is not delimited by a shadow at its bottom edge, giving it the most abstract appearance and offering a seamless transition to the *Corrugated Iron* (*Wellblech*, 1967, 1968; CR 161, 162, 193) paintings. The flickering effect of the curtains did, however, mean that viewers were inclined to read them as Op art, an association Richter disliked so much that he quickly abandoned the project, something he came to regret: "If I hadn't been surrounded by such poor examples then [meaning Op art], I would have spent more time on it. With a bit more patience, it might have amounted to something."

Large Curtain is bracketed in Richter's catalogue raisonné by two multipart corrugated iron paintings (CR 161, 162) and *Tubes* (CR 163/2), all from 1967. Two separate paintings titled *5 Doors* (*5 Türen*; CR 158, 159), also from 1967, further elaborate the curtain project. Though suggestive of photography, they too were painted from sketches. In CR 158 each door, reading left to right, opens a bit wider than the one before it, as in a film sequence.

When asked years later which of his paintings he would rather not see displayed in public, Richter said without hesitation, "Those *5 Doors*."[24] To this day, he calls the door paintings "tacky and stupid." He has, however, become resigned to the window paintings. The first, started in 1968, is titled *Passage* (*Durchgang*;

FIG. 5.13. *Large Curtain (Gro ßer Vorhang)*, 1967. OIL ON CANVAS. 200 X 280 CM. CR 163/1.

CR 203) and produces the illusion of a double frame through which the viewer's gaze falls onto an empty space marked only by light and shadow. Richter was not pleased with the result, which he deemed a bit "surrealistic." Even so he put it in an important exhibition, his first in an American museum. The 1969 show "Nine Young Artists" at the Guggenheim Museum in New York also included work by Dan Christensen, Barry Flanagan, Bruce Nauman, Richard Serra, James Seawright, John Walker, Peter Young, and Gilberto Zorio.[25] To his surprise, Richter received an award for *Passage*, which was purchased by the Theodoran Foundation for the museum's collection.

Around this time Richter also produced some paintings titled *Window* and *Shadow* (*Fenster*, CR 204, 205, 207; *Schattenbilder*, CR 209/1–9)—deceptive images in which bright frames and dividing bars in the foreground appear to cast shadows onto a back wall. Of these, he says, "I felt a bit like a cheater." The door, window, and shadow paintings, in their dual emphasis on "accuracy" and "illusion," poke fun both at the new regime of photography and at the supposed deficiencies of the medium in which they are rendered.[26] The same holds for *4 Panes of Glass*, which Richter once summarized as "See everything, understand nothing."[27] "The Doors, Curtains, Surface Pictures, Panes of Glass, etc. are metaphors of despair, prompted by the dilemma [caused by] our sense of sight, [which allows us to perceive things] but at the same time . . . restricts and partly precludes our apprehension of reality."[28]

CREAMCHEESE

On July 20, 1967—the twenty-third anniversary of the attempt to assassinate Hitler and the third of the Fluxus event that earned Beuys a bloody nose—Uecker, poet Ferdinand Kriwet, and the filmmaker Lutz Mommartz opened a bar in the old center of Düsseldorf at Neubrückstraße 12. They named it Creamcheese, after a song by Frank Zappa.[29]

Creamcheese was an artist's hangout. Famous for its decorations, it sported an aluminum bar fabricated by Heinz Mack as well as Uecker's kinetic *Electric Garden* and *Wind Machine*, which he went on to show at Documenta 4. Daniel Spoerri displayed two of his well-known "trap pictures," and Lueg contributed a "shadow wall" that used flashes of light to capture the shadows of guests on a wall sensitized with fluorescent paint. Dusting off his skills as a muralist, Richter painted a large, reclining half nude in gray on the wall behind the bar. Today the mural features prominently in a partial reconstruction of the bar's interior installed in the Museum Kunst Palast, one of Düsseldorf's most venerable art museums. Richter is not particularly pleased that something he slapped together for a saloon has ended up in a museum. "It was one of those things—I put no heart into it, just joined in out of high spirits and carelessness."

At the bar's grand opening Uecker, Lueg, Kriwet, and Gerd Hübinger read aloud a "Creamcheese Manifesto" composed by Uecker. There were other readings too, and Uecker hammered nails into a television set. Over the next six weeks guests were treated to a panoply of art happenings and dance. For Uecker and Kriwet the bar was the next logical step in an effort to locate serious art at a remove from the cloistered domain of museums and galleries, putting it into spaces frequented by ordinary people. Richter was never active in the Creamcheese program, but he frequented the bar, partly because his contribution to the décor allowed him to drink for free and partly because his friend Blinky Palermo worked there as a bartender.

COLOR CHARTS

One day in 1966, having completed the poignant and colorful *Ema (Nude on a Staircase),* but still shadowboxing with Duchamp, Richter walked into the Düsseldorf paint store Sonnenherzog, where he normally bought his supplies. He had passed the racks of color charts dozens of times, but this time they caught his eye—all those colors scientifically formulated and organized to capture the full chromatic spectrum. The charts had no message, no agenda; but they were vivid, and they instantly inspired him.

Thus the artist created, in a major departure from the photo-paintings, a brace

FIG. 5.14. RICHTER IN HIS STUDIO, 1966.

FIG. 5.15. *192 Colors (192 Farben)*, 1966. OIL ON CANVAS. 200 X 150 CM. CR 136.

of paintings he termed "color charts" (CR 135–144), each a grid of colored squares or rectangles separated by white lines (fig. 5.14). One of the earliest, *192 Colors* (*192 Farben*, 1966; CR 136; fig. 5.15), he painted in oil, but this gave the chart a quality he wished to avoid. He wanted the paintings to be unartistic, aesthetically neutral, so he turned instead to an industrial synthetic polymer paint. The paint application too is neutral, without visible brushstrokes, and the rigid design prevents any section from dominating the composition. The choice and distribution of colors are the only subjective variables.

The color charts would lead Richter along a new path that within a few paces would integrate nonobjectivity with abstraction and build on his burgeoning interest in color. Replacing the soft grays and blurred borders are strong colors uncompromised by texture or complexity, laid down frankly, without apology or transition, one next to the other. On one level, the color charts might be read as magnifications of their source—the commercial color chips one finds in paint stores. But Richter has incorporated no index of this medial relationship. While many of the photo-paintings call out their source through fragments of text and other signals, the color charts contain no such cues.[30]

Richter was not aware that other artists, such as François Morellet and Ellsworth Kelly, were also making color charts. His particular approach, he says, came more from American Pop art and the cloth pictures of Blinky Palermo than from hard-edge or color-field painting; the little paint chips he found in the store were banal inspirations, giving his color charts a formal referent. However, more explicitly than the curtain paintings, the color charts are autonomous, nonobjective constructed images. They contain not an iota of expressiveness. Even better, the closed system impedes interpolation by viewers. For the first time ever, Richter felt he had succeeded in making nonobjective work.

He had his doubts, though, initially. The color charts were vastly different from anything else he had tried. It took Lueg's coming to the studio and swearing up and down that the charts were good for Richter to start feeling confident about them. Today, he views them as a "happy stroke of luck."

These experiments—the color charts, curtains, doors, and tubes, along with *4 Panes of Glass*—were meant to respond to the rapidly shifting artistic and social environment in Europe. It was a difficult period that challenged the young painter's progress every inch of the way; equally upsetting was a personal and professional crisis that had been building for several years and now finally reached a head.

KONRAD FISCHER

In 1965 Alfred Schmela unwittingly committed a faux pas that would alter Richter's friendship with Konrad Lueg forever. Schmela had introduced them to fellow dealer Hans-Jürgen Müller, who was visiting Düsseldorf from Stuttgart, saying,

"That is Gerhard Richter, he'll be a great painter some day. And that's Konny; he'll turn out to be the best gallerist, you'll see."

Schmela's assessment touched a nerve in Lueg, but it helped direct him toward what was quickly becoming a foregone conclusion—that he would become a dealer. As Lueg put it, "Completely unconvinced by the work I was doing, I was happy to be able to do something else. One knows when something will endure or not. Some artists notice this, others don't, and I was completely sure."[31] Two years later, with Kasper König as a silent partner, he rented a small passageway between the street and a courtyard at Neubrückstraße 12, closed it off with two gates, and opened a gallery under his real name: Exhibitions at Konrad Fischer's (Austellungen bei Konrad Fischer). In his metamorphosis, he shed the name he had used as a painter. "Better than being a minor artist in Düsseldorf would be to bring great artists here," König recalls his saying.[32]

Exhibitions at Konrad Fischer's opened on October 21, 1967, with a show by the New York artist Carl Andre. Richter had met Andre a few days before the opening and wrote to Heiner Friedrich, "Carl Andre is in Düsseldorf. The opening is on Saturday. Nice person. Exhibition will probably be very good."[33] Andre showed only one work, *5 × 20 Altstadt Rectangle*, comprising square steel plates that nearly covered the floor of the exhibition space.

For his second endeavor Fischer presented work by Hanne Darboven, who, like Andre, lived in New York. By the end of his first year in business he had shown work by Charlotte Posenenske, Sol LeWitt, Blinky Palermo, Reiner Ruthenbeck, Fred Sandback, Richard Artschwager, Bruce Nauman, and Jan Dibbets—but nothing by Richter. "The focus of my exhibition work is minimal, concept, and land art. At first, I only showed sculptures from these movements because I did not like painters very much. I myself was once a painter."[34]

In a very short time the self-described "minor artist in Düsseldorf" had become one of the most influential gallerists in Europe.[35] Andre still raves about him: "He was a genius. Like one of those great Hollywood producers, Konrad knew how to gather the right people and get them what they needed to do their work. He was a tremendous facilitator."[36] In Richter's mind, Konrad's transformation from painter to gallerist seemed perfectly logical and was probably rooted in his identity as an artist. "Fischer viewed his activities as a gallerist as art, too. He never called himself a gallerist. Conceptually the exhibitions were like readymades for him. The exhibition became his art form."

With Fischer now a figure on the international art scene, Richter felt left out and the pair's friendship soured. When they had both been working artists Richter had been the more successful, but now the tables were turned. "Konrad really took advantage of that. He really took his revenge," Richter says. He remembers that at the dinner following Andre's opening, he, Polke, and Palermo were not seated at the artist's table but off to one side. "Carl Andre found out about this and came over to us. I thought it very nice that he demonstrated so openly that he liked us."

That wasn't the only time Richter felt snubbed by Fischer. He also remembers getting the cold shoulder when they were meeting with the New York gallerist Leo Castelli in London. But König, who had known the two of them since 1963, cannot imagine that Fischer ever behaved badly: "I don't believe it, that Konrad [gave the impression] 'Now I am more important.' This is surely a projection that comes from Gerhard Richter, from which he draws strength. Richter can be extremely sensitive."[37] Whatever the case, some three years passed before Richter exhibited in Fischer's gallery. While Richter may well have felt humiliated by Fischer's behavior (or success), this simply fit into a larger sense of uncertainty. By the end of the 1960s, Richter had serious doubts about the value of his entire artistic oeuvre.

The year 1967 was punctuated by the founding of the "extraparliamentary opposition" in Berlin. Student unrest in France had spread to Germany, and protesters carried the subjects of parliamentary debates into the streets. What started as a demonstration for university reform quickly escalated into a general opposition to the war in Vietnam, American imperialism, and the capitalist system, and ultimately into a call for sweeping social reform. Among German students the concerns of the international movement were complicated by the need to confront the older generation of Germans, who had never fully reckoned with their Nazi past. Important decision makers were being elected who seemed to embody a continuity between the Third Reich and the democratic Federal Republic of Germany. In 1966, for instance, Kurt Georg Kiesinger of the Christian Democratic Union was elected federal chancellor despite his onetime membership in the Nazi Party.

In 1967 the legendary Kommune I, Germany's first commune, was founded with the declaration that political freedom and individual freedom were of equal value and could not be separately achieved. The situation intensified in June of that year when the student Benno Ohnesorg was killed during a demonstration in Berlin against the shah of Iran. Then, with the shooting of student leader Rudi Dutschke in 1968, the protests reached a crescendo. While most students opted to try to reform society from the inside out, taking the "long way through the institutions," a small, radical group that came to be known as the Red Army Faction went underground and began an urgent attack on the political and economic system. Thus began a spiral of violence that would climax in the catastrophic events of October 18, 1977, which Richter would explore a decade later in a fifteen-part pictorial cycle (discussed at length in chapter 10).

Many working artists belonged to the same generation as the students and shared their political aims, albeit by different means. Joseph Beuys founded the Deutsche Studentenpartei (German Student Party) in Düsseldorf, and graphic artist Klaus Staeck designed his now-famous poster "German Workers! The SPD [Social Democratic Party] wants to take away your villas in Ticino!" (*Deutsche Arbeiter! Die SPD will Euch Eure Villen im Tessin wegnehmen!*). In Berlin Wolfgang Petrick, Peter Sorge, and Hans-Jürgen Diehl pulled together to work in

the tradition of social realism associated in the 1920s with Otto Dix and George Grosz. Beuys's student Jörg Immendorf titled his paintings with exhortations to his colleagues: in 1966, *Stop Painting (Hört auf zu malen)*, and in 1973, *Where Do You Stand with Your Art, Colleague? (Wo stehst Du mit Deiner Kunst, Kollege)*. The latter work depicts a painter alone in his studio, interrupted by a figure who has stormed through the door to urge him to join a protest march.

"I just went on painting," Richter recalls. "But I clearly remember that this antipainting mood did exist. At the end of the 1960s the art scene underwent its great politicization. Painting was taboo, because it had no 'social relevance' and was therefore a bourgeois thing."[38] Unless painting as a medium and method could be justified through political engagement, a consensus was building that it should be pronounced dead, pure and simple. Fischer's decision to show primarily sculpture and handle only very experimental painting was driven by this charged conceptual milieu; it had little to do with personal taste. But Richter, coming from East Germany, where art was in harness to political ideology, could not and would not let his work be used in that way again.

By and large, the interesting new developments in art during the late 1960s did seem to occur in three dimensions. Minimalists such as Andre reduced their formal vocabulary to elementary geometric structures and industrial materials. The New York conceptual artist Lawrence Weiner dematerialized the object to the point that printed verbal description became its sole physical remnant: one of Weiner's works from a 1969 exhibition at Fischer's gallery consisted of the text "A kilogram of enamel poured onto the floor." Bruce Nauman, who saw medium-based categories of art as irrelevant, turned to intermedial work that drew on disparate materials and techniques. Depending on the requirements of a project, his work would incorporate iron, wax, photographs, neon, video, audiorecordings, or chain-link fencing.

Five years earlier, when no one had been interested in their paintings, Lueg, Polke, and Richter had found solace in what they took to be their own superiority. By the end of the 1960s Richter was no longer cocky. The arrival of Carl Andre, Hanne Darboven, Sol LeWitt, Richard Serra, and Lawrence Weiner on the Düsseldorf scene prompted him to reconsider his own work. ("Maybe I was just admiring something that I can't do—something I'm in no position to do," he told Buchloh two decades later.[39]) Certain shifts in style and method in his paintings in the late 1960s come out of a deliberate confrontation with a minimalist aesthetic. *Two Grays Juxtaposed (Zwei Grau nebeneinander*; CR 143/1), *Two Grays, One upon the Other (Zwei Grau übereinander*; CR 143/2; fig. 5.16), and *Three Grays, One upon the Other (Drei Grau übereinander*; CR 143/3), all from 1966, were informed by minimalism. And *Shadow Picture (Schattenbild*; CR 209/8), painted two years later, was inspired by the grids of the Dutch minimalist Jan Schoonhoven.

Richter may have felt personally eclipsed by the stars of the neo–avant-garde,

FIG. 5.16. *Two Grays, One upon the Other (Zwei Grau übereinander)*, 1966. OIL ON CANVAS. 200 X 130 CM. CR 143/2.

but his work continued to be widely appreciated. He had received the Art Prize of the Young West. His work was featured in numerous exhibitions. *Der Spiegel* published a two-page profile of him in 1968 in connection with a show at Galerie Zwirner in Cologne.[40] A first retrospective followed in 1971 at the Düsseldorfer Kunstverein für die Rheinlande und Westfalen, and in 1972 Richter was Germany's sole representative at the Venice Biennale and took part in his first Documenta. Plus, a number of significant collectors had begun to acquire Richter's paintings in earnest, including Dieter Kreutz in Mühlheim am Ruhr, Ernst Plath and Manfred Wende in Münster, and Ludger Schäfer in Düsseldorf. Reinhard Onnasch, a collector and later a gallerist in Berlin, and the chocolate manufacturer Peter Ludwig, from Aachen, also were serious buyers.[41]

14 × 14

In April 1968 Richter and Günther Uecker joined forces for a show at the Staatliche Kunsthalle in the spa town of Baden-Baden. They had been invited to participate in a project called "14 × 14," the inaugural effort of the art museum's new director, Klaus Gallwitz. The program featured seven double exhibitions, a new pair every fourteen days.[42]

Uecker had expressly asked to exhibit alongside Richter, and together they staged their "Life in a Museum" (*Leben im Museum*). The two artists moved their studios into the museum, where they worked in the public eye. Visitors were allowed to watch as the exhibit was being installed. "The worlds of our lives and work were put on display; we were public," Uecker wrote. "Fantastic ideas were staged; and in this way it was possible to give the visitors a view into the world, the production, the life of the artist."[43] The two artists played at being artists in a series of actions that ranged from artful to anarchistic. Throughout the event Richter's wardrobe, consisting of shirt and slacks, sport coat, and bathrobe, gave him a decidedly bourgeois appearance.[44] Uecker, meanwhile, went around all day in striped pajamas, busy with various activities, including the symbolic storming of the museum using an oversize nail as a ramrod. In front of some mountains freshly painted by Richter, the two artists set off on a "flight over the Alps" (*Alpenflug*). Wrapped in tubes and holding a huge balloon—Uecker also wore a gas mask— they jumped from a console in the large exhibition room. In another display, they wrapped themselves in the balloon so that it looked like a gigantic growth on their legs (fig. 5.17). Eventually they took their artists' lives into the streets: Uecker dragged his giant nail around the city center for days, into cafés and stores, while Richter cowered like a beggar and offered passersby cheap reproductions of his new paintings. Documenting everything with a camera was Uecker's studio assistant, Peter Dibke, who would eventually work for Richter, too.

After the opening, the local newspaper, the *Badische Tagblatt*, reported to the

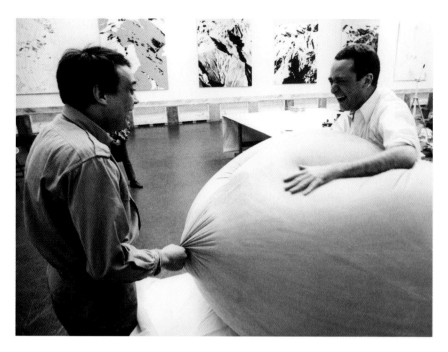

citizens of tranquil Baden-Baden: "The exhibition '14 × 14' got underway in the Staatlichen Kunsthalle with a bang, with a fortissimo of noise and spectacle and swarms of people.... As if they knew about it beforehand, young people streamed into the Kunsthalle, an unusual public there . . . while the serious Baden-Baden visitors, except for a few, were remarkable for their absence."[45] In the elegant city, with its noble villas and posh casino, the project must have been viewed by the citizens—insofar as they were aware of it—as nothing less than an affront.

That same year Richter received a major commission from the Siemens Corporation for a large painting to grace its Milan offices. At 275 by 290 centimeters it was to be the largest canvas Richter had painted to date. To alleviate the psychological pressure of producing such a monumental work, Richter primed two canvases so that he could paint knowing he could start over if he had to.

Siemens had asked for a typical photo-painting, and at first Richter balked. He set to work instead on a colossal townscape, using broad, impasto brushstrokes, merging the out-of-focus image with the inexactness of great surfaces of color summarily applied in an experimental mode. He was using the same painterly approach he had used in *Olympia*, but at such a large scale the experiment failed. He was so dissatisfied with the great glop of canvas that he cut it up into nine smaller pieces (*Townscape M 1–9* [*Stadtbild M 1–9*]; CR 170/1–9). Thus segmented and reduced in scope, the city motif became more abstract as well as more intense.

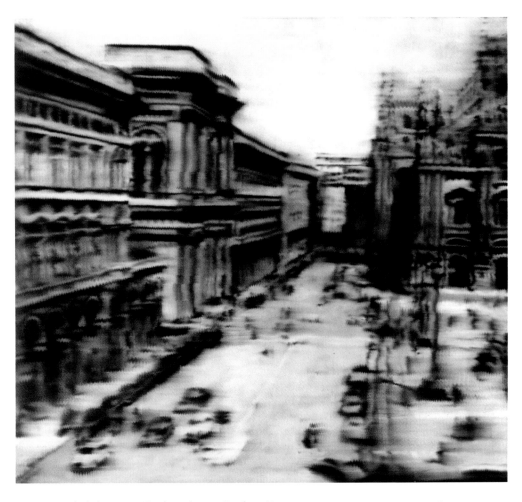

FIG. 5.18. *Cathedral Square, Milan (Domplatz, Mailand)*, 1968. OIL ON CANVAS. 275 × 290 CM. CR 169.

(One fragment [*Townscape M 8*] could not be salvaged so Richter overpainted it in monochrome gray.) Only after that did he move on to the second giant canvas and paint *Cathedral Square Milan* (*Domplatz Mailand*; CR 169; fig. 5.18), this time working in his familiar photo-painting vein. "Sometimes I've enjoyed doing commissioned work, in order to discover something that I wouldn't have found of my own accord. And so, when Siemens commissioned my first townscape, that led to all the townscapes that followed," Richter said in 1993. "It's also very nice when pictures [find a permanent home]."[46] *Cathedral Square Milan*, however, had not yet found such a home. In 1998 the painting would be sold at Sotheby's in London for two million pounds; since then it has been in the collection of the Park Hyatt Hotel in Chicago.

The failure of *Townscape M* left Richter even more determined to paint an experimental series of large townscapes. He wanted to convey the blocklike appearance of postwar urban architecture, using a structure of roughly applied hard gray and black paint. Most of the aerial photos on which he based the paintings came from architecture books. Each shows a distanced, oblique view of a network of streets running through a sea of houses. The impasto strokes in contrasting gray and black transform the play of light and shadow—the house fronts and the dark canals of the streets—into a moving painterly rhythm. Details are purposefully ignored. By using abbreviations as titles, Richter obscures the identity of the city; what interests him is not a distinct location but the sameness.[47] Even when a city is specified, as in *Townscape Paris* (*Stadtbild Paris*, 1968; CR 175; fig. 5.19), it is nearly impossible to recognize. These mostly large works (about two meters square) play with the interaction between their recognizable character as city views and the autonomy of the rough brushstrokes. Though Richter has applied the paint with heightened impasto, his brushstroke is nonetheless unexpressive, betraying not a hint of emotion. In the handout he produced for the exhibition in Baden-Baden, he described his intention in the cityscapes and in the mountain paintings that followed, as a "rejection of interesting content and illusionist painting. A spot of paint should remain a spot of paint, and the motif should not project meaning or allow any interpretation."[48] These cityscapes represent yet a further attempt by Richter to free himself from the bondage of photo-painting, his primary project between 1963 and 1967. To do this he needed to establish a new conception of the image and adjust his sense of form and gesture, all while avoiding subjective expression.

In a series of small nonobjective paintings made in 1968, Richter managed to take things a step further. These modest gray panels speculate on painting in a way that is at once free of models and objective associations and devoid of emotion.[49] They examine morphological structures of paint ranging from an elaborate Informel treatment of "line" (CR 194/9; fig. 5.20a) to grids (CR 194/5; fig. 5.20b) to faint streaks of color (CR 194/8; fig. 5.20c). Much of what Richter would later pursue in large-format series is already anticipated in these sketches, including experiments with the synchrony of gesture and motif (CR 194/22–23; figs. 5.20d–e).

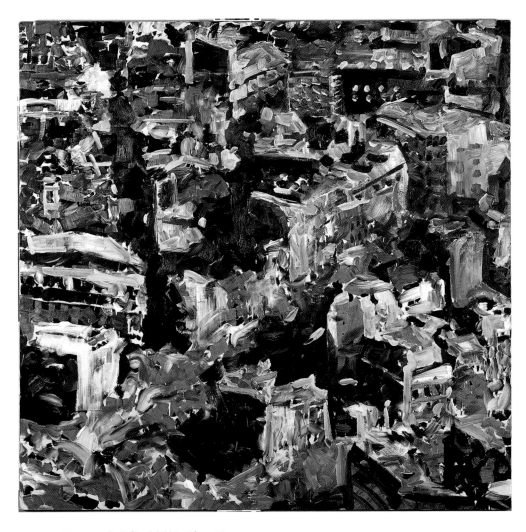

FIG. 5.19. *Townscape Paris (Stadtbild Paris)*, 1968. OIL ON CANVAS. 200 X 200 CM. CR 175.

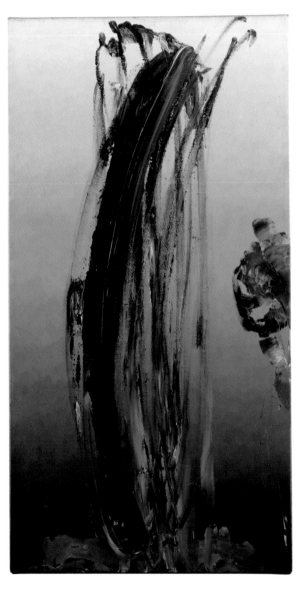

FIG. 5.20A. *Untitled*, 1968. OIL ON CANVAS.
80 X 40 CM. CR 194/9.

FIG. 5.20B. *Grid Streaks (Gitterschlieren)*, 1968.
OIL ON CANVAS. 65 × 50 CM. CR 194/5.

FIG. 5.20C. *Colored Grey (Bunt auf Grau)*, 1968. OIL ON CANVAS.
50 × 50 CM. CR 194/8.

FIG. 5.20D. *Untitled (Green) (Ohne Titel [grün])*, 1968. OIL ON CANVAS. 40 X 50 CM. CR 194/22.

FIG. 5.20E. *Seascape (Seestück)*, 1968. OIL ON CANVAS. 40 X 80 CM. CR 194/23.

For years Richter vehemently denied the suggestion that he had a private attachment to any of the subjects and themes of his photo-painting. Over time, as we have seen, his position has changed to the point that he now readily admits that feelings and memories have always had their place in his work, in the choice of motifs as well as in certain technical experiments such as the failed *Townscape M*. As Richter was working on that canvas, he later acknowledged, the fusion of motif and impasto reminded him of certain images of the firebombing of Dresden, his birthplace.[50]

At the time of the Allied bombing, Richter, still a boy, was safe in Waltersdorf, seventy-five kilometers away. Yet even from that distance, he took in the sounds and sight of fire lighting up the night and dark gray smoke billowing throughout the day. His maternal grandmother was still living in Dresden during the raid, and the anxiety over her safety remains a vivid memory even today, as does the image of an inner city still in ruin six years later when Richter entered the Dresden academy.

The artist found himself confronting these memories as he painted *Townscape M 1–9*. In the four works that quickly followed—*Townscape Paris* (*Stadtbild Paris*; CR 175) and *Townscape F* (*Stadtbild F*; CR 177/1–3)—the engagement intensified, the impression of demolition and destruction strengthened through a brushstroke that was now more open and did not necessarily follow the image projected onto the canvas.

In 1970 the disheartening television images of American carpet bombing in Vietnam once again triggered memories from Richter's youth. This time when he took up the townscape motif, the perspective was not the only thing that had changed. Each of the three canvases titled *Townscape PL* (*Stadtbild PL*; CR 249–251; fig. 5.21) shows an aerial, planar view of a city, which increases the viewer's distance and depersonalizes the impending destruction. "This is then truly modern war, neutral and from above. Other photographs involved searching for subjects, like a photographer seeking to make a city look beautiful, scenic. Now it's so flat, like a photograph made by a machine."

Three decades later, Richter took up the theme again, producing an edition of prints titled *Bridge 14 Feb 45*, based on two versions of an aerial photograph of Cologne taken from an Allied plane during the final weeks of World War II. Even from such a great height bombed-out targets and dark clouds of smoke from antiaircraft fire are recognizable. (February 14, 1945, is, importantly, the date of an attack on Dresden, not on Cologne.) Not coincidentally, the only locale in the photograph that can be identified with any certainty is the area immediately adjacent to Richter's current home and studio. The small printed sheet thus encompasses a personal history of fifty-five years, linking the artist in his present life with his destroyed past in Dresden.

Richter had first explored the theme of aerial warfare in 1963 and 1964. It derives, he has acknowledged, from a mix of naïve fascination and existential

FIG. 5.21. *Townscape PL (Stadtbild PL)*, 1970. OIL ON CANVAS. 200 X 200 CM. CR 249.

fear.[51] *Bombers* (CR 13), for example, shows a contingent of U.S. B-17s—"Flying Fortresses"—dropping their payloads.[52] Related paintings depict German dive bombers (*Stukas*), American fighters (*Mustang Squadron* [*Mustang-Staffel*], 1964; CR 19), and several other types of aircraft. Richter also depicted Russian planes, and with considerable accuracy. Near the end of the war, he had watched as Russian planes fired on German refugees passing by Waltersdorf as they tried to make their escape to the West; he retains the indelible image of the fighter planes flying in attack formation. By the end of the war, he had just turned thirteen, and like other boys of that age he was typically enthralled with weapons and soldiering. Looking up at the sky, he could identify any aircraft passing overhead and rattle off its attributes. With the paintings of bombers and fighters, Richter sought to recapture that elementary pleasure and terror of childhood.

6 STYLISTIC RUPTURE AS STYLISTIC PRINCIPLE

Richter's first solo exhibition in a public institution took place in Aachen from March 27 to April 22, 1969. Sponsored by the Art Association Gegenverkehr, the show was of particular importance to Richter not just because it was the largest display to date of his work but also because it was accompanied by a catalog with 122 small illustrations documenting his range. Thus it offered a corrective to the public perception that he was simply the painter who made those gray photo-based pictures.

The exhibition's curator, Klaus Honnef, opted to hang the work without regard for chronology, style, or method, thereby assigning equal value to everything, including the new, more experimental work. Among the paintings shown were *Table*, *Corrugated Iron* (CR 161), *Flemish Crown*, *192 Colors*, *Corsica (Fire)* (*Korsika [Feuer]*, 1969; CR 212), *Easter Nudes* (*Osterakte*, 1967; CR 148), *Stag*, *Colored Gray* (*Bunt auf Grau*, 1968; CR 194/8), *Helga Matura*, and the enormous five-part *Alps* (*Alpen*, 1968; CR 189), now in the Museum Moderner Kunst in Frankfurt am Main.

The choice of work and its presentation distressed dealer Rudolf Zwirner, who had recently sold several of Richter's canvases to Peter Ludwig, a prominent collector who lived in Aachen.[1] He predicted that after seeing such blatant incongruity Ludwig would never buy another painting by Richter. (He was wrong.)

For Richter this was nothing new. He had already adopted a pose of indifference to conventional matters of subject and style. Later he would tone it down, but he always defended his early stance, emphasizing that it had freed him to

explore radically different approaches to making art. Indeed, he and Honnef made this the overriding message of the Aachen show. In the catalog Honnef pronounced Richter's primary stylistic principle to be one of perpetual "stylistic rupture," a pithy formula immediately taken up by the critics.[2] Some used it to explore the range of Richter's technical virtuosity, admiring the ease with which he could shift from style to style. Curator Manfred Schneckenburger described Richter (in 1975) as a conceptual painter who "does not paint with broad gestures when he paints gestural paintings nor abstractly when he paints abstract paintings, nor monochromatically when he paints monochromatic paintings, nor expressionistically when he paints expressionistic paintings, just as he does not compose when he paints a photo of a family positioned hierarchically. He uses artistic styles as patterns, just as he uses photos as models, to explore the process of painting."[3] A decade later, Jürgen Harten wrote that Richter's fundamental indifference to style could be tracked back to the dialectic of Pop montage: "His initial use of pictorial citations increasingly gave way to a concern for the 'picture' of what is represented."[4]

Not everybody has been enamored of Richter's so-called commitment to stylistic diversity. *Der Spiegel* called his body of work so inchoate that it was no longer possible to identify the hand of just one artist: "When Richter represented Germany on his own at the Venice Biennale in 1972, the show was so diverse that it appeared as though at least three artists had been in the mix."[5] A writer for *Der Stern* even purported to have seen a half dozen different artists at work in Richter's studio.[6] However, Petra Kipphoff, reporting on Richter's Bonn retrospective in 1993, took a more studied approach:

> If one were to separate the styles from one another, a single Richter exhibition could yield five different exhibitions. Yet one would have to admit at the same time that a picture by Richter is always identifiable, whether it is a gray monochrome or a colored landscape or an abstraction.[7]

In 1991 Richter stressed not only the continuity of content in his work—irrespective of stylistic rupture—but also what might be termed, if you will, a perpetrator's fingerprint:

> I do perceive an unchangeable basic attitude, a constant concern that runs through all my works like a style. That's why it's quite easy to identify my pictures, however different they are externally; they're often easier to recognize . . . as "Richters" than pictures by any other painter. And that's why it's really wrong to talk about frequent changes of style in my work. You wear different suits on different occasions: that has nothing to do with style.[8]

Richter's fundamental artistic maneuver has always been the same. He addresses

modern and conceptual objections to painting by absorbing into the medium the very terms of its rejection. As a result, different strategic paths open up that allow him to continue painting even after the "end of painting." In the early gray photo-paintings, the source photographs took on something of the conceptual quality of readymades. In that Richter depicts the medium itself—newspapers, magazines, or photographs—the figural subject appears, on the surface at least, to have only a secondary importance. Instead of apprehending a folding dryer in *Folding Dryer*, we see first and foremost an advertisement clipped from a newspaper. Instead of a vacationing family in *Family at the Seaside*, Richter gives us the original snapshot. And instead of a geometric abstraction, he depicts common color charts, the kind found in any paint supply store.

What Richter effected, then, in the 1960s was a transfer of the characteristics and qualities of the photograph to painting. He essentially shut the door on the history of painting, choosing instead to engage with that of photography. By establishing a familial resemblance to the pictorialism of the late nineteenth century, he oriented himself toward a kind of photography that itself attempted to imitate the contemporary style of impressionist painting, gaining him the advantages of photography while sustaining the qualities of painting. Even later, when his romanticized landscapes, floral still lifes, and portraits brought him back into conversation with painting's art-historical tradition, the paintings' photographic status remained fully evident.

When Richter now says that he regrets never fully developing the curtain and window series, it is not out of fondness for the subject matter, which pushed him uncomfortably close to art movements he eschewed, but because of their near-photographic quality. Having not been rooted in actual photographs, the curtains and windows offer convincing evidence that a kind of painting is possible that can by itself *be* photography:

> If I disregard the assumption that a photograph is a piece of paper exposed to light, then I am practicing photography by other means. . . . Seen in this way, those of my paintings that have no photographic source (the abstracts, etc.) are also photographs.[9]

Even in the nonobjective (or nonrepresentational) works, Richter succeeds in extending the project of painting precisely because he questions the qualities traditionally connected to the medium. The result is antiexpressive painting free of representation or composition, foreclosing, more or less successfully, narrative or metaphorical interpretation. Richter's first attempts in this direction were two groups of small-format paintings from 1967–1968 (CR 194/1–5, mentioned briefly in chapter 5) and from 1969 (CR 224/11–16, 225/1–7). These works also rehearse the act of spontaneous invention that would soon become key to his nonrepresentational, abstract work.

DOCUMENTATION AS CONCEPTUAL ART

Toward the end of the 1960s, Richter tried to respond to the challenges of the minimalist and conceptual art he so admired. Carl Andre, Hanne Darboven, and Lawrence Weiner all exhibited with Konrad Fischer between 1967 and 1969, and it was in this period that Richter conceived of presenting and publicizing his paintings in a new way, by establishing a second-order level of representation. In 1969, for the catalog of the Aachen show, he arranged his documentary illustrations chronologically. That same year, he began to devise the *Atlas* and the first version of the catalogue raisonné, introducing the numbering system that he still uses today. Not every artwork is included. Richter was particularly selective when it came to the early work of 1962 and 1963, accepting only thirteen pictures from those years. The catalogue raisonné is thus conceived not as an exhaustive record of everything he has painted but as a corpus of works established by the artist himself. (Its precursor was a more inclusive list compiled and typed by the artist, which can also serve to authenticate works Richter formally accepts as his own.)

Richter published the first edition of the catalogue raisonné as offset lithographs in a limited run of 100, with each page signed, dated, and numbered by the artist, in effect elevating the very listing of his paintings to the status of an artwork. Its compilation and printing have thus become an important project both within and defining his artistic oeuvre. Updated versions have appeared in conjunction with major exhibitions: In his catalog for the 1972 Venice Biennale, Richter supplemented the catalogue raisonné with a "Painting Overview"—small reproductions grouped by the artist into portraits, nudes, city views, clouds, and landscapes. A 1993 edition, the third volume of the compendious catalog produced for a retrospective that traveled to Paris, Bonn, Stockholm, and Madrid, reproduced, in a fixed proportion (1:50) all of the accepted paintings up to CR 794/3 (1993). Another version, complete through 2004, was part of the catalog for Richter's 2005 retrospective in Düsseldorf.

CORSICA

In 1968 Richter could finally afford to take his family on a proper vacation, so he, Ema, and Betty went off to spend two weeks on the Mediterranean island of Corsica. While there, he took roll after roll of photographs of the island's mountains and coastal beaches. Then, back in his studio, he decided to paint five canvases from the images, three of which he completed that year: *Corsica* (*Korsika*; CR 199; fig. 6.1), *Corsica (Sun)* (*Korsika [Sonne]*; CR 200), and *Corsica (Ship)* (*Korsika [Schiff]*). (All measure 86 by 91 centimeters.) *Corsica (House)* (*Korsika [Haus]*; CR 211) and *Corsica (Fire)* (*Korsika [Feuer]*; CR 212) followed in early 1969.

The Corsica paintings possess all the characteristics of Richter's subsequent

FIG. 6.1. *Corsica (Korsika)*, 1968. OIL ON CANVAS. 86 × 91 CM. CR 199.

landscapes, including a distanced view that extends over a wide-open landscape to the horizon. Typically, the horizon is low so that the sky, often dramatically cloudy, dominates the picture. Nearly all of the landscapes are in color, with the edges between different chromatic grounds feathered away to achieve an effect of extreme subtlety and softness. Details of the ostensible scene elude the viewer, who, in trying to break through the photographic illusion, encounters a perceptual impasse: the subject surrenders its illusionism as a scene to be transformed again into painting.

Up to this point, Richter had transferred the characteristics of black-and-white photography into his painting; now, in his landscapes, he began to work in shades of violet and brown. It is no coincidence that in the politically fraught year of 1968 the landscape motif almost immediately became established as a discrete theme for the artist. The landscapes were atmospheric and removed from the politicized art that surrounded him. In making them, Richter staged a retreat into the private idyll he had always imagined and coveted. Asked in 1970 what had moved him to produce them, Richter replied provocatively, "I felt like painting something beautiful."[10]

But for Richter, the retreat was less a reaction to the political instrumentalization of painting than to American minimal and conceptual art. "The paintings were definitely not against minimal art, but more something like resignation"—a withdrawal from the pursuit of avant-gardism. "I had no business being in that area anyway. So I do what's fun for me, and I'm an old fogy who paints romantic atmospheres and I no longer fit in."

Initially Richter viewed the landscapes as private, something he was making for himself, without any direction-setting artistic agenda. Of course, paintings by important artists eventually enter the public sphere, where they are exhibited, judged, and made the objects of critical discourse. But this business of reassuring himself that success or failure doesn't matter has, time and again, helped Richter overcome his anxiety about trying something different. In 1973 it permitted him to paint the *Annunciation after Titian* (*Verkündigung nach Tizian*; CR 343/1–2, 344/1–3) in five variations:

> I returned from the Biennale in Venice, having seen the painting in the Scuola di San Rocco and thought, you paint this now for yourself and for your living room. Making such a claim, to paint only for myself, it worked. But the fact that I prepared so many stretchers shows that I didn't want just one painting at all.

Again in 1999, after a long hiatus, it took the same mindset for Richter to resume painting.

He relies on a similar trick of mind whenever he feels uncertain about work he has decided to show, first testing its reception far from the international art centers. For example, he premiered the very personal eight-part series *S. with*

FIG. 6.2. *Landscape near Hubbelrath (Landschaft bei Hubbelrath)*, 1969. OIL ON CANVAS. 100 X 140 CM. CR 221.

Child (*S. mit Kind*; CR 827/1–8) in the remote Carré d'Art–Museé d'art contem-
porain in Nîmes, France, in 1995. Likewise he previewed the controversial cycle
18. Oktober 1977 in the relative seclusion of the Museum Haus Esters in Krefeld.
In both cases, he went into the situation telling himself he could withdraw the
work if it flopped. Richter is reticent by nature, so when he agreed to publish some
diary notes in the catalog for a 1987 exhibition of works on paper at the Museum
Overholland in Amsterdam, it was only because he thought a catalog published
in Dutch would scarcely be noticed in Germany. Otherwise, he never would have
allowed his unflattering opinions of the exhibition business to be printed. "The
whole art world is one vast scene of pettiness, lies, deceit, depravity, wretchedness,
stupidity, nonsense, impudence. It is not worth wasting one word on it,"[11] he had
written on December 25, 1982, wasting far more than a word on it. Eventually of
course, everyone on the German art scene read all of his words, because the catalog
turned out to be bilingual—in Dutch *and* German.

As of today, Richter has been painting landscapes on and off for more than
fifty years. No other motif has absorbed him in quite the same way, over such a
long span. At the same time, the number of landscapes he has painted is low. Their
significance lies, not in a critical mass but in the prominent position they occupy
in the artist's oeuvre, and in how he thrusts them into dialog with other work. In
several senses—conceptual, aesthetic, and technical—they would serve as a bridge
from the photo-paintings to the abstract paintings soon to come. Richter's excuse
for turning his vacation photos from Corsica into painted souvenirs had been that
he was taking a break from producing work on a professional basis and simply
painting what he wished. But the pursuit would not have continued for decades
were there not an enduring aesthetic and conceptual program at the heart of it. Put
simply, Richter *had* to discover more than private impressions in his paintings.

Following the five Corsica scenes, Richter began to look for landscape motifs
at home, photographing his surroundings in Düsseldorf. Out of this came the
Landscape near Hubbelrath (*Landschaft bei Hubbelrath*; CR 221; fig. 6.2), *Ruhr
Valley Bridge* (*Ruhrtalbrücke*; CR 228), *Eifel-landscape (Street)* (*Eifellandschaft
[Straße]*; CR 229), and *Large Eifel-landscape* (*Große Eifellanschaft*; CR 230), all
from 1969.

CASPAR DAVID FRIEDRICH

Richter's landscapes are almost invariably understood in terms of the great histori-
cal tradition of German Romantic painting. They are especially compared to the
work of Caspar David Friedrich (1774–1840). Both artists follow a formal scheme
first detected by the art historian Oskar Bätschmann in Friedrich's 1801 drawings
from Rügen: their landscapes are marked by a deep-set horizon; a high, often
cloudless, sky; and an unremarkable foreground with perhaps a solitary building

or prominent topographic detail for scale.[12] In 1994 the Kunstverein Ruhr in Essen went so far as to devote a small exhibition to this intriguing similarity, titled "Gerhard Richter and the Romantic" (*Gerhard Richter und die Romantik*).

The comparison with Friedrich makes excellent sense. Not only is Friedrich foundational to the very notion of German landscape painting, but each artist spent important years of his life in Dresden. Indeed, several critics have concluded that, despite being separated by more than a century, the two share a similar experience of nature. Richter confirmed as much in a 1973 letter to Jean-Christophe Ammann:

> A painting by Caspar David Friedrich is not a thing of the past. What is past is only the set of circumstances that allowed it to be painted: specific ideologies, for example. Beyond that, if it is "good," it concerns us—transcending ideology—as art that we ostentatiously defend (perceive, show, make). Therefore, "today," we can paint as Caspar David Friedrich did.[13]

When he lived in East Germany, Richter had been interested in Friedrich. During his rare crossings into West Berlin to visit the Gemäldegalerie in Dahlem, he always made a point of studying its splendid group of pictures by Friedrich. Yet any similarities between the works of the two artists are bound to be superficial: the social view of the landscape and the media through which it can be translated have changed in fundamental ways. Richter has never presumed to paint a technically unmediated view of nature as Friedrich did, instead registering his surroundings through the mechanical reproduction of photography, even copying the tonalities of color film itself. With this technique he offers a solution for how the traditional genre of landscape painting, for many years relegated to the attic of art history, may be revitalized for contemporary visuality.

Richter's initial efforts to revive the landscape coincided with the very different attempts of several other artists. Roy Lichtenstein was painting sea- and cloudscapes in comic-book fashion. The American Allan D'Arcangelo and the German painters Peter Brüning, Werner Nöfer, and Peter Berndt were translating nature into a cartographic sign language.[14] His friend Blinky Palermo also explored aspects of landscape in some of his work, which may have encouraged Richter to do so. In any case, to Richter's surprise, his fellow artists tended to react to his romantic landscapes much more positively than did the critics. When he included the landscapes, seascapes, and cloud paintings in his retrospective at the Kunstverein für die Rheinlande und Westfalen, Günther Pfeiffer slammed them in the art magazine *Das Kunstwerk*, mistaking the paintings' romantic appearance for a lack of substance:

> The paintings leave behind Richter's Pop beginnings and also his accentuation of the commonplace, the quality of making the everyday remarkable, and offer

nothing in exchange but prettiness. Looking at the Alpine glaciers from enough of a distance, they are almost identical to the kitsch popularly sold in department stores. Richter's differ only in that he paints with more delicacy and more experience. Because the paintings lack the persuasive power of a Friedrich, they remain problematic, and Richter has been caught in a swiftly approaching dead end.[15]

As early as 1975, Rolf Wedewer was characterizing Richter's renunciation of a symbolic, over-elevated image of nature as what separated his landscapes from those of Friedrich. This distinction has been restated more recently by younger critics such as Hubertus Butin, who stresses that

> the most significant difference between the two artists lies . . . in their intentions. Richter's landscape paintings cannot be traced to a religious understanding of nature; he does not perceive any manifestation or revelation of the transcendent in the natural world. In his paintings, no painted figures beckon the viewers to imagine themselves in their place in order to achieve . . . immersion in a sublime natural spectacle.[16]

The landscape motif has remained a subliminal constant in Richter's work. In contrast to Friedrich's landscapes, which can be read as allegories of German national liberation from Napoleonic domination, Richter produces landscapes as manifestations of private, hidden sensibilities. The artist has implied in conversations and interviews that paintings produced decades apart—from the Davos impressions of the early 1980s (CR 468/1–3; fig. 10.3) to *Summer Day* from 1999 (*Sommertag*; CR 859/1; fig. 10.4)—can all be so interpreted.

In composing the landscapes, Richter consciously experiments with the position and distance of the viewer from the scene. The first Corsica painting from 1968 (CR 199) is a straightforward example. The landscape appears as a sequence of staggered horizontal bands: the foreground is established by an indeterminate modulation of color; above (and beyond) that runs a narrow line of trees, followed by a range of steep mountains, which, partially shrouded in fog, dissolve into the thickly clouded sky. What Richter began here, and what he emphasized even more in the landscapes that immediately followed, was the absence of classic perspective. The early gray photo-paintings dissolved the mediated world into a blur. Here it is the viewer who is destabilized. It is not possible in these paintings to gauge the distance between the viewer and some distinguishable landmark, and thereby to determine a precise vanishing point. "What counts isn't being able to do a thing, it's seeing what it is. Seeing is the decisive act, and ultimately it places the maker and the viewer on the same level."

Such indeterminacy also applies to the seascapes that Richter began to produce in 1969—and even more so to the perspectively indeterminate cloud paintings of the following year. The experience of reality in these pictures no longer has

any shred of romantic basis but is far more skeptical and modern. As Richter put it, "Though these pictures are motivated by the dream of classical order and a pristine world—by nostalgia, in other words—the anachronism in them takes on a subversive and contemporary quality."[17]

In the large-format seascapes of 1969 (CR 233, 234, 235, 239/1–2; fig. 6.3), Richter used combinations of photographs for the surface of the water and the sky. At first he masked the collage operation, trying first and foremost to perfect the image—"to approach the quality of earlier landscape painters." "I wanted to make it just a bit more beautiful because I noticed how difficult it was to have both at the same time—a suitable water surface and a beautiful sky along with it." But soon his manipulations became more overt. *Evening Landscape (with Figure)* (*Abendlandschaft [mit Figur]*; CR 260) and the two versions of *Seascape (See-See)* (*Seestück [See-See]*; CR 244, 245), all from 1970, as well as *Large Teyde Landscape (with 2 Figures)* (*Große Teyde-Landschaft [mit 2 Figuren]*; CR 284; fig. 6.4) and *Large Teyde Landscape* (CR 285), from 1971, articulate a sort of "sight irritation," introducing a sense of uneasiness into the viewer's experience.

In the two paintings titled *Seascape (See-See)*, Richter replaced the sky in the upper half of the photographic model with a different photograph of a body of water turned upside down. Because moving waves share some formal characteristics with certain cloud formations, the rather surreal intervention is not at first noticeable. For a moment, there is the illusion of a unified image of reality that could not possibly exist.

In *Large Teyde Landscape (with 2 Figures)* Richter takes it a step further. The image is divided horizontally in two. A panoramic landscape stretches out beneath an unchanging, pale sky. No details are discernable in the brownish, shifting surface of the earth. The viewer winds up having actively to imagine the hilly landscape instead of actually recognizing something in it. The two dark spots in the bottom left corner can be read as figures largely because the painting's title suggests them. (Though, even without this cue, a viewer confronted with an unclear, strange reality will be tempted to create a safe situation, interpreting the unfamiliar color structure, which keys into certain perceptual patterns, as a landscape and the vertical spots as figures.) In turn, the size of the figures is the only hint of the monumentality of the fictive landscape. For a model, Richter took a small detail from a photograph of the edge of a pathway, which he enlarged to a two-by-three-meter canvas.

"Painting is the making of an analogy for something non-visual and incomprehensible: giving it form and bringing it within reach,"[18] Richter noted in 1981. These manipulated landscapes at once prove how imperfect this process can be and expose the intensity with which the viewer tries to establish the echo of a familiar representation, even in abstract structures. In the abstract paintings after 1976, Richter would reach repeatedly for landscapelike connections. "The paintings take their meaning from the viewer's wish to recognize something in them.

FIG. 6.3. *Seascape (Wave)* (*Seestück [Welle]*), 1969. OIL ON CANVAS. 200 × 200 CM. CR 234.

FIG. 6.4. *Large Teyde Landscape (with 2 Figures) (Groβe Teyde-Landschaft [mit 2 Figuren])*, 1971. OIL ON CANVAS. 200 X 300 CM. CR 284.

Everywhere, they show similarities with real appearances, which somehow never allow themselves to come into focus."[19]

Starting in 1971 with the photographs used for the landscape and cloud paintings, Richter drafted several designs for monumental paintings intended for public spaces (see *Atlas*, panels 234, 245, 249). These designs drew upon his training as a muralist and sought to test the relevance of landscape to a broader social context. The drawings are utopian projects, which, in the face of art's actual social powerlessness, project the works into a public space, where they overwhelm visitors through their sheer size and grandeur. "That is such a dream of mine—that the picture will become an environment or become architecture."[20]

7 VENICE BIENNALE

The early 1970s brought several decisive changes for Richter. Major exhibitions were in the works. And a teaching appointment to the Düsseldorf Art Academy ensured him a steady income. Having lived in cramped quarters on Luegallee since 1968, he could now afford a more spacious apartment at Oberkasseler Straße 74. He also found a better studio. Located on Harkortstraße, at 120 square meters, it must have seemed vast compared with the tiny space he had rented for the previous six years. Richter took great care in designing the cabinets, shelves, and work tables for the new studio. He was initially so enamored of his sketches for the furnishings that he included them in the first edition of the *Atlas*.[1] "At the time, it was connected to this readymade attitude: Such drawings, which are not art, were simply declared to be art."

From April 11 to May 7, 1970, he showed for the first time at Konrad Fischer's gallery (fig. 7.1). The two men had reached a cautious rapprochement. Fischer was now highly successful, with ventures far and wide and an expanding business. He took the occasion of Richter's show to open a new space at Andreasstraße 25, at the same time filling the original gallery on Neubrückstraße with Blinky Palermo's wall painting *Staircase* (*Treppenhaus*). Richter showed thirty-five paintings, mostly small ones from previous years, including *Baker Family* (*Familie Baker*, 1965; CR 80/12–15) and several of the modest gray canvases from 1968 that featured color streaks and grids (CR 194/1–4, 12, 15, 17, 18). Today, Richter has fond memories of the show: "I had fun at Fischer's, with these small beat-up paintings hanging close together."[2]

FIG. 7.1. EXHIBITION AT KONRAD FISCHER GALLERY, DÜSSELDORF, 1970.

BLINKY PALERMO

It was no coincidence that Richter's and Palermo's exhibitions were held concurrently. By now they were close friends, and Palermo had supplanted Sigmar Polke and Konrad Lueg/Fischer as Richter's chief collaborator. Like Polke, Palermo came from East Germany and had met Richter at the Düsseldorf academy. Born Peter Stolle on June 2, 1943, as an infant he had been adopted by a couple named Heisterkamp.[3] In 1954 the family emigrated to Münster, in West Germany. Peter Heisterkamp entered the Werkkunstschule (School of Arts and Crafts) in 1961 but almost immediately transferred to the art academy in Düsseldorf, where for the first three semesters he studied with the painter Bruno Goller. It was during the annual student review in February 1963 that Lueg first pointed out Palermo's work to Richter. "Konrad said to me, 'There's a guy up there in Goller's studio. Pretty good.'" Richter remembers the paintings on display as being small and disarmingly quiet.

The next semester Palermo transferred into Joseph Beuys's class. "He was a real pipe smoker when he came to me, seemed absolutely calm and unhurried," said Beuys, recalling his first impression of Palermo. "I told him right away, 'Get rid of the pipe, then the paintings will get better.'"[4] It was in Beuys's class that Peter Heisterkamp was first dubbed "Blinky Palermo," allegedly by fellow student

Anatol Herzfelde who thought he looked like an American mafioso and boxing promoter who went by the name. Heisterkamp liked the nickname so much he adopted it. Certainly throwing a veil over his identity contributed to the aura of mystery that came to surround his persona, as did his untimely death at the age of thirty-three during an excursion to the Maldive Islands.

Palermo's mature work occupies a space where painting, object, and architecture intersect. His "cloth pictures," made from pieces of colored textiles stitched and mounted on stretchers, are simultaneously objects and pictures without painting and were featured in his first exhibition at Heiner Friedrich's Munich gallery in 1966. His wall paintings are conceived to integrate with a specific architectural space. Palermo attached considerable importance to the order and distribution of works in a room. Every piece had its place, which not only served to articulate it but also created a punctuation in space. "Exhibitions that Palermo produced himself always had an environmental character," wrote Johannes Cladders, director of the contemporary Museum Abteiberg in Mönchengladbach.[5]

What was it that drew Richter and Palermo together? On the surface, their art, personalities, and lifestyles seem to have had little in common. Palermo was wild and self-destructive. He partied hard. Richter is disciplined and self-contained. "Our personalities were actually quite different," Richter explains, "but we always agreed in our judgments."[6] The friendship resembled Richter's earlier relationships with Lueg and Polke, with one crucial difference. "Because we were so different, we didn't compete with each other. I always appreciated the way he could create something that seemed so silent. That was all foreign to me." In a conversation with Robert Storr, he said, "We could really just speak about painting. The main thing was about the surface of color or the proportion of color. It was impossible for me to talk to Polke about the opacity of color. With Palermo, yes."[7]

In 1970 and 1971 Richter and Palermo collaborated on several projects. First came *Finger-marks* (*Fingerspuren*, 1970; CR 253), which consisted of two 200-by-100-centimeter panels, one by each artist, which were finger- and brush-painted and then smeared (the work was later destroyed). This was followed by two untitled diptychs (CR 303, 304), in which off-white monochromes by Palermo were paired with paintings of blurred lightbulbs by Richter. The friendship helped fuel Richter's growing involvement with color and his consideration of how it might relate to or even overturn the grisaille palette he had always favored. Their first collaborative exhibition tested the boundary between aestheticism and kitsch. "For Salvador Dali"—the title a mock homage to the ruling king of kitsch—ran from October 10 to November 6, 1970, at Galerie Ernst in Hannover. "Dali was really out of favor, and in terms of social politics he was completely reactionary. The kitsch of his painting was also out of favor." The invitations were printed on edible paper. Palermo exhibited one wall painting, and Richter showed two large, colorful paintings, *Detail (red-blue)* (*Auschnitt [rot-blau]*; CR 273) and *Detail (gray-lilac)* (*Auschnitt [grau-lila]*; CR 274; fig. 7.2), both from 1970. The two-by-

FIG. 7.2. *Detail (Gray-Lilac)* (*Ausschnitt [grau-lila]*), 1970. OIL ON CANVAS. 200 X 300 CM. CR 274.

three-meter paintings belonged to a new group of work that had conceptual ties to *Large Teyde Landscape (with 2 Figures)*. The sources for these paintings were photographs Richter made of small sections of his paint palette. As with his previous photo-images, he then projected the images on to canvas at a monumental scale and copied them in paint. The results are colorful structures, configurations of shapes and gestures that are highly specific yet disallow any fixed signification. Even so, many gallerygoers who study *Detail (gray-lilac)* think they discern its subject. Some believe they are looking at a detail of the rings of Saturn, others see microscopic structures, and on and on. Of the two works Richter preferred *Detail (red-blue)*, but *Detail (gray-lilac)* was the painting that sold. The city of Hannover purchased it for DM 10,000. Since 1979 it has hung in the Sprengel Museum, Hannover.

In a 1980 letter to the author Birgit Pelzer, Richter mentioned how these new projects anticipated his method for producing later work:

> The detail paintings of 1970/71 are very small details, ca. 1–2 cm squared, of palettes or from paintings that through enlargement take on an abstract appearance or uncertain "beauty" as images. In contrast to the modern comic elegance of Lichtenstein's brush-stroke paintings, the "details" clearly do not reproduce anything but the illusion of a kind of painting we might think to find in the nineteenth century but that never actually existed, or never existed with such emptiness. Despite my reservations, what I like about these detail paintings is that they are so radically Not-Painting, as only a reproduction could be, insofar as it did not recall an actual image (the reservations: they are so likable, decorative, and interesting that their actual achievement and their antistance will be overlooked).[8]

Richter gave one of the *Details* the subtitle *Makart* (CR 288), a reference to the painter and decorator Hans Makart, a nineteenth-century Viennese *Malerfürst*, or "artist prince," who established a lavish salon and produced art in a decorative, bourgeois manner that, even then, verged on kitsch. Richter thus hinted at the dangerous balancing act in which he was involved. "I was certainly aware that this was a tricky business—if not kitsch, then something approaching it. So I fully expected someone to come along and pick at the scab. And that turned out to be Polke."

In 1971 Polke loaned a work to Richter's retrospective at the Kunstverein für die Rheinlande und Westfalen in Düsseldorf, and he stopped by as Richter was installing the show. Upon surveying the new landscapes and seascapes, and especially *Detail (Makart)* (CR 288) and *Detail (Karmin)* (CR 289), he remarked dismissively (according to Richter), "Why don't you just go ahead and paint some more trivia like that?" Richter, who was already insecure about the paintings, realized then just how far apart he and Polke had grown. Polke no longer seemed interested in his work, and that, for Richter, was what finally ended their

friendship. It is of course possible that Polke too suffered from a growing sense of alienation as Richter became closer to Palermo.

In October 1970 Richter and Palermo jointly submitted designs for the sports arena and the swimming stadium for the 1972 Olympic Games in Munich. For the front of the arena, they proposed an array of 1,350 glass windows in twenty-seven different colors; each color would appear fifty times, with the distribution determined randomly—a plan Richter would revisit three decades later in designing a window for the Cologne Cathedral (see chapter 12). More immediately, he randomized the arrangement of colors in a number of new *Color Charts* (*Farbtafeln*, 1971, CR 300/1–4; 1973/1974, CR 350/1, 359).

For the skin of the swimming stadium, the artists designed a pattern of ten horizontal stripes in different colors and widths to encase the entire structure. "The endless stripes will be functional and beautiful," they wrote laconically in their proposal.[9] In retrospect, Richter acknowledges that he had not been realistic about the project, which must have been apparent to the members of the Olympic committee. Not only did they reject the entry, they refused to pay an honorarium, scolding the artists for wasting their time on something so fanciful.

In November Richter and Palermo traveled to New York City to check out the art scene. They planned to stay for two weeks, but their itinerary proved so demanding and their impressions so intense that they returned home, spent, after only ten days. Their travel agent had booked them into a cheap hotel on Forty-second Street, which was then one of the seediest stretches in Manhattan, teeming with drug dealers and prostitutes and lined with strip clubs, adult movie houses, and pornographic bookstores. They had brought along portfolios of work but, confronted with the elegant galleries along Fifty-seventh Street and on the Upper East Side, felt too timid to introduce themselves. They showed their work instead to some of the artists they already knew from Germany—including Robert Ryman, whom Richter had met in 1968 when Konrad Fischer had given him a show.[10] The American turned out to be not terribly impressed by the abstract work but, to Richter's surprise, was much more enthusiastic about the romantic landscapes. They also saw James Rosenquist, to whom Richter had been introduced just a few days before coming to New York, when Rosenquist's exhibition opened at Galerie Ricke in Cologne. (Richter had shown with Rolf Ricke in 1968 at his gallery in Kassel, sharing the space with Cologne artist Michael Buthe.)

In spite of the overwhelming impression New York made on Richter and Palermo, each returned to Germany with a firmer sense of his own identity. Quick to acknowledge the many accomplishments of the American artists—since the end of the war, the presumptive center of the art world had shifted to New York—Richter also stresses that "we noticed for the first time that we were Europeans, and that this was something we could be proud of too."

In 1971, not long after "For Salvador Dali," Richter and Palermo had another collaborative exhibition, this time at Heiner Friedrich's new gallery in Cologne.

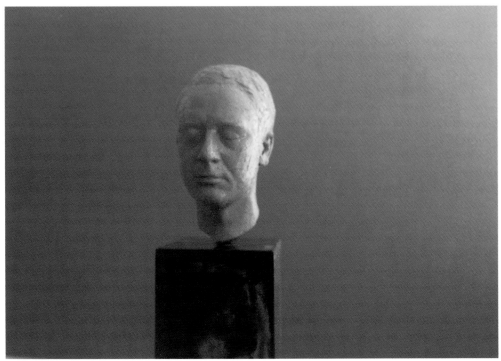

FIGURES 7.3 AND 7.4. BUSTS OF PALERMO (ABOVE) AND RICHTER (BELOW) FROM *Two Sculptures for a Room by Palermo* (*Skulptur für einen Raum von Palermo*), 1971. PAINTED PLASTER ON WOODEN BASES. 174 CM HIGH. CR 297.

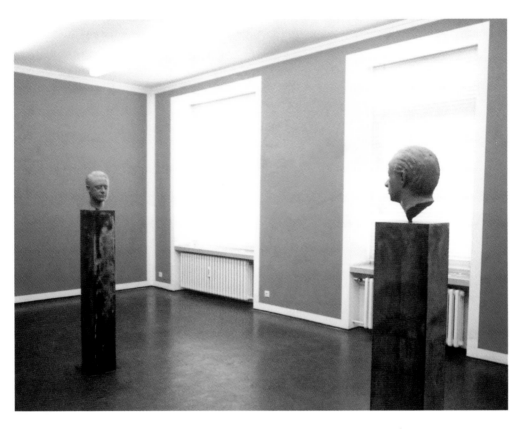

FIG. 7.5. *Two Sculptures for a Room by Palermo (Zwei Skulpturen für einen Raum von Palermo)*, 1971. PAINTED PLASTER ON WOODEN BASES. 174 CM HIGH. CR 297.

Friedrich had separated from his wife and was shifting most of his operation to the Rhineland, leaving Fred Jahn to run the Munich gallery. With the additional space, he wanted to offer the artists he represented in Düsseldorf and Munich a presence in Cologne, which had become the undisputed center of the German art market. Ricke had just opened his gallery in the new Galeriehaus at Lindenstraße 20/22, which was also home to Galerie Müller, which had moved from Stuttgart, and Galerie Thelen and Galerie Wilbrand. Paul Maenz also came to Cologne from Frankfurt in 1970 and opened a gallery in a neighboring building. Friedrich had initially hoped to run his Cologne branch jointly with Konrad Fischer, but Fischer pulled out at the last moment, leaving Friedrich to manage it on his own.[11]

The exhibition Friedrich mounted for Richter and Palermo, from April 11 to May 15, 1971, featured two of Richter's very few sculptures. Palermo had taken up the concept of "wall painting" somewhat earlier for an exhibition at Friedrich's Munich gallery, and his contribution to this new show was a "mural"; he painted all four walls of the room ochre, with white borders, to delineate the space and furnish an architectural setting for Richter's work. Richter responded with a piece titled *Two Sculptures for a Room by Palermo* (1971; CR 297/1). In a twist on academic tradition, he fashioned plaster casts of Palermo's head and his own (figs. 7.3, 7.4); painted them gray, in contrast to the rich ochre on the walls; and mounted them, facing each other, on tall wooden plinths also painted gray (fig. 7.5).

Later, when he had more money, Richter produced two sets of bronze casts of the heads. The first pair he mounted on plinths made of dolerite, painting both heads and support gray. The second pair was left unpainted and mounted on marble plinths (CR 297/3). Richter calls the latter the "night-table version."

The Cologne installation has conceptual links to Richter's romanticized landscapes and to the print *Transformation*, which he had created with Polke. The artistic fantasy of omnipotence is transformed here into an ironic homage to the artist as a heroic figure. The room is reminiscent of a hall of fame, a memorial, or—since both artists' eyes are closed—a mausoleum. It is designed to educe, with its classicist ambience, a certain reverence from visitors. As Richter tells it, the collaboration with Palermo originated in a shared sense of defiance against current fashion as well as a longing for a type of classical art that was scorned by the dominant avant-garde. The contemporary discourse on the social responsibility of the artist is conspicuously absent from this room.

As with the landscape paintings, Richter was here staking out a counterposition to the politically correct orientation of the time, retreating rather publically from debates about artistic contemporaneity and taking refuge in art history. The exaggerated solemnity of the installation has to be understood in light of Richter's feeling of artistic isolation at that particular moment. The positioning of the portrait heads expresses Richter's and Palermo's devotion to each other. Richter, in particular, drew strength from the friendship:

One doesn't make portraits like these, which look at each other with closed eyes, just for the fun of it or for tactical reasons. It had to be about something more significant, an admiration of the person and the painter Palermo, who made art despite the dominant Zeitgeist. At the time one felt quite isolated and was happy to find someone else who painted and thought in a similar way.[12]

PROFESSOR RICHTER

In the summer of 1971 Richter took a position as professor of painting at the Düsseldorf Art Academy. Art historian Eduard Trier, who headed the academy, had contacted him a few months earlier to let him know he was on a short list of candidates the school wanted to interview. "It all went very smoothly. I gave the impression of being responsible, dressed properly, and was polite."

Not all continued smoothly, however. By the time Richter took up his post, the student protest movement was well entrenched at the academy. Tensions were high, the corridors alive with explosive potential. Richter's calm, reserved demeanor helped mitigate trouble in the classroom, as did his consistent emphasis on quality and on the importance of developing a foundation in traditional artistic values. His students painted still lifes, not political slogans, and rather than discussing social economics, Richter tried to instill fundamental concepts of seeing. He never used the master studio furnished by the academy, making it available instead to his students. Soon, though, all his best efforts were overshadowed by a controversy surrounding—not surprisingly—Joseph Beuys.

On August 5, 1971, Beuys held a press conference to announce that 142 applicants who had been turned down by the academy would be admitted "to establish an objective basis for evaluating their capabilities during the trial semester." When the semester began on October 15, Beuys and his students took over the administrative offices, demanding that sixteen of the rejected applicants be allowed to enroll. Trier and his staff wanted to avoid a crisis, so they agreed to make a onetime concession. But the following October, when Beuys resumed his campaign, Johannes Rau, minister of science and education for the state of North Rhine–Westphalia, stepped in promptly to relieve him of his duties. In protest Richter, Günther Uecker, Georg Baselitz, Johannes Cladders, René Block, author (and later Nobel laureate) Heinrich Böll, and many others signed an open letter to Rau, accusing him of "using repressive tactics against persons who constructively engage themselves for an improved educational policy. To declare a professional or teaching ban on someone appears to us to be the least effective means of dealing with one of the most capable teachers in the German academy." The protest failed. Legal proceedings dragged on until 1978, finally ending in a compromise. Beuys accepted termination with the appropriate notice and in exchange was permitted to keep his studio at the academy along with the title of professor.

As the years passed, Richter's relationship to the institution would grow ever more conflicted. He minced no words in a private note written in 1983:

> In the Federal Republic, we have more than a dozen such Academies where the worst artists lurk as parasites and [promote their own kind through a system of prostitution and boredom]. They are given the title of professor and are thereby equipped with prestige, money, and studios. There, not only can they cultivate and disseminate their own imbecility and defile their students [with it]; they are also in a position . . . to ensure that every student and every newly appointed colleague is kept below their own lowest level, so that they can remain undisturbed in their own [stinking mess].[13]

In letters and conversations Richter also complained about his own situation. He lacked support from colleagues for his initiatives, he said. He couldn't get approval for appointments that he knew would be important for the academy. "Not even to mention the fact that I have very little influence at the Düsseldorf academy. Because, once again, they did not elect me, Kasper König, or other good people to the academy senate," he wrote to friends in 1986.[14] He believed, moreover, that he was not achieving much as a teacher.

But colleagues had a different perception. Uecker described Richter as a clever tactician in meetings, and König, who held the prestigious Chair for Art and the

FIG. 7.6. RICHTER'S CLASS AT THE DÜSSELDORF ART ACADEMY, 1992.

Public, had of course always admired him: "I spent four and a half years at the academy, and that would have been completely impossible without [Richter's] support."[15] Both also praised him as a teacher. "He achieved a great deal. He conducted his painting class in the classic sense, which is focused on the instructor and his stylistic methods," affirmed Uecker.[16] König describes the influence Richter had even on students who were not studying to be painters, especially the young generation of photographers being trained by Bernd and Hilla Becher. "The entire Becher class, from Thomas Struth to Andreas Gursky, cannot be fully understood without considering the presence of Gerhard Richter at the academy. There was not only Becher but also his polar opposite, Richter."[17] Ludger Gerdes, Thomas Schütte, Thomas Struth, Karin Kneffel, Michael van Ofen, and Richter's second wife, Isa Genzken, are just a few of the artists who studied with Richter between 1971 and 1994, when he finally resigned (fig. 7.6).

ATLAS

In 1970 Richter opened all the boxes of photographs and other preparatory material he had collected and exhibited it along with some of his graphic work under the title "Studies 1965–1970" at the Museum Folkwang in Essen. This early collection would officially become the *Atlas* two years later in an exhibition in Hedendaagse in Utrecht.

The *Atlas* was born of necessity. Since the late 1960s Richter had felt the need to vet and organize the mass of visual material he had accumulated and to make it presentable. "At first, I tried to put in everything that fell between art and trash, that somehow appeared to be important, and that would have been a shame to throw away."[18] His approach, however, was hardly arbitrary: he had been much impressed by conceptual art even as he had rejected the movement's condemnation of painting. When asked if the *Atlas* was a response to conceptual art, Richter says, "That may be, yes. But the initial reason for it was my desire for order and a clear presentation. The boxes full of photos and sketches are only oppressive as long as they remain unresolved. For this reason it is much better to arrange the usable things in an orderly fashion and to throw the rest away. This is how the *Atlas*, which I have exhibited a few times, came about."[19]

As a general organizing principle, Richter grouped the news clippings, reproductions, photographs, collages, and drawings according to the development of related paintings. He arranged the material on sheets of cardboard 51.7 centimeters wide and mostly 66.7 centimeters tall, and presented them in simple aluminum frames. The first panels display mainly personal photographs and illustrations clipped from the tabloids, featuring many of the motifs Richter worked with between 1962 and 1966. Other motifs and projects that he considered but rejected are also represented, including the exhibition he and Lueg had envisioned that

would have juxtaposed photos from the Holocaust with the raunchiest kind of pornography (*Atlas*, panels 16–23).

The *Atlas* represents an entire cosmos of images. Exemplifying Richter's fondness for classification systems, it lends his disparate material an associative structure. Alongside family snapshots and media clippings are many of his own photographs. Some are preparatory to other works, others are experimental, and some were clearly meant originally to be private. Interspersed throughout are draft drawings, construction plans, sketches, room designs, photographs that have been partially painted over, and thousands of landscape photographs, only a few of which the artist has ever elected to paint. Individual panels are developed according to iconography rather than chronology. Candles are with candles, clouds with clouds. There are panels of floral still lifes, and panels with views of Sils-Maria in the winter and Venice in the summer.

Via the *Atlas*, Richter emphasizes the contingency of meaning in his paintings, placing their motifs within a loose conceptual chain of becoming. Sometimes a source image from a tabloid appears next to the completed painting. Other times, an image may be inserted wishfully into an ideal architectural space, or a painted motif situated side by side, for comparison's sake, with the much more numerous *potential* paintings.[20]

In some cases the potential has eventually been realized. The *Atlas* includes dozens of images that Richter did not paint until years after adding them to his collection. His paintings of photos he made on a trip to Greenland in 1972, for example (panels 341–359), weren't completed until 1981 and 1982 (CR 476, 496/1–2), and *Betty*, the famous 1988 portrait of his daughter (CR 663/5), references a photograph from 1978. The more Richter worked on the *Atlas*, the more it became a mode of presentation that both accompanied and augmented his repertoire: "If you can't paint everything, then this is at least a way of showing all the pictures." He has continued to work on it, adding panels with some frequency. He has also removed material, often because he no longer feels it merits inclusion (for example, the sketches for the interior design of his studio on Harkortstraße); other material he believes can exist on its own. "After a while in the *Atlas* many pages did take on a different value, that is to say, it appeared to me that they could also stand alone, not only in the protection of the *Atlas*."[21] For instance, two watercolors from 1964, the portrait of Heiner Friedrich and *Interieur*, both included in the *Atlas* in 1972, were eventually upgraded to independent works.

Since its debut, the *Atlas* has been exhibited numerous times, occasionally in combination with paintings, but more often on its own.[22] In 1977 Heiner Friedrich offered the *Atlas* for sale to the Städtischen Museum Schloß Morsbroich, Leverkusen, but the museum was not in a position to acquire it. Later, in 1979, Fred Jahn privately bought the work via Konrad Fischer, then promptly resold it to pharmaceuticals executive Christian Graf Dürckheim-Ketelhodt. With the sale, the collector agreed to acquire all future panels added to the *Atlas*.

Interest in the *Atlas* increased steadily, with numerous requests for loans, giving rise to the idea that it should be housed in a public institution. In 1996 Jahn intervened again, arranging a sale to the Städtische Galerie im Lenbachhaus in Munich, which is said to have paid more than two million deutsche marks for half of the *Atlas*; the other half was donated by the owner. Richter helped support the financing by donating his Edition Fuji (1996, CR 839/1–110) to the museum, which offered the 110 paintings on aluminum-composite panels for sale for DM 12,000 each.

The *Atlas*, so called, was first exhibited in Utrecht in 1972. That same year brought Richter his first sustained international exposure: he was chosen to be Germany's sole representative to the Venice Biennale, and a selection of his work was presented at Documenta 5. It was also the year he met Benjamin Buchloh, who would become one of his most important interlocutors. Buchloh, who was then working for Rudolf Zwirner in Cologne, arrived in Richter's life at precisely the right moment. For several years Richter had been wishing for serious, sustained critical analysis and attention, and Buchloh was poised to deliver it. Writer, editor, and scholar, he has, over the years, been singularly effective in exploring the dialectics of Richter's intellectual and critical visual agenda. In turn, Richter has offered an ideal case upon which Buchloh has been able to test his ideas for a new history of postwar art. Despite their differences—which are many—the two men remain loyal friends.

Buchloh was born in Cologne in 1941, but his first years were spent in the relative safety of Switzerland. He was brought back to Cologne in 1946. As a young man he moved to Berlin to study German literature at the Freie Universitat, where he became "very involved with the rather radical wings of the German student movement."[23] This experience would inform his thinking about politics and artistic expression, something about which he and Richter have often disagreed. Richter brings to the subject a wary skepticism distilled from growing up under two ideological regimes that deployed art fervently to political ends. Buchloh, perhaps because he was raised in the freer atmosphere of West Germany, was more of a political activist and ideologically expressive. Over the years the intellectual tension between the two friends has helped spur some of the painter's strongest work, notably the Baader-Meinhof cycle of 1988.

For two years Buchloh edited the innovative art magazine *Interfunktionen*. He taught for a while at the Düsseldorf Art Academy and curated a number of important exhibits before finally leaving Germany to teach in North America.

48 PORTRAITS AND THE VENICE BIENNALE

Traditionally Germany had been represented at the Venice Biennale by several artists, usually recognizable faces reflecting a range of distinctive trends. In 1968,

for example, the German pavilion showcased the graphic artist Horst Janssen, surrealist painter Richard Oelze, and sculptor Gustav Seitz, all of whom had peaked artistically at least two decades earlier. In 1970, when Dieter Honisch was appointed commissioner of the pavilion, he debuted a younger generation of artists: former ZERO-ists Heinz Mack and Günther Uecker, the painter Georg Karl Pfahler, and the sculptor Thomas Lenk. Two years later, in a bold move, he showed only Richter. Given all the competing interests, Richter considers the decision a brave one. As Honisch explained it,

> Despite all the ways one can criticize the Biennale, one thing cannot be overlooked: the Biennale is today still an international arena of value assessment; that is, everything one brings to the arena is assessed, and I had to acknowledge after my experiences here that it is probably best to concentrate on a single approach and show it in a differentiated way, and so I thought of Gerhard Richter.[24]

The thirty-sixth Venice Biennale took place from June 11 to October 1, 1972, with twenty-two countries participating. Richter had met Honisch two years earlier when the curator mounted a show of his graphic work at Museum Folkwang in Essen. When, to his delight, he was invited to represent Germany at the Biennale, he traveled to Venice to inspect the German pavilion firsthand. The neoclassical building, erected during the Third Reich, was large and austere; it offered the perfect framework for a project he had been contemplating for several years but had never had the opportunity to realize: "The plan to paint the *48 Portraits* [was] very old. . . . When I received the invitation to go to Venice, it was immediately clear . . . that the spatial conditions were ideal for this work. Without this opportunity, I probably never would have painted them."[25]

48 Portraits constitutes a lexicon of "great figures" in Western modern culture. In culling images for the project, Richter placed several restrictions on himself: Every original had to be a black-and-white photograph, which limits the pool of candidates to the last 150 years or so. Further, he restricted the search to reference books, meaning that every potential subject already possessed at least some cultural cachet. The first selection yielded 270 possible source images (see *Atlas*, panels 30–37). Among the portraits are philosophers, poets, men of letters, composers, psychologists, psychoanalysts, physicists, chemists, and educators.

Richter consciously excluded visual artists to avoid the suggestion that he was staking out his own artistic pedigree. Similarly, politicians, whom he had considered in the initial cut, were ultimately excluded to discourage critics from sniffing around for an ideological message. Other images were thrown out because they would have destroyed the formal unity Richter was seeking: profile views, for example, were discarded along with a picture of André Breton with a pipe in his mouth.

There is another, much more conspicuous omission. Richter chose not a sin-

gle woman. When Benjamin Buchloh challenged him on this in 1992, Richter defended the decision. He had considered including Marie Curie, he said, but concluded that doing so would interrupt the repetitive flow of the work, which needed to function as a frieze. In any case, he could not think of any other women who matched the caliber of the men. Buchloh did not buy the explanation:

> The barely hidden and naïve sexism of this remark (after all, there are many women from this period of history whose achievements could certainly be compared with those of the figures depicted in Richter's work) is not enough to explain Richter's decision. Every attempt to resolve this provocative and problematic decision with a strenuous effort at formalistic explanation, which maintains that it was necessary because of the visual continuity or even uniformity, remains equally insufficient.[26]

In a later conversation with Susanne Ehrenfried, Richter described

> Buchloh's statement [as] wholly an accusation of [its] time. When I painted the *48 Portraits*, such a claim [that there were many women to choose from] could not have been made. One didn't think that way then. Today, I would not paint the *48 Portraits* either as it is or in any other way. Earlier, I emphasized the pseudoneutrality of the Lexica, the anonymity and leveling. The fact that only men were chosen corresponded to this idea of homogeneity.[27]

Richter has never ceased to stress how crucial formal homogeneity was to the project, both aesthetically and conceptually. And there is, to be sure, plenty of evidence that uniformity was indeed a priority: a comparison of the photographs in the *Atlas* and the completed paintings shows that Richter imposed the same cropping throughout, reduced the space around each head to a monochromatic gray, and portrayed some subjects, whose clothing in the original images might have disrupted the repetitive flow (Albert Einstein and Rudolf Borchardt, for instance), in dark attire like the others were wearing.

Richter further reduced disparities among the source photographs by throwing the images just barely out of focus, a stylistic practice he calls *Vermalung*. The term, most likely coined by Richter himself to describe what has become a defining component of his painting, has no precise equivalent in English, though Richter loosely translates it as "inpainting." He first used *Vermalung*/inpainting in 1972 to describe the process he was then using in making his black-and-white photo-paintings—including the *48 Portraits*—and subsequently extended it to other, predominantly nonfigurative works (notably in the *Gray* series, discussed in chapter 8). What it describes is a variant of feathering that disrupts the clarity and distinction of forms and figures in an image. But the effect is not the same as in Richter's blurred photo-paintings of the 1960s. Instead of figures or forms being

distinct from each other, with defined contours and details, they fuse or dissolve into one another to such an extent that the monochromatic paintings become studies in tonality, with only subtle gradations that hint at originating imagery. To further soften the focus, Richter then works the paint surface to remove all trace of brushstroke or paint texture. His *Malerei* (painting) is thus *vermalt*: de-, un-, or overpainted, painted out or away, painted to remove the painting. The term may also apply to a fiercely gestural technique that gives the impression of intentionally obliterating a subject.[28]

The forty-eight figures depicted range from the universally famous—Einstein, Kafka, Freud, Poe, Tchaikovsky—to those whose renown is more restricted: the writer Rudolf Borchardt, the biologist Otto Schmeil, and the Swedish physicist Kai Manne Siegbahn, who was awarded a Nobel Prize in 1924 (fig. 7.7). To arrive at this group, Richter actually painted more than forty-eight portraits, culling from them during a final edit.[29]

Richter had settled on a format for the portraits (70 × 55 cm) at the start, but his method of painting evolved more gradually. The first studies resemble the photographs far less than do the final versions sent to the Biennale. In a study of Freud, for example (CR 323/2; fig. 7.8), he experimented with the technique he was using for such overtly subjectless paintings as *Untitled (Green)* (*Ohne Titel [grün]*; CR 313; fig. 7.9), which intimate visually that something has been purposely occluded beneath a welter of brushstrokes. In the sequence of studies that follow *Freud*, one can discern the *destructive* intrusion on the figure becoming less overt. Richter moves through a phase of uniform wiping, parallel strokes that blur the image, but these interventions become less and less evident until finally all visible traces of manual painting have been suppressed, thereby attaining a rather close approximation to the original photographs. By December 1971 he set to work painting the portraits in earnest, a project that would take nearly half a year.

In using an identical method to paint each portrait, Richter undermined the figures' individuality, and he hung the *48 Portraits* in the German pavilion in a way that underscored this impression (fig. 7.10). The paintings were organized as a frieze that ran the full circuit of the room, interrupted only by the doorways; they hung well above eye level so that visitors were forced to look up at the subjects. Richter sequenced them according to the direction of the subject's pose: on both sides of the entrance and in the middle of the opposite wall, the portraits are full face (Franz Kafka, Alfred Mombert, and Patrick Maynard Stewart Blackett). In between, the heads gradually rotate to three-quarter view. (Panel 39 in the *Atlas* shows how Richter considered different schema for presenting the portraits according to the direction of the subject's gaze.)

Every decision—from the selection of the photographs and their transformation through painting to the final installation in Venice—can be seen as a move toward unifying the *48 Portraits*. In deindividualizing the images, Richter was trying to limit interpretation of the group to a formal one. He even went so far

FIG. 7.7. RICHTER IN HIS STUDIO, 1972.

as to revise the hanging after the grand opening, moving Kafka's portrait from a prominent position in the middle of the wall opposite the entrance. "Because Kafka is such a beloved figure and therefore too meaningful, I preferred the relatively unknown Blackett there."[30]

As with the photo-paintings in the 1960s, Richter insisted that his interest in his forty-eight subjects was not personal. Rather, his goal was to rebut the conceit of portraiture as a mode of capturing the psychological life, or "essence," of a subject. "I was interested in the unspoken language of these paintings," he explained to a reporter at the opening. "Heads, although themselves full of literature and philosophy, become completely unliterary. Literature is removed, the personalities become anonymous. That's what it is about for me."[31] That he himself established the identity of each subject with a name plate under the portrait may seem a contradiction, but this too hints at the insoluble discrepancy between the likeness and the life.

In any event, the links to the previous year's *Two Sculptures for a Room by Palermo* and to the historical significance of the German pavilion suggest an additional interpretation. The painter had responded to the pavilion's fascist architecture by producing a humanistic frieze of writers, musicians, philosophers, and scientists. "It is characteristic that Richter chose a theme . . . that was so am-

FIG. 7.8. *Study for Serial Number 324 (Freud) (Studie zu Werknr. 324 [Freud])*, 1971. OIL ON CANVAS. 70 X 55 CM. CR 323/2.

FIG. 7.9. *Untitled (Green) (Ohne Titel [grün])*, 1971. OIL ON CANVAS. 200 X 200 CM. CR 313.

FIG. 7.10. *48 Portraits (48 Tafeln),* INSTALLED IN THE GERMAN PAVILION AT THE VENICE BIENNALE, 1972. OIL ON CANVAS. 70 X 55 CM EACH. CR 324/1–48.

bitious and out of the ordinary," wrote Honisch. "Men, who changed the world through their work but are now hardly recognized, who exist in encyclopedias, are now called upon by Richter to demonstrate problems of contemporary painting in the context of the false representationalism of the fascist architecture of the German pavilion."[32]

In 1993 Buchloh offered a very different explanation, equating Richter's motivation for invoking great men of Western science and culture with the search for a father figure. For Buchloh, the Biennale entry exemplified the attitude of Germans born between 1930 and 1945, whose fathers' service to the great destruction wrought by National Socialism had disqualified them as role models for the younger generation. The task of the *48 Portraits* was, therefore, "to construct a subjective and historical identity that would be acceptable to an individual whose subjective father figure was traumatically devalued during the fascist period."[33] In a conversation with Susanne Ehrenfried, Richter acknowledged the insight but, typically, distanced himself from it with a chuckle, adding that, yes, the project probably had something to do with his search for a father figure, for he clearly was not searching for a mother.[34]

Richter rounded out his Biennale show with some large townscapes (CR 171, 175, 177/1–3, 217/1–3, 249), mountain paintings, (CR 189, 181, 182, 213), a three-part cloud panorama (CR 270/1–3) now in the collection of the National Gallery of Canada, and several examples of inpainting from the group *Untitled (Green)* (CR 313–319).

The traditional Biennale grand prize—the Golden Lion—had been temporarily discontinued, but this didn't stop participants and the media from talking about who should have received it. The favorite entry turned out to be, not *48 Portraits*, but a work by the Dutch artist Jan Dibbets. The lukewarm response to his most ambitious project to date disappointed Richter terribly. Not a single gallery approached him. Collectors were not clamoring to buy his paintings. Rudolf Zwirner did, however, sell *48 Portraits* during the Biennale for DM 48,000 to loyal collector Peter Ludwig.[35]

DOCUMENTA 5

On June 30, 1972, just three weeks after the Biennale opened, Documenta 5 kicked off in Kassel. The theme that year was "Questioning Realities," and Richter was included in a hanging of photorealistic paintings, overseen by Jean-Christophe Ammann. Ammann chose *Eight Student Nurses*, from 1966, and three color charts from 1971 (CR 300/1–3). The color charts were the first Richter had produced since 1966 and the first for which the color sequences were produced by random sampling. Still, Ammann's selection disappointed Richter, dampening the pleasure of being included in an event that had so impressed him when he first visited Kassel

in 1959. "I was there, but not with the works that I would have liked to represent me. I didn't like the context or company [of other works next to mine]. Everything was just too relative," he complained. That his next Documenta, five years later, would be much worse was something he could never have envisioned.

TRANSITIONS

All in all, 1972 had turned out well for Richter. He felt that he had become "a little bit famous." By the end of the year he was preparing for a one-man show at the Städtische Galerie im Lenbachaus, in Munich, scheduled to open on May 23, 1973. There, he offered new inpaintings (*Vermalungen*) as well as some gray paintings. The opening drew fewer than twenty people, counting the museum staff, Fred Jahn, and members of Richter's family. Nevertheless, what he did sell fetched good prices. The actress Barbara Nüsse bought the *Large Teyde Landscape* from 1971. Karl Ströher, an industrialist from Darmstadt, paid DM 60,000 (the equivalent of $88,000 in 2007) for the three-part gray *Inpainting* (*Vermalung*, 1972; CR 326/1–3), which now belongs to the Hessische Landesmuseum, Darmstadt.

At the same time Richter's business relationships were starting to change. Following the 1971 exhibition with Palermo at Heiner Friedrich's gallery, his formal arrangement with the dealer came to an end. The final obligations under their contract expired on April 1, 1972. Thereafter Friedrich was only entitled to sell the paintings that he had already obtained contractually from Richter. Fred Jahn recalls Friedrich's grumbling that Jahn had sold too much work early in the arrangement, so that now that Richter's paintings were more valuable, hardly any remained in stock. Richter, as previously noted, had been unhappy with the arrangement and was eager for the contract to expire. He had waited in vain for payment for work that had been sold, and he grew angry about the gallery's inequitable treatment of its artists. While Friedrich spared no expense when it came to Donald Judd, Michael Heizer, and Walter de Maria, he scrimped on Palermo and Richter. "The Americans stayed at the Four Seasons," Jahn acknowledged, "and Richter and Palermo at the Pension am Hofgarten."[36] In August 1972 Richter hired an attorney to collect the money still owed him and to retrieve eighteen paintings he had left for the gallery to sell on commission. Having turned over his financial problems to a lawyer, Richter left Düsseldorf for a hiatus in Greenland, a ten-day cruise through the Arctic ice. The original plan had been to travel with his friend Hanne Darboven, but at the last minute he decided to go on his own.

He made dozens of photographs during the journey. "I wanted to take photos in the mode of Caspar David Friedrich's *The Wreck of Hope*. The whole thing was a project." Friedrich created *The Wreck of Hope* (*Das Eismeer,* later known as *The Sea of Ice*) in 1823 and 1824 in Dresden. At 97 by 127 centimeters, it was an unusually large canvas for Friedrich, who had been inspired by William Edward Parry's

Greenland expedition just a few years earlier. Friedrich reinterpreted the ship's treacherous search for the fabled Northwest Passage as a shipwreck scenario. In an imagined snowy landscape, Parry's stranded ship, the *Griper*, is being crushed in a gigantic ice floe. Friedrich's painting has been in the collection of the Hamburg Kunsthalle since 1905, and Richter likely saw it when he was a guest professor at the city's art academy.

Many critics have interpreted *The Wreck of Hope* as a metaphor for the powerlessness of humanity in the face of nature's overpowering violence. Others have interpreted the painting politically, calling it an expression of Friedrich's unfulfilled hopes for liberalization and the granting of civil rights and freedom of the press after Napoleon and the French were expelled from Germany. What Richter saw reflected in the painting, however, was his own state of mind. His marriage was in crisis, and the photographs he took in Greenland were visual analogues for his own failed hopes. He was exhausted by the struggle to find his own way as a husband and father, and felt that his dream domestic happiness had, as a consequence, been wrecked. "The project was also an excuse for getting away. . . . Trouble in my marriage was reaching a climax. Going into the ice could be interpreted as longing for a place where one feels safe—just so long as there is no life, only ice," Richter says today.

A few months later, Richter joined Ema and Betty for a New Year's vacation in the Swiss town of Davos. The melancholy mood of the landscapes he photographed there are consonant with those from the Greenland trip. (See *Davos S.*, 1981; CR 468/3; fig. 10.3.) That year he also bought a row house with a yard. There were plenty of practical reasons for the purchase, but ultimately it amounted to a last desperate attempt to give his marriage, quite literally, a new foundation. At the very least, Richter had fulfilled a longstanding wish to own his own home. In a letter to Buchloh he wistfully described the house on Brend'amourstraße as his "paradise."[37]

In 1976 four large paintings, each titled simply *Seascape* (*Seestück*; CR 375–378) emerged from the Greenland photographs. Typical of the group is CR 376 (fig. 7.11), with its oppressive atmosphere. A hazy sky diminishes the horizon while, below, the greenish sea swells with a force hidden just beneath the surface. Given the painting's grand scale, the water seems on the verge of overflooding the foreground and engulfing the viewer.

Not long before, Richter had painted a series of four canvases called *Tourist* (CR 368–370/1; fig. 7.12), all based on illustrations from a 1974 article titled "Death in Safari Park" (*Tod im Safari-Park*) in the magazine *Der Stern* (*Atlas*, panel 133). The photos document the misfortune of a careless vacationer who emerged from his car in a Spanish safari park and approached a pack of lions he wanted to photograph. Two of them attacked, fatally injuring the man. In contrast to Richter's earlier photo-paintings, the scene here is legible—just barely—in only one of the canvases (CR 369). In two others, the scene has been abstracted,

FIG. 7.11. *Seascape (Seestück)*, 1975. OIL ON CANVAS. 200 X 300 CM. CR 376.

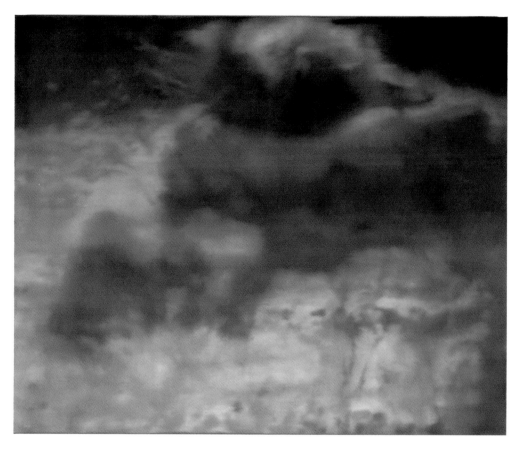

FIG. 7.12. *Tourist (with a Lion) (Tourist [mit einem Löwen])*, 1975. OIL ON CANVAS. 170 X 200 CM. CR 370/1.

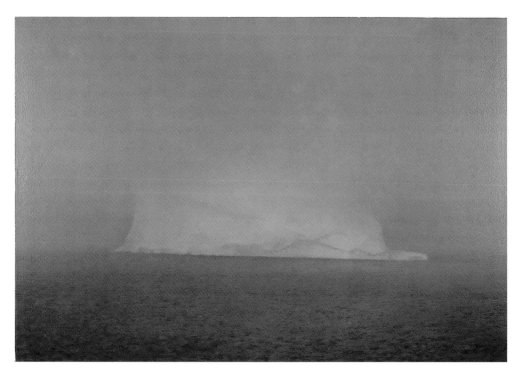

FIG. 7.13. *Iceberg in Mist (Eisberg im Nebel)*, 1982. OIL ON CANVAS. 70 X 100 CM. CR 496/1.

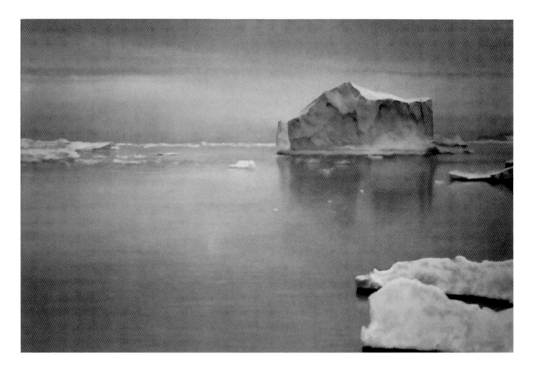

FIG. 7.14. *Iceberg (Eisberg)*, 1982. OIL ON CANVAS. 101 X 151 CM. CR 496/2.

with the attacking lions dissolving in cloudy masses of color; the fourth Richter painted over in shades of gray (CR 368). The series was in fact a deeply personal project. As Roald Nasgaard recounted after a conversation with Richter in 1988, the painter saw the tourist's situation as analogous to his own.[38] Richter recently confirmed the report. "I felt like someone who needs to hold himself aloof from everything, or else become like the foolish tourist and run the risk of being eaten up." (Remember what happened to the foolhardy Uncle Rudi.)

For Richter, the fear of being devoured may have been lurking for many years. Without putting too fine a point on it, one might ask why so many of the early photo-paintings—*Party, Helga Matura, Folding Dryer, Swimmers, Mother and Daughter*—feature women flashing toothy smiles at the viewer, and implicitly, at the painter. In any event, the *Tourist* paintings led Richter to seek help from a psychologist to overcome the personal crisis he faced with Ema. In the end, though, the marriage could not be saved: in 1979 Richter moved out of the house on Brend'amourstraße. He and Ema divorced two years later.

It was only after the divorce that Richter felt he could return to the photographic motifs from 1972–1973. He painted several views of Davos (1981; CR 468/1–3, 469/1–2, 471) as well as more scenes inspired by the Greenland photographs, including *Ice* (*Eis*, 1981; CR 476), *Iceberg in Mist* (*Eisberg im Nebel*, 1982; CR 496/1; fig. 7.13), and *Iceberg* (*Eisberg*, 1982; CR 496/2; fig. 7.14), attempting to work through his unfulfilled hope for familial happiness and to take final stock of a difficult period in his life.

8 GRAY

The *48 Portraits* may constitute a high spot in Richter's career, but all the effort of preparing for the Venice Biennale had forced him to interrupt a very different development in his practice. For some time he had been making a concerted effort to turn away from what felt like the emotional weight of subject matter and to attend more fully and fundamentally to "painting." The interplay between painting as an illustrative medium and its inherent painterly qualities has always fascinated Richter, and in the summer of 1971, just before immersing himself in the Biennale project, he had completed two multipanel paintings of a Düsseldorf park using a wide, brushy stroke (CR 310, 311; fig. 8.1). The effect was to obscure details not by softly painting away strokes of the brush but by letting the brushwork stand. The closer to these canvases one moves, the more the view of the park dissolves into an abstract jungle of green paint.

Richter quickly pushed this well beyond the park motif. In the series *Untitled (green)* (*Ohne Titel [grün]*; CR 313–319), "the brush goes on its allotted way, from patch to patch of paint, first mediating and then . . . destroying, mixing, until there is no place left intact." Even so, in many of these works there exists, at a certain distance from the canvas, a remarkable luminescence that offers the suggestion of a light source behind the thicket of green paint. The effect is one of depth, with sections of the canvas thrown into shadow or highlight. As we have seen, Richter had previously undertaken experiments in this direction: in the series of twenty-two small paintings from 1968 (CR 194), he attempted to eliminate formation,

FIG. 8.1. *Park Piece (Parkstück)*, 1971. OIL ON CANVAS. 250 X 375 CM. CR 310.

composition, and subjective expression from painting, and the large-format *Color Streaks* (*Farbschlieren*; CR 192/2), from that same period, seems fully to anticipate the approach he explored in the fall of 1972 in a series of gray "inpaintings." In each of three 250-centimeter-square panels titled *Inpainting (gray)* (*Vermalung [grau]*; CR 326/1–3), Richter distributed varying gray tones of paint in seemingly infinite, curvy paths over the entire canvas. The brushy traces of pigment suspended in oil interpenetrate to form a dense thatch that no longer offers a fixed point of view, leaving the eye to wander over the surface. "I applied the paint in evenly spaced patches, or blobs, on the canvas. Not following any system at all, there were black and white blobs of paint, which I joined up with a brush until there are no bare canvas [*sic*] left uncovered and all the color patches were joined up and merged into gray. I just stopped when this was done."[1]

He was particularly intrigued by the spark of illusion that can emerge from nonreferential streaks of paint. Richter's burgeoning interest in color—its possibilities and optical limits—led him to use the process also in examinations of how color works, starting, in *Red-Blue-Yellow* (*Rot-Blau-Gelb*, 1972; CR 329–333/5), with the three primaries. "Three primary colors, as the source of endless sequences of tones: either tone by tone, systematically multiplied, and [precisely] presented (color charts), or this artificial jungle. The shades and forms emerge through the constant blending of brushstrokes; they create an illusionistic space, without any need for me to invent forms or signs."[2] Within this group, Richter has always thought 333/5 (fig. 8.2) the best and 333/2 (fig. 8.3) the least successful, because it is the "most delicious."

During the early 1970s the American painter Robert Ryman became an increasingly important figure for Richter, in part because Ryman's practice seemed to confirm his own.[3] Ryman had rescued painting for himself by understanding it as an object. In his work, the meanings and functions of painting are put on an equal footing with the other factors and conditions that define the work: the support and ground, the mounting, and the format, as well as the application of paint. Ryman worked on canvas, aluminum, fiberglass, wood, and steel, and mounted the panels on gallery walls with adhesive tape, screws, brackets, and aluminum tracks. Every aspect of production and presentation determined the aesthetic formulation of the painting-object.

Richter, on the other hand, had now reached the point of defining his paintings exclusively as painting. There was ample precedent for this in postwar modernism, but Richter's approach nonetheless managed to defy convention. The application of paint in the gray and the red-blue-yellow inpaintings is gestural without being expressive. Richter pulls the paint in emotionless paths over the canvas, almost by rote, equalizing every area of the surface and thereby suppressing composition. Always uneasy about exposing subjective decisions in his work, Richter succeeded in taking the inpaintings to a threshold where they exist—period. There are no underlying or overriding themes, no justifications, hierarchies, or declamations.

FIG. 8.2. *Red-Blue-Yellow (Rot-Blau-Gelb)*, 1972. OIL ON CANVAS. 250 × 200 CM. CR 333/5.

FIG. 8.3. *Red-Blue-Yellow (Rot-Blau-Gelb)*, 1972. OIL ON CANVAS. 250 × 200 CM. CR 333/2.

It is nearly impossible, for example, to designate the red-blue-yellow inpaintings as *color* paintings or depictions of color; they possess, at best, an indifferent colorfulness. The title *Red-Blue-Yellow* is thus a tease—less a traditional label than a list of the ingredients used in the act of painting. Yet out of this denial of every traditional semiotic and aesthetic component of the medium grew a brilliant, high-quality painting. Richter would later elaborate and radicalize this approach in a series titled, quite simply, *Gray*.

In 1973 the Munich-based auto maker BMW approached the artist to paint three enormous works for the foyer of its new building on the Petuelring. Each was to be three by six meters, much too large for Richter's studio on Harkortstraße, but with the help of the Düsseldorf city government he found a ten-thousand-square-meter space at Brückenstraße 7, in the harbor area. He held on to the studio on Harkortstraße but moved part of his operation into a windowless room on the second floor of the new building (fig. 8.4), where he painted *Red*, *Yellow*, and *Blue (Rot, Gelb, Blau*; CR 345/1–3) to complete the BMW commission. Looking back to the *Detail* paintings of 1970 and 1971, he again photographed details of stirred paint and then projected them onto large canvases to paint. Richter kept the windowless hall until 1976, using it to produce some new,

FIG. 8.5. RICHTER'S STUDIO, 1974.

large-format color charts (fig. 8.5) and many of the gray paintings. When a room with abundant natural light became available on the ground floor in late 1976, he moved downstairs.

NEW COLOR CHARTS

The color charts of the 1970s lack the representational aspect of their predecessors, which reference specific charts found in paint stores. Each of the five that Richter made in 1971 consists of 180 different tones mixed from the three primary colors. In the large-format charts CR 300/1–4, the colors are randomly arranged as squares on a geometric grid. CR 301 comprises twenty smaller paintings, with nine colors each. When pressed on his method of random selection, Richter has said, "Colors fit together like the right lottery picks."[4]

In 1973, with the extra space afforded by the new studio, Richter was able to push the color-chart concept to the extreme. First came four canvases accurately titled *1024 Colors* (*1024 Farben*; CR 350/1–4; fig. 8.6), each measuring 254 by 478 centimeters. In *4096 Colors* (CR 359), from 1974, each of the previous year's 1,024

FIG. 8.6. *1024 Colors (1024 Farben)*, 1973. ENAMEL ON CANVAS. 254 X 478 CM. CR 350/1.

distinct tones is repeated four times in smaller swatches, pushing the bounds of the eye's ability to differentiate colors. This canvas, 254 centimeters square, was the last of the color charts. A group of them was shown at Rudolf Zwirner's gallery in June 1974 and the next year in a multiartist exhibition in the Palais des Beaux-Arts in Brussels.

Richter wrote a text for the Brussels show describing how he had produced the charts:

> In order to be able to represent all extant color shades in one painting, I worked out a system which—starting with the three primaries plus gray—made possible a continual subdivision (differentiation) through equal gradations. $4 \times 4 = 16 \times 4 = 64 \times 4 = 256 \times 4 = 1024$. The multiplier 4 was necessary because I wanted to keep the image size, the [size of each field], and the number of [fields] in a constant proportion to each other. To use more than 1024 tones (4096 for example) seemed pointless since the difference between one shade and the next would no longer have been detectable. The arrangement of the colors on the [fields] was done by a random process to obtain a diffuse, undifferentiated overall effect, combined with stimulating detail. The rigid grid precludes the generation of figurations, although with an effort these can be detected.[5]

The process of producing the color charts was so labor intensive, tedious, and physically exhausting that Richter hired assistants to paint alongside him.

The program of random distribution of colors in the charts worked in counterpoint to the semiautomatic inpainting Richter used in the *Red-Blue-Yellow* works. In the latter, gestural brushstrokes of the three primary colors dissolve into an indifferent colorfulness. In the charts, colors disappear retinally in an overabundance of mixed tones. Both processes serve to minimize subjective, creative decisions. The works "take complete responsibility for themselves," a status radically different from that of the gray photo-paintings, where Richter felt compelled to feign disinterest in the motifs he chose. With the color charts and the inpaintings, the question never came up.

GRAY

The Bauhaus color theorist Johannes Itten described gray as devoid of character, "an infertile, expressionless neutral."[6] Richter has put it in similar terms. "To me gray is the welcome and only possible equivalent for indifference, noncommitment, absence of opinion, absence of shape," he wrote to Edy de Wilde, director of the Stedelijk Museum in Amsterdam, who was putting several gray paintings into a group exhibition (fig. 8.7).[7] "I cannot think of a color that has less expression."[8] His gray paintings, produced amid the supposed death throes of painting and

FIG. 8.7. *Gray (Grau)*, 1973. OIL ON CANVAS. 250 X 200 CM. CR 348/1.

the strife of his own marriage, thus reflect an absolute rejection of any traditional attitude toward painting. They are meant to exist at the brink of creativity, and he could describe them only in negative terms.

Monochromatic gray work had, in fact, been part of Richter's practice since 1968, when he began to paint over failed canvases. This mode of working entailed an act of destruction followed by rescue:

> When I first painted a number of canvasses gray all over, I did so because I did not know what to paint or what there might be to paint: so wretched a start could lead to nothing meaningful. As time went on, however, I observed differences of quality among the gray surfaces—and also that these betrayed nothing of the destructive motivation that lay behind them. The pictures began to teach me. By generalizing a personal dilemma, they resolved it. Destitution became a constructive statement; it became relative perfection, beauty, and therefore painting.[9]

In 1973 Richter started translating this insight into a constructive quality in his paintings that was at once a symptom and resolution of the personal and artistic stresses he faced. Blinky Palermo's decision that year to resettle in New York City, leaving his friend and collaborator behind, only compounded Richter's gloom. Even today Richter recalls that "the gray paintings represented a kind of resignation in which one becomes so despairing and nothing comes to mind anymore and one approaches the recognition that it is all over." The problem was resolved through an artistic concept, however reductive the results may appear. Richter's gray paintings come close to being artless gray paint application, but not quite. It is precisely in his stripping away of *artistry* that the *painterly* qualities achieve a lasting effect.

De Wilde's exhibition, titled "Fundamental Painting," focused on the abiding issue of process: line, structure, color, and medium were explored as functions, not values. The show included work by many American painters—Brice Marden, Robert Ryman, Robert Mangold, Agnes Martin, and Jerry Zeniuk among them— as well as several Europeans, such as Raimund Girke and Alan Charlton. Much fundamental painting is monochromatic, and most is stripped of personal references. Critics in the mid-1970s tended to describe the work as analytic, silent, conceptual, or radical, and to write repeatedly about the same artists, many of whom had been producing fundamental paintings for years. Richter, however, took pains to stress to Benjamin Buchloh that his position was unique: "I thought I had every right to [make monochromatic paintings] because I was doing it for a different reason, because the paintings have something different to say and also look different."[10] For Richter, the variety of his technique is of fundamental significance. The surfaces of the canvases, some of which appear at first glance to be identical, are anything but. The paintings vary in format, gray values, and application and type of paint. Richter custom-mixed the paint for each work, then

FIG. 8.8. GERHARD RICHTER, 1974.

applied it with a brush, putty knife, or roller using a variety of gestures to produce a multitude of textures and effects. When he cataloged the gray paintings in 1976, he not only noted their catalogue raisonné numbers and technical data, such as year and dimensions, but in nearly every case wrote a short description of the painting's physical characteristics.[11] Of one small painting from 1968 (CR 194/12), Richter noted, "Lighter gray, medium rough, evenly dabbed." For CR 247/7, from 1970, the description is "spots of oil, painterly, medium wide brush strokes," to which he added, "One never knows what is top or bottom." He distinguishes other paintings as, for instance, "relatively rough, dabbed, blue-gray" (1973; CR 348/1) or "finely structured, rolled, raw linen canvas" (1974; CR 365/1).

The gray paintings of 1973 through 1976 coincided with the most difficult phase of his marriage to Ema. "They have emotion and sadness, and one can feel moved by them," Richter told Coosje van Bruggen in 1985.[12] In a conversation with the author, he said, "When you feel more alive, you don't care about criticism from others." But in the mid-1970s, feeling very depressed, Richter found himself becoming prickly and overly sensitive to criticism of any kind. From a professional standpoint, at least, he felt some sense of security (soon to be proven false): "With the gray paintings, there are few points to attack; one can't do too much wrong."

And the painterly variations represented for Richter a constant attempt to make these paintings "even more beautiful and critically unassailable" (fig. 8.8).

At the end of 1974 Richter showed thirty-one of the gray paintings in a major exhibition at the Städtisches Museum in Mönchengladbach, which was accompanied by a limited-edition catalog box with an "original gray" painting on its inner lid.[13] The museum also acquired a series of eight identical gray paintings (CR 367/1–8), which it displayed in 1976 in the exhibition "Rooms" (*Räume*), together with works by Carl Andre, Marcel Broodthaers, Daniel Buren, Hans Hollein, Bruce Nauman, and Ulrich Rückreim. For that show's catalog, Richter formulated a short statement:

> No one painting is meant to be more beautiful than, or even different from, any other. Nor is it meant to be like any other, but the same; the same, though each was painted individually and by itself, not all together and not all of a piece like multiples. I intended them to look the same but not to be the same, and I intended [people to be able to see this].[14]

The paintings later found an ideal exhibition space in the new building, designed by Hans Hollein, that the museum opened in 1982.

Within Richter's oeuvre, the gray and the red-blue-yellow inpaintings, the color charts, and the gray monochromes of 1972 to 1976 should be viewed as a conceptual unit. They are much more sophisticated than the nonrepresentational works of the late 1960s—technically proficient, high-quality aesthetic formulations of that which can be neither seen nor illustrated.

AMERICA

Many years later, in a cover story about Richter's 2002 retrospective at the Museum of Modern Art in New York City, the *New York Times Magazine* called the artist "Europe's greatest modern painter."[15] In fact Richter's reputation in the United States had been building slowly but surely ever since the Guggenheim Museum acquired the painting *Passage* after showing it in "Nine Young Artists" in 1969. This was followed in 1973 by the artist's first U.S. solo exhibition, at the Onnasch Gallery in New York's Soho district. The gallery was the brainchild of Reinhard Onnasch, a real-estate mogul from Berlin, who had built one of the most extensive collections of contemporary art in Germany. The collection featured eighteen paintings by Richter, including several key works: *Table, Stag, Swimmers, Volker Bradke*, and one of the large seascapes from 1969 (CR 234). Onnasch had operated a gallery since 1968, first on the Kurfürstendamm in Berlin and since 1971 also in Cologne.

In April 1973 Onnasch wrote to tell Richter that he had developed a relation-

ship with the Sidney Janis Gallery in New York, and mentioned the possibility of a one-man show there.[16] The plan fell through, but a few months later Onnasch opened his own commercial space at 139 Spring Street. The premier brought together paintings by Richter from the previous decade. The artist had been less than enthusiastic when Onnasch first approached him, thinking it was still too early for a one-person show in New York. Also, he would rather have been put forward by an American gallery than "forced upon the public by a German." But because Onnasch already had enough paintings in his own collection to mount a show, Richter finally agreed to the project, providing additional work from his studio: "If the exhibition is going to take place anyway, I would rather support it so at least the show is good."

When the show opened, on September 15, 1973, with the artist present, only two paintings from Onnasch's collection hung on the wall: *Stag* and *Seascape (Wave)* (CR 234). From Richter's studio came several early works—*Cow*, *Family at the Seaside*, and *Dancers* (*Tänzerinnen*, 1966; CR 123)—as well as his new inpaintings *Red-Blue-Yellow (reddish)* (*Rot-Blau-Gelb [rötlich]*; CR 327), *Red-Blue-Yellow (greenish)* (*Rot-Blau-Gelb [grünlich]*; CR 328), and the three-part *Inpainting (gray)*, later to be purchased by Karl Ströher, the father of the German businesswoman and art collector Sylvia Ströher.

During the show Onnasch managed to sell just one large cityscape (*Cityscape PL*; CR 249), which went to a collector not from the United States but from Sydney, Australia. Not only was the exhibition not a commercial success, it took some serious hits from the press. In a painful review in *Artforum*, James Collins ranked Richter well below the American artists Andy Warhol, Brice Marden, and Robert Ryman:

> The nature of Richter's hit-and-run approach to already existing styles of painting lacks the conviction of the painting by artists more deeply committed to these modes. This is not true so much of Richter's figurative work, especially the blurred focus paintings like "Hirsch" and "Tänzerinnen" which are more original, and for this reason alone, I suspect, more successful. It's the abstract ones with a more readily available contemporary history that fare badly comparatively. The '72 gray paintings particularly, with their single color matte- and gloss-inflected surfaces just seem too close, and in this case too late, to the whole Klein, Marden, Ryman Minimalist era, to have any particular importance individually.[17]

Onnasch put on only two more exhibitions (for George Brecht and William Copley) before folding his tent and pulling out of New York.

Just a few months later, however, René Block opened a satellite gallery in the Soho district with the backing of Günther Ulbricht, a Düsseldorf collector who had amassed a sizable collection of Richter's work.[18] The gallery had a good location on West Broadway, and Block's first effort was to introduce New York audiences to

Joseph Beuys, K. P. Brehmer, Reiner Ruthenbeck, and Sigmar Polke. Richter was represented by a single, large gray painting. For several days before the opening, Beuys took over the gallery with his now-notorious action *I Like America and America Likes Me*, during which he shared the space with an American coyote. Very few people attended.

Block kept the Soho gallery open for three years, finally closing it in 1977. During that time, he had become somewhat less enamored of Richter's work. The recent work—the inpaintings and color charts—had no moral or political dimension he could plug into. His last exhibition with Richter opened on February 8, 1974, in Berlin, on the eve of the artist's forty-second birthday. Shown were the four large-format *Red-Blue-Yellow* inpaintings (CR 335/1–4) from 1973.

HANS GROTHE

In 1975 a new powerhouse collector arrived on the scene. Hans Grothe was an entrepreneur from Duisburg who had gained notoriety by purchasing Sigmar Polke's show "Original + Forgery" (in the Kunstverein Münster in Westphalia) in its entirety, paying a total of DM 20,000 for all thirty-eight paintings. With Polke firmly in the bag, Grothe now trained his sights on Richter, contacting him to say he wanted to acquire paintings in quantity. Without mincing words, he asked the artist to assemble a representative group of work for him to buy. Richter chose twelve paintings, including several that Onnasch had shown in New York. Grothe bought the lot without hesitation. "I appreciated it. But I didn't get on too well personally with Grothe," says Richter. According to Grothe, the artist handed over the works saying simply, "From my photo-paintings through to my gray painting."[19]

"It was my luck to succeed in collecting something extraordinary. . . . It is impossible for someone else to collect what I did, no matter how much money they have. You can't get it anymore. . . . Because Gerhard Richter himself selected the paintings and how they should be arranged. [It is unique and] anything unique makes a collector happy,"[20] Grothe explained in 1995. From the vantage of the 1990s, he loved to talk about his prescience and price-conscious purchasing two decades earlier, when Polkes and Richters were to be had for "pocket change" and "the fact that the two would take off was something no one could have known at the time."[21]

A year after his first purchase from Richter, Grothe came back for more, this time acquiring the three-part landscape *Alps II* (*Alpen II*, 1968/1969; CR 213) and two color charts from 1973 (CR 355/1–2). In 1992 he acquired *Abstract Painting* (*Abstraktes Bild*, 1988; CR 666/4) via Christie's in London, and later *Abstract Painting* (*Abstraktes Bild*, 1992; CR 781/1–6), which comprises six narrow (340 x 65 cm) panels.

Over time, Grothe's collection grew to more than a thousand works of art, achieving not only art-historical significance but importance in terms of German cultural politics. Parts of it were put on display at the Kunstmuseum in Bonn, the Museum Weserburg in Bremen, and the Museum Küppersmühle–Sammlung Grothe in Duisburg, which was built in 1999 expressly to showcase the entrepreneur's acquisitions. By then the collection was filled with treasures by Georg Baselitz, Markus Lüpertz, Jörg Immendorff, Anselm Kiefer, Gotthard Graubner, Ulrich Rückriem, and Hanne Darboven, and by such younger artists as Andreas Gursky, Thomas Ruff, Stephan Balkenhol, and Rosemarie Trockel. With his commitment to the permanent display of artists' work and his vow never to sell anything, Grothe won over many artists. Even as late as 1999 he stressed, "Whether or not a Richter at some point will be worth 20 million marks is of no interest to me, for it hangs on the wall, and it will stay there. I will not sell it."[22]

Famous last words. Not two years later he sold *Dancers* for $8.8 million to the French collector François Pinault. At almost the same moment he auctioned off several more Richters, including *Detail (red-blue)* (CR 273) and *1024 Colors* (CR 355/2), together with numerous works by other artists. Finally, in 2005, Grothe sold his remaining collection of seven hundred works to Sylvia and Ulrich Ströher, heirs of the Wella cosmetics empire, for 50 million euros. The Ströhers also acquired the private Museum Küppersmühle in Duisburg from Grothe.

GILBERT & GEORGE

In 1975 Richter took up the Romantic theme of the artist friendship, which had surfaced before, particularly in his collaborations with Blinky Palermo. It was a kind of relationship he now recognized in the eccentric duo Gilbert & George, who, like Richter and Palermo, had positioned themselves outside the dominant art movements of the time: minimalism, conceptualism, and land art. "I liked them as outsiders, above all . . . too, I liked [their] very nostalgic side. They were the first people who liked my landscapes. I think what impressed me the most was the way they took their own independence as a matter of course."[23]

Richter met Gilbert & George during the pair's first show at Konrad Fischer's gallery in 1970. "The Pencil on Paper Descriptive Works" opened on May 10, immediately following Richter's show. Gilbert Proesch was born in 1943 in South Tyrol, and George Passmore in 1942 in Totness, Devon, in England. Both had studied at St. Martin's School of Art in London, and they had begun collaborating as Gilbert & George in 1968. Significant to their early practice were performances in which they presented themselves as "living sculptures."

During one of their later events at Fischer's gallery, in March 1974, Gilbert &

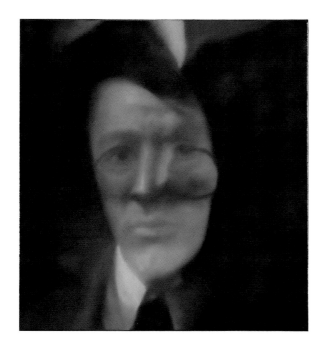

FIG. 8.9. *Gilbert*, 1975. OIL ON CANVAS. 65 × 60 CM. CR 381/1.

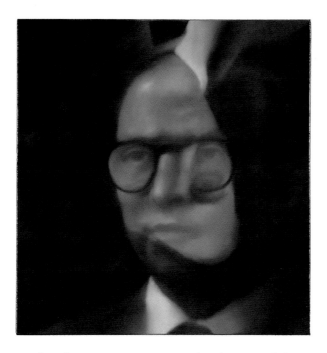

FIG. 8.10. *George*, 1975. OIL ON CANVAS. 65 × 60 CM. CR 381/2.

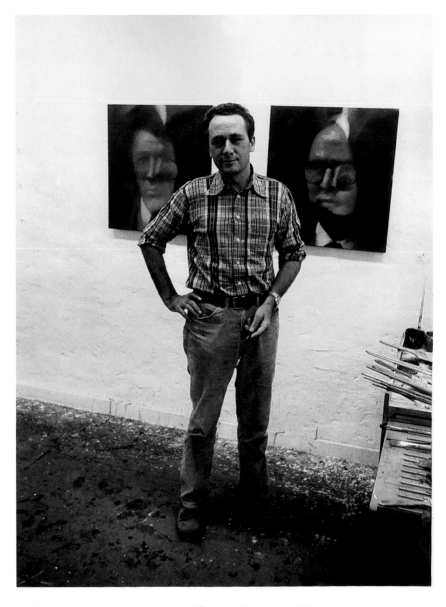

FIG. 8.11. RICHTER IN HIS STUDIO WITH *Gilbert* AND *George*, CR 381/1–2, 1975.

George asked Richter to paint their portraits. Though Richter respected the couple, he had little desire to take on the assignment and tried to slip out of it by insisting, for example, that they go on location to the Alps to take the photographs for the portraits. When the artists promptly agreed, Richter finally gave in—and shifted the photo shoot to the more convenient locale of his own garden at Brend'amourstraße. Marching around with a camera, he shot Gilbert & George from multiple positions and angles, making complex multiple exposures in which

both men appear upside down and their faces fold into themselves and each other. Richter made eight color paintings from the photographs but was not entirely satisfied with the results. What was an acceptable effect in photography looked too *artistic* when painted. "The difficulty is that it looks so much like a trick. Not to mention the paintings were also very manneristic. Both of the small portraits end up looking like they were by Francis Bacon."

Richter's favorite of the group is the schematic portrait *Gilbert* (CR 382/1). He finds the more harmonious *Gilbert & George* (CR 380) to be *too* accomplished, generating not enough aesthetic resistance for his taste. Gilbert & George themselves acquired the small paintings *Gilbert* (CR 381/1; fig. 8.9) and *George* (CR 381/2; fig. 8.10), shown in Richter's studio in figure 8.11.[24]

Konrad Fischer showed all eight of the paintings in a one-man show for Richter in 1975. He also displayed four seascapes (CR 375–378); the *Tourist* series; two paintings titled *Fiction*, which Richter would later destroy; and three gray paintings (CR 365/1–3), as well as the large-format color chart (CR 351) from 1973.

MORE EXHIBITIONS

In 1976 Klaus Honnef, who had organized Richter's 1969 show in Aachen, wrote a book about the artist as the fiftieth and final volume in the series Monographs on Contemporary Art in Rhineland and Westfalia (*Monographien zur rhein-isch-westfälischen Kunst der Gegenwart*). Honnef's thesis builds upon his earlier proposition that "stylistic rupture" constitutes a "stylistic principle" for Richter. His argument centers on the juxtaposition of three very different paintings from early in Richter's career: *Cow* (1964), *Twelve Colors* (1966; CR 137), and one of the small abstracts from 1968 in which the dominant vertical structure arises from an Informel gesture (CR 194/9; fig. 5.20A). Ruling the differences among the three paintings irreconcilable, Honnef concludes, "If one nevertheless wishes to filter out one characteristic that dominates the works throughout, it can only be a characteristic that is the opposite of 'artistic consistency.'"[25]

In 1973 the Society for the Promotion of Contemporary Art in Bremen had acquired *Red-Blue-Yellow* (1972; CR 333/2)—the version Richter found "most delicious"—for its Kunsthalle, and from that moment started planning a retrospective for the artist. The Bremen show would open two years later (November 30, 1975–January 18, 1976), offering, in thirty paintings, a concentrated but representative cross-section of Richter's work, ranging from the very early *Coffin Bearers* to *256 Colors* (CR 352/1–2) and the gray paintings of 1974 (CR 361, 363). A lavishly illustrated catalog included numerous works beyond those in the exhibition. Reviewing the retrospective for the weekly newspaper *Die Zeit*, Petra Kipphoff wrote:

Gerhard Richter denounces, from inconsequence to inconsequence, all maxims and standpoints; he shows, from style variation to style variation, that reality is only an optical question, that it can alternatively involve a detail or a birds-eye view, or something in between, figurative or abstract, that it can never be definitively experienced.[26]

The show then traveled to the Palais des Beaux-Arts in Brussels, where Richter rounded it out with two Gilbert & George paintings (CR 383, 384).

Richter was growing weary of retrospectives. His prominence as an artist was closely tied to the photo-paintings, and he wanted to move on. The opportunity arose when he was offered a show at the new Museé national d'art Moderne in the Centre Pompidou, in Paris's traditional Jewish quarter, the Marais. The exhibition was to be one of three celebrating the dedication of the building designed by Richard Rogers and Renzo Piano, and as such ensured Richter high exposure and an international audience. Richter took advantage of the opening to position himself as a conceptual painter whose abstract work is both accentuated and challenged at decisive moments by figurative or landscape cycles. Though virtually unknown to the French, he refused to show even a single early photo-painting or, indeed, any work from the 1960s. Instead, he chose newer and mostly abstract paintings, along with the *48 Portraits*, the four versions of *1024 Colors*, and several views of Mt. Vesuvius (CR 404, 406, 407, 409, 410). In conceiving and hanging the Paris show, he enlisted the aid of Benjamin Buchloh, who also wrote the text for the catalog.

In a preface to the catalog, Pontus Hulten, first director of the Museé national d'art Moderne, cited Richter as an outstanding painter and member of the generation of artists in Germany that came after Joseph Beuys: "So important today in Germany, these artists brilliantly practice a form of expression midway between conceptual art and Arte Povera. The particular contribution of Gerhard Richter will have been to reconcile this expression with the problems of realism."[27] Not everyone, however, was thrilled with the show. Years later Werner Spies, who was then director of the museum, remarked to Richter that the sparse selection of work he presented had been an "incredible mistake" and accused him of having snubbed the French public.

9 JUNO AND JANUS

Despite the energy that had gone into the gray paintings, their reductive potential was quickly exhausted, culminating in the eight identical canvases displayed in Mönchengladbach in 1976. "My paintings became more and more impersonal and general until nothing was left but monochrome gray or colors next to each other, any unmodulated color. Then I was totally outside my paintings. But I didn't feel well either. You can't live like that, and therefore I decided to paint the exact opposite."[1] Caught in an artistic cul-de-sac, Richter was finally ready to acknowledge that what he had been experiencing as an artistic crisis actually reflected a personal one. He sought psychiatric counseling. At the same time, his art underwent a dramatic transformation.

Choosing a large canvas (250 × 300 cm), he started to paint a complex, vibrantly multicolored abstract composition titled *Construction* (*Konstruktion*; CR 389; fig. 9.1). A more evocative antithesis to the numb gray paintings is hard to imagine: the dark brown ground is sliced by hard-edge vectors of color overlaid with strokes of fiery yellows and reds, creating the dramatic effect of a projection deep into infinite space. The perspective, however, is dizzying and illogical; it prevents the viewer's eye from settling on a specific figure or object. Even the colors seem charged with illusion: the homogeneous, acompositional application of paint in the gray paintings had given way to an anticompositional spate of pictorial elements.

Construction was important for Richter, not in its own right but as a stepping stone to even more abstract paintings. Indeed, the very title—*Construction*—describes what made the painting problematic. It was actually too "constructed

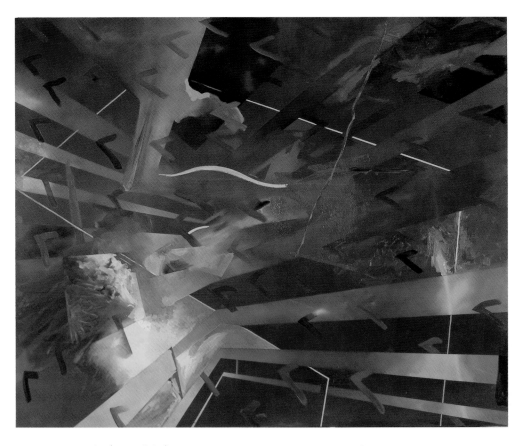

FIG. 9.1. *Construction (Konstruktion)*, 1976. OIL ON CANVAS. 250 × 300 CM. CR 389.

and thought out." The result, he concluded, was contrived, the perspectival space becoming too much of a subject in itself.

Dissatisfied with *Construction*'s pretense of infinitude, Richter decided to test his new way of painting on a more modest scale, working on canvases often less than 50 centimeters wide. In an interview with Marlies Grüterich, he described the new venture:

> After those strictly monochromatic or nonchromatic paintings it was rather diffi-cult just to keep going. Even if such a thing had been possible, I had no desire to produce variations on that theme. So I set out in the totally opposite direction. On small canvases I put random, illogical colors and forms—mostly with long pauses in between, which made sure that these paintings—if you can call them that—became more and more heterogeneous. Ugly sketches is what they are: the total antithesis of the purist grey pictures. Colorful, sentimental, associative, anachronistic, random, polysemic, almost like Rorschach inkblot tests except that they are not legible because they are devoid of meaning or logic—if such a thing is possible, which is a fascinating point in itself, if not the most important of all, though I still know too little about it. An exciting business, at all events, as if [I had opened a new door for myself].[2]

The sketches, as Richter called them, do not conform to any specific tradition. Critics sometimes cite Informel painting and the Ecole de Paris from the 1950s as a base reference, but only to distinguish them from Richter's other abstract work.[3] "Viewed superficially, [they] appear to speak the language of 'abstract expressionism,' and would therefore be in their decisive content an expression of psychic activity or of a world view. However, we search in vain for any of this in these paintings,"[4] wrote the curator Heribert Heere in 1982. Richter would have agreed with critics like Heere, who was sympathetic to his "antiposition" relative to Informel. On the other hand, he does not deny that Informel has influenced his work. "This 'Informel' runs through every picture I've painted, whether it's a landscape, or a family painted from a photograph, or the color charts, or a Grey Picture," he said in 1984. In 1993, talking with Hans-Ulrich Obrist, he elaborated, stressing that his personal interest in Informel has less to do with style than with a kind of arbitrariness and engagement with the found object/image that follows from Duchamp.[5]

SOFT ABSTRACTS

The small abstract works were raw and aggressive, so much so that at first Richter would not accept them as valid paintings. "I called them 'sketches' to render them harmless and to be able to continue to paint in peace."[6] Still, they fascinated him. They were nonobjective and illusionistic at the same time, thanks to the complex spatial effects that emerged in the course of painting. The paint, whether thick and

sensual or laid down in thin layers, offered evidence of its own materiality—in the small blobs, bleedings, cross-hatchings, and clusters that develop on a surface—yet these same features would serve as points of orientation for the viewer seeking a familiar environment in abstract art. The sketches did not aspire to chromatic harmony; on the contrary, the colors collided. To subdue their roughness and immediacy, Richter once again introduced the objectivity and distance that can be had through photography. Making photographs of several sketches, in some cases only of details (*Atlas*, panels 403–412), he used them as motifs in large photorealistic works that he described as "soft abstracts."[7]

In contrast to the small sketches, the large soft abstracts involve a complex intervention of photographic reproduction, projection, and painterly reconstitution. The contrariness of the sketches dissolves into a spatial illusion, giving the large works a visual presence distinct from that of their models. The large surfaces softly blurred with the brush present never-before-seen pictorial spaces. Richter titled these works *Abstraktes Bild*. As Robert Storr has written:

> The choice of title is significant in that it reinforces the impression conveyed by the illusionistic description of shoals, riptides, and cresting waves of pigment that these are pictures of gestural paintings not of the spontaneously eventful real thing.[8]

When he was younger Richter had excluded active "composition" from his process by adopting the composition of the photographs he was using as models. In the color charts and gray paintings he did so through a nonhierarchical, uniform application of paint. Now, through the interplay of image and model—the painting of the original sketches, their photographic transformation, and the recovery of the motif through repainting—the composition of shapes and colors becomes appropriated anew. These soft abstracts do, however, lack the immediacy of painting as such. Perhaps this is why in retrospect Richter has held a rather dim view of them: "I don't like these paintings. A few are very nice, the more broken, rough ones. But otherwise, the works have something mannerist, something unliberated. In particular, CR 421 is an idiotic painting, so sweet and so matte." It was precisely this canvas, however, that was slated for exposition at Documenta 6.

DOCUMENTA 6

If ever there was a notorious art event, it was Documenta 6, directed by art historian Manfred Schneckenberger. Evelyn Weiss, curator of the Museum Ludwig in Cologne, and Klaus Honnef headed up the painting division and invited several socialist realist artists from East Germany to participate, with explosive results. As Willi Sitte, Werner Tübke, Wolfgang Mattheuer, and Bernhard Heisig were added to the roster, other artists withdrew in protest, including Georg Baselitz, Markus Lüpertz, and A. R. Penck.

In the days that led up to the opening, the already difficult preparations escalated into a full-blown scandal; the preview was nearly canceled due to the chaos. When the spectacle finally opened to the public on June 24, 1977, sections of the New Gallery and of the Orangerie building in the Karlsaue of Kassel still weren't ready. Elsewhere, dealers were taking the liberty of repositioning artwork, including major pieces by Andy Warhol and Nancy Graves. During an interview Honnef revealed that he and the other curators were under immense pressure from certain dealers and had capitulated: "It's perhaps a bit too pointedly expressed, but I would say we were more or less blackmailed. I gave in, and I also have to explain why: I don't live alone in the world, and I have no desire to change my profession after Documenta is over. That is, I am dependent. I have to work with these people again. . . . It's simply facing reality."[9] The day after the opening, he and Weiss resigned.

Weiss and Honnef had chosen two of Richter's soft abstracts (1977; CR 421, 422), which were destined for the section "Painting as a Theme of Painting." Photographs taken before the grand opening show the paintings hanging side by side. The scattershot assemblage of artists—from Gotthard Graubner, Raimund Girke, and Gerhard Merz to Willem de Kooning, Chuck Close, and Hanne Darboven—illustrates just how weak and overworked the theme was. "'Painting about Painting.' It's astonishing how easily people swallow slogans like that . . . when in fact it's all total nonsense," Richter told an interviewer.[10]

What's more, Richter was dissatisfied with the presentation of his paintings. In his mind they had been put in a subordinate position to a colorful aluminum relief by Frank Stella (*Laysan Millerbird*, 1977, 370 × 550 cm) that hung nearby. Although not small—the larger *Abstract Painting* (CR 422) measured three by two meters—they were overpowered by the American's gargantuan work. "It was also injured vanity. A large painting of mine hung there, but next to it was a much bigger work by Frank Stella. I felt as if I had been mistreated, judged inferior," Richter says, remembering the situation. The experience may have reminded him of how Heiner Friedrich always seemed to favor American artists at his expense. He submitted a formal request that his paintings be moved, but when nothing happened, he took them down himself and had them shipped back to his studio.

KONRAD FISCHER

The two Documenta paintings were not shown in public until several months later, in Richter's fourth exhibition with Konrad Fischer (October 22–November 22, 1977). For that show Richter chose four soft abstracts (CR 423, 426, 428, 429), along with nine of his abstract sketches, only one of which had served as the model for an included painting (CR 431/1; fig. 9.2). He quite consciously hung the sketch and its larger avatar (CR 428; fig. 9.3) in separate rooms, wanting each to stand on its own and not be forced into comparison.

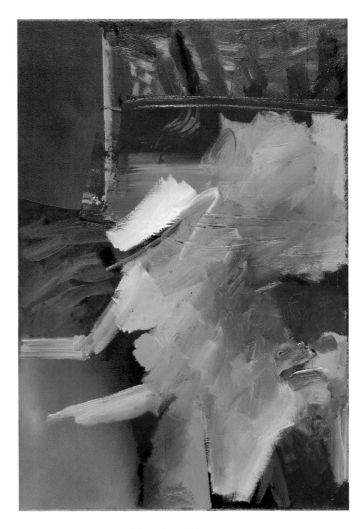

FIG. 9.2. *Abstract Painting (Abstraktes Bild)*, 1977. OIL ON CANVAS. 78 × 52 CM. CR 431/1.

FIG. 9.3. *Abstract Painting (Abstraktes Bild)*, 1977. OIL ON CANVAS. 200 X 300 CM. CR 428.

Local reviewers reacted with irritation. "At Fischer's gallery, the small formats serve only as—for better or worse—necessary preparations for the large paintings. All told, they are dull . . . though in the less-charged atmosphere of the studio, the small sketches reveal a unique strength," reported the *Rheinische Post* (fig. 9.4).[11]

In 1975 Fischer had joined dealer Gian Enzo Sperone from Turin in establishing a gallery in Manhattan, with Angela Westwater as the director. Sperone Westwater Fischer opened in October with an exhibition by Carl Andre, who was also the first artist Fischer had shown in Düsseldorf. Shortly after Richter's Düsseldorf exhibition, Fischer sent the show to New York, though the selection was slightly different. As in 1973, Richter had reservations about showing his work in New York: "I didn't really want to have this exhibition so soon. I thought, I'm not at that point yet, I can't do it." At least in terms of American critical response, his concerns turned out to be well founded. In *Artforum*, Barbara Flynn formulated a helpless lack of understanding: "I like looking at these paintings, which is a lot as far as I am concerned, but I've never bought the theoretical groundwork that goes with them. I've always felt it was the work of people who liked to look at the pictures as I do, but went too far in explaining why."[12]

Fischer remained a partner in the New York gallery until 1981. When Sperone started to weight the program toward the young Italian Arte Cifra painters with their highly introspective marks and ciphers, and as a new wave of trans–avant-gardism and neo-expressionism loomed, Fischer pulled out. "From a business standpoint, my withdrawal was foolish. The neo-expressionists became a huge success," he admitted later in a conversation with Stella Baum.[13]

Over the course of the 1970s Fischer had continued to build his position as one of the most influential avant-garde gallerists in Europe. He possessed flair and intelligence and had pulled in many of the outstanding artists of his generation, from Carl Andre to Sol LeWitt, Richard Long, Bruce Nauman, and Lawrence Weiner, not to mention Mario Merz and Robert Ryman. He also had an eye for new talent: Wolfgang Laib, Thomas Schütte, Reinhard Mucha, Ludger Gerdes, Lothar Baumgarten, Isa Genzken, and Tony Cragg all had early shows with Fischer.

Between 1968 and 1976 Fischer, together with his childhood friend and fellow gallerist Hans Strelow, organized three exhibitions in Düsseldorf's Städtische Kunsthalle under the general title "Prospect." From the beginning, the idea of entrusting private dealers to develop publically funded exhibitions met with skepticism. In 1976 especially, the catalog that Fischer, Strelow, and John Matheson produced for "ProspectRetrospect" was vehemently criticized. The curators gave a highly subjective account of the most important artistic events in Europe since 1946, with Fischer exerting considerable influence over which exhibitions and artists were discussed. In an op-ed piece in *Kunstmagazin*, Wieland Schmied accused the organizers of a "distortion of history without equal," citing numerous

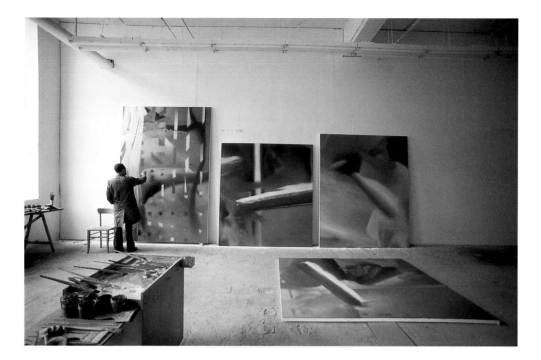

FIG. 9.4. RICHTER IN HIS STUDIO, 1977.

points that demonstrated their bias, the most blatant being their mention of two of the artists shown in the German pavilion at that year's Venice Biennale—Joseph Beuys and Reiner Ruthenbeck, both represented by Fischer—but not the third, Jochen Gerz.[14] A protest ensued, with the result that "Prospect*Retrospect*" was Düsseldorf's final "Prospect" exhibition.

Throughout Europe, Fischer wielded enormous power, and for years Richter participated in shows in public institutions dominated by his artists. The 1974 show at the Palais des Beaux-Arts in Brussels, organized by Yves Gevaert, included works by Carl Andre, Marcel Broodthaers, Daniel Buren, Victor Burgin, Gilbert & George, On Kawara, Richard Long, and Richter. Of these, only Burgin had never exhibited with Fischer (though Broodthaers did not show with Fischer until 1978). Similarly, of the artists in the 1976 exhibition "Spaces" (*Räume*) at the Städtisches Museum in Mönchengladbach, only architect Hans Hollein was not somehow connected to Fischer. Two years later, the Halle für Internationale neue Kunst in Zürich even held an exhibition with the express purpose of showcasing a group of "Fischer artists" (Beuys, Broodthaers, Buren, Kounellis, Merz, and Richter).

In February 1979 Richter was one of only seven non-Canadian artists picked for an exhibition at the National Gallery of Canada in Ottawa. Of the seven, five—Richter, Beuys, Ryman, Nauman, and Richard Serra—had shown with

Fischer (the other two were Jannis Kounellis and James Turrell). Richter wrote to Benjamin Buchloh:

> As much as I recognize my advantage, and as flattered as I am to be one of only seven non-Canadians . . . I am equally uncomfortable with the ungainliness of this exhibition and the entire trend in which I place it, and with Konrad's growing importance and monopolistic position. Perhaps I am seeing it incorrectly, but it makes me angry that Konrad, like many other politicians, has so much power and as such prevents everything from moving along.[15]

Having lived through two oppressive regimes, Richter had always been wary of affording too much power and influence to any one person; thus he sometimes downplays the significant role Fischer played in marketing his work. "There weren't that many exhibitions, the contact was not good, and he was also not my most important gallerist. But I also did not have one who was more important" in the 1970s. Between 1970 and 1983, in fact, Richter exhibited six times with Fischer, who also sold numerous paintings between shows. Today Kasper König is quick to underscore how important Fischer was to Richter's career. The international context in which his paintings were exhibited and received was "absolutely to Gerhard Richter's benefit."[16]

Fischer, who died in 1996, was in many ways an unconventional dealer. His supposed disinterest in the commercial side of the art business was legendary and could intimidate collectors. König believes the behavior was of conscious design: acting as though it was beneath him to actively promote anything set him up to receive customers as petitioners.[17] Daniel Birnbaum, who succeeded König as director of the Städelschule and the Austellungsbox Portikus in Frankfurt, put it this way: "[His] unorthodox unwillingness to sell, and at times even to communicate, no doubt confused and alienated some. If potential clients wanted to buy for the wrong reasons, Fischer would pretend that there was nothing for sale or even feign an inability to hear what they were saying."[18] Such behavior infuriated Richter and was one reason he quit showing with his former comrade-in-arms after 1983. Fred Jahn had just offered him a show in Munich, which made the decision to leave Fischer that much easier.

Jahn had joined Galerie Friedrich in 1966, when he was just twenty-three, working first as a freelance salesman and later becoming a managing partner. When he left the gallery in 1977 he was prevented by a clause in his contract from doing business with any of the gallery's artists for a period of two years. Once that restriction ended, however, Jahn opened his own gallery at Maximilianstraße 10. Because Richter had departed so unhappily from Galerie Friedrich, Jahn had lost contact with him. But he had been privately buying Richter's paintings and drawings, and his expert handing of the sale of the *Atlas* served to reestablish cordial relations with the artist. The next step was direct collaboration: Jahn was the driving force

behind exhibitions of Richter's abstract paintings at the Kunsthalle Bielefeld and the Kunstverein Mannheim (1982), of his watercolors at the Staatsgalerie Stuttgart (1985), and of the *Atlas* at the Städtische Galerie im Lenbachhaus (1989) and at the Museum Ludwig in Cologne (1990).

ISA GENZKEN

Isa Genzken was already an accomplished artist when she was introduced to Richter at the Düsseldorf academy. Born in 1948 in Bad Oldesloe in northern Germany, she had studied with Almir Mavignier at the Fine Arts Academy in nearby Hamburg, beginning in 1969. In 1971 she transferred to the Fine Arts Academy in Berlin, and then, two years later, to Düsseldorf. Upon graduating, she taught sculpture at the academy, followed by a one-year appointment at the Fachhochschule Niederrhein (University of Applied Sciences) in Krefeld. As a student Genzken had already shown in "Konrad Fischer's room" on Neubrück-straße (January 10–22, 1976), which is where he exhibited young artists after moving his main gallery to Platanenstraße.

Gifted and keenly smart, Genzken quickly established a conceptual practice far removed from the surge of young neo-expressionist artists like Rainer Fetting and Walter Dahn, who were gaining popularity in Germany and storming the art scene in New York. Her work was exhibited in 1979 at Museum Haus Lange, Krefeld, and she also took part in the "Europa 79" exhibition in Stuttgart, where gallerists Ursula Schurr, Max Hetzler, and Hans-Jürgen Müller (whom Richter had painted in 1965; CR 71) showcased 120 young European artists. In 1981 Konrad Fischer showed one of her sculptures in the "Heute" (Today) section of Kasper König's "Westkunst" exhibition in Cologne. With work by thirty-seven international artists—Jenny Holzer, Francesco Clemente, Anselm Kiefer, Gerhard Merz, Thomas Schütte, and Jeff Wall among them—the show promised "a snapshot of the current, contemporary scene."[19]

Genzken's early conceptual work is especially distinctive. One of her interests was in how oral/aural communication could be presented visually: in one work she combined large close-ups of human ears with a shortwave radio and presented the ensemble on a plinth. In another, she photographed ads for high-fidelity audio components from various manufacturers, which she enlarged and framed. Such projects linked Genzken to American artists Richard Prince, Sherrie Levine, and Jeff Koons, all of whom were conducting experiments in semiosis by retrieving photographs made by other people and presenting them in new contexts.

What brought Genzken the most attention, though, were her painted wood Ellipsoids and Hyperbolos. These sculptures fascinate through their unusual form, being several meters long but only a few centimeters wide. The most ex-

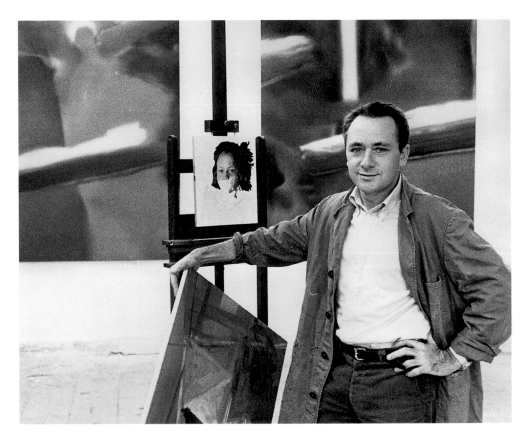

FIG. 9.5. RICHTER IN HIS STUDIO, 1977. ON THE EASEL IS A PORTRAIT OF BETTY.

treme is *Red Gray Open Ellipsoid* (*Rot-graues offenes Ellipsoid*) from 1978, which is 11.8 meters long and, at maximum, 26 centimeters wide. The volume, which swells and shrinks slightly along its length, was designed using a computer, crafted out of wood using a rather complicated procedure, and finished with the application of various colors of enamel. The Ellipsoids rest on only one surface point, while the Hyperbolos rest on two points, appearing to float gently above the floor.

Genzken had met Richter in passing in the early 1970s through Benjamin Buchloh. They became reacquainted in 1977, the year Buchloh left Germany to teach at the Nova Scotia College of Art and Design in Halifax (fig. 9.5). Not long after arriving in Canada, Buchloh asked Richter if he would like to come over to teach during the 1978 summer semester. From Richter's perspective, a stay in far-off Canada would offer a temporary respite from his troubles at home. By then, he and Genzken had started to grow close even though he was still married to Ema. However, the situation was somewhat further complicated by the fact that Genzken, too, was in a serious relationship—with Buchloh.

HALIFAX

Richter went to Halifax nonetheless, where he and Buchloh seem to have enjoyed a productive collaboration. Richter lacked a proper studio at the school and so decided to improvise some small projects. In the evenings, he worked on a series of sixty-six tiny abstract pencil drawings, each only 9 by 7 centimeters. Konrad Fischer exhibited these drawings in October 1979 along with works by Blinky Palermo and Mario Merz. He also painted *Halifax* (1978; CR 432/5), an abstraction of modest size, which he then subjected to rigorous photographic analysis, shooting numerous details from different angles. He chose 128 views in black and white, mounted prints in four-by-four grids on eight white cardboard panels, and arranged the panels in two rows of four. The resulting work confronts the viewer with the simultaneity of 128 interruptions in the painting's surface, preventing a full reconstruction of the painted original. Richter showed this version of *128 details from a picture (Halifax 1978)* in a room of the Nova Scotia College of Art and Design from August 21 to September 9, 1978.[20]

Richter also published the photographs as the second volume in the Nova Scotia Pamphlet series, with four images per two-page spread. Richter had returned to Germany, prompting a lengthy correspondence about the project with Buchloh, who was serving as editor. The printed book, which appeared in 1980, contains a concise text by Richter detailing how the photos were produced and transformed into a book and a set of image panels. Richter had actually prepared several alternative texts but left the final choice to Buchloh.[21] One of the alternatives offered a "more complicated" description of the project in which Richter mulls over the complex relationship between painting and photography in his practice:

> For the exhibition 17 PICTURES in the Summer of 78 at Anna Leonowens Gallery [July 4–18], which included small-format abstract sketches, landscapes and gray monochrome paintings, I emphasized the term "picture" instead of "painting." In doing this, I wanted to place the emphasis on the distance demonstrated by the dissimilarity of the subject from painting, which I had used as a method, but was not striving for as a goal. Over the last two years, I had transformed the above-mentioned oil sketches (as an attempt at painting without a plan, without style, construction or expression, but at the same time not blind or determined automatically or according to coincidence) into large-format "pictures," which replace the reality of the painting of the sketches with their appearance. The method for the 128 photos shown here is similar; the difference is that the photo is more decisively about appearance than a painting ever could be. For the painted picture, even if it is wholly illusionistic, it always retains its reality as a hand-made picture such as is traditionally defined as a painting. On the other hand, the photo loses its own reality ever more, the more exactly it depicts the other. Seen in this way the only "reality" of the photo is its own unreality, the non-presence of the photo is its fundamental quality.

MORE EXHIBITIONS

Returning from Halifax, Richter immediately started to prepare for an exhibition of the soft abstractions in the Stedelijk van Abbemuseum in Eindhoven. The paintings were still not very well known; Richter had shown only a handful in two prior gallery shows. The museum's director, Rudi Fuchs, describes the works in the catalog's preface as "artificial miracles" but then adds, "The problem, it seems to me, is what exactly to look at; and then too, what is there to see? These new (abstract) paintings by Gerhard Richter are evidently quite complex. In them different concepts of the pictorial *craft* (I do not say, at this moment, art) are combined—in a certain order, as they were required in the process of making these images, but in the end (looking at the paintings now) without hierarchy."[22] Fuchs's measured response shows the fascination, but also the irritation, that these abstract pictures could provoke in a viewer.

The exhibition's second stop, the Whitechapel Art Gallery in London, was Richter's first show in Great Britain, so he salted the show with a few earlier works—*the Great Sphinx of Giza* (1964; CR 46), *Helga Matura with Her Fiancé*, two gray panels (1973; CR 349/1–2), the *Tourist* series, and two *Vesuvius* landscapes (1976; CR 408, 409)—to introduce the British audience to the full range of his practice. Two days before the opening he seemed satisfied with the hanging: "In Whitechapel, things are going better than I thought; I had difficulties at home in planning for the nonmuseum rooms. But now that everything's hanging, I even like it a bit better than in Eindhoven. Somehow everything seems to be fresher and more colorful (and I am learning to understand the paintings more and more with time)."[23]

Richter was also planning to show some of the large abstract pictures and small sketches at the Galleria Salvatore Ala in Milan. A truck carrying the work departed from his studio, but once in Milan the two drivers left the vehicle unattended for half an hour, long enough for it and its cargo to be stolen. The truck was found empty three days later, but Richter's paintings have never been recovered.

In May 1979 Richter and Ema formally separated, and he moved from the family home to his studio on Brückenstraße. Almost simultaneously Genzken and Buchloh ended their relationship too. "Separations [seem] to be in the air," Richter observed in a letter to Buchloh, and his own, at least, had proved "much less catastrophic than I imagined it would be."[24] He toyed with the idea of moving to Hamburg to teach again at the art academy there, but finally decided not to. Though he had never been terribly satisfied with his situation in Düsseldorf, the academy in Hamburg was, he felt, too "comfortable and unambitious." He rented an apartment in a high-rise building on Kaiserswertherstraße in Düsseldorf, and it wasn't long before Genzken moved in (fig. 9.6). The relationship was like nothing he had ever experienced before. It was intense; he was living with another

FIG. 9.6. RICHTER WITH ISA GENZKEN, 1980.

ambitious artist, and he valued Isa's frank criticism. She "was a merciless critic" of everything, including his work. No doubt her ready willingness to pass judgment also awoke memories—not so sentimental, probably—of the early 1960s and his involvement with Konrad Lueg and Sigmar Polke. They had never spared each other's feelings either. On June 1, 1982, a year after Richter's divorce was final, he and Genzken married.

Genzken brought Richter into contact with a younger crowd of artists and musicians, including Dan Graham, Jeff Wall, and the sound artist Glenn Branca. In 1982 he would paint the dramatically colorful *Static* (CR 487; fig. 9.7), which took its title from Branca's band. He also made a large abstract painting he titled *Glenn* (CR 532), after the musician, and together he and Genzken designed a poster for the band's concert at the Düsseldorf academy, which took place on May 24, 1983.

FIG. 9.7. *Static*, 1982. OIL ON CANVAS. 200 X 320 CM. CR 487.

STROKE

In 1979 Richter received a prime commission to create art for the large foyer of a new vocational school in Soest, a town not far from Essen in the west of Germany. The building's architect, Wolfgang Schwartz, had recommended him for the job, and he was excited about it. "There is a chance for another large commission, and if I get it, it will suit my interests exactly," Richter wrote to Buchloh. "I.e., I can do what I want, an extensive series of paintings using themes of my own choice. A lucky stroke."[25] Only the site was a given—the open two-story foyer of the school. Initially Richter thought he might produce a group of small abstract paintings, but he decided that a pair of extremely long paintings integrated into the architecture offered a better—and far more interesting—alternative.

The preparatory oil sketches for the project reveal how he developed it through several stages. The first drafts were not unlike his other abstract sketches, with paint applied using a seemingly random gesture; however, the elongated, narrow proportions of the foyer made the result seem, at best, eccentric. Such a format—"that one would never select oneself"—made little sense for an autonomous abstract painting. In subsequent sketches, the paint application starts to resemble the final product, which looks like a single, elongated brushstroke. By early June Richter had completed the final models: strong, impasto brushstrokes on two sheets of cardboard, one on a red ground, the other on a blue ground with small red flecks.

When Richter presented his proposal to the Westphalia state representatives, he was, he remembers vividly, "horrifically nervous." Another candidate for the commission, the sculptor Ferdinand Gräsel from Bochum, had prepared his proposal so perfectly that it made Richter less sure of himself. Even today, he thinks he received the commission only because the sheer number of sketches he presented overwhelmed the committee and they felt compelled to give it to him.

In the weeks and months that followed he worked intensively to make two final sketches (at a scale of 1:20) that would function as direct models for the large paintings. In usual fashion, he photographed and projected them onto canvases (four for each "stroke"), then traced them with charcoal and finally, painstakingly, painted the copies. In terms of process, the *Stroke* paintings closely resemble the soft abstracts he had been painting since 1977. Yet their visual impact is quite different.

In the softly blurred abstractions Richter had shown in Eindhoven and London, the material presence of the paint transforms into an abstract illusion at a certain distance. Yet the brushstroke motif for the school in Soest is first and foremost a kind of mirage because of the paintings' position high above the viewer in the foyer. But Richter also wanted to be able to borrow the paintings from time to time to present them in exhibition settings where viewers would

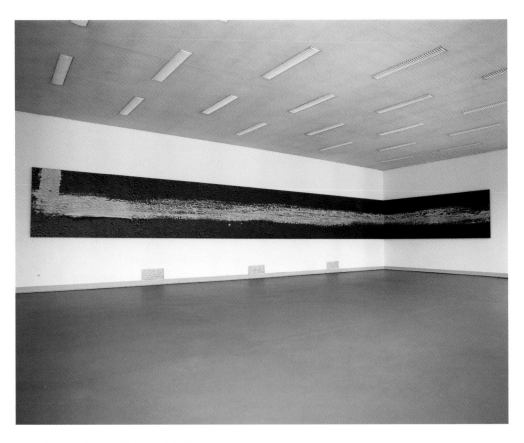

FIG. 9.8. *Stroke (on Red) (Strich [auf Rot])*, 1980. OIL ON CANVAS. 190 × 2000 CM. CR 452.

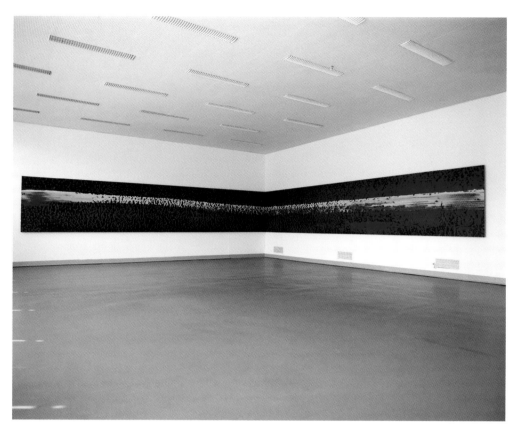

FIG. 9.9. *Stroke (on Blue) (Strich [auf Blau])*, 1979. OIL ON CANVAS. 190 × 2000 CM. CR 451. IN EXHIBITION.

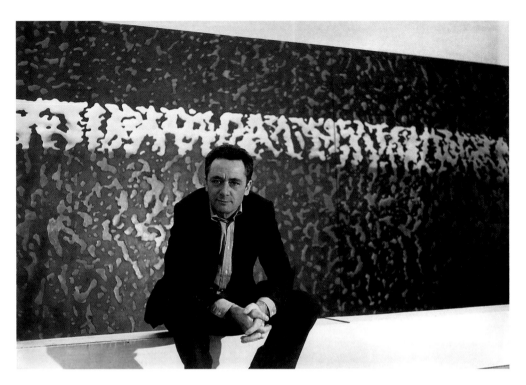

not be restricted to a single, distant vantage point (figs. 9.8, 9.9). Under that circumstance the two paintings offer a dynamic and contradictory experience of reality: the illusion that there are two large, individual brushstrokes traced along the wall by a giant hand can be discerned only from a distance; as the viewer gradually approaches, the strokes dissolve into a blur. From a distance, too, the paintings seem to have been made using impasto, whereas on closer inspection one finds that the gigantic gestures have been simulated using thin and softly dispersed paint (fig. 9.10).

Although such interplay had become commonplace for Richter, he was deliberate in his decision to use the representation of two brushstrokes. They not only made sense given the elongated space of the foyer but impressively reformulated Richter's fundamental artistic problem: to achieve a perception and awareness of reality employing the possibilities and inadequacies of painting. The paintings manifest Richter's skepticism toward any attempt to propose an image of the world, be it large or small. How long, one must ask, can such attempts continue, if even a banal brushstroke proves to be an illusion?

In a conversation with the author, Richter described the problematic of his painting in terms of Werner Heisenberg's uncertainty principle. Heisenberg pro-

posed that the location of a subatomic particle and its momentum cannot both be measured simultaneously with the same degree of precision. Richter's painting posits a different kind of uncertainty—a visual one:

> The big Strokes are first of all only reproductions of brushstrokes, that is, manifestations of their outward semblance. But even the semblance is also called into question, first because it is not painted in a "deceptively real" way, and second because there can be no such thing as a truly credible semblance, for the simple reason that such big brushstrokes cannot really exist. But the pictures do show a brushstroke, though they neither display it as a real object, nor represent it realistically, nor manifest it illusionistically in the *trompe-l'oeil* sense.[26]

For a time Richter attached particular significance to the Stroke project. "It is at any rate a work that means a lot to me," he wrote to Buchloh, "even if it should prove to be less important than much of what came before it, which came about perhaps unconsciously. Certainly no prior work demanded as much effort and time to produce as the strokes—it took almost an entire year."[27] Later, though, Richter could not fathom how or why the paintings had been so important to him: "They are just too professional; they make such a grand gesture."

EPIPHANY

Richter still wanted to develop the raw abstract sketches—with their spontaneity, dissonant colors, and contrasting structures—more directly into *real* paintings. But his intensively planned attempts created problems of their own:

> Now that I want to do the actual sketches, to catch up with what's been hurried, and to produce with a conscious understanding that which came about so unconsciously—what results is musty, tortured stuff. And I see no way of getting out of this dilemma because hard work in itself does not help. As I said, an old problem: I have always produced nonsense when I try to paint [something serious], which means nothing other than that I cannot paint. At the same time this is an old dream of mine which I always try to make real—to paint, it doesn't matter if it's representational or not, but like a proper painter, cleverly and beautifully organizing a surface with color and form. . . . And when I do it, I am convinced every time that I am on the right path and every time I see, sooner or later, that it has turned out again to be nothing, or worse.[28]

Richter's way out of the predicament came not by by way of formulating a new conceptual raison d'etre for painting, but through acceptance of the provisional and incalculable nature of painting itself. "It was a long time before I realized that

what I do—the desperate experimentation, all of the difficulties—is exactly what they all do: that's the normal nature of the job. That's painting."[29]

The epiphany occurred in 1981, when Richter began gradually to succeed in transferring the powerful gestures of the abstract sketches to larger formats. *Abstract Painting* (CR 473/1; 125 × 150 cm) is the first example. *Krefeld* (CR 482), completed soon after, measures 200 by 320 centimeters and involves the first effort to paint from the sketches on a truly monumental scale. Richter also stopped characterizing the small-format works as "sketches." He exhibited many of them at the Kunsthalle Bielefeld, from January 10 to February 21, 1982, and gave them a place in the catalogue raisonné.

In *Kunstforum International* Peter Moritz Pickhaus described his impression of the Bielefeld installation:

> A floor full of very colorful paintings—paint, like a fist in your eye, finger thick and criss-crossing everywhere, shouting and garish, as if there really were a new spirit in painting. But everything is only half as wild; with Gerhard Richter it only appears that way, it is not at all what is meant. Even now his painting is neither sloppy nor of the unreflective subjectivity like that which is circulated abroad today as "new German chic." Richter's chaos is calculated.[30]

The early 1980s were marked by a worldwide upsurge of "neo-expressionist" painting, much of it figural. Finally, for better or worse, painting was back in vogue. In New York, Julian Schnabel led the charge, his paint-caked indulgences decked with broken plates. In Germany there were A. R. Penck, Georg Baselitz, and many others producing overflows of heightened color. It was inevitable that critics would start to gauge every gestural painting—including abstractions such as Richter's—against this international milieu. In 1985, for example, Wilfried Dickhoff wrote:

> Richter achieved something here that corresponds to the positive developments in painting that appeared in the late 1970s in Italy, Germany, the USA, and elsewhere. Massively retrospective, the movement involved an abandoned receptivity to any manifestation of intense involvement, calling upon all existing stylistic and technical means to attain this.[31]

Even Richter acknowledged certain parallels between his work and that of some of his younger contemporaries: "It surprised me. . . . I hadn't realized that such things were going on in the studios . . . and that my pictures bore a certain resemblance to them. When I started on these in 1976, I thought to myself, '[What I'm doing now, it's my own personal problem]."[32]

Richter for the most part continues to avoid formal composition. "Invent nothing—no idea, no composition, no object, no form—and receive everything:

composition, object, form, idea, picture," he wrote in 1986.[33] Yet he concedes that a purely arbitrary approach, relying on coincidence, never produces good results. He once described his solution to the problem as a mode of working consciously *within* a paradox. By way of example, he cited the color charts:

> An architect once asked me what was so good about the color charts, what was supposed to be the art in them. I tried to explain to him that it had cost me a great deal of work to develop the right proportions and to give it the right look. . . . Because there would have been other possible ways of realizing this idea. I could have painted these biscuits here in different colors and thrown them across the room, and then I would have 1024 colors in a chance form.[34]

Richter found a solution—that is, the appropriate form for the abstract paintings—by allowing first for the interplay of planning, composition, and homogeneity and second for spontaneity, arbitrariness, coincidence, destruction, and distance. In his world, the actual making of an abstract painting, which can stretch out over weeks, involves incessant activity, back and forth between opposite poles, with no single element or value permitted to dominate. Richter once described his process for the abstract works as "a multitude of Yes/No decisions, with a Yes to end it all."[35]

He usually begins by applying a light ground to a canvas using two to three colors that blend subtly. He then applies paint in several layers using now a brush, now a palette knife or squeegee. What results is a mix of gestural strokes, areas completely painted over, speckled structures of pigment, and gentle inpainting. After this, according to Richter, he tries to add what he perceives as being the *subject* "as colorfully and as complicatedly as possible." In most cases, the numerous stages are interspersed with rather long pauses. These interruptions give Richter the detachment to work against the initial effort. By leaving a work untouched, sometimes for weeks, he manages to separate himself from any preconceptions and discover a new path to the subject. Sometimes the spontaneous, arbitrary application of paint helps him take a painting in a new direction. Or he may simply turn the canvas on its head and continue to paint.

For Richter, the squeegee is the most important implement for integrating coincidence into his art. For years, he used it sparingly, but he came to appreciate how the structure of paint applied with a squeegee can never be completely controlled. It thus introduces a moment of surprise that often enables him to extricate himself from a creative dead-end, destroying a prior, unsatisfactory effort and opening the door to a fresh start. "It is a good technique for switching off thinking," Richter has said, "Consciously, I can't calculate the result. But subconsciously, I can sense it. This is a nice 'between' state."[36] Use of the squeegee thus places him in a situation where he does not have to actively create, but can observe as a paint structure comes into being on the canvas. "Letting a thing come, rather than creating it," noted Richter in February 1985, "no assumptions,

constructions, preparation, invention, ideologies—to come closer to the actual, richer, more lifelike, to that which is beyond my comprehension."[37]

Richter has been known to liken his distanced position, in which he observes and corrects rather than steers, to the strategic passivity of General Kutsov in Tolstoy's *War and Peace*, which he read at the age of twenty. Kutsov used a method of "not intervening, of planning nothing, but watching to see how things worked out, choosing the right moment to put his weight behind a development that was beginning of its own accord." Richter was pleased to learn in 1985 that his old friend Sigmar Polke had a similar attitude: "As ever, Polke, I am glad to say, is doing something comparable."[38] Polke had begun to make abstract paintings in the early 1980s, employing chemistry as a significant element. He experimented with silver nitrate, synthetic sealant, shellac, micaceous iron ore (hematite), and other materials that react to changes in temperature and humidity, setting up chemical reactions that could cause his paintings to continue to change, sometimes for years.[39]

Blinky Palermo, who died in 1977, had also worked in an experimental, undirected manner and understood that something could be achieved through the process of painting that could never be planned in advance. In 1975 he wrote, "Most often, several layers of colors lie on top of each other because the original concept of the painting changes during the process, and the finished painting consists of a color progression, or color tone I could not have thought out and imagined when I started work on the painting."[40]

In 1990 Richter summed it up in this way: "I don't have a specific picture in my mind's eye. I want to end up with a picture that I haven't planned. . . . [I] want to get something more interesting out of it than [what I can think up for myself]."[41] Most of the time, however, disillusionment returns as soon as a painting is finished. "You never stop hoping to make something great, and then it just becomes another painting among other paintings."[42]

U-BAHN

In 1980 Richter and Isa Genzken together received a commission to decorate the multilevel U-Bahn (subway) station at König-Heinrich-Platz in Duisburg. (Due to construction delays, the project would not be completed until 1992.) Each developed a concept for the project involving various sites, formal elements, and media. For the walls facing each other across the tracks on the third sublevel, Genzken proposed two segments of a circle. In her description, Genzken states that "one curve corresponds to the curvature of Mars on a scale of 1:1,000, another curve to Venus on a scale of 1:40,000."[43] That she referred to the planets Venus and Mars, named after the Roman gods of love and war, was no coincidence. She was alluding to her romance with Richter, who responded in 1983 with two large abstract paintings titled *Juno* (CR 528; fig. 9.11) and *Janus* (CR 529; fig. 9.12), honor-

FIG. 9.11. *Juno*, 1983. OIL ON CANVAS. 300 X 250 CM. CR 528.

FIG. 9.12. *Janus*, 1983. OIL ON CANVAS. 300 X 250 CM. CR 529.

ing the goddess of marriage and the two-faced god who can see into the past and the future at once. As Richter told the author, he appropriated the shape of Genzken's ellipsoids in the vertical columns of *Juno*. Both canvases are distinguished by an explosive collision between red and blue, painted over in green and yellow. That same year, Genzken completed a standing hyperbolic cone painted in black enamel, which she christened *Meister Gerhard*, in honor of her former teacher and current life partner. One of her smaller objects from the previous year bore the name *Betty*, after Richter's daughter.

For each side of the platform on the second sublevel of the station, Richter specified an alternating sequence of six panels in different colors and six mirrors. Each of the panels (twenty-four in all) measured 3 by 19 meters. The mirrored surfaces, Richter says, effect a "pleasant" expansion of the space, and by reflecting the colored surfaces on the opposite side, they create, out of two simple parallel rows, a complex interplay between the two sides of the platform. Richter hoped that the design would also fulfill a "social component." The waiting passengers "see themselves in relation to their surroundings and to others. This may temper one's normal sense of isolation and potential for aggression; it also fosters greater social awareness and better behavior."[44]

Richter and Genzken installed a text in the entryway to the station with information about Duisburg, along with an abstract image that Richter designed and had executed as an enameled plaque. In the artists' final report on the project, Richter mentions the science fiction quality that he tried to impart. At the same time, he takes pains to stress that in no way should this work be equated with one of his paintings. It is meant simply "to enrich the station with its bright lively color and also—not entirely without irony—to offer a beautiful picture."[45]

MIRRORS

Out of the U-Bahn project came a new group of works: reflective surfaces made of glass backed by opaque monochromatic color and fused at high temperatures. The first two of these glass paintings, both titled *Mirror* (*Spiegel*, 1981; CR 470/1–2; fig. 9.13), were quite large—225 by 318 centimeters each—and were exhibited without apology alongside Richter's regular paintings. Two smaller versions followed (CR 485/1–2) and another (CR 619) in 1986. The conceit seems to suit the artist. After 1991 he produced numerous mirrors made of colored glass, and in 2003 he created three monumental multipanel installations with eight identical gray mirrors each, responding to the bleak opacity of his eight gray paintings (1975; CR 367/1–8) at the Städtisches Museum Abteiberg in Mönchengladbach.

The mirrors carry forward Richter's earlier credo for *4 Panes of Glass*: "See everything, comprehend nothing." He produced a few other glass constructions

FIG. 9.13. *Mirror (Spiegel)*, 1981. GLASS MIRROR. 225 X 318 CM. CR 470.

in the 1970s but nothing that so succinctly addressed the relationships between painting, architecture, subject, and viewer as the mirrors. In a 1981 note Richter addressed how they fit into his total corpus: "(a) Four Panes of Glass of [1967], Grey Pictures, Color Charts; (b) Picture in itself: cropped effect, likeness to photography, ready-made character (Berges furniture store); (c) Polemic: de-valuing of all other pictures; provocation of the viewer, who sees himself instead of a picture."[46] Richter on several occasions has described his mirrors as "sober demonstration objects" (much as he once termed his abstract pictures "fictive models"[47]). These works reflect their environment without reflecting upon it; that is, the image in the mirror is just as incomprehensible as reality itself, because the mirror merely replicates reality. And the mirror image, unlike a conventional painting, resists interpretation.

BASELITZ

In 1981 Richter showed the two earliest mirror paintings in a joint exhibition with Georg Baselitz at the Düsseldorf Kunsthalle.[48] Born Hans-Georg Kern in 1938, in Deutschbaselitz, Baselitz was several years younger than Richter, but he too grew up in East Germany, moving to the West a few years before Richter. He studied with Informel painter Hann Trier at the Hochschule für Bildende Künste in West Berlin at the same time that Richter was studying with Informel painter Karl Otto Götz in Düsseldorf. And like Richter, he would eventually return to teach at the school where he had studied. But beyond such surface similarities, the two artists could not have been more different. Over more than two decades, they had developed highly independent practices, neither yielding to art-world fashion. Now, in the early 1980s, they were viewed as giants in op-posing artistic camps: Baselitz was a pioneer of the new, fiercely gestural return to figurative painting known in the United States as neo-expressionism and in Germany as Wild Painting. Working in highly personal pictorial modes, paint-ers like Baselitz embraced their roots in the intense German expressionism of the 1910s and 1920s.

Richter, on the other hand, worked to suppress any hint of emotion in his painting. Whereas Baselitz had become a father figure to the young Wild art-ists thriving in Germany's urban centers, Richter, in his capacity as a professor, influenced a host of artists who came through the academy, particularly those interested in photography and theories of media.

The idea of a joint exhibition had numerous supporters. "Jürgen Harten, Rudi Fuchs, Konrad Fischer, Michael Werner, and many others wanted it. It was a piece of showmanship. We were both sort of famous by that time, and it was as if we had to be put into the ring together."[49] The hope was that bringing the two together would result in an enlightening dialog, but at the exhibition, the artists

FIG. 9.14. *Orangerie*, 1982. OIL ON CANVAS. TWO PANELS, 260 X 400 CM. CR 495.

kept their distance, retreating to separate rooms. And they did absolutely nothing to establish a conversation through their work, nor, really, did the organizers. The failure did not go unnoticed by the press. In a review for *Die Zeit*, Raimund Hoghe commented matter-of-factly:

> That they are now presented as a "two-man combination" at the Kunsthalle could also have the effect on many visitors as more arbitrary than enlightening and result in a somewhat cramped search for similarities. Certain similarities can certainly be found within specific biographical limits, but significant new knowledge about the work of the two painters is not to be found through this.[50]

Kasper König still talks about what a flop the show was: "There was a completely misguided demand for harmony, in which the two heroes were suddenly supposed to embrace each other."[51] Richter perhaps anticipated the outcome. He was never terribly enthusiastic about the idea and two months before the opening found himself so full of misgivings that he wrote Jürgen Harten, the director of the Düsseldorf Kunsthalle, to say, "You could have simply had Baselitz and spared me the disappointment."[52]

DOCUMENTA 7

After two disappointing experiences at Documenta, Richter was given a prominent position at the seventh one, in 1982. The organizer, Rudi Fuchs, had selected five of his new large-format abstract paintings, which he distributed throughout the exhibition. Visitors would thus encounter a Richter practically anywhere they went. Here, they would come across one in dialog with an Oldenburg; there, one communing with a Robert Mangold or a Gilbert & George; farther on, another flanked by the gray panels of Alan Charltons or text works by Lawrence Weiner—nearly all of them works by artists Richter admired. He titled two of the paintings after their locations at the art fair: The painting *Oldenburg* (1982; CR 489) hung on the second floor of the Fridericianum near a work by the pioneer of soft sculpture.[53] Another painting, *Orangerie* (CR 495; fig. 9.14), was located, appropriately, in the Orangerie.

CANDLES AND SKULLS

Nothing could be as antipodal to Richter's gargantuan abstract paintings of the early 1980s as his candle and skull paintings of the same period (figs. 9.15, 9.16). The flickering light of these intimate scenes constitutes an enlivening intervention in the still-life tradition known as memento mori—reminders of mortality

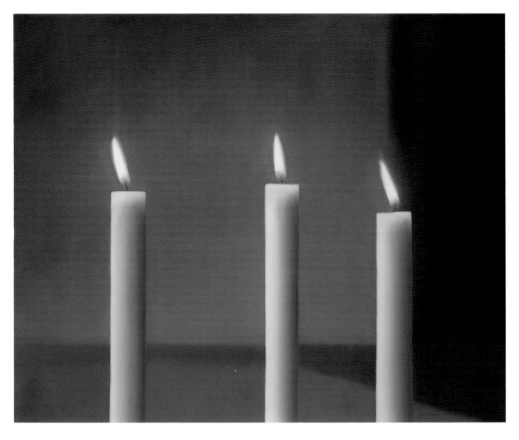

FIG. 9.15. *Three Candles (Drei Kerzen)*, 1982. OIL ON CANVAS. 125 X 150 CM. CR 513/1.

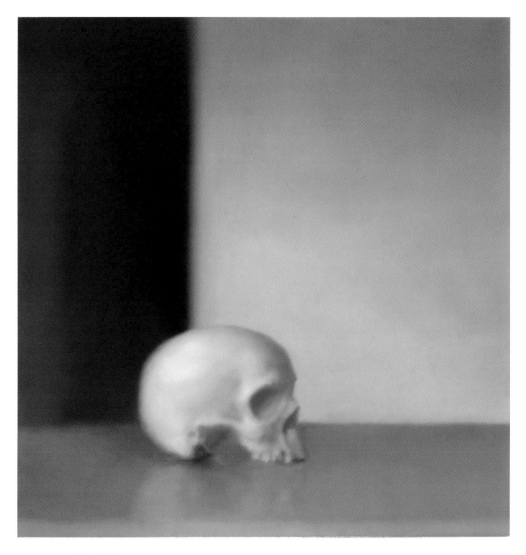

FIG. 9.16. *Skull (Schädel)*, 1983. OIL ON CANVAS. 95 × 90 CM. CR 548/2.

and the transience of life. The glowing, illuminated color and gentle mood of the paintings serve, according to Richter, to mask his very real fear of death:

> I was fascinated by these motifs, and that [fascination] is also nicely distanced. I felt protected because the motifs are so art-historically charged, and I no longer needed to say that I painted them for myself. The motifs were covered by this styled composition, out-of-focus quality, and perfection. So beautifully painted, they take away the fear.

Or do they? Coming off Documenta, Richter put four of the paintings in a show at Galerie Max Hetzler in Stuttgart, along with *Orangerie* and some small abstract paintings. The candles and skulls seem to have irritated the gallery's avant-garde clientele—or disturbed them. They did not find a single buyer.[54]

By now Richter had grown tired of high-rise living. He longed for a nest closer to the earth, something human in scale. The studio building on Brückenstraße was about to be torn down, so it seemed like the time to start a serious search for new space for himself and Genzken. Once again, he turned to the Düsseldorf city government for assistance, offering, in exchange, to donate a painting to the Kunstmuseum. But the search in Düsseldorf came up empty, prompting Richter finally to consider a move to Cologne, where Rudolf Zwirner was offering him space in a former cardboard factory at Bismarckstraße 50. Richter took the plunge, taking over the entire third floor of the building and remodeling six hundred square meters into two spacious studios and a modest living area. Paul Maenz moved his gallery into the first floor, opening on October 8, 1983, with the show "Master Works of Contemporary Art."

Near the end of the year Richter and Genzken moved into their new quarters. The magazine *Art* saw the artists' removal to Cologne as a "signal" that Düsseldorf had fallen behind its rival as the center for contemporary art in West Germany. Düsseldorf still had its renowned academy, but Cologne had a synergy of galleries, the Museum Ludwig, and an annual fair that fostered a vibrant art scene that was nothing if not au courant. Fighting back, Düsseldorf hatched a plot for a spectacular exhibition that it hoped would allow it to regain a foothold. A society founded by both private and public organizations donated three million deutsche marks to the effort and hired Kasper König as curator. On September 28, 1984, a two-month extravaganza called "Von hier aus. Zwei Monate neue deutsche Kunst in Düsseldorf" (From here on. Two months of new German art in Düsseldorf) opened in the city's fair hall, which had been remodeled into a lively urban space for the event by the Viennese architect Hermann Czech. Artists showed their work in open plazas, wide aisles, and individual pavilions.

Richter presented nine abstract works painted expressly for the occasion (CR 552/2–4, 553/1–3, 555, 559/1–2), which he set off against two recent landscapes, *Barn*

(*Scheune*; CR 550/1) and *Haystack* (*Schober*, 1984; CR 550/2). His contribution made a lasting impression on König, who also noticed that Richter and his old friend Sigmar Polke seemed to be in competition: "In 'Von hier aus' Richter exhibited the large yellow paintings, which were wonderful. Polke, in turn, showed even bigger ones. Somehow it became, simplistically, all about who had more space."[55]

It was with this group of paintings that Richter finally succeeded in breaking through to the international art market. "The bright yellow, abstract, large-format paintings caused an avalanche," he acknowledges. The next year he included most of the works from "Von hier aus" in an extensive double exhibition of his work in New York City. SperoneWestwater in Soho (Fischer had left the partnership by then) gave Richter his fourth solo exhibition at the gallery, and he also had his first one-person show at the Marian Goodman Gallery on Fifty-seventh Street, which like Bond Street in London was home to some of the world's most successful dealers.

Interest among American collectors and museums was so great that prices were raised twice before the shows even opened.[56] Both sold out on opening night. The Museum of Modern Art acquired the landscape *Meadowland* (*Wiesental*, 1985; CR 572/4; fig. 10.2). Another version of *Barn* (1983; CR 549/1) went to the Australian National Gallery in Canberra, and Boston's Museum of Fine Arts bought the large abstraction *Vase* (1984; CR 553/1). Such international success had long been Richter's aspiration, and he had subsidized his commercial success over the years with a conservative pricing structure. Now he felt more pressure than ever to produce. "One isn't used to being in demand, to getting calls and offers. All of a sudden I lost all impetus to paint, but it is all right. One can remain free," he said that year in an interview, describing his new situation.[57]

Plans for a 1980 retrospective at the Kunsthalle in Cologne had fallen through, and it wasn't until 1984 that Richter again took up the idea of a major retrospective, this time with the Städtische Kunsthalle Düsseldorf. After intense preparation, the most extensive exhibition of the artist's paintings to date opened on January 17, 1986, featuring 133 works (fig. 9.17). The retrospective traveled to the Neue Nationalgalerie in Berlin, the Kunsthalle Bern, and the Museum moderner Kunst/ Museum des 20. Jahrhunderts in Vienna. The organizing curator, Jürgen Harten, wrote a wide-ranging preface for the catalog that emphasized the continuing relevance of Richter's practice:

> Gerhard Richter is regarded as one of the leading artists of his generation, [but it has not been] easy to do his work justice. He has had recent paintings in most of the international exhibitions of contemporary art, and in his one-man shows . . . he has in the past few years almost only shown works from the latest group. Leading authors have written about his work but the last major exhibition was around ten years ago . . . before the "abstract painting" that is now so crucial to an appreciation of his art. So it is time to give the public another comprehensive

overview. It is not the aim of the retrospective to give a historical review, but to demonstrate the actuality of Gerhard Richter. But if at the height of his powers he challenges us to discuss the whole level of painting today he is legitimized by his achievements matured over time.[58]

The critical reception was unanimously positive. Gabriele Honnef-Harling wrote in *Kunstforum International* that "the exhibition . . . is staged in such a fascinating manner that . . . picture spaces of suggestive power open themselves up to the viewer." The critic from the *Frankfurter Allgemeine Zeitung* called the artist one "of the most interesting skeptics and tacticians of doubt," and Germany's leading newsmagazine, *Der Spiegel*, highlighted Richter's singular artistic rank: "No one else has explored the potential of painting in an age of mass photography in as coolly engaged and intelligent a manner as he has, or has been as tough and as ready to experiment as he is."[59]

10 SUBLIME LANDSCAPE,
EXCEPTIONAL DISASTER

As Richter has matured, he has
become less self-conscious about the diversity of his work and the challenges
it poses to critical judgment. He works without apology in a variety of modes
and styles, from photo-painting to installation, from glassworks to an ongoing
exploration of abstraction. The abstract paintings have opened up such a broad
vocabulary for the artist that today they serve a critical function within the over-
all oeuvre. Ever since 1976, his repertoire of shapes and colors has continued to
develop, at times surprising even the artist himself. "I have thought many times,
'Now it's really over,'" he said in 2001, "and now it *really* appears to be over. But
then again, there is something new for me, this remarkable, misty atmosphere
that is now emerging in the paintings."

The first large-format abstractions from 1981 featured gray impasto surfaces
built up on a soft yellow-red ground to create an illusion of spaciousness. Soon
thereafter, strong, luminous colors began to dominate. And after 1984 Rich-
ter's color constructions became increasingly multilayered and concerned with
detail. He began more and more to rely on a squeegee. After 1987 the painted
ground of the canvas often disappears beneath a dense, polychromatic fabric
of paint.

In 1991 Richter created a small group of abstract paintings dominated by
the color red. These red paintings followed an intensive exploration of colored
mirrors, including a commissioned work for the Hypo-Bank in Düsseldorf
(1991; CR 740–761). Then, gradually, his canvases became more multihued

FIG. 10.1. *Abstract Painting (Abstraktes Bild)*, 1992. OIL ON CANVAS. 200 X 180 CM. CR 774/2.

again. His use of a squeegee intensified, creating works throughout the early 1990s through a process of layering and destruction (fig. 10.1). On September 22, 1992, Richter noted:

> For about a year now, I have been unable to do anything in my painting but scrape off, pile on and then remove again. In this process I don't actually reveal what was beneath. If I wanted to do that, I would have to think what to reveal (figurative pictures or signs or patterns); that is, pictures that might as well be produced direct. It would also be something of a symbolic trick: bringing to light the lost, buried pictures, or something to that effect. The process of applying, destroying and layering serves only to achieve a more varied technical repertoire in picture-making.[1]

Elsewhere Richter admitted that the scraping during this time also had something to do with aggression and injury.[2] The pictures produced coincide with his difficult separation from Isa Genzken in 1993.

In the 1990s the impasto carpet of iridescent color gave way to soft inpainting again, for example, in the monumental *Bach* group (1992; CR 785–788; each 300 × 300 cm). Here, on a quartet of three-meter-square canvases, Richter used a wet-on-wet technique, applying the top color before the layers beneath it were dry. Here, the formations of paint next to and on top of one another melt into a delicate, flowing structure of colorful transitions.

On the smooth aluminum-composite surfaces that Richter used for the first time in the Edition Fuji in 1996 (CR 839/1–110), this effect intensifies into a painterly transparency that buoys the illusionistic quality of the paint. "The paintings gain their life from our desire to recognize something in them. At every point they suggest similarities with real appearances, which then, however, never really materialize."[3] Some of the abstract works bear associative titles that come to Richter after the painting is finished. "When I am painting, I try to destroy every similarity to any representative object that emerges. But the similarity that comes about on its own and shows itself only later is fine with me."[4] He reused the title *Table* (*Tisch*; CR 508), for example, for a 1982 canvas with a red surface shape over vertical brushstrokes in its left half. *Birds* (*Vögel*, 1982; CR 509) contains strong, bright V shapes suggesting a flock in flight. In other cases, titles refer to the painting's dominant color—*Red* (*Rot*, 1982; CR 493) or *Yellow* (*Gelb*, 1983; CR 533)—or where they were first exhibited (*Orangerie*). Several paintings can be seen as homages—for example, to Gustave Courbet (*A. B. Courbet*, 1986; CR 615, 616) and Piero de la Francesca (*Piero*, 1984; CR 564/2). Others are named for their owners: *Ingrid* (1984; CR 556/1), *B. B.* (1985; CR 579/4). For the cover story of the May 1985 issue of *Artforum*, written by Coosje van Bruggen, the wife of Claes Oldenburg, Richter photographed one of his abstract paintings in various stages of completion.[5] In

the article, he called the work "Co." Later, he lengthened it to *Coosje* (1984; CR 569/1).

Obviously such titles are not meant as clues to interpreting the works, though there are a handful of exceptions. *SDI*, the title of a large abstract painting from 1986 (CR 590), refers to the Reagan administration's Strategic Defense Initiative—the so-called Star Wars missile-defense shield. In an interview, Richter recalled an earlier conversation with Benjamin Buchloh and connected the painting's formal language to its title:

> The picture looks like a big science-fiction sky or something else dramatic in this direction. The title came about in a conversation, quite provocative, with a friend, a strict Marxist. I let the title stand, it had something to do with the painting, probably more than I thought at the time, and at the same time it showed something of the fundamental powerlessness of painting in the face of these and other such realities.[6]

But such indicative titles are the exception. At Documenta in 1982, when Richter showed his new large-format polychromatic abstractions, Bazon Brock, an artist and professor of aesthetics from Wuppertal, remarked that the works were simply outpourings of the artist's braggadocio:

> An older master in all his academic dignity has the good fortune of attracting a young woman's interest, and so he must prove that he is still young, that he is capable of change, as full of surprises as someone who is just at the beginning [of his career] and has not yet found his direction.[7]

As rude as Brock's comment was, it is hard to believe Richter's personal state does not shine through in those paintings. Indeed, Richter himself rarely discusses them in formal terms, dwelling instead on their atmospheric and emotional qualities. Talking with Julian Heynen, he characterized the abstract paintings from 1999, which he had painted after a long break, as melancholy, tired, sad, or resigned, equating them to human states of mind.[8]

In private Richter will admit that the glowing, explosive colors in the first large abstract paintings from 1981 and 1982 (after CR 484) are tied to his euphoric mood during the early years of his relationship with Isa Genzken. Thus, it is interesting to note that after their first separation, in 1984, the playful lightness in the application of paint and the transparency of the colors give way to a more compact formal structure (beginning with CR 556/1). The construction of these paintings has become more complex; the total impression is disrupted and contradictory; individual elements collide. The paint application has a dull, heavy force, and the intense coloration is disrupted by dark intermediate tones.

LANDSCAPES

Richter also describes his landscapes from early 1985, such as *Troisdorf* (CR 572/2), *Meadowland* (fig. 10.2), and *Buschdorf* (CR 572/5), in emotional terms. "I was a bit lonely at the time," he says. In the fall of 1984 he had gone to the Eifel, a low mountain range near Cologne in the west of Germany, and taken some photographs (see *Atlas*, panels 427, 428). In tone and hazy atmosphere, these photos recall Richter's *Davos* paintings from 1981–1982 (fig. 10.3). The three paintings that resulted evoke a melancholy mood, particularly when compared with the bright landscapes that preceded them: *Barn* (CR 549/1, 550/1), *Meadow* (*Wiese*; CR 549/2), *Haystack*, and *Rhine Landscape* (*Rheinlandschaft*; CR 550/3) all display heightened coloration, and Richter alludes to a human presence and scale in them—not by including actual figures but by depicting the buildings they would occupy.

In contrast, the Davos and Eifel landscapes are bereft of human life. The artist looks for and finds only loneliness. Here, as in the earlier candle paintings, the artistic mechanism of subjective appropriation and thematic displacement comes into play. Richter explores his own state of mind through a visual metaphor that he can examine from an art-historical distance. By appropriating the Romantic landscape genre that was so popular in Germany during the early nineteenth century, he adopts for his own melancholy a traditional, stylized embodiment, helping him to objectify and overcome it. "The motif gains a form similar to a funeral, where everything likewise gains unity through a practiced form," Richter says. The ceremony of taking leave helps one work through the loss.

According to Richter, he did not want to part with the 1992 painting *House* (*Haus*; CR 772/7) for a long time after he made it because he feared "people might think he was as burned out as [this painted house]."[9] The landscape *Summer Day* (*Sommertag*; CR 859/1; fig. 10.4) from 1999 also conveys information beyond the obvious subject matter. "It has a lot to say," Richter admits: "in this case about a summer afternoon, extremely hot, still, good smells, happy feelings, children. And because of the contrast of light and dark, it was a very rich picture. The darkness coming from the left side seems to threaten and endanger. This resulted in such a strange combination, but which can only be seen after the second or third look. At first glance, it is just a completely normal picture of a summer day."[10]

Since 1988 Richter has punctuated his other work with small clusters of landscapes, painted from his own photographs and often devoted to a specific subject. For a time, he liked to hang landscapes and abstractions together in exhibitions. To do so was to stage a confrontation between seemingly irreconcilable image concepts (yet let us not forget that Richter's early examinations of the cusp between illusion and material presence relied heavily on optical transitions from abstract

FIG. 10.2. *Meadowland (Wiesental)*, 1985. OIL ON CANVAS. 90 × 95 CM. CR 572/4.

FIG. 10.3. *Davos S.*, 1981. OIL ON CANVAS. 70 X 100 CM. CR 468/3.

FIG. 10.4. *Summer Day (Summertag)*, 1999. OIL ON CANVAS. 117 × 82 CM. CR 859/1.

marks and patterns into landscape; see, for example, CR 194). He eventually decided that this type of presentation was too didactic and discontinued it, though he still says, "For me there is no difference between a landscape and an abstract painting. In my opinion the term 'realism' makes no sense."[11]

The exploration of landscape culminated in 1987 with twenty-three field and meadow pieces that included two unusually large paintings titled *Chinon* (each 200 × 320 cm; CR 644, 645). The central works in this group are *Country Path* (*Feldweg*; CR 629/4), filled with an iridescent summer light, and *Apple Trees* (*Apfelbäume*; CR 650/1–3), painted in three variations.

Over the years, however, Richter's fascination with landscape has waned. He has produced only a handful since the early 1990s. In 1995 he painted *Keitum* (CR 826), *Piz Lagrev* (CR 834/1), and *Jerusalem* in two versions (CR 835/1–2). *Waterfall* (*Wasserfall*; CR 847/1–2) was painted in 1997. Then came three snowscapes: *Farm* (*Gehöft*, 1999; CR 861/1), *Snow* (*Schnee*, 1999; CR 861/2), and *Branch* (*Zweige*, 2000; CR 870/2), which Richter blurred using a squeegee. Among his more recent landscapes are two versions of *Waldhaus* (CR 890/1, 891/1), showing a renowned hotel located in the Engadin alpine valley in southeast Switzerland.

Although Richter has been painting landscapes for more than thirty-five years, critical appreciation for this body of work has been late in coming. Following a modest exhibition in 1994 at the Kunstverein Ruhr in Essen, "Gerhard Richter und die Romantik," the Sprengel Museum Hannover held a retrospective in 1998, curated by the author, that presented the artist strictly as a landscape painter. Possibly the belated, reserved critical response to the romantic subject matter arises from a certain sense of helplessness in the face of paintings that seem pitched to a broad audience in search of something it recognizes and can experience emotionally. In 1970 Richter had explained his motivation with disarming candor; quite simply, he "felt like painting something beautiful."[12] That motive hardly fit the dominant concerns of the period: it was not political nor did it engage the media-critical discourse of the late 1960s and early 1970s. But of course the mere fact that Richter chose to produce paintings that were lovely to look at did in effect politicize them—precisely because they were so blatantly apolitical, uncritical, and timeless in sentiment.

If Richter's landscapes permit critique, it is in the historical context of German Romantic painting with its rhetoric of the sublime. The landscapes from 1968 to 1981, from the Corsica paintings to the views of Davos, have indeed provoked such interpretation. Their open skies, in some cases, their dramatic sunsets, atmospheric rainbows, and sunlight breaking through clouds have elevated the atmosphere of these landscapes into transcendental metaphors of light.

Richter's approach to landscape has changed over the years. At first he preferred a low horizon with a few clouds and a tense contrast between foreground and background. He repeatedly fell back on a scheme in which a cluster of trees or shrubbery blocks a portion of the horizon and divides the image both horizontally

and vertically. A meadow pathway leads from the foreground into the background, connecting the two planes, as for example, the small road in the *Landscape at Hubbelrath* (CR 221) from 1969. Such paths would hint at a human presence, as would other small details—a solitary building, a bridge or fence in the distance—without his actually depicting the human figure. The details thus confer upon the works the explicit quality of social landscapes. Later, he began to move the view and viewer closer to the subject matter. After 1983, using photographs he made in Upper Bavaria, he consciously began to alter the mood of the landscape, shifting from muted tones to the vibrant green of forests and meadows. To make this shift he switched from Kodachrome to Fuji film.

Despite the popular reaction to them, these paintings show neither untouched regions nor the fictive or idealized world view of the German Romantics. Although Richter has brought back countless photographs from many vacations, he has avoided, at least since the mid-1980s, romanticized views. The photos in the *Atlas* are surprisingly bland and repetitive. Only after they have been transformed into painting do the subjects take on an atmosphere, a mood of their own. "It has more reality than a photograph because a painting is more of an object in itself, because it's visibly hand-painted, because it has been tangibly and materially produced," said Richter.[13]

The abundance of photographed landscapes in the *Atlas* conveys something of the seemingly endless views in the glass installations and the mirrors that Richter has produced since 1981. Of course, his painted landscapes result from a process of selection that is nowhere near as random or ambivalent as the views in his glassworks. "I see countless landscapes, photograph barely one in 100,000, and paint barely 1 in 100 of those that I photograph. I am therefore seeking something quite specific; from this I conclude that I know what I want," he wrote in 1986.[14] What Richter wants are photographs that transcend the time-bound, captured moment and avoid the anecdotal concreteness of a specific situation. These are the ones he paints, producing landscapes free of elements that could connect the subject to a certain place, time, or event. The soft blurring of details at the end of the painting process enhances the sense of timelessness and general mood of the depiction. Even in the landscapes whose titles link them to particular locations, such as *Davos*, *St. Moritz*, or *Hahnwald* (1997; CR 840/1), the image transcends the knowable topography. Similarly, the seven *Vesuvius* paintings evoke the volcano more than they actually depict it, and both *Chinon* landscapes deny the viewer the distinctive silhouette of the nuclear power plant in the distance. It is precisely because the painted landscapes contain so little of this type of information and do not fulfill any *function* that they are able to depict our reality in such an exemplary fashion.

Since the mid-1980s Richter has worked to close the gap between his abstractions and his landscapes, though in fact he and Sigmar Polke in 1968 had already transformed a landscape painting into an abstraction and vice versa, albeit ironi-

FIG. 10.5. *Abstract Painting (Abstraktes Bild)*, 1984. OIL ON CANVAS. 43 × 60 CM. CR 551/2.

FIG. 10.6. *Clump of Trees (Baumgruppe)*, 1987. OIL ON CANVAS. 72 X 102 CM. CR 628/1.

cally, in their pseudoscientific *Transformation*, where they temporarily turned a mountain into a sphere. Today Richter comes at the problem from two extremes—the smooth, blurred, illusionistic landscapes and the abstract paintings with their complex structures and gestural strokes—seeking to bring the two together. In a group of small abstract works from 1984, featuring a sketchlike impasto brushstroke (CR 551/1–9; fig. 10.5), he sometimes imitated the scheme of a photographed landscape, land below and sky above, even picking up the horizontal partitioning of his early landscapes. Within this series, CR 551/2, for example, incorporates overlapping horizontal and vertical elements, much like those in the landscapes he painted after 1981. Richter even gave some abstract paintings titles suggestive of landscape: *Arizona* (1984; CR 551/9), *Godthab* (1984; CR 570/5), *Abstract Painting Materdell* (1995; CR 833/8), and *Sils Lake* (1995; CR 835/6).

Echoing the agenda of the first work in his catalogue raisonné, *Table*, in which he partially obscured the image using circular brushstrokes, Richter began, in 1986, to take a squeegee to some of the landscapes to create a clash of realities: illusionistic space versus material presence (fig. 10.6). The viewer's eye is coaxed to reconcile the disparity, and indeed, the photographic depiction and the frankness of the paint ultimately fuse, giving rise to a new and surprising image of reality.

PAINTED PHOTOS

Richter had often said that his paintings were in fact photographs—albeit photographs produced using the means of another medium.[15] So it was easy for him to apply his painting process to conventional photographs. "Now there's painting on one side and photography—that is, the picture as such—on the other," he told an interviewer in 1991:

> [A photograph lacks almost all inherent] reality; it is almost a hundred percent picture. And painting always has [its own] reality: you can touch the paint; it has presence; but it always yields a picture—no matter whether good or bad. That's all theory. It's no good. I once took some small photographs and then smeared them with paint. That partly resolved the problem, and it's really good—better than anything I could ever say on the subject.[16]

Richter had been producing painted photographs—as distinct from photopaintings—since 1989, had added some to the *Atlas* (panels 468, 469), and had published others as a book in conjunction with an exhibition "Sils" at the Nietzsche-Haus in Sils-Maria, organized by Hans-Ulrich Obrist.[17] His engagement with painted photographs culminated in his hundred-part cycle *Firenze*. These small photos of Florence and Cologne, each measuring 12 centimeters square, are

painted over in oils using a palette knife or run by hand through the moist paint on the palette, producing surprising chance effects.[18] It would be almost twenty years before he showed his overpainted photographs in a retrospective of their own; he finally presented some four hundred examples at the Museum Morsbroich in Leverkusen in 2008.

NEW VENTURES

In 1986 Richter received a commission for two large paintings from Victoria-Versicherung, an insurance company in Düsseldorf. It was arranged by Helge Achenbach, an art consultant with whom he would also collaborate on later projects. Richter won over the selection committee with a group of pencil drawings on A4 sheets of paper (see *Atlas*, panels 488 and 489). While the *Stroke* paintings had been produced in sections, four panels apiece, each of these monumental paintings was to be executed on a single canvas, six meters high and four wide. In retrospect Richter confesses that it was "a little megalomaniacal" to confront such large canvases in the first place. The project required that he first design a complicated stretcher on which to mount the canvas. He then rented a warehouse next door to the insurance company's building and went to work, using ladders and brushes fastened to long poles, aided only by his assistant at the time, Andreas Schön. The two worked through the summer of 1986.

Richter named both paintings after the insurance company that commissioned them: *Victoria I* and *Victoria II* (CR 601, 602; figs. 10.7, 10.8). He saw their completion as a personal victory over the monumental format, for despite their great size, he had succeeded in achieving the gestural effect and light-handedness of some of the small abstract paintings.

The late 1980s also saw ventures with new galleries. In Germany Richter was talking both with Michael Werner and with Paul Maenz, whose exhibition space was in the same building as Richter's studio. In the end, though, he decided not to show with either of them because their galleries had become too closely identified with neo-expressionism, an association he wished to avoid. Instead, he chose to show again with Rudolf Zwirner in Cologne, but the 1987 show would be his last with Zwirner.[19] Richter's involvement with Konrad Fischer, and Fischer's former New York gallery, had also nearly run its course; a third multisite show in New York in February 1990 was his last with SperoneWestwater. Since then, Richter has been represented in New York exclusively by the Marian Goodman Gallery.

In March 1988 he presented a group of new work at the Anthony d'Offay Gallery in London. At about the same time, Galerie Liliane and Michel Durand-Dessert presented an exhibition of his recent paintings in Paris. D'Offay, a prominent dealer of established modern artists, was not particularly interested in nurturing young talent. He represented major figures such as Beuys, Twombly, Hamilton,

FIG. 10.7. *Victoria I*, 1986. OIL ON CANVAS. 608 X 406 CM. CR 601.

FIG. 10.8. *Victoria II*, 1986. OIL ON CANVAS. 608 x 406 CM. CR 602.

Lichtenstein, Warhol, and Kelly. For the next decade, he would be Richter's most important dealer in Europe. The artist attached great significance to the show, called "London Paintings," and decided to display, in addition to seven landscapes, a group of abstracts named after towers and chapels in London. Whereas Konrad Fischer in the 1970s had helped link Richter's work internationally to advanced conceptual art, D'Offay presented Richter's work in a new international context, with the declared goal of ratcheting up its commercial value. According to Fred Jahn, the challenge of maintaining his newly minted international stature was something Richter was eager to meet.[20]

In Paris the large-format *Chinon* landscapes were offered at DM 200,000 each, and abstract paintings from 1987 measuring 225 by 200 centimeters cost DM 110,000 each (CR 648/1–4). Three years earlier, two-meter-square abstractions had cost only DM 60,000. Still, Richter's price structure remained relatively conservative, even though the demand for his work now exceeded the supply. He once described his approach thus: "I am a popular artist, a painter [according to profession], and I want to remain [successful being] just that."[21] Richter's gallerists, though, were faced with the quandary of how to place his works in the right hands, to ensure they would not simply be resold on the secondary market at much higher prices.

A retrospective that started in Düsseldorf and traveled to Berlin, Vienna, and Bern (1986) had bolstered Richter's international profile, making him quite the hot commodity. Another exhibition toured North America beginning in April 1988, debuting at the Art Gallery of Ontario in Toronto, then traveling to the Museum of Contemporary Art in Chicago, the Hirshhorn Museum in Washington, and the San Francisco Museum of Modern Art. The seventy-seven works in that show spanned Richter's career from 1962 (*Table*) to 1987 (*Cathedral Corner* [*Domecke*]; CR 629/1). A large percentage came from American and Canadian collections, including seven from museums.

In late 1989 the Museum Boymans-van-Beuningen in Rotterdam also held an extensive exhibition. It included several gray paintings from the 1970s and a few recent abstractions, but the centerpiece was Richter's controversial cycle of paintings from the previous year, *18. Oktober 1977* (CR 667/1 to 674/2), which marked a radical new departure in his work.

18. OKTOBER 1977

Between February and November of 1988 Richter painted fifteen works which he titled collectively *18. Oktober 1977*. The title refers to the day, during the so-called German Autumn (*der Deutsche Herbst*), when the confrontation between the West German state and the Red Army Faction (RAF), a radical political group characterized as terrorist, escalated into a deadly catastrophe. The painting cycle,

exceptional within Richter's oeuvre, has turned out to be an artistic project of signal importance. Arguably no other work of twentieth-century art has been discussed so vehemently or provoked such ongoing controversy in Germany.[22]

The RAF had evolved out of the late-1960s student movement and the extra-parliamentary opposition. At first its activities largely took the form of peaceful demonstrations against the war in Vietnam, American imperialism, and Germany's unresolved Nazi past. The conflict intensified, however, after a student, Benno Ohnesorg, was killed by a police officer on June 2, 1967, during a protest against the shah of Iran, who was visiting Germany. The radical minority of the student movement used the event and others like it to justify violence as a form of protest. In April 1968 future RAF leaders Andreas Baader and Gudrun Ensslin planted and detonated firebombs in two Frankfurt department stores. The bombs caused considerable damage, though luckily no one was injured.

Baader was something of a glamorous figure who had a long history of petty crime. He and Ensslin were arrested and convicted of arson. They were given prison sentences of three years but were then released under an amnesty program for political prisoners. When ordered to return to custody several months later, they fled and went underground. Baader was again arrested but later escaped with the help of Ulrike Meinhof, a well-known leftist journalist turned urban guerilla. The breakout is generally seen as the beginning of the Red Army Faction as an organized group. During the escape two Justice Ministry employees were injured, the first RAF casualties. A round of armed robbery and violence followed, prelude to the fierce political battles that were to come. Baader led the faction in deadly bombings of police stations, American military installations, and the Springer building in Hamburg. The government response was severe. The police force was expanded and charged with conducting intensive searches and dragnets. The government also instituted new "antiterror laws." In June 1972 these intensified efforts seemed to be paying off: Baader, Ensslin, Meinhof, and their fellow RAF ringleaders Holger Meins and Jan-Carl Raspe were all arrested.

But the state's victory was short-lived. In the years that followed, second and third generations of RAF activists conducted even more merciless attacks, taking hostages and plotting to murder leading government officials. Baader, Meinhof, and Ensslin all had political roots in the leftist student movement, but the new violence intensified to such a ferocious level that political ideology could no longer justify it.

Holger Meins died during a hunger strike in 1975 while in custody. A year later, Ulrike Meinhof was found hanged in her jail cell while she was on trial. The others—Baader, Ensslin, and Raspe—received life sentences in the maximum security Stammheim prison in Stuttgart. In the fall of 1977 the ten-year saga came to a head. On September 5, terrorists in Cologne kidnapped Hanns-Martin Schleyer, president of the Confederation of German Employers' Association, killing three bodyguards and his driver in the process. In exchange for Schleyer's release, the

terrorists demanded that the government free the RAF members imprisoned in Stuttgart-Stammheim. The ordeal dragged on for weeks until October 13, when Palestinian terrorists sympathetic to the RAF hijacked a Lufthansa plane loaded with German tourists returning from Mallorca, increasing pressure on the West German government. Still, Chancellor Helmut Schmidt refused to yield to the terrorists' demands. Lufthansa flight 181 finally landed in the Somali capital, Mogadishu, after several stops for refueling and refusals of permission to land. On the eve of October 18, 1977, German federal police stormed the airplane, freeing the hostages and shooting three of the hijackers. Shortly after midnight, the press received word that the hostages had been rescued.

The following morning prison guards in Stuttgart-Stammheim found Andreas Baader and Jan-Carl Raspe shot dead, Gudrun Ensslin hanged, and another RAF member, Irmgard Möller, injured with stab wounds to her chest. All were in their cells, and the official verdict was that they had jointly committed suicide, though others have challenged that finding. (Möller later accused the government of arranging the killings.) The same day, Hanns-Martin Schleyer was murdered by his kidnappers.

Richter chose the date of this final reckoning as the title for his cycle. Many of the paintings are modest in size. Richter used the technique he had employed with the gray photo-paintings of the 1970s, blurring the subjects to varying degrees. But the surfaces are more painterly and tend not to imitate the soft grays of the original newspaper and magazine illustrations; Richter chose not to work directly from these sources but from higher-contrast photocopies that eliminated the middle tones. His terse summation of the work in his diary reads:

> What have I painted. Three times Baader, shot. Three times Ensslin, hanged. Three times the head of the dead Meinhof after they cut her down. Once the dead Meins. Three times Ensslin, neutral (almost like pop stars). Then a big, unspecific burial—a cell dominated by a bookcase—a silent, gray record player—a youthful portrait of Meinhof, sentimental in a bourgeois way—twice the arrest of Meins, forced to surrender to the clenched power of the State. All the pictures are dull, grey, mostly very blurred, diffuse. Their presence is the horror and the hard-to-bear refusal to answer, to explain, to give an opinion. I'm not so sure whether the pictures "ask" anything; they provoke contradiction through their hopelessness and desolation, their lack of partisanship.[23]

Of the nineteen works mentioned, fifteen made it into the cycle. At least three of the remaining works were painted over, rendered invisible beneath abstract works: one of the hanged Ensslin disappeared like a corpse beneath *Blanket* (*Decke*; CR 680/3); it is believed the third version was destroyed. And images of the dead Meins and Baader were covered over by CR 686/9 and CR 677/4, respectively.

The fifteen paintings in the formal cycle have no sequence. Each time Richter shows them he hangs them differently, depending on the features of the exhibition space. Viewers can thus begin with any painting and organize the cycle according to their own lights. If, however, one wants to follow the sequence in the catalogue raisonné, the three versions of *Dead* (*Tote*; CR 667/1–3; figs. 10.9–10.11) open the cycle. All three depict the same view: the head of Ulrike Meinhof appears in profile lying on a flat surface, ligature marks clearly visible on her neck. These signs of strangulation vary in size and sharpness. The artist's use of blurring serves to erase the graphic brutality of the photographs published in the media, and to minimize the hint of voyeurism.

Richter had originally painted three versions of the next subject, *Hanged* (*Erhängte*; CR 668; fig. 10.12), but only one made the final cut. It depicts Gudrun Ensslin, who used the cable from a loudspeaker to hang herself from her cell window. Her body is only dimly visible. The dark, undifferentiated area under the figure differs noticeably from the photocopy Richter made of the original photograph.[24] In the painting the dead figure has lost the ground beneath her feet in the truest sense.

The next two paintings, *Man Shot Down (1–2)* (*Erschossener [1–2]*; CR 669/1–2; figs. 10.13, 10.14), show Andreas Baader lying on the floor of his cell, shot with a pistol. Working from a single image, Richter used the same format for the two paintings but chose to represent different details and to vary the degree of blurring. The weapon, clearly visible in a pool of blood to the left of Baader's head in the original photograph, is indiscernible in Richter's rendering.

Cell (*Zelle*; CR 670; fig. 10.15) is the same size as *Hanged* (200 × 140 cm). It depicts a corner of Baader's cell, a crammed bookcase filling the right half of the image and a dark article of clothing hanging on the left.

The three iterations in *Confrontation* (*Gegenüberstellung 1–3*; CR 671/1–3; figs. 10.16–10.18) capture Gudrun Ensslin in three tense moments during her famous confrontation with the police. Ensslin moves through the paintings like an apparition, as if in three frames from a newsreel, turning and smiling briefly at the viewer in the second frame and then moving away to exit the third frame, head down.

Youth Portrait (*Jugendbildnis*; CR 672/1; fig. 10.19) presents the only subject not directly related to the actions of the RAF. This portrait of Ulrike Meinhof came from a publicity photo made several years earlier in connection with Meinhof's teleplay *Bambule*. It was on the set of that film that Meinhof, then a prominent journalist, had first met Andreas Baader.

Record Player (*Plattenspieler*; CR 672/2; fig. 10.20) shows detail from Baader's cell. The record player is said to have been the hiding place for the gun that Baader used to shoot himself.

Funeral (*Beerdigung*; CR 673; fig. 10.21) is by far the largest painting in the group, at 200 by 320 centimeters. The original photograph was taken on October

FIG. 10.9. *Dead (Tote)*, 1988. OIL ON CANVAS. 62 × 67 CM. CR 667/1.

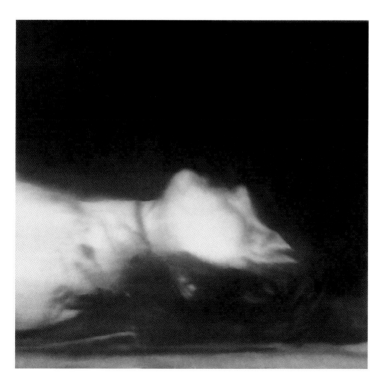

FIG. 10.10. *Dead (Tote)*, 1988. OIL ON CANVAS. 62 × 62 CM. CR 667/2.

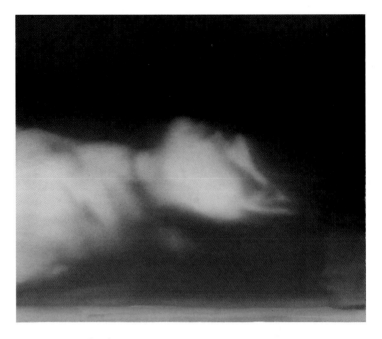

FIG. 10.11. *Dead (Tote)*, 1988. OIL ON CANVAS. 35 × 40 CM. CR 667/3.

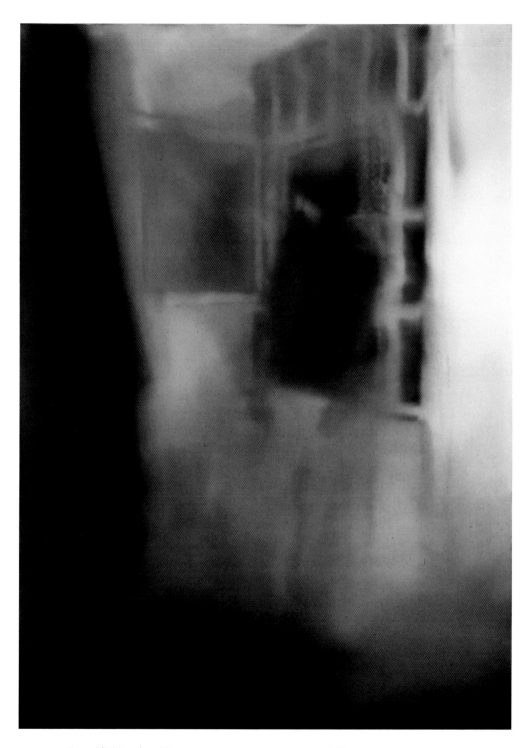

FIG. 10.12. *Hanged (Erhängte)*, 1988. OIL ON CANVAS. 200 X 140 CM. CR 668.

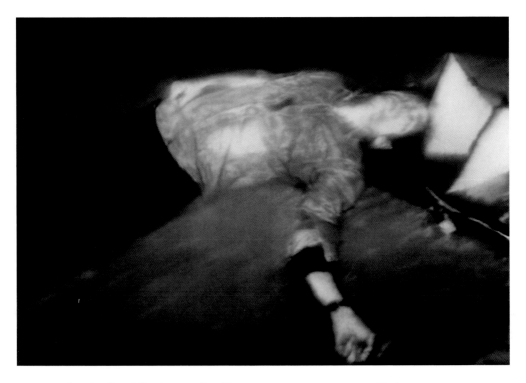

FIG. 10.13. *Man Shot Down 1 (Erschossener 1)*, 1988. OIL ON CANVAS. 100 X 140. CR 669/1.

FIG. 10.14. *Man Shot Down 2 (Erschossener 2)*, 1988. OIL ON CANVAS. 100 X 140 CM. CR 669/2.

FIG. 10.15. *Cell (Zelle)*, 1988. OIL ON CANVAS. 200 X 140 CM. CR 670.

FIG. 10.16. *Confrontation 1 (Gegenüberstellung 1)*, 1988. OIL ON CANVAS. 112 X 102 CM. CR 671/1.

FIG. 10.17. *Confrontation 2 (Gegenüberstellung 2)*, 1988. OIL ON CANVAS. 112 X 102 CM. CR 671/2.

FIG. 10.18. *Confrontation 3 (Gegenüberstellung 3)*, 1988. OIL ON CANVAS. 112 X 102 CM. CR 671/3.

FIG. 10.19. *Youth Portrait (Jugendbildnis)*, 1988. OIL ON CANVAS. 67 X 62 CM. CR 672/1.

FIG. 10.20. *Record Player (Plattenspieler)*, 1988. OIL ON CANVAS. 62 X 83 CM. CR 672/2.

FIG. 10.21. *Funeral (Beerdigung)*, 1988. OIL ON CANVAS. 200 X 320 CM. CR 673.

FIG. 10.22. *Arrest 1 (Festnahme 1)*, 1988. OIL ON CANVAS. 92 X 126 CM. CR 674/1.

FIG. 10.23. *Arrest 2 (Festnahme 2)*, 1988. OIL ON CANVAS. 92 × 126 CM. CR 674/2.

27, 1977, at the funeral for Baader, Ensslin, and Raspe at the Waldfriedhof cemetery in Stuttgart. The three coffins are depicted only as light spots in the center of the painting.

The last paintings in the cycle, as enumerated in Richter's catalogue raisonné, are *Arrests 1* and *2* (*Festnahme 1–2*; CR 674/1–2; figs. 10.22, 10.23), which show the apprehension of Holger Meins, Andreas Baader, and Jan-Carl Raspe on June 1, 1972, in Frankfurt. Both paintings capture a moment in which Meins strips down to his underwear at the behest of the police, an armored truck in the background and several cars toward the foreground—details that can be identified only by reference to the photograph. The subject and composition of the arrest paintings recall Richter's 1964 painting *Administrative Building*.

When Richter began his research for *18. Oktober 1977* in late 1987, he was far from sure that the sensitive subject matter could be successfully handled in paint:

> The wish was there that it might be—had to be—paintable. But there have been some themes that weren't. In my mid-twenties I saw some concentration camp photographs that disturbed me very much. In my mid-thirties I collected and took photographs and tried to paint them. I had to give up. That was when I put the photographs together in that weird and seemingly cynical way in the Atlas.[25]

He started his hunt in the photo archives of *Der Spiegel*, in Hamburg, and later mined the archives of another newsmagazine, *Der Stern*. At the same time he read the 1984 book *The Baader-Meinhof Complex: The Inside Story of a Phenomenon*. "Stefan Aust's book was very important to me. Such knowledge of the people [involved], knowing the people, was basic to the pictures."[26]

Richter collected numerous images that documented the private lives of the RAF members, as well as their pre-RAF activities. He also acquired pictures of various crime scenes. He initially imagined that the project would demand unusually large paintings and wide-ranging subject matter. But as he worked, his selection of images narrowed and he found himself concentrating on the specific events of October 18, 1977 (fig. 10.24). The paintings were based on shocking images, rendered tolerable only through Richter's transformation:

> The ones that weren't paintable were the ones I did paint. The dead. To start with, I wanted more to paint the [entire problem, the reality of that time, life itself]. I was thinking in terms of something [great and all-encompassing]. But then it all evolved quite differently, in the direction of death. And that's really not all that unpaintable. Far from it, in fact. Death and suffering always have been a [theme in art].[27]

Richter had already confirmed with Kasper König that the cycle would debut at the Portikus space in Frankfurt, when Gerhard Storck suddenly showed interest

in showing it in Krefeld. In retrospect, König acknowledges that a premier at the Museum Haus Esters made good sense: "In Krefeld, they had proven for thirty years that they knew how to deal critically with art, and in Frankfurt it would be more difficult to present the works as painting rather than as illustration, so the cycle was shown in Krefeld first, where it hung in that wonderful private home [designed by Mies van der Rohe in 1928–1930]. At Portikus, on the other hand, it would have been shown in that merciless box." Still, he is a little irritated that he agreed to let Storck show the paintings first. "I did notice . . . how the work was received, that it was seen, so to say, as a Krefeld initiative. But it was because of us [Portikus] that Richter was prepared to show the paintings at all."[28]

The cycle opened at Museum Haus Esters on February 12, 1989. At Richter's request there was no opening reception. He also tried to block the media from reproducing the paintings of Ensslin hanged and Baader shot, out of respect for the individuals and their families, though this proved impossible. When the cycle moved to Portikus, König also presented three large abstract paintings whose titles suggested a connection to the October cycle: *November* (CR 701; fig. 10.25), *December* (CR 700), and *January* (CR 699), all from 1989. "We showed the three large abstracts; really based on the argument that they are much less grim," König explained.[29] Richter ratified Konig's decision: "He was right to do that. Even so, it's difficult, because figurative paintings are always more attractive than abstract ones. As soon as there are persons or objects to be seen [people get more interested]."[30]

The *18. Oktober 1977* cycle then traveled to the Institute of Contemporary Arts in London, the Museum Boymans-van Beuningen in Rotterdam, the Saint Louis Art Museum, the Grey Art Gallery at New York University, the Musée des beaux-arts in Montréal, and the Lannan Foundation in Los Angeles before arriving at the Frankfurt Museum für Moderne Kunst, where it would remain for ten years on loan from the artist. (Like the paintings themselves, the loan agreement sparked controversy. The Dresdner Bank in Frankfurt rescinded a pledge of support to the museum, claiming the cycle harmed the memory of Jürgen Ponto, a member of the bank's board who was murdered by the RAF.)

The paintings astonished the public. Their provocative political subject matter was (and is) unique in Richter's work. An artist who had never taken any po-litical position was suddenly exploring a controversial and divisive topic from recent German history. Yet he did so, he says, with no intention of making a particular political statement. As Richter wrote later in his diary, "The political topicality of my October paintings means almost nothing to me, but in many reviews it is the first or only thing that arouses interest, and the response to the pictures varies according to current political circumstances. I find this rather [disruptive]."[31] The broad spectrum of public reaction confirms Richter's obser-vation; the critics, quite frankly, did not know what to make of the cycle. Critics on the left and on the right both co-opted it to suit their own purposes—which

FIG. 10.24. RICHTER IN HIS STUDIO, 1988.

sometimes meant insisting that the artist's political sympathy lay with their opponents.

In a 1998 interview, a decade after the paintings' debut, the artist Georg Baselitz still reacted vehemently: "I was ashamed when Gerhard Richter painted Baader-Meinhof, I was ashamed as a painter because I think that as a painter living today, you can't just paint such a completely distressing image of history because then you are demanding grand subject matter." As a German post–World War II artist, Baselitz objected to any such depiction of "grand" historical subjects. After Auschwitz, that was no longer seen as appropriate. "But Richter succumbs, makes mistakes, and in my opinion, stupid mistakes in which he with his sentimentality or senility tosses too much fodder to the masses."[32]

Many Germans, however, appreciated the aesthetic virtuosity of the cycle. "With these 15 paintings, Richter finds himself, from a purely artistic standpoint, at the zenith of his creativity," wrote Heiner Stachelhaus. "It is excellent painting, in terms of the sensitively graduated gray values between black and white and the composition."[33] *Der Spiegel* agreed: "They are crass, they are banal and, in a manner that is difficult to grasp, beautiful, sometimes all at once."[34] Jean-Christophe Ammann also appreciated Richter's achievement: "Gerhard Richter has created a work that no one but he could have created, because it fits seamlessly into the

FIG. 10.25. *November*, 1989. OIL ON CANVAS. TWO PANELS, 320 X 400 CM. CR 701.

painterly work process that he has developed and maintained for decades. Nevertheless, it stands out as the inexorable truth, created in a time in which art is seeking its own legitimacy."[35] Richter's worry that he would fail artistically with the project and "end up with bad pictures" proved unfounded.[36]

Other critics have taken Richter's exclusive focus on the RAF prisoners as an indication of sympathy or approbation of their deeds. Why, asked Walter Grasskamp, are the *victims* missing from the paintings? "To leave out Hanns-Martin Schleyer, whose death also occurred on that date, the photos of him being taken hostage or the haunting image of the crime scene with the bodies of his driver and bodyguards—this tilts the series heavily in one direction."[37] Richter protested: "After [painting Schleyer you could go on] painting the same sort of thing. That was an ordinary crime, an ordinary disaster that happens every day. What I chose was an exceptional disaster."[38]

Some critics have pronounced the cycle a new type of documentary history painting and compared it to such works as Francisco Goya's *The Shootings of May Third 1808* (1814), which Richter's title recalls. Others, though, object to the idea that the cycle stands as a renewal of history painting, because Richter's treatment denies the viewer the ability to endow the paintings with nationalistic or moral meaning. For Richter,

> The paintings raise a number of technical and professional issues, though these are of no fundamental interest to me. For instance, [painting's illusionistic, representational] quality, imperiled or made redundant since the invention of photography; and my own reversion to a painting technique that I was using in the 1960s—an unmodern attempt at a painting based on content, on history painting.[39]

But the paintings are "not directly political," he has stressed, "and least of all in the sense of political painting, which everyone has always assumed to be left wing—an art that serves exclusively to criticize so-called bourgeois-capitalist society. That was not my concern."[40] Rather, the cycle formulates questions, describes approaches. In preparing for a press conference, he wrote:

> It is impossible for me to interpret the paintings. That is: in the first place they are too emotional; they are, if possible, an expression of a speechless emotion. They are the almost forlorn attempt to give shape to feelings of compassion, grief and horror (as if the pictorial repetition of the events were a way of understanding those events, being able to live with them).[41]

There is no explicit political statement. On the contrary, Richter is trying to convey his sense of powerlessness in the face of the events of the time as well as of his own paintings.

Such explanations did not, of course, satisfy everyone. Hansgünther Heyme,

a theater director from Essen, wrote in the magazine *Art* that "the process of bereavement in art, if it is to avoid service at monstrous perpetuation [or memorialization], at trivialization, must be clearer, more precise, more revealing."[42] But to argue this is to ignore the consistent epistemology of Richter's process. As early as 1964, Richter noted that he sometimes uses blurring to eliminate an excess of unimportant information.[43] The technique, that is, is not merely an artifact of the photographic origins of his images. In the *18. Oktober* paintings, as in other series, the multiple versions of a particular subject reflect his conviction that a single standpoint is impossible. He had come to this realization more than two decades before:

> Pictures which are interpretable, and which contain a meaning, are bad pictures. A picture presents itself as the Unmanageable, the Illogical, the Meaningless. It demonstrates the endless multiplicity of aspects; it takes away our certainty, because it deprives a thing of its meaning and its name. It shows us the thing in all the manifold significance and infinite variety that preclude the emergence of any single meaning and view.[44]

Two corollaries to this analysis are worth noting: On the one hand, appropriation, by offering "an alternative world, or a plan or a model for something different, or a reportage [can], even when it only repeats or recalls something, . . . still creates meaning."[45] On the other, declaring a political position through painting is impossible.

Richter had lived through the Nazi regime as a child, and then under the repressive communist system in East Germany for the first thirty years of his life. He knew well the consequences of ideology. In the month the cycle was first shown, Richter set it in this context:

> In the early 1960s, having [recently] come over from the GDR, I naturally declined to summon up any sympathy for the aims and methods of the Red Army Faction (RAF). I was impressed by the terrorists' energy, their uncompromising determination and their absolute bravery; but I could not find it in my heart to condemn the State for its harsh response. That is what States are like; and I had known other, more ruthless ones. The deaths of the terrorists and the related events both before and after stand for a horror that distressed me and has haunted me as unfinished business ever since, despite all my efforts to suppress it.[46]

In 1988 the GDR stood on the brink of collapse. In reading about the RAF, Richter discovered a different ideology, one that had to end tragically because of its radical and violent nature. In this regard, for Richter, the events of October 18, 1977, became a metaphor for any ideology and its attendant inhumanity, which must lead, inevitably, to ruination. In an interview with Jan Thorn Prikker, Richter

FIG. 10.26. *Betty*, 1988. OIL ON CANVAS. 102 X 72 CM. CR 663/5.

explained: "What interests me is something different . . . the why and wherefore of an ideology that has such an effect on people; why we have ideologies at all; whether this is an inevitable, a necessary part of our make-up—or a pointless one, a mere hindrance, a menace to life, a delusion." Asked by Prikker if the dead RAF terrorists had become victims of their own ideology, Richter said "Yes, certainly. Not the victims of any specific ideology of the left or of the right, but of the ideological posture as such. This has to do with the everlasting human dilemma in general: to work for a revolution and fail."[47]

Following this train of thought, *Youth Portrait*, showing a fictively young Ulrike Meinhof, takes on a specific function. Although the photograph used for the painting was taken when Meinhof was already thirty-five years old, Richter has rendered her as a much younger woman, hardly more than a girl. As the only subject within the cycle that does not stem directly from events surrounding the RAF, the portrait operates as the innocent, still-hopeful counterpoint to the dramatic images of a failed ideology. A depiction of Richter's daughter Betty (fig. 10.26), which he painted during a break from the cycle, was later seen by some writers as especially consonant with *Youth Portrait*. *Betty* was not shown in public when the first exhibitions of the cycle were held in Krefeld, Frankfurt, and other cities. But the painting did receive a brief mention in a February 1989 review in *Der Spiegel*, titled "The end of the RAF, painted mercifully away":

> In the same room in Krefeld hangs a work that brings almost a moment of senti-
> mentality into this otherwise hauntingly sober exhibition, a "Youth Portrait" (Ul-
> rike Meinhof). Richter revealed that he had painted a "kitschy colorful" photo of
> his daughter parallel to this but had decided to abandon the attempt. The Youth
> Portrait, too, had also been "too cute" at an earlier stage.[48]

Apparently Richter was unsure whether the painting of Betty was any good, think-ing it might even be a full-blown failure. But when *Frieze* published the results of a 2001 survey of artists, museum employees, exhibitors, and gallery owners that asked, "If you could have any five artworks for your home, what would you choose?" Richter's *Betty* came in second, behind Andy Warhol's *Electric Chair* series, in a tie with Warhol's *Jackie* and *Hunters in the Snow* by Jan Brueghel the Elder.[49]

Of Richter's 1993 retrospective in Bonn, the critic from *Der Spiegel* wrote, "The RAF shock finds its carefree counterpart and its consolation image in the brightly colored 'Betty,' which was painted around the same time from a snapshot of Richter's daughter."[50] Benjamin Buchloh had made the same connection in the exhibition catalog, where he described *Betty* as the embodiment of "the hopeful image of the private, or the anti-utopian pretense of happiness."[51] In 1989 Richter denied that the two portraits had anything in common. "But," he added, "I did find it interesting that the portrait of Ulrike Meinhof came out so much better than that picture."[52] He continues to dismiss the idea of a common thread linking the

family portrait to that of the young Meinhof. But it is likely more than coincidence that Richter painted his own daughter as he worked on *18. Oktober 1977*. Betty was twenty-one years old in 1988, about the same age as the fictive rendering of Ulrike Meinhof. While Richter portrayed Meinhof as younger than she was in the source photo, he chose as a model for his daughter's portrait a photo showing her from the back, rendering her ageless. The photo had been taken eleven years earlier, together with two photos that he had painted in 1977 (*Betty*; CR 425/4–5). In the end, *Betty* and the Meinhof portrait must be seen as complementary. It is the wistful gaze of Ulrike Meinhof that makes the fatal consequences of her ideology seem that much more incomprehensible; *Betty*, seen alongside *Youth Portrait*, reinforces the tragic irony of how easy it is to descend from a protected bourgeois existence into an irrational, ideological worldview.

In 1995 the Museum of Modern Art in New York purchased the complete cycle for $3 million. In Germany the news that the work had been sold to a foreign institution was met with shocked disbelief.[53] Richter had accepted MoMA's offer not so much because of the museum's prestige, but because he felt that both he and the paintings had been misunderstood in his own country.[54] In Germany the cycle could not escape being viewed in historical terms—as probing yet another dark chapter in recent German history. He had been far more satisfied with its reception outside of Germany, and, as he later told Hubertus Butin, he hoped this less parochial perspective would prevail in New York: "Perhaps because of their distance from the RAF, the Americans will see the more general aspect of the subject, which is one that affects almost every modern or unmodern country: the general danger of faith in an ideology of fanaticism and insanity."[55] Asked today whether he made the right decision in sending the work to New York, Richter still answers "yes, absolutely." So in the fall of 2000, at the end of the ten-year loan to the Museum für Moderne Kunst in Frankfurt, the paintings were sent to their new home, where they were featured in the millennium exhibition "Open Ends."

What matters to Richter "is that the pictures . . . become universal. They are there to show themselves and not me: that would be dreadful. That's why form is so important—and that is difficult nowadays."[56] That Richter succeeded in giving form to his topic is evident in the criticism. Over the decades the cycle has remained a lively subject in artistic and critical discourse. The artist Alexander Roob depicted the paintings' being moved out of the museum in Frankfurt in an extensive cycle of drawings, and the writer Don Delillo chose the exhibition of the cycle in Richter's 2002 MoMA retrospective as the starting point for his short story "Baader-Meinhof." The story begins by describing the mood in the galleries as one character experiences it:

> She knew there was someone else in the room. There was no outright noise, just an intimation behind her, a faint displacement of air. She'd been alone for a time, seated on a bench in the middle of the gallery with the paintings set around her,

a cycle of 15 canvases, and this is how it felt to her, that she was sitting as a person does in a mortuary chapel, keeping watch over the body of a relative or a friend.[57]

Critics, too, have found themselves impressed by the very presence of the images, describing the cycle as "shocking, harrowing, yet at the same time fascinating," as "great, meaningful, and stirring painting at a time when one would not have thought it possible."[58]

A recurring question, though, is why it took so long, more than a decade after the events, for Richter to respond? For the paintings to have a chance of being seen in universal terms, of course, requires some distance.[59] Richter's reluctance to acknowledge publicly any kind of personal subtext for his paintings makes further explanation challenging. He did later note that the images had something to do with working through the large-scale horrors that have enveloped him as a modern German.[60] And in Robert Storr's monograph on the cycle, published in 2000, Richter alludes to Isa Genzken's student years, when she had traveled in circles close to the RAF.[61] Later, when pressed by the author, Richter elaborated on why he had finally taken up the project. For more than ten years, he had been engaged in a prolonged and rather contentious conversation with Genzken and with Buchloh about terrorism and its causes and consequences. There had been a time when both Genzken and Buchloh sympathized with the agenda of the RAF and admired its members' uncompromising radicalism. In the early 1970s in Berlin, Genzken had reported her identification card stolen, and later one of the fugitive terrorists had used her name as an alias.[62] That Buchloh had a measure of sympathy for the terrorists is certain given his contribution to the catalog for the cycle's debut in 1989: "Richter's group of paintings 'October 18, 1977' imitates this development of a tolerant memory of these people and of the ideals of these individuals, whose supposed crimes remain partly unresolved, even though they . . . remained in custody for years, as does the crime to which they fell victim."[63] Buchloh does not, however, discuss Richter's intentions. Still, the intense discussions with Buchloh and Genzken had provided the impetus for Richter to address the topic artistically, and one sees in the project an attempt to understand not only the terrorists' behavior but also the perspective of his friends. The appropriation, or as Richter calls it, the "pictorial repetition of the events," is certainly capable of setting a process of discovery in motion.[64] To be successful, however, the paintings must transcend the personal stake of the artist. Thus *18. Oktober 1977* does indeed come to be about the futility of ideology—all ideology. "It does seem important now," Richter said in a 1990 interview with Sabine Schütz. "With the collapse of the socialist system, these pictures are taking on a different and more general component, which they didn't have quite so obviously before."[65] In a conversation with the author, Richter shared the sense of relief he felt when Jean-Christophe

Ammann told him that the paintings had come into their own and no longer had anything to do with Richter.

Richter was aware that the cycle had altered viewers' perception of his work and would make it difficult for him to return to the abstract paintings: "I realize that these pictures set a new standard, set a challenge to me. I may be deceiving myself. It's all still too fresh. But one thing I have realized; it's hard for me to go on painting."[66] The first abstract paintings that follow have compact, closed surfaces dominated by leaden gray tones and dramatic contrasts of black and white. Gradually, though, Richter freed himself from this gloomy palette and began to reintroduce color.

18. Oktober 1977 is also a striking example of how the *Atlas* functions as a storehouse for both painted and unpainted source material. The ten panels devoted to the cycle (panels 470–479) include none of the photos actually used for the paintings. Some of the paintings' subjects do appear, but Richter has rephotographed the original photos so that the scenes depicted are out of focus and only dimly recognizable.

Reacting to the pressure of increasing demand, Richter decided to take some time off from the exhibition business, postponing several shows. On August 16, 1990, he noted in his diary:

> Since the Rotterdam exhibition [October 1989], painting has become more laborious. At the end of December, I cancelled the exhibitions planned for this year at d'Offay and Durand-Dessert, so as to have a whole year to "evolve" something without commitments. Since then there have been small and medium-sized pictures—very few big ones—nothing special, on the whole. Alongside this, the work for the Hypo-Bank design [18 *Mirrors* for the Hypo-Bank, Düsseldorf], not very exciting either. A kind of aimless drifting. About twelve unfinished pictures in the studio at the moment: almost perversely wrong or nonsensical in the way they're laid out, without a governing idea, in the manner of a disoriented gambler who stakes a vast amount on a random card.[67]

11 HAHNWALD

I would like to try to understand what *is*. We know very little, and I am trying to do it by creating analogies. Almost every work of art is an analogy. When I make a representation of something, this too is an analogy to what exists; I make an effort to get a grip on the thing by depicting it. I prefer to steer clear of anything aesthetic, so as not to set obstacles in my own way and not to have the problem of people saying: "Ah, yes, that's how he sees the world, that's his interpretation."[1]

So said Richter in an interview with the critic Rolf Gunther Dienst in 1970, still early in his career. He was reflecting on the main challenge he had set for himself, which was to understand the *work* of art—whether abstract or representational: the point was to offer an analogy to or model of the complexity and contradictions inherent in the reality that surrounds us. In Richter's painting, reality is consciously recreated, becoming manageable and perhaps slightly more explicable in the process.

A decade later, in 1981, Richter noted in regard to his abstract work:

Painting is the making of an analogy for something nonvisual and incomprehensible: giving it form and bringing it within reach. And that is why good paintings are incomprehensible. Creating the incomprehensible has absolutely nothing to do with turning out any old bunkum, because bunkum is always comprehensible. "Not comprehensible" partly means "not transitory": i.e., essential. And it partly means an analogy for something that . . . transcends our understanding, but which our understanding allows us to postulate.[2]

Some years later, he compared painting to a view of nature seen through a window:

> When I look out the window, then what I see is true for me, the different tones, colors, and proportions. It is a truth and has a correctness. This detail, any detail in fact, of nature is a constant challenge, and a model for my painting.[3]

This "truth" and "correctness" are present in every detail of nature framed by a window, no matter how arbitrary the view. The theme presides openly over *4 Panes of Glass*, completed in 1967, and ten years later over the gray-painted *Panes of Glass* (*Glasscheiben*, 1977; CR 415/1–2) and *Double Pane of Glass* (*Doppelglass-cheibe*, 1977; CR 416). The frames for all of these structures conspicuously recall the model of a window frame. Related to these, of course, are the mirror pieces, the first of which was created in 1981.

All of these objects—the transparent panes, the reflective mirrors—simulate the perception of reality as a view through a window. Richter dramatized this idea in the photographs he made to document some of these works. For *Mirror, Gray* (CR 735/1; fig. 11.1), he arranged the shot so that the mirror would reflect him looking out the window of his studio, demonstrating the concept of the mirror as self-reflexive window to the world. The works offer the viewer a framed detail of reality that changes and renews itself moment by moment and every time the viewer moves. And each of these transitory images possesses the truth and correctness that Richter has always sought. But because they create only a reflective double of reality, the works remain a "demonstrative, helpless gesture" that cannot approach the cognitive achievement of the analogies to reality one finds in the abstract paintings.

Richter has carried the experience of looking through a window to find a picture over into his abstract work since 1976 when he abandoned the flat, gray monochromes for the paintings he referred to as *Abstraktes Bild* (abstract pictures):

> I don't have a specific picture in my mind's eye. I want to end up with a picture that I haven't planned. This method of arbitrary choice, chance, inspiration and destruction may produce a specific type of picture, but it never produces a predetermined picture. Each picture has to evolve out of a painterly or visual logic: it has to emerge as if inevitably. And by not planning the outcome, I hope to achieve the same coherence and objectivity that a random slice of Nature (or a Readymade) always possesses.[4]

This analogy between his abstractions and the experienced phenomena of nature is one that Richter has emphasized again and again in his notes and in interviews.[5] It is also evident in the titles for some of the abstractions, which evoke elements of landscape: *Hedge* (*Hecke*, 1982; CR 504), *Garden* (*Garten*, 1982; CR 515), *Rock* (*Fels*, 1989; CR 694), *River* (1995; CR 822–824).

In discussing his favored method of working Richter is quick to stress that the result must also have "the right look," which comes from formal structure.[6] In the

FIG. 11.1. *Mirror, Gray (Spiegel, Grau)*, 1991. GLASS MIRROR WITH COLOR. 280 X 165 CM. CR 735/1.

abstractions the structure emerges as Richter interrupts his process of arbitrary choice and effacement (spreading the paint on the canvas and scraping it away with a spatula, palette knife, or squeegee) with controlled steps that give the work a defined direction. This, in turn, is disputed with the next application of paint. The final painting thus represents a sustained tension between what is planned and what is coincident. "They have to be cleverer than I am," said Richter in 1990. "I have to be unable to follow quite all the way; they have to be something that I no longer completely understand. [As] long as I can grasp them theoretically, it's boring."[7]

Richter's take on reality and its artistic reflection was already well established by the mid-1960s. The catalog for his joint exhibit with Sigmar Polke at Galerie h featured satiric descriptions of characters based on each of them. Of his character Richter wrote, "Carlton looked at the front gardens, the birds and the women, and then the scales fell from his eyes; he knew that he would never get the hang of it all."[8]

In an oft-quoted statement that Richter prepared for the 1982 Documenta catalog, he planted the abstract paintings and illusionistic landscapes firmly on an equal footing:

> When we describe a process, or make out an invoice, or photograph a tree, we create models; without them we would know nothing of reality and would be animals. Abstract paintings are fictive models, because they make visible a reality that we can neither see nor describe, but whose existence we can postulate. We denote this reality in negative terms: the unknown, the incomprehensible, the infinite. . . . Of course, pictures of objects also have this transcendental side to them. Every object, being part of an ultimately incomprehensible world, also embodies that world; when represented in a picture, the object conveys this mystery all the more powerfully, the less of a "function" the picture has.[9]

The abstract and the concrete, then, are both fragments of a single view, or exploratory intent:

> This is not some abstruse game but a matter of sheer necessity: the unknown simultaneously alarms us and fills us with hope, and so we accept the pictures as a possible way to make the inexplicable more explicable, or at all events more accessible. . . . So, in dealing with this inexplicable reality, the lovelier, cleverer, madder, extremer, more visual and more incomprehensible the analogy, the better the picture.[10]

All of this bears on Richter's decision to show the abstractions and the landscapes together:

> If the Abstract Pictures show my reality, then the landscapes and still-lifes show my yearning. This is a grossly oversimplified, off-balance way of putting it, of course; but though these pictures are motivated by the dream of classical order

and a pristine world—by nostalgia, in other words—the anachronism in them takes on a subversive and contemporary quality."[11]

Richter acknowledges an implicit contradiction in describing his paintings as "nostalgic":

> I would not have anything against describing my perception of landscape as nostalgia. But it is an inexact term; it means backward looking, longing for that which has been lost, and that is nonsense. How am I supposed to look back, when something is in the present.[12]

Yet the paintings work precisely because they take a moment fixed in time and space in a photograph and elevate it into the placeless, timeless experience of nature.

The abstract paintings do not presume to settle the problems of the reality from which they are drawn, but they do provide some comfort for Richter. The invisible becomes visible because it is, according to him, "tangibly and materially produced."[13] Meanwhile, the landscapes, painted from photographic views of that which can be seen, promise a more holistic experience.

The landscape paintings, however, show only a slice of nature, which corresponds to visible reality but not to the intrinsic truth of our modern world. Richter meticulously copies the photograph, but the choice of subject, the exclusion of everything that falls outside the photographer's frame or is subsequently cropped, the painterly dissolution of the details—all of these are manipulations. In this way Richter's landscapes can be described as visual models of a lost reality. In this way too they are extensions of the abstract pictures, which Richter has described as "fictive models" of the invisible.[14]

In any event, as we have seen, models can only ever attain a limited similarity to their original frame of reference. Every painting is merely one more approach to reality, and none will ever get there. The one, true painting can never exist, only a multitude of possible pictures. Sigmar Polke thematized this lack of certainty in 1969 by inscribing mathematical equations on paintings with false, or perhaps better, alternative solutions.

In 1962 Richter expressed hope that he might achieve at least an artificial truth: "Since there is no such thing as absolute rightness and truth, we always pursue the artificial, leading, *human* truth. We judge and make a truth that excludes other truths. Art plays a formative part in this manufacture of truth."[15] In the abstract paintings Richter realizes a multitude of alternative possibilities as equally valid in the pursuit of reality. Some of the landscapes explore the same issue, though in more concrete ways. In 1987, for example, he painted three versions of *Apple Trees* (CR 650/1–3), in which the subject progressively dissolves. And there are two variations each of *Jerusalem* (CR 835/1–2) and *Waterfall* (*Wasserfall*; CR 847/1–2; figs. 11.2, 11.3). Here the filial works have been painted from the same source photograph but differ in more than format.

FIG. 11.2. *Waterfall (Wasserfall)*, 1997. OIL ON CANVAS. 126 X 90 CM. CR 847/1.

FIG. 11.3. *Waterfall (Wasserfall)*, 1997. OIL ON LINEN. 165 X 110 CM. CR 847/2.

Multiple variants of other motifs have found their way into the *Atlas* as photographs, underscoring the futility Richter experiences in his repeated pursuit of reality through painting. "The longing for the one valid image keeps everything going," wrote Rudolf Schmitz in a profile of the artist in the *Frankfurter Allgemeine Zeitung*.[16] Approximately thirty years after his early, hopeful avowal, Richter revisited his original idea, this time sobered by experience: "I don't believe in the absolute picture. There can only be approximations, experiments and beginnings, over and over again."[17]

FRANKFURT

In 1987 Frankfurt, Germany's banking center, was experiencing an astounding cultural revival under the astute leadership of Hilmar Hoffmann, the city's head of cultural administration. Museums were taking shape along the riverfront, including the Museum für Angewandte Kunst (Museum for Applied Art), national museums for architecture and film, and the Schirn Art Gallery. The new building for the Frankfurt Museum für Moderne Kunst, designed by the Austrian architect Hans Hollein, was scheduled to open in 1990. The city had established a contemporary art fair along with a series of exhibitions to showcase new trends in art every three years.

Hoffman wanted to find a distinguished international figure to run Germany's smallest art academy, the Städelschule, and Kasper König appeared to be the ideal candidate. He had fostered the work of many new artists and had earned a reputation as a charismatic organizer of exhibitions, with "Westkunst" (1981), "Von hier aus" (1984), and the "Skulptur Projekte" in Münster (1977 and 1987) to his credit. The opportunity appealed to König because of the artistic ferment in the city, which he hoped to enhance: "[Frankfurt] is very contemporary. It has many disadvantages, but the advantage is its location and that no one knows at all where the journey will end. When you can have an influence on the fate of an identity as it is being shaped, then I am especially interested."[18] The small exhibition space Portikus was to become important to König's plan.

König had previously taught a course on "art and the public" in Düsseldorf. When he took up his new position on October 1, 1987, he brought Richter and the sculptor Ulrich Rückriem with him as new faculty. Long dissatisfied with his situation at Düsseldorf, Richter readily accepted when König offered him a job at the Städelschule. He had already toyed with the idea of moving to Frankfurt, and now he began to look for a home and studio space for Genzken and himself. Almost immediately, however, his initial enthusiasm wore off: "That is no city for me. I never felt at home there. I noticed it after that one semester."[19] Following a short stint as a visiting professor, Richter returned to his position in Düsseldorf. "I was happy to be out of there. Düsseldorf, even though it's horrible, is much nicer."

Richter wanted to own his own home, as he had during his marriage to Ema. He was tired of having strangers in the building where he and Isa lived and wished for a private house with a garden. Over the next few years he and Genzken looked for real estate in the areas surrounding Cologne. They finally settled on two empty lots, one behind the other, in Hahnwald, an exclusive residential district in the south of the city, on the west side of the Rhine. From Richter's perspective, the lots were ideal. He bought them "relatively spontaneously," then began to ponder what to build, producing a host of sketches and designs. At first the idea was to build a house for himself and Genzken, but the two separated for good in 1993. He proceeded with plans to move in alone, but by then was involved with Sabine Moritz, who would soon become his third wife; the design expanded to accommodate a family, including children.

The house he finally built was a two-story cruciform with arms of equal length. Each arm contains a good-sized room; the space at the intersection of the two long halls houses closets, a bath, and the staircase. Richter had the house set back from the street and left the front lot empty. Later, when he drafted plans for a new studio, he designed an extended building that appears from the street to be windowless, effectively sealing off the private area behind it. His planning for the house included detailed designs even for the staircase handrails. He hired the Cologne architect Thies Marwede, who had remodeled his studio in the factory building on Bismarckstraße. In June 1996 Richter moved in, along with Sabine and their sixteen-month-old son, Moritz. In an interview published in *Der Spiegel*, Richter described the house as a "paradise," the same word he had used to describe the house he had shared with Ema.[20]

MARKETS AND MIRRORS AND MOVIES

The year 1991 saw two important exhibitions. "Painting, Sculpture and Mirrors" ran from April 22 to June 17 at the Anthony d'Offay Gallery in London. And a show of abstract paintings opened on September 7 at Durand-Dessert in Paris. Richter's prices had risen significantly. Paintings two meters square were now selling for DM 200,000 (e.g., CR 747/1–4) and mirrors of the same size for half that. *Betty* was still for sale, probably because Richter and his gallerists wanted it to go to a museum. Ultimately it did; the St. Louis Art Museum purchased the striking oil in 1992.

Around this time Richter also lay claim to a larger share of the proceeds from sales of his work. Instead of an equal split between artist and dealer, Richter now received 55 percent of the sale price for works in exhibitions and 60 percent if the gallery simply handled a transaction. For d'Offay he agreed to a special arrangement: the gallery was permitted to sell works for more than the official price,

with any extra amount to be divided equally between the two parties. In 1995, for example, d'Offay received $225,000 for a landscape that was priced at $165,000 on Richter's official list.

By then there was no doubt that Richter's work was collectable and would hold its value. The recession on the international art market that followed the New York Stock Market crash of 1987 ("Black Monday") had no effect on demand for his work—prompting Richter's despairing observation that "the market would take any rubbish I might turn out."[21] That Richter was able to resist the temptations of the marketplace and maintain the standard he had set for his practice is apparent from the numerous watercolors and drawings that wound up in the waste bin, not to mention the painted-over landscapes that failed to measure up. At the same time, Richter admits that he is not always the best judge of his paintings. "Here I have to say, that *I* can be wrong and am allowed to be wrong when I think a painting is bad or good, or the other way around—and that those who buy paintings have the responsibility, which I can no longer have, once the paintings leave the studio. It is also the collectors' fault if they buy something that is lacking, just because I painted it."[22]

This period of intense market interest in Richter's output had been preceded by years of hard work and a number of major commissions. Among them were the two large *Victoria* paintings for the insurance company Victoria-Versicherung, a commission negotiated by Helge Achenbach, who also represented Richter five years later for an installation of 18 mirrored panes in the lobby of the Hypo-Bank in Düsseldorf (CR 740, 741). In June 1991 Achenbach mounted a show of Richter's latest abstract paintings in the spacious rooms of his agency in Frankfurt. The *Tourist* cycle served as the spectacular centerpiece. As it turned out, Achenbach had paid too high a price for the *Tourist* paintings, and Richter thus felt compelled to agree to the consultant's rather outrageous demand that he take on a new project, which he would later come to regard as "pure foolishness." During one of Achenbach's visits to Richter's studio, he floated the idea of shooting a film in Japan, though neither had more than a passing notion of what the film's subject might be. Richter envisioned something akin to the *Atlas*, using film to organize diverse materials—"to attempt a foreign view of a country," as Henning Lohner put it.[23] Lohner, who was thirty years old at the time, happened to be in the studio during Achenbach's visit and, because he had some experience in filmmaking, was assigned the role of director by Richter.

Off they went, flying to Tokyo on September 16, 1991. Richter was accompanied by Isa Genzken; Lohner brought along Van Theodore Carlson, an American, as a cameraman. And Achenbach traveled with them the first few days, hoping to introduce Richter to collectors and curators and to sell paintings in Japan. The group stayed in Japan for two weeks, traveling from the capital to Kamakura, Hakone, Osaka, Kyoto, and Kobe, on to Hiroshima, and then back to Osaka. Richter had an extra camera lens at his disposal, which he used to frame the shot

FIG. 11.4. RICHTER IN JAPAN, 1991.

and direct the cameraman. Lacking a concept, they simply filmed everything that came their way: impressions of the Japanese landscape, views from cars, trains, and hotel windows, passersby in the cities, the bustling activity of the fish market, Buddhist temples, shopping arcades, subway stops, parks and monuments (fig. 11.4). "I just went along with it blindly. The camera ran continuously." By the time Richter returned to Cologne, he had 152 hours of raw footage. He certainly didn't understand how to edit film. Except for the short experimental film *Volker Bradke* (1966), he had virtually no experience with the medium. "I had no conception and thought somehow it'll work itself out. But it didn't." After several failed attempts to cobble something together, Lohner suggested they divide the footage into eighteen "elements" that would shift according to a defined rhythm, at least give it a shape. Some elements could be sensibly organized according to subject: close-ups of people; houses, architecture, perspectives; bushes and plants. Others would derive from the language of film aesthetics: "subjective camera movements," "worm's eye view," "pan shots 360 degrees." Finally in 1994, they produced a ninety-minute raw cut. The broadcast network Westdeutsche Rundfunk had expressed interest in airing the film, which lacked only a soundtrack. But at that point, Richter finally admitted, "I am not a filmmaker. I can't do this at all." And that was the end of it.

DOCUMENTA 9

In 1992 Richter took part in the ninth Documenta, overseen this time by Jan Hoet, director of the Stedelijk Museum voor Actuele Kunst (Municipal Museum of Art) in Ghent. Initially Richter had wanted to show the two monumental *Victoria* canvases, but transporting them proved prohibitive. This sent him in a different direction. Because space at Documenta was limited, the organizers had arranged for several aluminum trailers to be put in the Karlsaue, a park on the bank of the Fulda. Richter decided to develop his contribution around one of these mobile pavilions. To counteract the temporary, trade show ambience of the trailer, Richter asked the architect Paul Robbrecht to install luxurious paneling on its walls. "The idea was to make a proper room out of the trailer. There were lots of architectonic designs in the *Atlas* already."

By engaging in installation Richter was not only reviving his interest in the arrangement of architectural situations and spaces, which had started with his education as a mural painter in Dresden; he was also commenting on modernist exhibition practice. Rather than hang his paintings in isolation, far apart on neutral white walls, he stepped back in history. The paintings were arranged in two rows, one above the other. This, combined with the wood paneling, gave the installation an air of permanency and intimacy and unified the work and the space.

Richter had often engaged with art history. Consider his romanticized landscapes, the candle paintings and floral still lifes, the classical busts of Blinky Palermo and himself, his revival of history painting in *18. Oktober 1977*, and his depiction of domestic bliss in the series *S. with Child* (*S. mit Kind*, 1995; CR 827/1–8). In each case Richter intentionally veered from the avant-garde course and, in so doing, revitalized a type of painting whose end had been erroneously declared. But his trailer-cum–club room surprised and irritated the critics. Thomas Wagner wrote in the *Frankfurter Allgemeine Zeitung*, "The museumlike wood paneling in his bunker . . . does not do much to help Gerhard Richter's paintings. These abstract paintings, medium-sized panels, are two-dimensional and decorative, with their color hidden beneath thick anthracite streaks and veiled layers."[24] Wolf Schön complained that Richter had presented uncharacteristically mediocre work.[25]

Richter hung fourteen works in the modest room: twelve abstract paintings, one flower painting (1992; CR 764/2), and the double gray *Mirror* (*Spiegel*, 1992; CR 765), whose two sides fold out and away from each other. The abstractions were rendered almost exclusively in dark tones, producing an effect that even Richter described as "sad."[26] In such a muted, melancholy atmosphere, the small, exquisite flower painting was a hope-inspiring accent. Richter liked the appearance of the wall paneling so much that he duplicated it in the office of his studio.

FIG. 11.5. RICHTER WITH KASPER KÖNIG (LEFT), 1993.

On September 22, 1993, the most comprehensive retrospective of Richter's work to date opened at the Musée d'Art Moderne de la Ville de Paris. At the artist's request, Kasper König served as curator (fig. 11.5) and Benjamin Buchloh edited the three-volume catalog, which collected much of his writing on Richter.[27] The exhibition featured more than 130 works spanning thirty years and played extremely well with the press. As critic Doris von Drathen said, "There are exhibitions that, like great milestones, reset the standards in contemporary art. Richter's retrospective, launching now at the ARC in Paris, is of this quality."[28] From Paris, the retrospective traveled across Europe, with stops in the Kunst- und Ausstellungshalle der Bundesrepublik Deutschland in Bonn, the Moderna Museet in Stockholm, and the Museo Nacional Centro de Arte Reina Sofia in Madrid, where it closed on August 22, 1994.

NÎMES

The reaction was far different three years later when Richter showed his new cycle *S. with Child*, comprising eight paintings of his new wife and baby. Critics were

FIG. 11.6. *Isa*, 1990. OIL ON CANVAS. 35 × 35 CM. CR 717/7.

ambivalent, if not downright dismissive of the new work. In painting *S. with Child*, Richter had resorted to a psychological strategy that had always sustained him when he wanted to explore personal themes that were decidedly not avant-garde: he would convince himself that he was painting only for himself. But the fact remains that he did put this intimate cycle before the public. Perhaps because the paintings were so personal, he opted to show them first at the Carré d'Art in Nîmes, on the fringe of the international art stage. The exhibition, called "100 Paintings," included mostly new and smaller paintings, with the *S. with Child* cycle at the heart of it.

Richter had painted the works from recent photographs he had made of his wife Sabine and their son Moritz. Sabine Moritz had been his last student at the academy in Düsseldorf. She had joined his class in the winter semester of 1992, by which time Richter badly wanted to stop teaching. He was reluctant to take on new students, but as the year progressed, he found himself growing closer to the young painter.

By then he and Genzken had separated and were getting a divorce. Once the divorce was final, Richter married Sabine. Their son Moritz was born on January 6, 1995, and a daughter, Ella Maria, followed a year later. The eight small paintings in the domestic cycle, none larger than 62 by 72 centimeters (CR 827/6), depict ostensible scenes of familial happiness. Not since the painting of his first wife, *Ema (Nude on a Staircase)*, had Richter painted in a way that laid so bare a deeply intimate attachment.

The Nîmes show featured other personal work, too, including two small portraits of Isa Genken that he had painted in 1990 (fig. 11.6). Richter had painted his second wife's facial features so softly that she is barely recognizable. He also covered the surface surrounding her face with brushy impasto marks such that both portraits appear unfinished. Richter had spoken often about having to rescue his paintings, but with the portraits of Isa he seems to have capitulated to the subject. In Nîmes, he showed them together with *I. G.* (1993; CR 790/4–5; fig. 11.7), two nude views of Isa from behind, as if she has turned away from the viewer. The artist painted the nudes soon after their separation, as paintings of alienation and as a way of saying goodbye.

Several additional paintings of Sabine (fig. 11.8) relate to the group *S. with Child*. As early as 1994 Richter had introduced her figure in *Reader* (*Lesende*; CR 799/1), *Reading* (CR 804; fig. 11.9) and *Small Bather* (*Kl. Badende*, 1994; CR 815/1). All three paintings, made from Richter's own photos, reference works in the art-historical canon. "I wanted to make a Vermeer out of every photograph, but I never, never was able to," he later admitted to Uwe M. Schneede, the director of the Kunsthalle in Hamburg.[29] *Reading* is a clear attempt to bring Jan Vermeer's *A Girl Reading a Letter by an Open Window* (ca. 1659) into the twentieth century, the handwritten letter having been replaced by the mass-produced newsmagazine *Der Spiegel*. Richter knew the Vermeer painting well; it belongs to the Staatliche

FIG. 11.7. *I.G.*, 1993. OIL ON CANVAS. 72 × 102 CM. CR 790/4.

Kunstsammlungen (State Art Collections) in Dresden. *Small Bather*, an oil on paper, borrows plainly from a picture by French artist Jean-Auguste-Dominique Ingres, whose technique Richter has always admired. Richter freely admits that he also had canonical works in mind as he made the photographs for *S. with Child*. Of course, given the subject, the images cannot help but recall the Madonna and Child (figs. 11.10–11.13).[30]

As a father, Richter attempted to take possession of his domestic happiness through a long painterly process, as if only this would make the situation believable (figs. 11.14, 11.15). In this sense, the eight paintings may be considered private work. But for public presentation, Richter renders the subjects anonymous through overpainting. On six of the canvases, he employs techniques familiar from his abstract works: paint applied to the surface and then scraped away—this time aggressively, using a palette knife. In contrast with his abstract, partially overpainted landscapes, though, the intent here is not to pit realism against abstraction but to create distance. The abstract-gestural interventions may also be seen as attacking the family idyll. The title of the group, *S. with Child*, reinforces the need for both recognition and concealment. The abbreviation hints at the personal but also denies it. It also specifically suggests "Saint." The easier it is to recognize his wife in the painting, the more intensively Richter works to obscure

FIG. 11.8. RICHTER WITH SABINE MORITZ, 1994.

FIG. 11.9. *Reader (Lesende)*, 1994. OIL ON CANVAS. 72 X 102 CM. CR 804.

FIG. 11.10. *S. with Child (S. mit Kind)*, 1995. OIL ON CANVAS. 36 × 41 CM. CR 827/1.

FIG. 11.11. *S. with Child (S. mit Kind)*, 1995. OIL ON CANVAS. 52 × 62 CM. CR 827/3.

FIG. 11.12. *S. with Child (S. mit Kind)*, 1995. OIL ON CANVAS. 52 × 56 CM. CR 827/4.

FIG. 11.13. *S. with Child (S. mit Kind)*, 1995. OIL ON CANVAS. 46 × 41 CM. CR 827/8.

FIG. 11.14. GERHARD RICHTER WITH MORITZ RICHTER, 1998.

her identity. In the *Atlas* there is only one photo in which Sabine looks directly at the camera, an image Richter did not choose to paint.

The remaining two paintings in the cycle were allowed to stand as softly drawn "photographic" representations, without any distancing intervention. One depicts Moritz nursing (CR 827/5), a distinctly intimate scene, and the other annoys by virtue of its unbearably kitschy pink-violet color scheme (CR 827/7).

Uwe M. Schneede acquired the group directly from Richter's studio for the Kunsthalle in Hamburg, where he squared off the domestic paintings against the political cycle *18. Oktober 1977*:

> The Baader-Meinhof cycle consists of distanced, hopeless painting of death in the face of a utopia defeated by violence. "S with Child" shows, in light of the vanished utopia, paintings that arose out of private happiness, but that also speak to the fraudulence of everyday paintings and their necessary destruction, and to misdeeds and death.[31]

A four-page article in *Der Spiegel* published the works even before they were presented in Nîmes. Upon visiting Richter's studio, Jürgen Hohmeyer wrote enthusiastically, "Underground drama is created, an expression of danger for mother and child, who almost drown . . . in the turmoil of paint. Great painting arises

FIG. 11.15. GERHARD, MORITZ, ELLA MARIA, AND SABINE RICHTER, 2001.

out of this tension."[32] Other reactions were less euphoric. The art critic for the *Frankfurter Allgemeine Zeitung* saw in the paintings only the "deceptive realm of what had become a shallow 'mushy realism.'"[33] The series also left Stefan Gerner ambivalent: "The diffuse unease one feels upon turning away from these paintings may come from the difficulty in deciding whether they functionalize the private for aesthetic purposes or use the aesthetic to legitimize the private."[34]

In October 1997 Marian Goodman showed the abstract paintings that had been included in the Nîmes exhibition. Small ones (51 × 56 cm) were then priced at $38,000. Four years later in New York, collectors would be paying $100,000 for abstract paintings of the same size. Fred Jahn says:

Richter . . . was aware of what was going on in the market and at the auctions. [Regarding supply and demand] his strategy was to say, "I don't have anything left, I let it all out of the studio." Until someone finally said to him, "Well, make it more expensive." . . . It always seemed as if he was acting out of defensiveness, and he never appeared to be happy about announcing price increases . . . but in hindsight . . . he actually . . . did it especially well and especially right.[35]

THE REICHSTAG PROJECT

In the 1990s the German government set aside DM 70 million to fund an ambitious art program for its buildings in Berlin, capital of the newly unified Germany. The parliament, the new chancellery, the ministries, and other government offices were to be outfitted with contemporary art, and various experts were brought in to advise the acquisitions board. On the recommendations of Götz Adriani and Karin Stempel, major works by Katharina Sieverding, Georg Baselitz, Markus Lüpertz, and Ulrich Rückriem were acquired, and new site-specific works were commissioned from Hans Haacke, Jenny Holzer, Günther Uecker, and Bernhard Heisig.

But the most prominent sites—the two high side walls just inside the main entrance to the Reichstag building—were given to Sigmar Polke and Gerhard Richter. For his project Polke created five large light boxes that reveal various subjects from German history as the viewer moves around the room. The work plays on the fleeting quality of painting but also serves to comment on Germany's contradictory history.

From the outset Richter wanted his intervention on the opposite wall both to reflect the history of the Reichstag and to satisfy the architectural demands of the extremely tall, narrow space. At first Richter wanted to revisit a theme that had not worked for him in 1967 and which ultimately did not work for him here: the persecution and annihilation of Jews under the Third Reich. He had collected numerous documentary photographs from the era and thought to render four subjects in large gray paintings to be installed, one above the other, on the wall. Having survived the vehement debate over his Baader-Meinhof cycle Richter hoped it would now be possible to address what was undeniably the most abject theme in German history. But these paintings, on permanent public display in the Reichstag, would have provoked enormous controversy and misunderstanding. "Perhaps it was shame or pity or piety that held me back. I never figured it out," said Richter several years later, struggling to account for his change of heart.[36]

He turned instead to a variety of apolitical alternatives based on the German national colors—black, red, and gold—a theme he had used in *Abstract Painting* (CR 848/11; fig. 11.16), from 1997. The materials and designs collected in the *Atlas*

FIG. 11.16. *Abstract Painting (Abstraktes Bild)*, 1997. OIL ON ALUMINUM-COMPOSITE PANEL. 46 × 41 CM. CR 848/11.

FIG. 11.17. *Atlas* (PANEL 651), *Reichstag*, 1998. FELT-TIP PEN, WITH COLLAGE AND PHOTOCOPY ELEMENTS.

FIG. 11.18. RICHTER AT WORK ON REICHSTAG COMMISSION

(panels 635–655) allow us to reconstruct how the concept for the Reichstag project developed. Initially Richter experimented with variations on the color charts from the 1970s (*Atlas*, panels 650, 651), breaking up the symbolic character of the colors by spreading many small squares playfully over the wall's surface (fig. 11.17). As the concept evolved (fig. 11.18), he hit upon the idea of using the same material he had employed for the colored mirrors and deploying the same reductive process that had resulted in the *Stroke* paintings years before. The result was a narrow bar in the colors of the German flag that captures its surroundings in reflective surfaces, a work persuasive in its simplicity, clarity, and presence that integrates perfectly into the difficult architecture of the Reichstag foyer. The three-part work, 3 meters wide by more than 20 meters high, was installed in early 1999 (fig. 11.19). Richter

FIG. 11.19. *Black, Red, Gold (Schwarz, Rot, Gold)*, 1999. GLASS WITH COLORED ENAMEL. 2043 × 296 CM. CR 856.

is more than satisfied with the effect. "I don't care if it's art or not. It's the most elegant solution," he has said in defense against critics who had been expecting a conventional painting. "It looks good. What can I say? I wanted to represent—or produce—these colors as beautifully as possible: for the room and for the cause. Visible and almost palpable, as thin panes floating in front of the wall, large but also fragile, and of course reflective."[37]

MOMA

In August 1998 Richter suffered a stroke in his studio. Thanks to swift medical treatment and a course of rehabilitation he recovered quickly, but the shock remained. Richter did not paint for nearly a year. Slowly, he returned to work. A number of pencil drawings were followed by some abstract paintings in muted colors and with compact surfaces that close themselves off to the viewer (fig. 11.20). Richter described these new paintings as sad, melancholy, and resigned.[38]

On February 13, 2002, four days after Richter's seventieth birthday, the Museum of Modern Art in New York City launched a full-dress retrospective of his work. Robert Storr, the museum's then senior curator, had been the driving force behind MoMA's acquisition of *18. Oktober 1977*, out of which grew his determination to launch a major U.S. retrospective. As Storr wrote in the exhibition catalog, "The present retrospective of paintings by Gerhard Richter is long overdue."[39] As the last large exhibition before the building closed for expansion and renovation, the show marked the end of one era in the museum's distinguished history and an opening to another.

The exhibition collected 190 works, with *48 Portraits* accounting for a quarter of them. Storr had never meant the show to be exhaustive. "It is the most comprehensive exhibition I can do, but it is not in any way a definitive one."[40] After its premiere in New York, the exhibition traveled to the Art Institute of Chicago, the San Francisco Museum of Modern Art, and the Hirshhorn Museum in Washington, D.C.

The show began like many before it, with the programmatic number 1 from Richter's catalogue raisonné, *Table* from 1962 (now in an American collection). It also featured a somewhat personal painting, made from a photograph of Richter with his longtime collaborator Benjamin Buchloh (fig. 11.21).

Overall, the mood of the exhibition was elegiac, with Peter Schjeldahl describing the show as "Gerhard Richter's triumphant sorrow."[41] Starting with the early gray photo-paintings, Storr built a convergence of subjects with a buried connection to Richter's past or to historical events that were somehow tragic. Surrounding the exhibit's central room, where the *18. Oktober 1977* cycle was installed, he grouped abstract paintings from the late 1980s and 1990s, which, with their reserved hues, pick up the disturbing mood of the cycle. Storr gave

FIG. 11.20. *Abstract Painting (Abstraktes Bild)*, 2000. OIL ON ALUMINUM-COMPOSITE PANEL. 50 × 72 CM. CR 869/6.

disproportionate attention to Richter's recent family portraits. What is striking is how his relationship to his "models" has changed over the years. In the 1960s he had painted the aesthetic of the photographic medium into his paintings partly to obscure his personal connection to the subjects. By comparison, his depictions of Isa Genzken and of Sabine and Moritz are almost oppressive in their intimacy.

In his catalog essay Storr places Richter among the artists who have formulated the basic principles and standards for the art of the twenty-first century:

> A broadly philosophical painter, more than a strictly conceptual one, a radical thinker and often traditional maker, among the great artists of the second half of the twentieth century, and a frontline explorer of the twenty-first, Richter is an image-struck poet of alertness and restraint, of doubt and daring.[42]

12 FIRST LOOK

PANES OF GLASS

When his retrospective at the Museum of Modern Art premiered, Richter was already busy in the studio with a new project: an installation of eight gray mirrored surfaces that refer to the eight-part *Gray* painting cycle from 1975. The mirrors are significantly larger (320 × 200 cm) than the paintings and feature adjustable steel mounts so that every panel stands at a slightly different angle to the wall. In spite of their considerable weight—180 kilograms each—the panels create an effect of lightness and appear to float in front of the white walls of the studio (fig. 12.1).

This was not the first time Richter had turned to mirrors or panes of glass at an important juncture in his career. In 1967, when he was beginning to think he had exhausted the possibilities of gray photo-painting, he made *4 Panes of Glass*. Ten years later, during the transition to soft abstractions that led him out of his *Gray* cul-de-sac, he created the first gray *Panes of Glass* and the *Double Pane of Glass*. The colored mirrors from 1991 (CR 735/1 to 741) came soon after *18. Oktober 1977*. It is as if by reflecting reality quite literally in a mirror, Richter could find his way into a new perceptual groove that would allow the work to advance. And again, even as the MoMA show summed up forty years of painting, Richter seemed to be contemplating a new direction.

What followed the eight-mirror ensemble were the *Standing Panes* of 2002. These freestanding glass-and-steel constructions may at first seem to repeat *4 Panes of Glass* in versions using four (CR 877/1), five (CR 877/2), and seven (CR 879/1–2) panes, but structurally the works are quite different. Each of the 1967 panes rotates

FIG. 12.1. *Eight Gray (Acht Grau)*, 2001. 320 x 200 x 30 CM. GRAY ENAMELED GLASS AND STEEL. CR 874/1–8.

FIG. 12.2. *7 Standing Panes (7 Stehende Scheiben)*, 2002. 234 x 167 x 336 CM. GLASS AND STEEL. CR 879/2.

independently on a single axis; those in the new work stand fixed in parallel. Richter had wanted the *4 Panes of Glass* to be understood as a transparent and, in a figurative sense, clear antithesis to Duchamp's mystical *Large Glass*; now, in 2002, he wanted to foster an expanded experience. *4 Panes of Glass*, in its modernistic frames, had been presented as an alternative model to painting; the four windows offer an infinite number of views into reality but with no possibility of realizing it. At the time Richter described this experience as seeing without comprehending.[1]

In contrast, *7 Standing Panes* (CR 879/2; fig. 12.2) confronts the viewer with a completely different visual and physical experience. The object is freestanding, bidding the viewer to examine it from all sides. In circling the structure, the viewer experiences a constant flux of optic interruptions, irritations and illusions, appearing and disappearing images. The panes create multiple, layered reflections and distortions, even suggesting at times Richter's early photo-paintings. The visual complexity of *7 Standing Panes* (and the other pieces in this group) baffles precisely for the reason that the construction is so simple. The visual sophistication and understanding that Richter had lacked in the 1960s is expressed thirty-five years later in a multitude of fictive images.

While Richter was busy with these works, an edition of tinted prisms in cardboard boxes was produced in connection with the exhibition "Eight Gray" at the Deutsche Guggenheim Berlin (December 11, 2002–January 5, 2003). They presented, in a small format, yet another variation on the motif of transient images appearing in the mirror.[2]

SILICATE

The epistemological implications of the image as fictive model had preoccupied Richter in one form or another for years. But now he wanted to examine the theme from a different angle, one that resonated with the limits of scientific representation. On July 26, 2000, an article had appeared in the *Frankfurter Allgemeine Zeitung* that struck him as a belated vindication of his conceptual approach to painting. "First look into the inside of an atom," read the caption of an accompanying photograph. "Now, for the first time, details of the inside of an atom have been made visible with the aid of a scanning tunneling microscope." But the photograph showed only a sort of cloudiness: no discernible details, no spontaneous revelation of the elementary structure of the universe. Richter saw the image as corroborating his own artistic insight. The physicists at the University of Augsburg had reproduced, with the aid of a microscope, the phenomenological blur that Richter had been exploring for four decades, even as he also pursued a rigorous structural understanding of paint and painting. To commemorate the event, he created a small-edition offset print of the image along with a snippet of the text. Tellingly, he titled it *First Look (Erster Blick*, 2000; fig. 12.3).

Foto Universität Augsburg

Erster Blick in das Innere eines Atoms

Mit einem Rastertunnelmikroskop konnten jetzt erstmals Details innerhalb eines einzelnen Atoms sichtbar gemacht werden. Auf diesem Bild sind die Elektronenwolken eines Siliziumatoms zu erkennen. Vom Halbleiter Silizium ist bekannt, dass an seiner Oberfläche einige Atome hervor-

Stiel haben, erklären die Physiker als Artefakt, das durch die Technik des Abbildens entsteht („Science", Bd. 289, S. 422).

Die höhere Auflösung erreichten die Forscher, indem sie einen verbesserten Sensor verwendeten. Er besteht aus einer „Stimmgabel" aus einkristallinem Quarz,

FIG. 12.3. *First Look (Erster Blick)*, 2000. 18.2 × 15.1 CM. OFFSET PRINT ON PAPER. EDITIONS CR 112.

FIG. 12.4. *Silicate (Silikat)*, 2003. 290 × 290 CM. OIL ON CANVAS. CR 885/1.

FIG. 12.5. *Silicate (Silikat)*, 2003. 290 × 290 CM. OIL ON CANVAS. CR 885/3.

While Richter had always professed a passing interest in science—in scientific culture at least—the theme of fictive reality now engendered a new, heightened ambition to examine the artifice of scientific representation and digital modeling. The "pictures" of atomic structure created by a scanning tunneling microscope are not optical enlargements, of the kind produced by an ordinary microscope. Rather, they are computer-generated from strings of numeric data—visual fictions whose relation to reality seemed unexpectedly similar to that of Richter's paintings. "Abstract paintings are fictive models," he had written in 1982, "because they make visible a reality that we can neither see nor describe, but whose existence we can postulate."[3]

Several years after the photo of the atom's interior, another interesting image appeared in the science pages of the *Frankfurter Allgemeine Zeitung* (March 12, 2003). Under the headline "A colorless coat for shimmering colors," the article reported on attempts to recreate in the laboratory the shimmer produced in nature by silicates in the hard outer sheaths of insects, and it included an illustration of one such silicate film. Richter used this particular scientific fiction as the model for four monumental canvases from 2003, each titled *Silicate* (*Silikat*; CR 885/1–4). From the beginning he had planned the four paintings as a cycle, and, indeed, the viewer becomes increasingly absorbed in the formal resolution of the image when moving from painting to painting.

In the first painting (fig. 12.4), the computer-generated representation of the silicate structure appears as bundles of three dark, cell-like ovals embedded in a honeycomb lattice. The cells are distributed evenly across the picture, but because they are hand painted, they are not identical. They vary in light value and are slightly blurred. In keeping with Heisenberg's uncertainty principle, they elude precise placement in the image space. In the next three paintings, the structure shifts into something more dynamic. In the second painting the image has been rotated 180 degrees, the visual resolution varies across the canvas, and two cells in each bundle of three have been darkened, emphasizing the horizontal organization. The model is even more blurred in the last two paintings; a woven texture begins to develop in the third (fig. 12.5), culminating in a strong sense of diagonal movement in the fourth.[4]

After the *Silicate* cycle came *Strontium* (2004; CR 888), a monumental C-print. The theme of fictive scientific models has continued to occupy the artist. In 2006 he prepared six large canvases on which to paint such motifs, but halfway through the project he abandoned it, recycling the canvases into a suite of six abstract paintings he called *Cage I–VI* (897/1–6), partly in homage to John Cage, whom he had always admired, but also, as Armin Zweite wrote, as a play on his own activity in the studio where he often felt trapped.[5] Perhaps not by coincidence, that was also the year that Richter's second son, Theodor, was born, making his family complete, he hoped.

SEPTEMBER

Richter had spent most of 2005 working on a single theme. A solo exhibition in November at Marian Goodman Gallery in New York included the four *Silicate* paintings, but the show's core was a twelve-part series of abstract paintings (892/1–12) and four related pencil drawings.[6] The paintings were untitled, and remained so until they appeared in the exhibition "From Caspar David Friedrich to Gerhard Richter" at the Getty Museum in Los Angeles, at which point Richter named the series *Wald* (*Forest*). The title seemed both consistent with the paintings' formal appearance and appropriate in the context of the Romantic landscapes on display. In many of the works the paler colors seem to shine through like light from a distant clearing, with ghostly, treelike vertical shapes looming up against the picture plane.

In reality the titles were meant to distract from the paintings' genuine theme, which is September 11, 2001, when the terrorist group al-Qaeda launched an attack on American soil, using four commercial passenger jets as weapons. The drawings speak more openly to the 9/11 motif than do the abstract paintings, showing blocklike vertical structures interrupted by horizontal hatching and strong lines. The paintings suggest the two towers of New York's World Trade Center on the morning of 9/11. We witness an all-out struggle here between the vertical and the horizontal, between structure and gravity, a theme Richter elaborates through the clash of eruptive colors and massive, dark shapes; the instability of the towers is implied by what seem to be falling, dissolving structures of paint in the center of the canvases (CR 892/12; fig. 12.6).

If one knows the origins of the paintings, the terror, shock, tragedy, and drama of that day are immediately reinstantiated. In an interview with the author, Richter confirmed the connection between these paintings and the events of 9/11. (He also admitted in an interview with Jan Thorn Prikker that the association of the title *11 Panes* (886/1–5) from 2003–2004 with 9/11 was "very correct."[7]) Like most people Richter remembers where he was that day. He was in a plane en route to New York to open a show at Goodman's gallery just as American Flight 11 and United Flight 175 crashed into the twin towers. Richter's plane was rerouted to Halifax, his first time there since his teaching gig at the Nova Scotia College of Art. After several days, he managed to get a flight back to Cologne.

Beyond these works, there is a small, more realistic painting that Richter kept to himself for years. It is titled, quite simply, *September* (CR 891/5; fig. 12.7). That it too is concerned with 9/11 is suggested by a photo in the catalog for the Goodman exhibition that shows three of the unfinished drawings for the *Wald* project hanging in Richter's studio. In front of them on an easel is a canvas showing the pencil drawing for the painting in question. The blocklike silhouette of the twin towers is unmistakable. *September* is expressive, realistic, and very strong, but

FIG. 12.6. *Abstract Painting*, 2005. 197 × 132 CM. OIL ON CANVAS. CR 892/12.

FIG. 12.7. *September*, 2005. 52 x 72 CM. OIL ON CANVAS. CR 891/5.

Richter hesitated to show it. In an interview published in *Der Spiegel* he indicated he might even decide to destroy the painting:

> The standard photo of the two towers with the explosion cloud and the bright blue sky would not let go of me until I finally tried to paint it. Nothing came of it. While I was painting, I noticed that it was heading in the wrong direction. . . . It will be destroyed, or I'll paint over it at some point, the canvas is still good.[8]

Gradually, however, he began to accept the painting, and in 2006 he mentioned for the first time the possibility of showing it.[9] In January 2008 *September* was featured in his first solo exhibition at the Marian Goodman Gallery in Paris, not in New York.

CATHEDRAL WINDOW

In 2002, the same year as the MoMA retrospective, metropolitan chapter of the Cologne Cathedral invited Richter to design a stained glass window to replace the one in the cathedral's south transept that had been destroyed during World War II. More than eight hundred years old, the Cologne Cathedral is one of the most significant Gothic churches in Europe and has been designated a UNESCO World Heritage Site. For Richter the cathedral had special importance: the children from his marriage to Sabine had been baptized there. To create a window for such a culturally and historically important building represented a fascinating challenge for the artist: "It's difficult even to admit that this is a wonderful thing. It is unparalleled. The cathedral has stood there forever, and then such a publicly effective window, and the south window at that, where the light shines through—it is truly a gift."[10]

With the commission, however, came certain conditions that nearly caused Richter to withdraw. It was the wish of the project's Catholic sponsors that the window depict six Christian martyrs of the twentieth century, a theme that was too traditional and too cultish for Richter:

> Of course I was impressed by this honorable request, but I soon realized that I was absolutely not up to the task. After a few failed attempts to approach the theme and when I was almost at the point of giving up entirely, an illustration of 4096 Colors landed on the table. I placed the template of the window's frame on it and saw that this was the only possibility.[11]

The resulting scheme, at first glance stunningly simple (and reminiscent of Richter's 1970 proposal, with Blinky Palermo, for the Munich Olympic stadium), would take five years to realize (fig. 12.8). Designing and building the window, which

FIG. 12.8. *Cathedral Window*, 2007. COLOGNE CATHEDRAL, SOUTH TRANSEPT. 23 M HIGH. CR 900.

stands 23 meters tall and has an area of 103 square meters, required a merger of aesthetics and technology. Among the myriad questions to be resolved: What size should the colored rectangles be in order to remain differentiated and yet evenly fill the frames of the window's various components, which included six lancet windows? After a number of trials, Richter decided on 9.7-centimeter squares—which some of his team called "pixels."

The final work incorporates seventy-two different colors, but it took a while to get there. Some questions about the choice and distribution of hues were answered through nondigital observation. In the first trial hanging, the intensity of the natural light streaming through the window caused the palest colors to read as white holes in the pixilated field of saturated hues. This had to be rectified, and to calculate the optimum number of squares for each color, Richter and his team made use of a randomizing computer program. The designs show how the overall tonal value of the window could be finely adjusted between a blue-, yellow-, or red-dominated optic. Ultimately Richter selected a version in which the frequency of each color is distributed to create the most even illumination possible. Richter also found that a random distribution of colors over the entire window tended to create a turbulent impression, a problem he solved by repeating certain areas in mirror image: the first lancet window is mirrored in the third window, the second in the fifth, and the fourth in the sixth.

The selected material—mouth-blown antique glass—brought with it other challenges. Eventually the artist and cathedral officials agreed on an innovative procedure in which the glass would be mounted on a supporting pane using silicon gel that never hardens completely. This allows the panes to expand and contract at different rates, so they would not break from the intense light and changing temperatures on the cathedral's south face.

The whole, protracted process was documented by Corinna Belz in a film. The numerous designs and drawings associated with the project were displayed at the nearby Museum Ludwig coincident with the window's dedication in August of 2007.[12] Richter donated his design and time to the project "for charity's sake." The other costs of producing and installing the large window were paid for by the citizens of Cologne, through thousands of donations, large and small.

The new window was dedicated on August 25, 2007. Because of the prominent setting and the strong identification of the people of Cologne with their cathedral, the window captivated the entire community. For weeks talk about the "Richter window" filled the news and the op-ed sections of newspapers. Public reaction was overwhelmingly positive, countering critics who complained that the design was too abstract, too random, and too little related to the sacred status of the cathedral and its religious history. The sharpest objection came from the archbishop of Cologne, Cardinal Joachim Meisner. In an interview with the *Kölner Express* newspaper, he said the window did not belong in the cathedral, but rather in a mosque or prayer house.[13] Later, during a church service, he went further: "There,

where culture becomes estranged from worship, the cult stagnates into ritualism, and culture degenerates." That last word, "degenerates" (*entartet*), raised for many the specter of Hitler's condemnation of advanced art in the 1930s.[14] Faced with a storm of horrified protest, Meisner quickly apologized.

With the window Richter had indeed achieved a trinity of goals. Visitors to Cologne Cathedral perceive the window, though a purely abstract design, as a metaphor for or emanation of the presence of god. The holy presence, which has long been represented by the appearance of light in Christian iconography and enhanced by actual light at religious sites, is celebrated here in a spectacular symphony of color. But having been designed by Richter, the window is also, of course, a contradiction. With its random order, which neither emphasizes the center or deemphasizes the edges, the field of color becomes a contemporary, egalitarian, and democratic alternative to the hierarchical structure posed by the Roman Catholic church, where the infallible representatives of Christ occupy the uppermost ranks. Thus the window both typifies the artist's aesthetic and, by virtue of its prominence, is a high point in his oeuvre. In his catalogue raisonné, Richter has assigned it the significant number 900.

NOTES

The abbreviation GR is used throughout the notes and index to indicate Gerhard Richter. Citations to the artist's self-organized catalogue raisonné are abbreviated CR. DPP refers to Gerhard Richter, *The Daily Practice of Painting: Writings and Interviews, 1962–1993,* edited by Hans-Ulrich Obrist and translated by David Britt (Cambridge: MIT Press, 1995); where quotations from this book have been revised by translator Elizabeth M. Solaro, the modified phrases are set in brackets in the text and the initials EMS, also in brackets, follow the page reference.

CHAPTER 1

1. Hitler's appointment as chancellor was made by German president Paul von Hindenburg, under duress, on January 30, 1933.

2. GR, in Peter M. Bode, "Immer Anders, immer er selbst" [Always different, always himself], *Art. Das Kunstmagazin,* May 1983, 60.

3. Judging from Marianne's symptoms, she likely suffered from schizophrenia. Richter learned the details of his aunt's death many years later when Jürgen Schreiber was doing research for a biography of the artist. Schreiber, *Ein Maler aus Deutschland. Gerhard Richter: Das Drama einer Familie* [A painter from Germany. Gerhard Richter: The drama of a family] (Munich: Pendo Verlag, 2005).

4. Neither Richter nor his sister remembers why the family moved to Waltersdorf, though both have tried to find out.

5. GR, in Jürgen Hohmeyer, "Richter. Wenn's knallt" [When things go bang], *Der Spiegel,* August 19, 1968, 91.

6. Horst worked at the textile mill from November 1950 to January 1953, then became an administrator at the Zentralstelle für das Fachschul-Fernstudium in Dresden (Central Office for the Technical School Distance Learning Program).

7. GR, in Coosje van Bruggen, "Gerhard Richter, Painting as a Moral Act," *Artforum*, May 1985, 83; GR, in Robert Storr, "Gerhard Richter: The Day Is Long" (interview, 1996), *Art in America*, January 2002, 68.

8. GR, in Bode, "Immer Anders," 60. Richter does not remember the name of his previous employer, the sign painter.

9. See, e.g., GR, "Notes, 1964," in *DPP*, 22, and Hohmeyer, "Richter. Wenn's knallt," 90.

10. GR, in Peter Sager, "Mit der Farbe denken" [Thinking with color], *ZEITmagazin*, November 28, 1986, 33.

11. Walther Ulbricht, speech given at the second conference of the Sozialistische Einheitspartei Deutschlands (SED), July 9–12, 1952, quoted in Karin Thomas, *Die Malerei in der DDR, 1949–1979* [Painting in the GDR, 1949–1979] (Cologne: DuMont, 1980), 42.

12. GR, in Dorothea Dietrich, "An Interview," *Print Collector's Newsletter*, September/October 1985, 132.

13. Hans Grundig, affiliated with the New Objectivity movement that arose in opposition to German expressionism during the Weimar Republic, was designated a degenerate artist by the Nazis, and his work was included in the infamous *Degenerate Art* exhibition of 1937. Lea Grundig was a printmaker whose primary subject was Germany's working poor. The two married in 1928. Both were born in Dresden, both studied at the Dresden Academy of Art, and both were members of the Communist Party.

14. Robert Storr, "Interview with Gerhard Richter, 2001," in *Gerhard Richter: Forty Years of Painting* (catalog; Museum of Modern Art, New York, 2002), 21; see also chap. 1, "Beginnings," 90n15.

15. GR, "Über meine Arbeit im Deutschen hygienemuseum Dresden" [On my work in the German Hygiene Museum], *farbe und raum*, no. 9, 1956, 7.

16. Ibid., 9–10.

17. Ibid., 8.

18. GR, in the *Dresdner Morgenpost*, quoted in Monika Flacke, preface to *Ausgebürgert. Künstler aus der DDR und aus dem Sowjetischen Sektor Berlins 1949–1989* [Expatriated. Artists from the GDR and Berlin's Soviet sector 1949–1989] (catalog; Staatliche Kunstsammlungen Dresden, 1995), 7; Jeanne Nugent, discussion with University of Chicago Press editor Susan Bielstein, 2009.

19. Certainly we see this interest play out in Richter's many sketches of ideal spaces for his monumental paintings of 1970 and 1971, later collected in his *Atlas* (panels 234, 243, 249).

20. GR, "Auseinandersetzungen halfen mir weiter" [Disagreements helped me move forward], *Sonntag*, April 20, 1958, 12.

21. Ibid.

22. Werner Haftmann, "Einführung," in *Documenta 2, Painting* (catalog; Kassel, 1959), 18.

23. GR, "Interview with Benjamin H. D. Buchloh, 1986," in *DPP*, 132.

24. Ibid., 133.

25. GR, "Interview with Jonas Storsve, 1991," in *DPP*, 230.

26. *Positions* had shown from October 31 to November 30, 1986, at the Neue Berliner Galerie im Alten Rathaus in East Berlin and subsequently traveled to the Sprengel Museum Hannover (January 25–March 8, 1987). The other West Germans represented in the exhibition were Horst Antes, Ernst Wilhelm Nay, Raimund Girke, and Emil Schumacher.

27. GR, "Notes, 1962," in *DPP*, 13.

28. GR, letter to Heiner Friedrich, December 31, 1964. Richter's comments allude to "Notes, 1964," in *DPP*, 22–25.

CHAPTER 2

1. Heinz Mack, quoted in Helga Meister, *Die Kunstszene Düsseldorf* [The Düsseldorf art scene] (Recklinghausen: Verlag Aurel Bongers KG, 1979), 7.

2. Winfred Gaul, quoted in ibid., 8.

3. Karl Ruhrberg, "Yves Klein," *Düsseldorfer Nachrichten*, June 4, 1957.

4. Günther Uecker, "weißstrukturen" [White structures] (1961), in *nul negentienhondered vief en zestig* (catalog; Stedelijk Museum, Amsterdam, 1965), n.p.

5. GR, "Interview with Benjamin H. D. Buchloh, 1986," in *DPP*, 133.

6. For more on Lueg's artistic activity, see *Ich nenne mich als Maler Konrad Lueg* [As a painter I call myself Konrad Lueg] (catalog; Kunsthalle Bielefeld, 1999). Lueg, born April 11, 1939, was twenty-two at the time he met Richter.

7. Karl Otto Götz, *Erinnerungen und Werk* [Memories and work], vol. 1b (Düsseldorf: Concept-Verlag, 1983), 912.

8. Alexander Deisenroth, "Zur Ausstellung" [On the exhibition], in *M. Kuttner, G. Richter. Düsseldorf* (catalog; Galerie Junge Kunst, Fulda, 1962), n.p.

9. CoBrA's founders were Karel Appel, Constant, Corneille, Christian Dotremont, Asger Jorn, and Joseph Noiret.

10. GR, in Robert Storr, "Gerhard Richter: The Day Is Long" (interview, 1996), *Art in America*, January 2002, 74.

11. GR, "Notes, 1964," in *DPP*, 24.

12. GR, "Interview with Hans-Ulrich Obrist, 1993," in *DPP*, 256.

13. Lueg and Richter have reported independently how each first encountered American Pop art in *Art International*. For Lueg, see Dieter Hülsmanns, "Ateliergespräch mit dem Maler Konrad Lueg" [A conversation with the painter Konrad Lueg in his studio], *Rheinische Post*, April 26, 1966; Stella Baum, "Die Frühen Jahre. Gespräche mit Galeristen" [The early years. Conversations with gallerists] (interview with Konrad Fischer), *Kunstforum International*, no. 104, November/December 1989, 278. For Richter's account, see GR, "Interview with Benjamin H. D. Buchloh, 1986," in *DPP*, 137. *Refrigerator* is based on a 1962 newspaper advertisement; Lichtenstein enlarged the small clipping onto a 132-by-312-centimeter canvas, thus calling attention to the benday halftone dots used in newspaper printing. *Art International* reproduced the work in its January 1963 issue, under the title "Woman Cleaning," on pages 25 and 36.

14. GR, "Notes, 1964," in *DPP*, 22.

15. Götz, *Erinnerungen und Werk*, 912. Not until 1993 did Richter, somewhat reluctantly, add *Party* to his catalogue raisonné.

16. A version of the *Atlas* was published in 2006, in German, by Verlag der Buchhandlung Walther König and, in English, by Thames and Hudson.

17. GR, interviewed by Elmar Hügler for *Kunst und Ketchup. Popkunst, Happening und Fluxus* (television show), Süddeutscher Rundfunk network, February 14, 1966.

18. Y. F., "Die letzte Masche" [The last stitch], *Rheinische Post*, May 16, 1963, n.p.

19. Richter's interest in Bacon was again evident in 1975 when he painted portraits of his friends Gilbert & George (CR 381/1–2); see chapter 8.

20. GR, "Interview with Wolfgang Pehnt, 1984," in *DPP*, 117. For a discussion of recent criticism on whether or not American Pop artists were engaging in cultural critique as defined by the Frankfurt School, see Robert Storr, "Beginnings," in *Gerhard Richter: Forty Years of Painting* (catalog; Museum of Modern Art, New York, 2002), 91–92n69.

21. GR, letter to Plinio de Martiis (Galleria La Tartaruga, Rome), November 22, 1965.

22. GR, in *Gerhard Richter* (catalog; Tate Gallery, London, 1991), 125.

23. In June 1964 the Munich gallerist Heiner Friedrich purchased *Table* for DM 150 during a visit to Richter's studio. He in turn sold it to Reinhard Onnasch, and it remained in Onnasch's collection for many years. On December 4, 1996, *Table* was auctioned at Christie's in London for £249,000 to a private collector, who has since placed it on long-term loan with the San Francisco Museum of Modern Art.

24. GR, "From a letter to Benjamin H. D. Buchloh, 23 May 1977," in *DPP*, 84.

25. GR, in Peter Sager, *Neue Formen des Realismus* (Cologne: DuMont, 1973), 243.

26. GR, "Interview with Dieter Hülsmanns and Fridolin Reske, 1966," in *DPP*, 56–57.

27. GR, "Interview with Rolf Schön, 1972," in *DPP*, 72–73.

28. Dieter Honisch, "Zu den Arbeiten Gerhard Richters" [On the work of Gerhard Richter], in *Gerhard Richter* (catalog; 36th Biennale, German Pavilion, Venice, 1972), 3–4.

29. GR, "Interview with Hans-Ulrich Obrist, 1993," in *DPP*, 260.

30. GR, "Interview with Rolf Schön, 1972," in *DPP*, 73.

31. GR, "Arbeitsübersicht" [Work overview], in *14 × 14. Junge deutsche Künstler* [14 × 14. Young German artists] (catalog; Staatliche Kunsthalle Baden-Baden, 1968), n.p.

32. GR, "Interview with Rolf Schön, 1972," in *DPP*, 72.

33. GR, "Notes, 1964," in *DPP*, 23; GR, "Interview with Rolf Gunther Dienst, 1970," in *DPP*, 62.

34. Konrad Fischer, in Baum, "Die Frühen Jahre," 277.

35. Quoted in Meister, *Die Kunstszene Düsseldorf*, 9. Five Düsseldorf painters—Fritz Bierhoff, Alfred Eckhard, Karl Heinz Heuner, Otto Pesch, and Walter Ritzenhofen—had established what was at first called the Künstlergruppe Niederrhein 1953 e.V., shortened, two years later, to Gruppe 53. Gerhard Hoehme was elected president, and with newly added members Horst Egon Kalinowski, Rolf Sackenheim, Winfred Gaul, Peter Brüning, Karl Fred Dahmen, Konrad Klapheck, Heinz Mack, and Otto Piene, Gruppe 53 held an exhibition every year from 1956 to 1959 in the Düsseldorfer Kunstverein für Rheinland und Westfalen (the Düsseldorf Art Society for North Rhine Westphalia).

36. Konrad Lueg, untitled typescript (1963), in the estate of Konrad Lueg.

37. Konrad Lueg, draft of a letter, with corrections by Gerhard Richter (March 30, 1963), in the estate of Konrad Lueg.

38. GR, "Letter to a newsreel company [Neue Deutsche Wochenschaug Düsseldorf], 29 April 1963," in *DPP*, 16.

39. Ibid., 16, 15.

40. GR, letter to Heiner Friedrich, August 17, 1965.

41. Y. F., "Die letzte Masche."

42. Ibid.

43. Ileana Sonnabend, letter to GR, January 19, 1966.

44. GR, "Notes, 1964," in *DPP*, 22.

45. GR, "Text for catalogue *Beuys zu Ehren*, 1986," in *DPP*, 166.

46. GR, in *Gerhard Richter: Forty Years of Painting* (catalog; Museum of Modern Art, New York, 2002), 31.

47. The date of the festival, July 20, 1964, was approved by the academy administration without considering its significance, as Beuys had anticipated; see J. Beuys, "Krawall in Aachen. Interview mit Joseph Beuys" [Riot in Aachen. Interview with Joseph Beuys], *Kunst* 4, September 1964, 95. A snapshot of Beuys's salute, taken by Heinrich Riebesehl, became an icon of the Beuys cult. An enlargement of the photograph later hung in the artist's classroom at the Düsseldorf Art Academy.

48. GR, letter to Heiner Friedrich, July 24, 1964. For more on the event, see Adam C.

Oellers, "Fluxus an der Grenze: Aachen 20. Juli 1964" [Fluxus on the border: Aachen, July 20, 1964], in *Deutschlandbilder. Kunst aus einem geteilten Land* [Pictures of Germany: Art from a divided country] (catalog; Martin-Gropius-Bau, Berlin, 1997), 232–39.

49. GR, "Interview with Benjamin H. D. Buchloh, 1986," in *DPP*, 139; GR, in Dorothea Dietrich, "An Interview," *Print Collector's Newsletter*, September/October 1985, 131.

50. GR and Konrad Lueg, "Programme and Report: the exhibition *Leben mit Pop—eine Demonstration für den Kapitalistischen Realismus,* Düsseldorf, 11 October 1963," in *DPP*, 19; Konrad Lueg and GR, "Script; Quotes, 1963," in the estate of Konrad Fischer.

51. GR and Lueg, "Programme and Report," in *DPP*, 20. For more on the demonstration, see Susanne Küper, "Gerhard Richter, der kapitalistische Realismus und seine Malerei nach Fotografien von 1962–1966" [Gerhard Richter, capitalist realism and his photo-paintings from 1962–1966], in *Deutschlandbilder*, 265–68.

52. Küper, "Gerhard Richter, der kapitalistische Realismus," 266.

53. GR and Lueg, "Programme and Report," in *DPP*, 18–20.

54. Lueg and GR, "Script; Quotes, 1963."

55. GR and Lueg, "Programme and Report," in *DPP*, 20.

56. Lueg and GR, "Script; Quotes, 1963."

57. Ibid.

58. GR and Lueg, "Programme and Report," in *DPP*, 21.

59. Berthold Franke, *Die Kleinbürger. Begriff, Ideologie, Politik* (Frankfurt am Main: Campus Verlag, 1988), 214–15.

60. Küper, "Gerhard Richter, der kapitalistische Realismus," 267; cf. also Ingrid Misterek-Plagge, *"Kunst mit Fotografie" und die frühen Fotogemälde Gerhard Richters* ["Art with photography" and Gerhard Richter's early photo-paintings] (Münster/Hamburg: LIT Verlag, 1992), 175.

61. GR, "Interview with Hans-Ulrich Obrist, 1993," in *DPP*, 253.

62. GR, letter to Heiner Freidrich, January 16, 1965.

63. Kasper König, conversation with the author.

64. Baum, "Die Frühen Jahre," 277.

65. Konrad Fischer, in ibid., 278.

66. GR, in I. Michael Danoff, "Heterogeneity. An Introduction to the Work of Gerhard Richter," in *Gerhard Richter. Paintings* (catalog; Museum of Contemporary Art, Chicago/ Art Gallery of Ontario, Toronto, 1988), 10. GR, "Interview with Rolf Gunther Dienst, 1970," in *DPP*, 62.

67. Baum, "Die Frühen Jahre," 278. Contrary to Fischer's recollection, which situates the event in 1961, it actually took place on Christmas 1962. The artists did not know each other the year before. And Richter did not lose his funding; he received a stipend.

68. Günther Uecker, conversation with the author.

69. *Secretary* has been in the collection of the Federal Republic of Germany since 1977. *Cow* is in the Sylvia and Ulrich Ströher Collection at the Museum Küppersmühle für Moderne Kunst (Center for Modern and Contemporary Art) in Duisburg; *Stukas* belongs to the Staatsgalerie moderner Kunst (State Gallery for Modern Art) in Munich; and *Terese Andeszka* is owned by the Museum Wiesbaden.

70. Kasper König, conversation with the author.

CHAPTER 3

1. GR, "Poster text for the exhibition *Klasen und Richter,* Galerie Friedrich & Dahlem, Munich, 1964," in *DPP*, 26.

2. GR, "Interview with Hans-Ulrich Obrist, 1993," in *DPP*, 256.

3. Heiner Freidrich, letter to GR, July 16, 1964. *Table* (*Tisch*, 1962; CR 1) was not on the list of exhibited works, but was sold directly from the studio by Friedrich in June 1964.

4. W. Christlieb, "Nun auch in München: Pop-art. Die letzten Tage der Malerei" [Now in Munich too: Pop art. The last days of painting], *Abendzeitung*, June 22, 1964, 8.

5. GR, letter to René Block, August 17, 2000.

6. Telegram, September 9, 1964, in GR's archives.

7. Andy Warhol's first photo booth portrait was *Ethel Scull 36 Times*, painted in June–July 1963.

8. GR, "Interview with Dieter Hülsmanns and Fridolin Reske, 1966," in *DPP*, 57.

9. Stella Baum, "Die Frühen Jahre. Gespräche mit Galeristen" [The early years. Conversations with gallerists] (interview with René Block), in *Kunstforum International*, no. 104, November/December 1989, 255.

10. René Block, in ibid., 263.

11. René Block, "Mein letztes Wort (Ich will hier nicht erklären warum)" [My last word (I do not want to explain why here)], in *Graphik des Kapitalistischen Realismus* (catalogue raisonné; Berlin, 1971), 15.

12. René Block, in Baum, "Die Frühen Jahre," 256.

13. The exhibition ran from July 10 to August 5, 1965, and included the following paintings by Richter: *Pedestrians* (*Fußgänger*, 1963; CR 6), *Schmidt Family* (*Familie Schmidt*, 1964; CR 40), *Girl's Head* (*Mädchenkopf*, 1965; CR 63), and an unidentifiable *Curtain with White Border*.

14. Block, "Mein letztes Wort," 15.

15. Botho Strauß, *Trilogie des Wiedersehens* [Trilogy of Goodbye] (Stuttgart: Reclam, 1978), 105.

16. The following works were also shown: *Stukas* (CR 18/1), *Terese Andeszka* (CR 23), *Philipp Wilhelm* (CR 27), *Woman with Umbrella* (*Frau mit Schirm*; CR 29), *Prince Sturdza* (CR 32), *Colette Dereal* (CR 34), *Familie* (CR 30), *Renate und Marianne* (CR 31), *Family at the Seaside* (*Familie am Meer*; CR 35), *Great Sphinx at Giza* (*Große Sphinx von Giseh*; CR 46), *Small Pyramid* (*Kleine Pyramide*; CR 48/1), *Frau Marlow* (CR 28), and *Helen* (CR 25), all from 1964; GR, "Letter to Heiner Freidrich, 23 November 1964," in *DPP*, 29–30.

17. GR, "Letter to Heiner Freidrich, 23 November 1964," in *DPP*, 28.

18. René Block, conversation with the author; see also Baum, "Die Frühen Jahre," 257.

19. René Block, conversation with the author. Polke and Lueg held solo exhibitions in Galerie René Block for the first time in 1966. Only toward the end of the decade was Block able to make significant sales of Polke's works.

20. GR, "Letter to Heiner Freidrich, 23 November 1964," in *DPP*, 29.

21. Rudolf Jährling, in Baum, "Die Frühen Jahre" (interview with Jährling), 224.

22. The following paintings were also shown: *Mustang-Staffel* (1964; CR 19), *XL 513* (1964; CR 20/1), *Evelyn (blau)* (1964; CR 20/3), *Portrait Schmela* (1964; CR 37/2), *Portrait Schniewind* (1964; CR 42/1), *Negroes (Nuba)* (1964; CR 45), *Engelskopf* (1964; CR 67). The painting *Tame Kangaroo* (*Zahmes Kängeruh*), which Richter later destroyed, was also on display; see GR, "Letter to Heiner Freidrich, 23 November 1964," in *DPP*, 29.

23. GR, "Letter to Heiner Freidrich, 23 November 1964," in *DPP*, 28.

24. GR, "Interview with Rolf Schön, 1972," in *DPP*, 71–75.

25. GR, "Interview with Amine Haase, 1977," in *DPP*, 93. Richter set several of his works apart from their photographic sources by painting them in monochromatic blues (CR 20/3), reds (CR 51, 90, 101), or greens.

26. GR, "Interview with Dieter Hülsmanns and Fridolin Reske, 1966," in *DPP*, 57.

27. "Pictures are something different, you see; for instance, they are never blurred. What we regard as blurring is imprecision, and that means that [pictures] are different from the

object represented. But, since pictures are not made for purposes of comparison with reality, they cannot be blurred, or imprecise, or different (different from what?). How can, say, paint on canvas be blurred?" GR, "Interview with Rolf Schön, 1972," in *DPP*, 74.

28. Willi Warstat, quoted in Ursula Peters, *Stilgeschichte der Fotografie in Deutschland 1839–1900* (Cologne: DuMont, 1979), 304.

29. Peters, *Stilgeschichte der Fotografie*, 304.

30. GR, "Notes, 1964–1965," in *DPP*, 37.

31. GR, "Interview with Rolf Schön, 1972," in *DPP*, 74.

32. GR, "Notes, 1964–1965," in *DPP*, 34.

33. GR, in Robert Storr, "Interview with Gerhard Richter, 2001," in *Gerhard Richter: Forty Years of Painting* (catalog; Museum of Modern Art, New York, 2002), 295.

34. GR, in *Gerhard Richter* (catalog; Tate Gallery, London, 1991), 126.

35. GR, "Interview with Wolfgang Pehnt, 1984," in *DPP*, 117.

36. GR, "Notes, 1989," in *DPP*, 180.

37. GR, "Interview with Rolf Schön, 1972," in *DPP*, 73.

38. GR, "Interview with Sabine Schütz, 1990," in *DPP*, 218.

CHAPTER 4

1. Six of the paintings he labeled "old" (CR 2, 2/1, 3, 5, 7, 8). He also placed particular emphasis on "paintings with writing." *Stag* (*Hirsch*, 1963; CR 7; 150 × 200 cm) was priced at DM 1,600; *Cow* (*Kuh*, 1964; CR 15; 130 × 150 cm) at DM 1,200; and *Oswald* (1964; CR 16; 130 × 110 cm), which is currently part of the collection of the Hamburg Kunsthalle, at DM 1,000. The small-format *Necklace* (*Collier*, 1965; CR 48/4; 40 × 40 cm) is listed at DM 350, and *Negroes* (*Nuba*), 1964; CR 45; 145 × 200 cm) at DM 1,600. The last two were auctioned in 1993 and 1995 for £290,000 and £270,000, respectively, at Christie's in London.

2. GR, letter to René Block, June 20, 1965.

3. In Christiane Vielhaber, "'Manchmal hat man eben keine Lust, abstract zu malen . . .' Ein Gespräch mit Gerhard Richter" [Sometimes you just don't feel like painting abstract art. A conversation with Gerhard Richter] *Kunst Köln*, no. 1, 1989, 23.

4. Rolf Gunther Dienst, *Pop Art. Eine kritische Information* (Wiesbaden, 1965), 70.

5. GR, letter to Heiner Friedrich, August 17, 1965. The forty-five-minute program *Kunst und Ketchup* aired February 14, 1966, on the Süddeutscher Rundfunk network.

6. GR, letter to Heiner Friedrich, April 17, 1965.

7. GR, "Notes, 1966," in *DPP*, 58.

8. GR, letters to René Block, May 3 and 4, 1965.

9. See, for example, Sean Rainbird, "Variations on a Theme: The Painting of Gerhard Richter," in *Gerhard Richter* (catalog; Tate Gallery, London, 1991), 13; Jean-Philippe Antoine, "Photography, Painting and the Real: The Question of Landscape in the Painting of Gerhard Richter," in *Gerhard Richter* (Paris, 1995), 56.

10. GR, letter to René Block, June 20, 1965.

11. GR, letter to Heiner Friedrich, March 3, 1966. This despite offering *Small Curtain* (*Kleiner Vorhang*, 1965; 24 × 18 cm; CR 48/15) for a modest DM 180. Haseke later sold this painting, and he bought another one, titled *Chair in Profile* (*Stuhl im Profil*, 1965; CR 98), for himself. *Kitchen Chair* was priced at DM 800, *Flemish Crown* at DM 900, *Tiger* at DM 1,800, and *Swimmers* at DM 2,400. Also displayed were *Portrait Ema* (CR 65), *Meadow* (*Wiesenfeld*; CR 76), *Uncle Rudi* (*Onkel Rudi*; CR 85), *Cow II* (*Kuh II*; CR 88), *Two Women with Tart* (*Zwei Frauen mit Torte*; CR 95), *Man with Two Children* (*Mann mit zwei Kindern*; CR 96), and *Cyperus* (*Zypermandelgras*; CR 115), all from 1965.

12. GR, letter to Heiner Friedrich, August 17, 1965.

13. GR, "Interview with Hans-Ulrich Obrist, 1993," in *DPP*, 256.

14. GR, "Text for exhibition catalogue, Galerie h, Hannover, 1966, written jointly with Sigmar Polke," in *DPP*, 49.

15. Ibid., 42.

16. Ibid., 51.

17. GR, in Gislind Nabakowski, "Interview mit Gerhard Richter über die 'Verkündigung nach Tizian'" [Interview with Gerhard Richter on the "Annunciation after Titian"], *heute Kunst*, July 1974, 5.

18. GR, "Text for exhibition catalogue, Galerie h," in *DPP*, 50. In that same year Richter wrote in a note to himself: "Now that there are no priests or philosophers left, artists are the most important people in the world." GR, "Notes, 1966," in *DPP*, 58

19. GR, in *Gerhard Richter* (Tate Gallery catalog), 125.

20. For an illustration, see *Ich nenne mich als Maler Konrad Lueg* [As a painter I call myself Konrad Lueg] (catalog; Kunsthalle Bielefeld, 1999), 34.

21. GR, in Robert Storr, "Interview with Gerhard Richter, 2001," in *Gerhard Richter: Forty Years of Painting* (catalog; Museum of Modern Art, New York, 2002), 300.

22. *Omaggio a Marcel Duchamp* was initiated by Galeria Arturo Schwarz in Milan (June 5–September 30, 1964), then traveled to Kunsthalle Bern (October 23–November 29, 1964), Gimpel Fils in London (December 1964–January 1965), Haags Gemeentemuseum in the Hague (February 3–March 15, 1965), Stedelijk Van Abbemuseum in Eindhoven (March 20–May 3, 1965), Museum Haus Lange in Krefeld (June 6–August 1, 1965), and Kestner-Gesellschaft in Hannover (September 7–18, 1965).

23. GR, letter to Heiner Friedrich, June 25, 1965. Many critics—Klaus Honnef, Jürgen Harten, Jonas Storsve, and Benjamin H. D. Buchloh, among others—have teased out on their own or in conversation with Richter how aspects of his work from the 1960s seem to be in dialog with Duchamp's. For example, his early photo-paintings have been interpreted as painted readymades, because they emphasize the choice of a photo from the newspaper or a family album and its transposition from that original context into the realm of "art." Duchamp, however, saw his readymades as "nonart." Richter acknowledges the connection but says he came to it indirectly through Pop art and Fluxus. See GR, "Interview with Benjamin H. D. Buchloh, 1986" (*DPP*, 132–66) and "Interview with Hans-Ulrich Obrist, 1993" (*DPP*, 270–72).

24. GR, in Roald Nasgaard, "Gerhard Richter," in *Gerhard Richter. Paintings* (catalog; Museum of Contemporary Art, Chicago/Art Gallery of Ontario, Toronto, 1988), 51.

25. Werner Haftmann, quoted in Stella Baum, "Die Frühen Jahre. Gespräche mit Galeristen" [The early years. Conversations with gallerists] (interview with René Block), in *Kunstforum International*, no. 104, November/December 1989, 263.

26. GR, "Interview with Jonas Storsve, 1991," in *DPP*, 225.

27. The name of the event, as given on the invitation (in Richter's handwriting), is "Volker Bradke." The difference in spelling from the name of Richter's subject—Bradtke with a *t*—was intended to distance the exhibit from the man.

28. Günther Uecker, conversation with the author.

29. GR, letter to Heiner Friedrich, April 17, 1965.

30. GR, letter to Heiner Friedrich, July 25, 1965.

31. The contract, a copy of which is in Richter's archives, set forth the following specific conditions:

 I. G. Richter delivers 30 paintings per year with a total gross value of DM 43,200.00 (according to the price list from April 19, 1966).

 II. H Friedrich pays a total of DM 14,400.00 per year in monthly installments of DM

1,200.00 (i.e., 33.3 percent of the gross value of paintings delivered by Richter).

III. Paintings, which Richter produces in addition to the 30 paintings mentioned above, remain the property of Richter, as long as they are not sold to Friedrich (at 40 percent of the gross value).

IV. Richter may only sell paintings from his studio to collectors not sent by Friedrich with Friedrich's prior consent. The purchasers are obligated to pay the entire price to Friedrich. For these sales, Richter retains 50 percent of the gross value. The same condition applies to the sale of paintings to dealers, with the difference that Richter retains only 33.3 percent of the gross sale price.

V. Friedrich has sole discretion over the sale of the paintings acquired. Friedrich has limited discretion over all paintings by Richter in terms of exhibitions (in the case of exhibitions, the agreement of both parties is strictly required).

VI. The contract goes into effect on May 1, 1966, and ends on April 30, 1968. The contract can be altered on April 30, 1967, should one of the parties deem it necessary.

32. The revised contract (again, in Richter's archives) also spelled out terms for paintings sold after year's end: "Upon the sale of paintings, which H. Friedrich acquired during the second year of the contract for 20 percent of the gross value, Gerhard Richter is involved as follows: From April 1, 1968, to March 31, 1970, Richter receives an additional 20 percent of the agreed upon or obtained price; from April 1, 1970, to March 31, 1972, Richter receives an additional 10 percent of the agreed upon or obtained sale price at the time."

33. The draft for the 1966 contract gives as an example a price of DM 1,400 for a 150-by-110-centimeter painting, which would have corresponded to a multiplier of only 5.4.

34. Specifically *Easter Nudes* (*Osterakte*; CR 148), *Spanish Nudes* (*Spanische Akte*; CR 150), *Wee Girls* (*Pi-Mädchen*; CR 151), *Sisters* (*Schwestern*; CR 153), and *Bathers* (*Badende*; CR 154).

35. GR, "Statement, December 1967," *Art International*, March 1968, 55.

36. *Spanish Nudes*, then priced at DM 3,600, sold at Sotheby's in New York in 1990 for $560,000. Other paintings in the series (all from 1967) in the exhibition were *Wee Girls* (CR 151), *Nude* (*Akt*; CR 152), *Sisters* (CR 153), *Bathers* (CR 154), *Diana* (CR 155), *Gymnastik* (CR 156), and *Olympia* (CR 157). Also shown were *Cow* (*Kuh*, 1964; CR 15), *Curtain II* (*Vorhang II*, 1966; CR 55), *Forest Piece* (*Waldstück*, 1965; CR 66), *Eight Student Nurses* (*Acht Lernschwestern*, 1966; CR 130), *Large Pyramid* (*Große Pyramide*, 1966; CR 131), *Lamp* (*Lampe*, 1967; CR 146/1), and *Five Doors* (*Fünf Türen*, 1967; CR 158).

37. Jürgen Harten, "Der romantische Wille zur Abstraktion" [The romantic will to abstraction], in *Gerhard Richter. Bilder 1962–1985* (catalog; Städtische Kunsthalle Düsseldorf, 1986), 34.

38. GR, letter to Heiner Friedrich, May 5, 1967.

39. Ibid.

40. Richter and Mack had traded work in 1966, before Richter received the prize. Mack received *Zero-Rakete* (CR 110/1) in the swap; the painting was destroyed in 1984 in a fire at the artist's studio.

41. Wunderlich even commissioned a portrait from Richter (CR 164), depicting him as a hunter, with a rifle in his right hand and a shot rabbit in his left. From the various photographs given to Richter, he chose the image with the most static composition, one that corresponds exactly to his previously stated idea of photographic composition: "the main person stands in the middle." GR, "Arbeitsübersicht" [Work overview], in *14 × 14. Junge deutsche Künstler* [14 × 14. Young German artists] (catalog; Staatliche Kunsthalle Baden-Baden, 1968), n.p.

42. Other participants were Hans Meaer's op-art-Galerie, Esslingen; Appel & Fertsch, Frankfurt am Main; Grusberg, Hannover; Gunar and Niepel, both of Düsseldorf; Der Spiegel,

Aenne Abels, and Tobiès & Silex, Cologne; Springer, Berlin; Thomas, Munich; van de Loo and Stangl, both Munich; and Müller, Stuttgart.

43. Bon., "Maler machen Märkte" [Painters make markets], *Die Zeit*, September 22, 1967.

44. The exhibition ran October 14–November 14, 1967, and also included *Stukas* (1964; CR 18/1), *Pillow* (*Kissen*, 1965; CR 74), *Flemish Crown* (1965; CR 77), *Frau Niepenberg* (1965; CR 86), and *Rocket* (*Rakete*, 1966; CR 110/2).

45. GR, letter to Heiner Friedrich, October 17, 1967.

46. GR, "Conversation with Jan Thorn Prikker concerning the Cycle *18 October 1977*, 1989," in *DPP*, 199.

CHAPTER 5

1. Susanne Ehrenfried, *Ohne Eigenschaften. Das Portrait bei Gerhard Richter* [Without characteristics. The portrait in the work of Gerhard Richter] (Vienna: Springer Verlag, 1997), 12.

2. Klaus Honnef, "Problem Realismus. Die Medien des Gerhard Richter" [Problem realism. The mediums of Gerhard Richter], *Kunstforum International*, nos. 4/5, 1973, 82; Klaus Krüger, "Der Blick ins Innere des Bildes. Ästhetische Illusion bei Gerhard Richter" [The view into the interior of the image. Aesthetic illusion in the work of Gerhard Richter], *Pantheon*, 1995, 161.

3. Hans-Ulrich Obrist, Preface to *DPP*, 8.

4. GR, "Interview with Rolf Gunther Dienst, 1970," in *DPP*, 60.

5. GR, "Arbeitsübersicht" [Work overview], in *14 × 14. Junge deutsche Künstler* [14 × 14. Young German artists] (catalog; Staatliche Kunsthalle Baden-Baden, 1968), n.p.

6. Ingrid Misterek-Plagge, *"Kunst mit Fotografie" und die frühen Fotogemälde Gerhard Richters* ["Art with photography" and Gerhard Richter's early photo-paintings] (Münster/Hamburg: LIT Verlag, 1992).

7. *Quick*, February 20, 1966, 23.

8. Robert Storr, *Gerhard Richter: Forty Years of Painting* (catalog; Museum of Modern Art, New York, 2002), 29.

9. GR, "Interview with Benjamin H. D. Buchloh, 1986," in *DPP*, 143.

10. GR, "Interview with Doris von Drathen, 1992," in *DPP*, 233.

11. GR, "Interview with Sabine Schütz, 1990," in *DPP*, 211 [EMS}. In a similar manner, Richter admitted to other subliminal connections to the series *Tourist* (CR 368 to 370/1), from 1975, and *Haus* (CR 772/7), from 1992, even though these motifs also derived from magazines.

12. Susanne Küper, "Gerhard Richter, der kapitalistische Realismus und seine Malerei nach Fotografien von 1962–1966" [Gerhard Richter, capitalist realism and his photo-paintings from 1962–1966], in *Deutschlandbilder. Kunst aus einem geteilten Land* [Pictures of Germany. Art from a divided country] (catalog; Martin-Gropius-Bau, Berlin, 1997), 265. Küper's *Deutschlandbilder* catalog essay was among the first to reveal the personal resonances in Richter's family pictures.

13. Roger Boyes, "Nazi Ghosts Haunting a Family," *Times* (London), June 17, 2006.

14. Storr, *Gerhard Richter: Forty Years of Painting*, 40, 92nn85–86.

15. Julian Heynen, "Februar/März 2000" [February/March 2000], in *Gerhard Richter. Bilder 1999* [Gerhard Richter. Paintings 1999] (catalog; Kaiser Wilhelm Museum, Krefeld, 2000), n.p.; Benjamin H. D. Buchloh, "Archaeology to Transcendence: A Random Dictionary for/on Gerhard Richter," in *Gerhard Richter: Paintings 1996–2001* (catalog; Marian Goodman Gallery, New York, 2001), 21n6.

16. GR, "Notes, 1964–1965," in *DPP*, 39.

17. GR, "Text for exhibition catalogue, Galerie h, Hannover, 1966, written jointly with Sigmar Polke," in *DPP*, 49.

18. Michael Kimmelman, "An Artist beyond Isms," *New York Times Magazine*, January 27, 2002, 20.

19. Günther Uecker, conversation with the author; Helga Meister, *Die Kunstszene Düsseldorf* [The Düsseldorf art scene] (Recklinghausen: Verlag Aurel Bongers KG, 1979), 164.

20. Lucie Schauer, "Hommage à Lidice," *Die Welt*, November 3, 1967, 9.

21. GR, "Statement, December 1967," *Art International*, March 1968, 55.

22. GR, "Interview with Rolf Schön, 1972," in *DPP*, 73.

23. GR, "Statement, December 1967," 55.

24. Christiane Vielhaber, "'Manchmal hat man eben keine Lust, abstract zu malen . . .' Ein Gespräch mit Gerhard Richter" [Sometimes you just don't feel like painting abstract art. A conversation with Gerhard Richter] *Kunst Köln*, no. 1, 1989, 18. Peter Ludwig purchased CR 158 from Rudolf Zwirner's gallery in 1968; today it is in the collection of Museum Ludwig in Cologne.

25. Besides *Passage*, Richter showed *Window* (*Fenster*, 1968), *Moonscape* (*Mondlandschaft*, 1968; CR 191), and *Alps (Atmosphere)* (*Alpen [Stimmung]*, 1969; CR 214).

26. GR, "Statement, December 1967," 55.

27. Jürgen Harten, "Der romantische Wille zur Abstraktion" [The romantic will to abstraction], in *Gerhard Richter. Bilder 1962–1985* (catalog; Städtische Kunsthalle Düsseldorf, 1986), 33.

28. GR, "Note, 1971," in *DPP*, 64 [EMS].

29. Günther Uecker, conversation with the author. This fact was established in Stephan von Wiese and Maria Kreutzer, eds., *Brennpunkt Düsseldorf 1961–1987: Joseph Beuys, die Akademie, der allgemeine Aufbruch* (catalog; Kunstmuseum, Düsseldorf, 1987). Christine Mehring points out the significance of the opening date in "Creamcheese, or the Art of Being Minor," in Josiah McElheny, *The Metal Party* (New York: Josiah McElheny, 2002).

30. In the *Atlas* (panels 265, 267) there are only a few drafts that explore the possibility of medial contextualization for the color charts.

31. Konrad Fischer, in Heinz-Norbert Jocks, "Einseitig muß man sein, damit etwas weitergeht" [One has to be one-sided to continue], *Kunstforum International*, no. 127, 1994, 402.

32. Kasper König, conversation with the author.

33. GR, letter to Heiner Friedrich, October 17, 1967.

34. Konrad Fischer, in Stella Baum, "Die Frühen Jahre. Gespräche mit Galeristen" [The early years. Conversations with gallerists] (interview with René Block), in *Kunstforum International*, no. 104, November/December 1989, 279.

35. Konrad Fischer, in Jocks, "Einseitig muß man sein," 402.

36. Carl Andre, quoted in Daniel Birnbaum, "Art and the Deal," *Artforum*, February 2000, 17.

37. Kasper König, conversation with the author.

38. GR, "Interview with Jonas Storsve, 1991," in *DPP*, 225.

39. GR, "Interview with Benjamin H. D. Buchloh, 1986," in *DPP*, 139.

40. Jürgen Hohmeyer, "Richter. Wenn's knallt" [When things go bang], *Der Spiegel*, August 19, 1968, 90–91.

41. In 1971 Onnasch owned twelve works by Richter: *Arnold Bode* (1964; CR 33), *Family at the Seaside* (*Familie am Meer*, 1964; CR 35), *Curtain III* (*Vorhang III*, 1965; CR 56), *Three Sisters* (*Drei Geschwister*, 1965; CR 82), *Swimmers* (*Schwimmerinnen*, 1965; CR 90), *Volker Bradke* (1966; CR 133), *Corrugated Iron* (*Wellblech*, 1967; CR 161B), *Townscape Madrid* (*Stadtbild Madrid*, 1968; CR 171), *Townscape Ha* (*Stadtbild Ha*, 1968; CR 172), *Clouds* (*Wolken*, 1968; CR 188), *Townscape Sa* (*Stadtbild Sa*, 1969; CR 219/1), and *Townscape PL* (*Stadtbild PL*, 1970; CR 249). Between

1968 and 1974 Ludwig acquired nine large-format works, including *Ema (Nude on a Staircase)*, the five-part *Park Piece* (*Parkstück*, 1971; CR 311), and *48 Portraits* (1972; CR 324/1–48).

42. After the event's premiere with Richter and Uecker, the following pairs were featured until July 7: Raimer Jochims/Werner Knaupp, Georg Baselitz/Dieter Haack, Hans Martin Erhardt/Bernd Völkle, and Hans Baschang/Ferdinand Kriwet.

43. Günther Uecker, "Museen können bewohnbare Orte sein" [Museums can be inhabitable places], in *Günther Uecker. Bühnenskulpturen und optische Partituren* [Stage sculpture and optical scores] (catalog; Neues Museum Weimar, 2001), 45.

44. Klaus Gallwitz, "Leben im Museum. Günther Uecker und Gerhard Richter in der Kunstahalle Baden-Baden" [Life in the museum: Günther Uecker and Gerhard Richter in the Kunsthalle Baden-Baden], in *Günther Uecker. Bühnenskulpturen und optische Partituren*, 38.

45. N.N., "Auftakt mit Blitzen und Krachen," *Badisches Tagblatt*, April 8, 1968. Uecker showed, among other works, his *Terror Orchestra* (*Terrororcheste*, 1967), an ensemble of sculptures and nail objects with optical, motor, and acoustic elements, and *New York Dancer* (1965). Richter showed several mountain motifs and townscapes, all from 1968, including *Himalaya* (CR 181), *Mountains* (*Gebirge*; CR 183, 185), *Townscape Madrid* (*Stadtbild Madrid*; CR 171), and *Townscape Ha* (*Stadtbild Ha*; CR 172). He also showed the second version of *5 Doors* (1967; CR 159), *Ema (Nude on a Staircase)*, *Easter Nudes* (*Osterakte*, 1967; CR 148), and *Student* (*Studentin*; CR 149), which was acquired by Düsseldorf collector Ludger Schäfer. (In 1974 Bernd Lutze, a gallery owner from Friedrichshafen, bought *Student* from the Galerie des 4 Mouvements in Paris for $10,000, an improbably huge sum at the time, paying for it in part with Richter's *Small Door* [*Kleine Tür*, 1968; CR 210/1], which was valued at an equally exaggerated $5,000. In his first Richter exhibition, in 1979, Lutze offered the pornographic *Student* for DM 35,000 without, however, finding a buyer.)

46. GR, "Interview with Hans-Ulrich Obrist, 1993," in *DPP*, 266 [EMS].

47. *Townscape Ha* (*Stadtbild Ha*; CR 172) shows Hamburg, *Townscape D* (*Stadtbild D*; CR 176) Düsseldorf, *Townscape F* (*Stadtbild F*; CR 177/1–3) Frankfurt am Main. All are from 1968.

48. GR, "Arbeitsübersicht."

49. The single exception is *Seascape* (*Seestück*, 1968; CR 194/23), which was added to this group later.

50. GR, in *Gerhard Richter* (catalog; Tate Gallery, London, 1991), 126.

51. GR, "Interview with Sabine Schütz, 1990," in *DPP*, 202.

52. The source image came from the October 13, 1963, edition of *Quick*. Ingrid Misterek-Plagge, *"Kunst mit Fotographie" und die frühen Fotogemälde Gerhard Richters* ["Art with photography" and Gerhard Richter's early photo-paintings] (Münster/Hamburg: LIT Verlag, 1992), 199.

CHAPTER 6

1. Much of Ludwig's collection is now housed in the Museum Ludwig in Cologne and the Suermondt-Ludwig-Museum in Aachen.

2. Klaus Honnef, "Schwierigkeiten beim Beschreiben der Realität. Richters Malerei zwischen Kunst und Gegenwart" [Difficulty in describing reality. Richter's painting between art and the present], in *Gerhard Richter* (catalog; Gegenverkehr, Aachen, 1969), n.p.

3. Manfed Schneckenburger, "Gerhard Richter oder ein Weg, weiterzumalen" [Gerhard Richter, or a way to continue painting], in *Gerhard Richter. Bilder aus den Jahren 1962–1974* [Gerhard Richter. Paintings from 1962–1974] (catalog; Kunsthalle Bremen, 1975), 15. Cf. Karl-Heinz Hering, "Zur Austellung Gerhard Richter" [On Gerhard Richter's exhibition], in *Gerhard Richter. Arbeiten 1962–1971* [Gerhard Richter. Works 1962–1971] (catalog; Kunstverein für die Rheinlande und Westfalen, Düsseldorf, 1971), n.p.

4. Jürgen Harten, "Der romantische Wille zur Abstraktion" [The romantic will to abstraction], in *Gerhard Richter. Bilder 1962–1985* (catalog; Städtische Kunsthalle Düsseldorf, 1986), 25.

5. N.N., "Strich am Bau" [Brushstroke in construction], *Der Spiegel*, June 9, 1980, 202.

6. Anja Lösel, "Meistermaler ohne Markenzeichen" [Master painter without a trademark], *Der Stern*, September 16, 1993, 225.

7. Petra Kipphoff, "Der Maler am Ende seines Mythos" [The painter at the end of his myth], *Die Zeit*, December 17, 1993, 51. Peter Winter, too, wrote in the *Frankfurter Allgemeine Zeitung* that Richter was a principled artist irrespective of his chameleonlike approach (February 10, 1982, 23). At first Richter disliked the chameleon metaphor. "It sounds so much like adaptation. But at the same time, adaptation is something very positive. It is after all how we have managed to survive." GR, in Peter Sager, "Mit der Farbe denken" [Thinking with color], *ZEITmagazin*, November 28, 1986, 30.

8. GR, "Interview with Jonas Storsve, 1991," in *DPP*, 229.

9. GR, "Interview with Rolf Schön, 1972," in *DPP*, 73.

10. GR, "Interview with Rolf Gunther Dienst, 1970," in *DPP*, 64.

11. GR, "Notes, 1982," in *DPP*, 101.

12. Oskar Bätschmann, "Landschaften in Unschärfe" [Landscapes out of focus], in *Gerhard Richter. Lanschaften* (catalog; Sprengel Museum Hannover, 1998), 28. Cf. Jean-Philippe Antoine, "Photography, Painting and the Real: The Question of Landscape in the Painting of Gerhard Richter," in *Gerhard Richter*, ed. Robert Fleck and Gertrud Koch (Paris: Dis Voir, 1995), 53–89.

13. GR, "Letter to Jean-Christophe Ammann, February 1973," *DPP*, 80 [EMS]. See, too, Jon L. Seyold and Anna Greve, eds., *From Caspar David Friedrich to Gerhard Richter: German Paintings from Dresden* (catalog; J. Paul Getty Museum, Los Angeles, and Walther König, Cologne, 2006).

14. Rolf Wedewer, "Zum Landschaftstypus Gerhard Richters" [On Gerhard Richter's landscape types], *Pantheon* (Munich, 1975), 43.

15. Günter Pfeiffer, "Gerhard Richter. Kunstverein für die Rheinlande und Westfalen, Düsseldorf," *Das Kunstwerk*, September 1971, 81.

16. Hubertus Butin, "Die unromantische Romantik Gerhard Richters" [Gerhard Richter's unromantic romantic], in *Ernste Spiele. Der Geist der Romantik in der deutschen Kunst 1790–1990* [Serious games: The spirit of the romantic in German art (1790-1990)] (catalog; Haus der Kunst, Munich, 1995), 455; Wedewer, "Zum Landschaftstypus Gerhard Richters," 41–49.

17. GR, "Notes, 1981," in *DPP*, 98.

18. Ibid., 99.

19. GR, in Stefan Koldehoff, "Gerhard Richter. Die Macht der Malerei" [The power of painting] (interview), *Art. Das Kunstmagazin*, December 1999, 20.

20. GR, in Dorothea Dietrich, "An Interview," *Print Collector's Newsletter*, September/October 1985, 130.

CHAPTER 7

1. GR, *Atlas van de foto's en schetsen* (Utrecht: Hedendaagse Kunst, 1972), n.p.

2. Richter's paintings had sold well the previous year, allowing him to raise his prices. He still based the gallery sale price on the dimensions of the painting (height plus width, in centimeters) but now increased the multiplying factor to 20. Thus *Vintage* (CR 195; 95 × 115 cm) was offered for DM 4,200 and the smaller *Herr Baker* (CR 80/12; 46 × 46 cm) for DM 1,720.

3. The discovery that the artist was born with the name Peter Stolle was made (years after Palermo's death) by his twin brother, Michael Heisterkamp. See Moritz Wessler, "Palermo:

Known Facts and New Insights into His Person: Moritz Wesseler in Exchange with Robin Bruch, Kristin Heisterkamp, Michael Heisterkamp, and Babette Scobel," in *Palermo*, ed. Susanne Küper, Ulrike Groos, and Vanessa Joan Müller (catalog; Cologne: DuMont, 2008).

4. Joseph Beuys, in Laszlo Glozer and Joseph Beuys, "Über Blinky Palermo" (interview), in *Blinky Palermo* (catalog; Musem der bildenden Künste, Leipzig, 1993), 201.

5. Johannes Cladders, quoted in Bernhard Bürgi, "Palermo Werke 1963–1977," in *Blinky Palermo* (Leipzig catalog), 195.

6. GR, in Jürgen Harten, "Der romantische Wille zur Abstraktion" [The romantic will to abstraction], in *Gerhard Richter. Bilder 1962–1985* (catalog; Städtische Kunsthalle Düsseldorf, 1986), 49.

7. GR, in *Gerhard Richter. Forty Years of Painting* (catalog; Museum of Modern Art, New York, 2002), 59.

8. GR, letter to Birgit Pelzer, March 25, 1980.

9. GR and Blinky Palermo, "Vorschlag für die Glasfront der Sporthalle; Vorschlag für die Glasfront der Schwimmhalle, zwei Blatt" [Proposal for the glass façade of the sports arena; Proposal for the glass façade of the swimming stadium. Two pages], Richter archives.

10. Ryman exhibited at Fischer's gallery from November 21 to December 17, 1968, and from November 11 to December 12, 1969.

11. Fred Jahn, conversation with the author.

12. The painted bronze version of the heads (CR 292/2) was acquired in 1984 by the Munich Städtische Galerie im Lenbachhaus, where Richter reconstructed the installation, including Palermo's mural.

13. GR, "Notes, 1983," in *DPP*, 105 [EMS].

14. GR, letter to Helmut and Erika Heinze, December 12, 1986.

15. Kasper König, conversation with the author.

16. Günther Uecker, conversation with the author.

17. Kasper König, conversation with the author.

18. GR, in Dieter Schwarz, "Über Aquarelle und verwandte Dinge. Gerhard Richter im Gespräch mit Dieter Schwarz" [On watercolors and related things. Gerhard Richter in conversation with Dieter Schwarz], in Gerhard Richter and Dieter Schwarz, *Aquarelle/Watercolors 1964–1997* (catalog, Kunstmuseum Winterthur; Düsseldorf: Richter Verlag, 1999), 6.

19. GR, in Stefan Koldehoff, "Gerhard Richter. Die Macht der Malerei" [The power of painting] (interview), *Art. Das Kunstmagazin*, December 1999, 19.

20. For his 1971 retrospective at the Düsseldorf Kunstverein, Richter for the first time built a scale model of the exhibition space and used miniature ink drawings of his paintings (on a scale of 1:50) to assist in hanging the show. He wound up including the model in the exhibition. (Later, he integrated collaged pages with their tiny images, some now colored in with watercolor, into the Utrecht version of the *Atlas*.) In the catalog he reproduced a sketch of the exhibition hanging, thereby elevating the plan to the conceptual level of something itself worthy of exhibition. In establishing a dialog between the real exhibition and its model, Richter's effort took on a self-reflexive dimension. In a way, he echoed Konrad Fischer's attempt to establish the curatorial process as an independent aesthetic achievement.

21. GR, in Schwarz, "Über Aquarelle," 6.

22. In 1997 Richter showed the *Atlas* at Documenta 10, organized by Catherine David. Installed in parallel rows on the ground floor of the main building, the Fridericianum, the by then almost unmanageable corpus of images asserted itself as one of the central features of the entire Documenta. The *Frankfurter Allgemeine Zeitung* reported, "Ms. David is exemplifying what she wants with her favorite, Gerhard Richter. In the Fridericianum, she is showing only the giant image archive from which the painter took his source material. By not showing the

paintings, they are undone, dissolving back into the laboratory." Eduard Beaucamp, "Was er-starrt ist, soll wieder umtreiben" [Everything petrified should come to life again], *Frankfurter Allgemeine Zeitung*, June 23, 1997, 33.

23. Christine Mehring, e-mail to University of Chicago Press editor Susan Bielstein, January 20, 2009. See Mehring, "Benjamin Buchloh," in *Art: Key Contemporary Thinkers*, ed. Jonathan Vickery and Diarmuid Costello (Oxford: Berg/Oxford International, 2007), 53–55. See, too, Mehring's entry on Buchloh in the forthcoming *Encyclopedia of American Art*, ed. Joan Marter (Oxford: Oxford University Press, 2010).

24. Dieter Honisch, quoted in Hanno Reuther, "36. Biennale in Venedig," *Das Kunstwerk*, July 1972, p. 15.

25. GR, in Susanne Ehrenfried, "Gespräch mit Gerhard Richter am 8. August 1995" [Conversation with Gerhard Richter on August 8, 1995], in Ehrenfried, *Ohne Eigenschaften. Das Portrait bei Gerhard Richter* [Without characteristics. The portrait in the work of Gerhard Richter] (Vienna: Springer Verlag, 1997), 219.

26. Benjamin H. D. Buchloh, "Die Malerei am Ende des Sujets" [Painting at the end of the subject], in *Gerhard Richter* (catalog; Kunst- und Austellungshalle der Bundesrepublik Deutschland, Bonn, 1993), 2:38.

27. GR, in Ehrenfried, *Ohne Eigenschaften*, 220.

28. Most often the German prefix *ver-* indicates a process that is extensive. *Vermalung*, for Richter, generally implies a process of painting away or painting out, referencing the destruction of both the clarity of forms and the indices of the painting process. (Richter also sometimes applies the term, not just to this specific technique but to any act of removing, blotting out, or covering an image.) But *ver-* can also point to error, like the English prefix *mis-*. In that sense *Vermalung* might refer to the artist's making a mistake while painting, essentially losing the way. Thus, to translate *Vermalung* as "paint away" has a certain appeal, as it can refer to removing or covering an object or image with paint, or it can identify a process of an artist who is "painting away" at a canvas. Richter, however, prefers that it be translated as "inpainting," a word that, of course, has other, preexisting meanings: it denotes both a restorer's practice of "painting in" areas of a damaged painting that have been lost and, more generally, the practice of filling in a form or shape with color. Neither meaning approximates Richter's *Vermalung*; however, it is possible that Richter is thinking not so much (or not just) of the additive sense of *in-* (inject) as of its contrary sense (insincere).

29. Other portraits painted but not included were of the Russian poet Vladimir Maya-kovsky, the Danish physician and 1926 Nobel laureate Johannes Fibiger (CR 323/6), and the French writer Henry de Montherlant (CR 323/7).

30. GR, in Ehrenfried, *Ohne Eigenschaften*, 60.

31. GR, in Matthias Schreiber, "Ein gutes Foto von mir gibt es nicht" [There are no good pictures of me], *Kölner Stadt-Anzeiger*, June 14, 1972.

32. Dieter Honisch, "Zu den Arbeiten Gerhard Richters" [On the work of Gerhard Richter], in *Gerhard Richter* (catalog; 36th Biennale, German Pavilion, Venice, 1972), 5.

33. Buchloh, "Die Malerei am Ende des Sujets," 2:38.

34. GR, in Ehrenfried, *Ohne Eigenschaften*, 220.

35. In the last weeks of the event, Zwirner displayed a photo version of the *48 Portraits* in his Cologne gallery. Richter had just completed it and wanted to produce it in an edition of six—until Ludwig learned of the plan and asked him not to go through with it. Ludwig did, however, buy the one completed photo version for a generous sum. Today, both sets belong to the Museum Ludwig in Cologne. Richter was not happy with the way the painted portraits were hung when the museum opened its doors in 1986, in a block of four rows of 12 paintings each—"like a bar of chocolate," he said, referring to the source of Ludwig's fortune (GR, in

Ehrenfried, *Ohne Eigenschaften*, 219). In 2001 the museum's new director, Richter's old friend Kasper König, rehung the portraits as they had been presented at the Biennale, in a single row as a frieze. A special edition of the *48 Portraits* was eventually produced in 1998. The Anthony d'Offay Gallery in London published four impressions, priced at $150,000 a set, during a solo exhibition of Richter's work.

36. Fred Jahn, conversation with the author.

37. GR, letter to Benjamin H. D. Buchloh, December 12, 1975.

38. GR, in *Gerhard Richter. Paintings* (catalog; Museum of Contemporary Art, Chicago/ Art Gallery of Ontario, Toronto, 1988), 106.

CHAPTER 8

1. GR, in *Gerhard Richter* (catalog; Tate Gallery, London, 1991), 127.

2. GR, "From a Letter to Edy de Wilde, 23 February 1975," in *DPP*, 82.

3. GR, "Interview with Benjamin H. D. Buchloh, 1986," in *DPP*, 132.

4. GR, in Christine Mehring, *Blinky Palermo: Abstraction of an Era* (New Haven: Yale University Press, 2008), 176, 266n15. The translation here is a revision by Mehring of that in *DPP*, 144, based on the German in *Richter. Text, Schriften und Interviews*, ed. Hans-Ulrich Obrist (Frankfurt am Main: Insel, 1993), 131.

5. GR, "Text for catalogue of group exhibition, Palais des Beaux Arts, Brussels, 1974," in *DPP*, 81–82. In a five-part work from 1974, which is now in the collection of the Ludwig Forum in Aachen, Richter presented this multiplication by four to 1,024 colors in a similar manner. He left out the white lines between the individual colors in these paintings.

6. Johannes Itten, in Heinz Holtmann, "Grau als Indifferenz. Zu Gerhard Richters mono-chromen Bildern" [Gray as indifference. On Gerhard Richter's monochromatic paintings], in *Gerhard Richter Graue Bilder* [Gray paintings] (catalog; Kunstverein Braunschweig, 1975), n.p.

7. GR, "From a letter to Edy de Wilde, 23 February 1975," in *DPP*, 82–83. The exhibition "Fundamental Painting" ran from April 25 to June 22, 1975.

8. GR, in Holtmann, "Grau als Indifferenz."

9. GR, "From a letter to Edy de Wilde, 23 February 1975," in *DPP*, 82.

10. GR, "Interview with Benjamin H. D. Buchloh, 1986," in *DPP*, 154.

11. The catalog begins with the overpainted cityscape from 1968 (CR 170/8) and ends with an unfinished 1976 entry (CR 398, 403, 403/1).

12. GR, in Coosje van Bruggen, "Gerhard Richter, Painting as a Moral Act," *Artforum*, May 1985, 88.

13. The exhibition ran from December 4, 1974 to January 12, 1975, in Mönchengladbach, then traveled to the Kunstverein Braunschweig (February 9 to March 9, 1975). It included the gray paintings CR 170/8, 247/1–4, 247/9, 334, 334a, 334b, 334/3, 334/10–11, 348, 348/1, 348/6–7, 349/1, 349/3, 361/1–3, 362/2–5, 363/1, 364/1–2, 365/2, 366, and 366/2.

14. GR, "Text for catalogue of *Acht Künstler—acht Räume*, Mönchengladbach, 1975," in *DPP*, 84 [EMS].

15. *New York Times Magazine*, January 27, 2002, cover.

16. Reinhard Onnasch, letter to GR, April 12, 1973.

17. James Collins, "Gerhard Richter, Onnasch Gallery," *Artforum*, January 1974, 73.

18. Ulbricht made a permanent loan to the Kunstmuseum Düsseldorf of several works: *Diana* (1967; CR 155), *Star Picture* (*Sternbild*, 1969; CR 255/4), and *Clouds (Window)* (*Wolken [Fenster]*, 1970; CR 266). Other paintings in his collection include *Dead* (*Tote*, 1963; CR 9), *Mrs. Wolleh with Children* (*Frau Wolleh mit Kindern*, 1968; CR 197/1), the Documenta paint-ing *180 Colors* (*180 Farben*, 1971; CR 300/1), and *Inpainting (gray)* (*Vermalung [grau]*, 1972; CR

236/5). Reinhard Onnasch distributed his works by Richter later as loans to the Kunsthalle in Kiel, the Museum Folkwang in Essen, the Staatsgalerie moderner Kunst in Munich, and the Nationalgalerie in Berlin.

19. Hans Grothe, in Peter Sager, *Die Besessenen—Begegnungen mit Kunstsammlern zwischen Aachen and Tokio* (Cologne: DuMont, 1992), 111. Richter paid Konrad Fischer and Heiner Friedrich 10 percent each of the purchase amount for the twelve paintings. In Friedrich's case, Richter made the emphatic point that the payment was strictly an act of good will, given their difficult financial history (GR, letter to Heiner Friedrich, December 7, 1975).

20. Carl Friedrich Schröer and Hans Grothe, "Man muß immer was Gigantisches machen . . ." [One must always make something gigantic . . .] (interview), *Kunstforum International*, no. 130, May–July 1995, 434.

21. Hans Grothe, in Sager, *Die Besessenen*, 111. The block of work included, in addition to the previously mentioned New York paintings, the large-format *Cityscape Madrid* (*Stadtbild Madrid*, 1968; CR 171), the three-part inpainting *Untitled (green)* (*Ohne Title [grün]*, 1971; CR 315/1–3) as well as three gray paintings from 1973 (CR 334) and 1974 (CR 361/1, 363/3).

22. Heinz Peter Schwerfel and Hans Grothe, "Ich hätte gerne alles, aber ich muß es nicht haben" [I would like to have everything, but I don't have to] (interview), *Art. Das Kunstmagazin*, December 1999, 76.

23. GR, "Interview with Hans-Ulrich Obrist, 1993," in *DPP*, 262.

24. The portraits were offered at Christie's in London on June 29, 1995, where the pair sold for £100,000, and again at Christie's in New York on November 16, 1999, by which time the price had about doubled, to $390,000.

25. Klaus Honnef, *Gerhard Richter* (Recklinghausen: Verlag Aurel Bongers, 1976), 10.

26. Petra Kipphoff, "Kissenkunst, zerrissene Realität" [Pillow art, severed reality], *Die Zeit*, December 19, 1975, 36.

27. Pontus Hulten, "Preface," in *Gerhard Richter* (catalog; Centre national d'art et de culture Georges Pompidou–Musée national d'art moderne, Paris, 1977), 3.

CHAPTER 9

1. GR, in Dorothea Dietrich, "An Interview," *Print Collector's Newsletter*, September/October 1985, 131.

2. GR, "Answers to questions from Marlies Grüterich, 2 September 1977," in *DPP*, 88–90 [EMS].

3. Benjamin H. D. Buchloh, "Die Malerei am Ende des Sujets," in *Gerhard Richter* (catalog; Kunst- und Austellungshalle der Bundesrepublik Deutschland, Bonn, 1993), 2:60; Roald Nasgaard, "Gerhard Richter," in *Gerhard Richter. Paintings* (catalog; Museum of Contemporary Art, Chicago/Art Gallery of Ontario, Toronto, 1988), 32, 109; Bernard Blistène, "Gerhard Richter ou l'exercice du soupcon," in *Gerhard Richter* (catalog; Musée d'Art et d'Industrie, St. Etienne, 1984), 6.

4. Heribert Heere, "Gerhard Richter—Die Abstrakten Bilder. Zur Frage des Inhalts," in *Gerhard Richter. Abstrakte Bilder 1976 to 1981* (catalog; Kunsthalle Bielefeld, 1982), 16.

5. GR, "Interview with Wolfgang Pehnt, 1984," in *DPP*, 113; GR, "Interview with Hans-Ulrich Obrist, 1993," in Hans-Ulrich Obrist, *Interviews*, vol. 1 (Milan: Charta, 2003), 770–71.

6. GR, in Buchloh, "Die Malerei am Ende des Sujets," 2:62.

7. Between 1977 and 1980 Richter used the method to produce twenty-four large-scale paintings that he described as "soft abstracts." The last of these is the monumental *Faust* (1980; CR 460), which he compiled as a triptych from three independent works.

8. Robert Storr, *Gerhard Richter: Forty Years of Painting* (catalog; Museum of Modern Art, New York, 2002), 68–69. *Abstraktes Bild* has been translated by Storr as "abstract pic-

ture," conveying Richter's original emphasis on representation and illusion; others, including Richter today, prefer the more neutral "abstract painting," with its implicit stress on action and medium.

9. Georg Jappe and Klaus Honnef, "Bekenntnisse eines Ausstellungsmachers" (interview), *Kunstforum International*, no. 21, 1977, 99–100.

10. GR, "Answers to questions from Marlies Grüterich," in DPP, 88.

11. Peter Moritz Pickhaus, "G. Richter bei Fischer. Aufsässig," *Rheinische Post*, November 16, 1977, n.p.

12. Barbara Flynn, "Gerhard Richter," *Artforum*, April 1978, 62.

13. Stella Baum, "Die Frühen Jahre. Gespräche mit Galeristen" [The early years. Conversations with gallerists] (interview with Konrad Fischer), in *Kunstforum International*, no. 104, November/December 1989, 281.

14. Wieland Schmied, "Falsche Perspektiven, Intoleranz und Manipulation" [Wrong perspectives, intolerance, and manipulation], *Kunstmagazin,* no. 1, 1977, 25. See also "Kunsthändler als Historiker" [Gallerists as historians], *Frankfurter Allgemeine Zeitung,* October 27, 1976; Jürgen Harten, "Forum der Auseinandersetzung" [Forum for debate] (letter to the editor), *Frankfurter Allgemeine Zeitung,* November 5, 1976.

15. GR, letter to Benjamin H. D. Buchloh, February 3, 1979.

16. Kasper König, conversation with the author.

17. Ibid.

18. Daniel Birnbaum, "Art and the Deal," *Artforum*, February 2000, 17.

19. Kasper König, "Preface," in *Westkunst. Heute* (catalog; Museen der Stadt Köln, 1981), n.p.

20. The panel version of *128 details* was later acquired by the Kaiser Wilhelm Museum, Krefeld. Gerhard Storck acquired the series of small drawings for the museum in Krefeld for DM 8,000.

21. GR, untitled text in *128 details from a picture (Halifax 1978)*, Nova Scotia Pamphlets, no. 2 (Halifax, 1980), 65; GR, letter to Benjamin H. D. Buchloh, August 30, 1979.

22. Rudi H. Fuchs, "Artificial Miracles," in *Gerhard Richter* (catalog; Stedelijk van Abbemuseum, Eindhoven, 1978), 3. The exhibition opened in Eindhoven on October 8, 1978. In London it ran from March 14 to April 22, 1979.

23. GR, letter to Benjamin H. D. Buchloh, March 12, 1979.

24. GR, letter to Benjamin H. D. Buchloh, May 12, 1979.

25. Ibid.

26. GR, "Notes, 1981," in DPP, 96.

27. GR, letter to Benjamin H. D. Buchloh, June 17, 1980.

28. GR, letter to Benjamin H. D. Buchloh, May 15, 1979.

29. GR, "Conversation with Jan Thorn Prikker concerning the Cycle *18 October 1977*, 1989," in DPP, 206.

30. Peter Moritz Pickhaus, "Gerhard Richter. Abstrakte Bilder 1976–1981" [Abstract pictures], *Kunstforum International*, April/May 1982, 220.

31. Wilfried Dickhoff, "Gerhard Richter. 'Malerei ist eine moralische Handlung,'" *Wolkenkratzer Art Journal,* April–June 1985, 40.

32. GR, "Interview with Wolfgang Pehnt, 1984," in DPP, 113.

33. GR, "Notes, 1986," in DPP, 129.

34. GR, "Interview with Hans-Ulrich Obrist, 1993," in DPP, 264.

35. GR, "Notes, 1990," in DPP, 218.

36. GR, in Stefan Koldehoff, "Gerhard Richter. Die Macht der Malerei" [The power of painting] (interview), *Art. Das Kunstmagazin*, December 1999, 20.

37. GR, "Notes, 1985," in *DPP*, 119. [EMS].

38. Ibid. , 120.

39. Martin Hentschel, "Tauschgeschäft der Bilder—Zirkulation der Substanzen. Sigmar Polkes Universalwissenschaft der Malerei," in *In the Power of Painting I. Warhol, Polke, Richter* (catalog; Daros Collection, Zürich, 2001), 79.

40. Blinky Palermo, letter to Evelyn Weiss, quoted in Max Wechsler, "Über Blinky Palermo," *Künstler. Kritisches Lexikon der Gegenwartskunst*, no. 22 (Munich, 1993), 10.

41. GR, "Interview with Sabine Schütz, 1990," in *DPP*, 216 [EMS].

42. GR, in Koldehoff, "Richter. Die Macht der Malerei," 18.

43. GR and Isa Genzken, "Beschreibung der Konzeption für die Gestaltung des U-Bahn-hofes, 'König-Heinrich-Platz,'" 1980.

44. GR and Isa Genzken, "Schlußbericht. Gestaltung des U-Bahnhofes, 'König-Heinrich-Platz,'" December 10, 1992.

45. Ibid.

46. GR, "Notes, 1981," in *DPP*, 99.

47. GR, "Text for catalogue of *documenta 7*, Kassel, 1982," in *DPP*, 100.

48. The show ran from May 30 to July 5, 1981.

49. GR, "Interview with Jonas Storsve, 1991," in *DPP*, 224.

50. Raimund Hoghe, "Düsseldorf: Georg Baselitz–Gerhard Richter," *Die Zeit*, June 19, 1981, 37.

51. Kasper König, conversation with the author.

52. GR, letter to Jürgen Harten, March 24, 1981.

53. Three additional works, *Yellow-Green* (*Gelbgrün*; CR 492), *Red* (*Rot*; CR 493), and *Lilac* (*Lilak*; CR 494), hung on the same floor but in a different wing of the building.

54. Twenty years later, however, on May 15, 2001, a private collector paid the record sum of $5,395,750 for *Three Candles* (*Drei Kerzen*, 1982; CR 513/1, 125 × 150 cm) at Sotheby's in New York City. At the 1982 Stuttgart exhibit, the prices for the works ranged from DM 16,000 for an 80-by-100-centimeter painting (CR 510/3) to DM 24,000 for *Two Candles* (*Zwei Kerzen*; 150 × 100 cm; CR 499/2).

55. Kasper König, conversation with the author.

56. Large abstract paintings, two meters square, that had been priced at DM 40,000 in 1982 climbed from the equivalent of DM 50,000 to DM 60,000. The landscapes were valued 50 percent higher than abstract paintings with the same format.

57. GR, in Dietrich, "An Interview," 131.

58. Jürgen Harten, Karl-Heinz Hering, Dieter Honisch, Ulrich Loock, and Dieter Ronte, "Preface," in *Gerhard Richter. Bilder 1962–1985* (catalog; Städtische Kunsthalle Düsseldorf, 1986), 6.

59. Gabriele Honnef-Harling, "Gerhard Richter. Bilder 1962–1985" [Gerhard Richter: Paintings, 1962–1985], *Kunstforum International*, March–May 1986, 232; Eduard Beaucamp, "Der virtuose Zweifler" [The virtuous skeptic], *Frankfurter Allgemeine Zeitung,* January 23, 1986, 25; Jürgen Hohmeyer, "Einfach ein Bild" [Simply a picture], *Der Spiegel*, January 20, 1986, 160.

CHAPTER 10

1. GR, "Notes, 1992," in *DPP*, 245.

2. GR, "Interview with Doris von Drathen, 1992," in *DPP*, 237.

3. GR, in Stefan Koldehoff, "Gerhard Richter. Die Macht der Malerei" [The power of painting] (interview), *Art. Das Kunstmagazin*, December 1999, 20.

4. GR, in Dieter Schwarz, "Über Aquarelle und verwandte Dinge. Gerhard Richter im

Gespräch mit Dieter Schwarz" [On watercolors and related things. Gerhard Richter in conversation with Dieter Schwarz], in Gerhard Richter and Dieter Schwarz, *Aquarelle/Watercolors 1964–1997* (catalog, Kunstmuseum Winterthur; Düsseldorf: Richter Verlag, 1999), 16.

5. Coosje van Bruggen, "Gerhard Richter, Painting as a Moral Act," *Artforum*, May 1985, 88.

6. GR, in Peter Sager, "Mit der Farbe denken" [Thinking with color], *ZEITmagazin*, November 28, 1986, 33–34.

7. Bazon Brock, *Besucherschule zur documenta 7* [Visitors school for Documenta 7] (Kassel, 1982), 74.

8. Julian Heynen, "Februar/März 2000" [February/March 2000], in *Gerhard Richter. Bilder 1999* (catalog; Kaiser Wilhelm Museum, Krefeld, 2000), n.p.

9. Dieter Schwarz, "Zwei Landschaften von Gerhard Richter," in *Texte zu Werken im Kunstmuseum Winterthur* (Düsseldorf: Richter Verlag, 1999), 239.

10. GR, in Koldehoff, "Richter. Die Macht der Malerei," 20.

11. GR, in Schwarz, "Zwei Landschaften," 238.

12. GR, "Interview with Rolf Gunther Dienst, 1970," in *DPP*, 64.

13. GR, "Interview with Doris von Drathen, 1992," in *DPP*, 23.

14. GR, "Notes, 1986," in *DPP*, 130.

15. GR, "Interview with Rolf Schön, 1972," in *DPP*, 71.

16. GR, "Interview with Jonas Storsve, 1991," in *DPP*, 227 [EMS].

17. See Hans-Ulrich Obrist, ed., *Gerhard Richter* (Munich/Stuttgart: Sils, 1992).

18. See Dietmar Elger, ed., *Gerhard Richter. Firenze* (Ostfildern-Ruit, 2001). See also GR, *City Life per Contempoartensemble* (Prato, 2002).

19. During a show that ran from October 3 to November 10, 1987, Zwirner offered *Claudius* (CR 604), one of Richter's paintings from Documenta 8, for DM 175,000. Fourteen years later, an anonymous buyer at auction paid $1.8 million for the work.

20. Fred Jahn, conversation with the author.

21. GR, "Notes, 1986," in *DPP*, 125 [EMS].

22. No fewer than six books and catalogs have been published on the cycle: *Gerhard Richter. 18. Oktober 1977*, with contributions by Gerhard Storck, Benjamin H. D. Buchloh, and Jan Thorn Prikker (catalog, Museum Haus Esters, Krefeld/Portikus, Frankfurt am Main; Cologne: Walther König, [1989] 2005); Hubertus Butin, *Zu Richters Oktober-Bildern* [On Richter's October paintings] (Cologne: Walther König, 1991); Kai-Uwe Hemken, *Gerhard Richter 18. Oktober 1977* (Frankfurt am Main/Leipzig, 1998); Martin Henatsch, *Gerhard Richter. 18. Oktober 1977* (Frankfurt am Main: Insel Verlag, 1998); Martin Henatsch, *Gerhard Richter. 18. Oktober 1977* (Frankfurt am Main: Fischer Verlag, 2001); and Robert Storr, *Gerhard Richter. October 18, 1977* (New York: Museum of Modern Art, 2000).

23. GR, "Notes for a press conference, November–December 1988," in *DPP*, 175.

24. For an illustration, see Storr, *Gerhard Richter. October 18, 1977*, 112.

25. GR, "Conversation with Jan Thorn Prikker concerning the Cycle *18 October 1977*, 1989," in *DPP*, 183–185.

26. Ibid., 190.

27. Ibid., 186 [EMS].

28. Kasper König, conversation with the author.

29. Ibid.

30. GR, "Interview with Doris von Drathen, 1992," in *DPP*, 236.

31. GR, "Notes, 1989," in *DPP*, 177–78 [EMS].

32. Georg Baselitz, *Darstellen, was ich selber bin. Georg Baselitz im Gespräch mit Eric Darragon* [Representations, what I am myself. Georg Baselitz in conversation with Eric Darragon] (Frankfurt am Main/Leipzig, 2001), 157.

33. Heiner Stachelhaus, "Der Terroristen-Tod—malerisch verschlüsselt" [The death of the terrorists—encrypted in painting], *Neue Ruhr Zeitung/Neue Rhein Zeitung*, November 2, 1989.

34. Jürgen Hohmeyer, "Das Ende der RAF, gnädig weggemalt" [The end of the RAF, painted mercifully away], *Der Spiegel*, February 13, 1989, 226.

35. Jean-Christophe Ammann, "18. Oktober 1977," *DU*, February 1989, 99.

36. GR, "Conversation with Jan Thorn Prikker," in *DPP*, 206.

37. Walter Grasskamp, "Gerhard Richter: 18. Oktober 1977," *Jahresring: Jahrbuch für Moderne Kunst* 36 (Munich: Verlag Silke Schrieber, 1989).

38. GR, "Conversation with Jan Thorn Prikker," in *DPP*, 192 [EMS].

39. GR, "Notes for a press conference," in *DPP*, 174 [EMS].

40. GR, "Interview with Sabine Schütz, 1990," in *DPP*, 174.

41. GR, "Notes for a press conference," in *DPP*, 174.

42. Hansgünther Heyme, "Trauerarbeit der Kunst muß sich klarer geben," *Art. Das Kunstmagazin*, April 1989, 15.

43. GR, "Notes, 1964–1965," in *DPP*, 37.

44. Ibid., 35.

45. GR, "Conversation with Jan Thorn Prikker," in *DPP*, 194.

46. GR, "Notes for a press conference," in *DPP*, 173.

47. GR, "Conversation with Jan Thorn Prikker," in *DPP*, 183.

48. Hohmeyer, "Das Ende der RAF," 232.

49. "If you could have any five artworks for your home, what would you choose?," *Frieze*, November/December 2001, 65–80.

50. N.N., "Ein Strahlemann kehrt zurück" [A golden boy returns], *Der Spiegel*, September 30, 1993, 250.

51. Benjamin H. D. Buchloh, "Die Malerei am Ende des Sujets," in *Gerhard Richter* (catalog; Kunst- und Austellungshalle der Bundesrepublik Deutschland, Bonn, 1993), 2:56. See also Rudolf Schmitz, "Gerhard Richter," *Frankfurter Allgemeine Magazin*, January 7, 1994, 17; Stefan Germer, "Familienanschluß. Zur Thematisierung des Privaten in neueren Bildern Gerhard Richters" [Family connection. On the thematization of the private in newer works by Gerhard Richter], *Texte zur Kunst*, June 1997, 111–12.

52. GR, "Conversation with Jan Thorn Prikker," in *DPP*, 192.

53. Axel Hecht, "Wohlfeile Klagen um das deutsche Geschichtsbild," *Art. Das Kunstmagazin*, July 1995, 105.

54. Hubertus Butin and Gerhard Richter, "Richters RAF-Zyklus nach New York verkauft: kultureller Gewinn oder Verlust?" (interview), *Kunstforum International*, no. 132, November 1995–January 1996, 433.

55. GR, in ibid.

56. GR, "Conversation with Jan Thorn Prikker," in *DPP*, 197.

57. Don DeLillo, "Baader-Meinhof," *New Yorker*, April 4, 2002.

58. Torsen H. Wallraff, "Gerhard Richter," *Noema,* Summer 1989; Bertram Müller, "Der Tod der Terroristen," *Rheinische Post,* February 15, 1989.

59. GR, "Conversation with Jan Thorn Prikker," in *DPP*, 197.

60. GR, "Notes for a press conference," in *DPP*, 173.

61. Storr, *Gerhard Richter. October 18, 1977*, 98n11.

62. Ulf Erdmann Ziegler, "Wie die Seele den Leib verläßt. Gerhard Richters Zyklus, '18. Oktober 1977,' das letzte Kapitel westdeutscher Nachkriegsmalerei" [How the soul leaves the body. Gerhard Richter's cycle, *18 Oktober 1977*, the last chapter for West German postwar painting], in *Deutschlandbilder. Kunst aus einem geteilten Land* [Pictures of Germany. Art from a divided country] (catalog; Martin-Gropius-Bau, Berlin, 1997), 412.

63. Benjamin H. D. Buchloh, "Gerhard Richter: 18. Oktober 1977," in *Gerhard Richter. 18. Oktober 1977* (Museum Haus Esters catalog), 59.

64. GR, "Notes for a press conference," in *DPP*, 174.

65. GR, "Interview with Sabine Schütz, 1990," in *DPP*, 207.

66. GR, "Conversation with Jan Thorn Prikker," in *DPP*, 207.

67. GR, "Notes, 1990," in *DPP*, 220.

CHAPTER 11

1. GR, "Interview with Rolf Gunther Dienst, 1970," in *DPP*, 63.

2. GR, "Notes, 1981," in *DPP*, 98.

3. GR, in Christiane Vielhaber, "Interview mit Gerhard Richter," *Das Kunstwerk*, no. 2, April 1986, 43.

4. GR, "Interview with Sabine Schütz, 1990," in *DPP*, 216.

5. GR, "Notes, 1985," in *DPP*, 118–119; GR, "Interview with Jonas Storsve, 1991," in *DPP*, 223; GR, "Interview with Hans-Ulrich Obrist, 1993," in *DPP*, 270.

6. GR, "Interview with Sabine Schütz, 1990," in *DPP*, 216.

7. Ibid., 213.

8. GR, "Text for exhibition catalogue, Galerie h, Hannover, 1966, written jointly with Sigmar Polke," in *DPP*, 41.

9. GR, "Text for catalogue of *documenta 7*, Kassel, 1982," in *DPP*, 100.

10. Ibid.

11. GR, "Notes, 1981," in *DPP*, 98.

12. GR, quoted in Marlies Grüterich, "Gerhard Richters Phänomenologie der Illusion—Eine gemalte Ästhetik gegen die reine Malerei" [Gerhard Richter's phenomenology of illusion—a painted aesthetic against pure painting], in *Gerhard Richter. Bilder aus den Jahren 1962–1974* (catalog; Kunsthalle Bremen, 1975), 60.

13. GR, "Interview with Doris von Drathen, 1992," in *DPP*, 235.

14. GR, "Text for catalogue of *documenta 7*, Kassel, 1982," in *DPP*, 100.

15. GR, "Notes, 1962," in *DPP*, 15.

16. Rudolf Schmitz, "Gerhard Richter," *Frankfurter Allgemeine Magazin*, January 7, 1994, 17.

17. GR, "Conversation with Jan Thorn Prikker concerning the Cycle *18 October 1977*, 1989," in *DPP*, 199.

18. Kasper König and Wolfgang Max Faust, "Kasper König in Frankfurt" (interview), *Wolkenkratzer Art Journal,* November/December 1987, 34.

19. GR, in Christiane Vielhaber, "'Manchmal hat man eben keine Lust, abstract zu malen . . .' Ein Gespräch mit Gerhard Richter" [Sometimes you just don't feel like painting abstract art. A conversation with Gerhard Richter] *Kunst Köln*, no. 1, 1989, 23.

20. GR, in Jürgen Hohmeyer, "Selbstentblößung in Schmerz und Wut" [Self-exposure in pain and anger], *Der Spiegel*, March 25, 1996, 216; GR, letter to Benjamin H. D. Buchloh, May 12, 1975.

21. GR, "Conversation with Jan Thorn Prikker," in *DPP*, 207.

22. GR, in Vielhaber, "'Manchmal hat man eben keine Lust,'" 18.

23. Henning Lohner, conversation with the author.

24. Thomas Wagner, "Die Kunst schlägt Purzelbaum" [Art turns a somersault], *Frankfurter Allgemeine Zeitung*, June 17, 1992, 33.

25. Wolf Schön, "Nabelschau des Himmelsstürmers" [The navel-gazing of an idealist], *Rheinischer Merkur,* June 19, 1992, 19.

26. GR, in N.N., "Ein Strahlemann kehrt zurück" [A golden boy returns], *Der Spiegel,* September 20, 1993, 250.

27. *Gerhard Richter. Catalogue Raisonné 1962–1993* was published as a boxed set by Hatje Cantz Verlag. Volume 1 includes a complete catalog of the exhibition. Volume 2, profusely illustrated in black and white, includes texts by Buchloh, Peter Gidal, and Birgit Pelzer. Volume 3 is a version of Richter's own catalogue raisonné updated to 1993, with approximately 2,000 paintings and sculptures reproduced in four-color and black and white plates. It also includes a biography, exhibition history, bibliography, and filmography (in German).

28. Doris von Drathen, "Gerhard Richter," *Kunstforum International,* no. 124, November–December 1993, 425.

29. GR, in Uwe M. Schneede, *Gerhard Richter in der Hamburger Kunsthalle* (Hamburg, 1997), 33.

30. This is most apparent in the body position of the two figures in the last painting in the group (CR 827/8). In the *Atlas,* the photographs of the young woman with the baby fill a total of 30 panels (panels 586–615), yet Richter chose only seven for his paintings, using one of these photos as the basis for two of the painted works.

31. GR, in Schneede, *Gerhard Richter in der Hamburger Kunsthalle,* 35.

32. Hohmeyer, "Selbstentblößung in Schmerz und Wut," 218.

33. Gislind Nabakowski, "Heilig, heilig, heilig" [Holy, holy, holy], *Frankfurter Allgemeine Zeitung,* July 18, 1996, 36.

34. Stefan Germer, "Familienanschluß. Zur Thematisierung des Privaten in neueren Bildern Gerhard Richters" [Family connection. On the thematization of the private in newer works by Gerhard Richter], *Texte zur Kunst,* June 1997, 115.

35. Fred Jahn, conversation with the author.

36. GR, in David Galloway, "Quick-Change Master," *Artnews,* March 2002, 107.

37. GR, in Stefan Koldehoff, "Gerhard Richter. Die Macht der Malerei" [The power of painting] (interview), *Art. Das Kunstmagazin,* December 1999, 19. In conjunction with the Reichstag commission, Richter created four editions and eight colored mirror objects titled *Black-Red-Gold* (*Schwarz-Rot-Gold,* 1998, CR 855; 1999, CR 856/1–7), each a variation on the tricolor theme.

38. GR, in Julian Heynen, "Februar/März 2000" [February/March 2000], in *Gerhard Richter. Bilder 1999* (catalog; Kaiser Wilhelm Museum, Krefeld, 2000), n.p.

39. Robert Storr, "Introduction," in *Gerhard Richter: Forty Years of Painting* (catalog; Museum of Modern Art, New York, 2002), 13. At the same time, the *New York Times Magazine* published an extensive profile of the artist (Michael Kimmelman, "An Artist beyond Isms," January 27, 2002, 20).

40. Robert Storr and Tom Holert, "Call to Order" (interview), *Artforum,* January 2002, 101.

41. Peter Schjeldahl, "The Good German," *New Yorker,* March 4, 2002, 84.

42. Robert Storr, "Permission Granted," in *Gerhard Richter: Forty Years of Painting,* 89.

CHAPTER 12

1. GR, in Jürgen Harten, "Der romantische Wille zur Abstraktion" [The romantic will to abstraction], in *Gerhard Richter. Bilder 1962–1985* (catalog; Städtische Kunsthalle Düsseldorf, 1986), 33.

2. The Berlin edition appeared in a limited run of eighty copies and measured 16 by 4.7 by 4.1 centimeters. A second edition, *Prisma II,* was published simultaneously by Richter's Japanese gallery, Wako Works of Art, Tokyo; it was limited to eighty-eight copies and was

slightly smaller in size (12 × 4.7 × 4.1 cm). See *Gerhard Richter. Editionen 1965–2004* (catalog; Kunst Museum Bonn, 2004).

3. GR, (Untitled, 1982), in *Gerhard Richter: Text 1961 bis 2007. Schriften, Interviews, Briefe*, ed. Dietmar Elger and Hans Ulrich Obrist (Cologne, 2008), 121. See also GR, "Notes, 1982," in *DPP*, 100.

4. The cycle was first shown in Düsseldorf, at the Kunstsammlung Nordrhein-Westfalen, from December 2, 2004, to May 16, 2005; the exhibition then traveled to the Kunstbau, Städtische Galerie im Lenbachhaus, Munich (June 4–August 21, 2005). *Gerhard Richter* (Kunstsammlung Nordrhein-Westfalen, Düsseldorf, 2005). The Düsseldorf museum eventually acquired the group; the purchase hinged on major contributions from several sponsors and foundations, a fact stressed by museum director Armin Zweite in a publication that accompanied the purchase. See Armin Zweite, "Die Silikat-Bilder von Gerhard Richter und andere Mikrostrukturen" [The silicate paintings of Gerhard Richter and other microstructures], in *Gerhard Richter, Silikat*, ed. Kulturstiftung der Länder (Berlin, 2007; Patrimonia [series] no. 322), 12.

5. Zweite, "Die Silikat-Bilder," 14n19.

6. The exhibition took place from November 17, 2005 to January 14, 2006. The catalog included texts by Benjamin H. D. Buchloh and Dieter Schwarz, as well as an interview with Richter by Buchloh.

7. GR, in Jan Thorn Prikker, "Gerhard Richter im Gespräch mit Jan Thorn-Prikker" [Gerhard Richter in conversation with Jan Thorn Prikker], in *Gerhard Richter im Albertinum* (catalog; Galerie neue Meister, Albertinum, Dresden, 2004), reprinted in *Gerhard Richter: Text*, 492.

8. GR, in Susanne Beyer and Urike Knöfel, "Mich interessiert der Wahn" [I am interested in the illusion] (interview), *Der Spiegel*, August 15, 2005, reprinted in *Gerhard Richter: Text*, 514–15.

9. GR, in Hans-Ulrich Obrist, "Gerhard Richter" (interview), *Domus*, no. 899 (January 2007), 540. Translated from the original German transcript.

10. GR, in Georg Imdahl, "Das südliche Fenster und seine Erstrahlung" [The south window and its lumination] (interview), *Kölner Stadt-Anzeiger*, February 3, 2005, reprinted in *Gerhard Richter: Text*, 508.

11. GR, "Notizen zur Pressekonferenz" [Notes for a press conference], July 28, 2008, in *Gerhard Richter: Text*, 527.

12. The exhibition *Gerhard Richter—Zufall, das Kölner Domfenster und 4900 Farben* [Gerhard Richter—Coincidence, the Cologne Cathedral Window and 4,900 Colors] took place from August 25, 2007, to January 13, 2008.

13. Archibishop Joachim Meisner, quoted in the *Kölner Express*, August 30, 2007, 9.

14. See Michael Kimmelman, with photographs by Thomas Struth, "Let There Be Art: Houses of Worship Where the Feelings of Exaltation Come from the Light," *New York Times Style Magazine*, Holiday 2007 issue (December 2).

ILLUSTRATION CREDITS

Listing is by figure number. Images not listed below courtesy of the Gerhard Richter Studio.

2.7
Photograph: Heinrich Riebesehl

2.8, 2.9, 4.12
Photographs: Reiner Ruthenbeck, Ratingen

3.1, 11.8
Photographs: Benjamin Katz

3.2
Photograph courtesy of Archiv Galerie Schmela, Düsseldorf

3.4, 3.5
Photographs courtesy of Archiv Galerie Konrad Fischer, Düsseldorf, and the Estate of Konrad Lueg

3.8, 4.10, 11.17, 11.21
Courtesy Städtische Galerie im Lenbachhaus, Munich

3.11
Photograph: Beatrice Shoppmann

4.9
Photograph: The Philadelphia Museum of Art/Art Resource, NY

INDEX

U-Bahn, König-Heinrich-Platz, Duisburg (collaboration with Genzken), 252–55; social component of, 255

Uecker, Günther, 68–69, 96, 143, 144, 333; collaboration with Richter, 155–56

Ulbricht, Günther, 222

Uncle Rudi (Rudolf Schönfelder), 6, 50, 124, 133–40, 144, 363; in "Hommage à Lidice," 143; personal nature of, 137

United States of America, Richter's initial reception in, 221–23

Untitled (green) (*Ohne Titel [grün]*), 196, 209–10

van Bruggen, Coosje, 220, 267

Venice Biennale 1972, 155, 194–201; German pavilion, 194, 197. See also *48 Portraits*

Vermalung. See inpainting (*Vermalung*)

Vermeer, Jan, 325

Victoria I–II, 278, 320, 322

Victoria-Versicherung, 278

Vietnam war, 152, 163, 282

Vostell, Wolf, 96, 144

Wagner, Thomas, 322

Wald (*Forest*) series, 349–52

Waltersdorf, 5, 6, 357

War and Peace (Tolstoy), 252

warfare, aerial, 163–65; *Bombers*, 165; *Bridge 14 Feb 45*, 163; childhood fascination with, 6, 165; *Stukas*, 165, 361

Warhol, Andy, 88–93, 112; comparison with Richter, 91–92; Richter on, 92

Warstat, Willi, 85

Waterfall (*Wasserfall*), 315

Wedewer, Rolf, 175

Weiner, Lawrence, 153, 169

Werkverzeichnis (worklist), 44

Werner, Michael, 278

Westwater, Angela, 236

Whitechapel Art Gallery, London, 242

Wide White Space, Antwerp, 119–20

Wilhelm, Jean-Pierre, 33, 60

Window (*Fenster*), 147

Woman Descending the Staircase (*Frau, die Treppe herabgehend*), 85, 88

Woman with Umbrella (*Frau mit Schirm*), 50, 89; and Warhol, 92

Wunderlich, Paul, 117, 365

Youth Portrait (*Jugendbildnis*), 284; and *Betty*, 307–8

Zeit, die, 118, 227, 259

ZERO, 34, 37, 76

Zweite, Armin, 348

Zwirner, Rudolf, 94, 106, 112, 278; concerns about Richter's style, 166; Galerie Zwirner, 155

DATE			